The Edwardian Sense

Studies in British Art 20

The Edwardian Sense
Art, Design, and Performance
in Britain, 1901–1910

Edited by Morna O'Neill and Michael Hatt

Published by
The Yale Center for British Art
The Paul Mellon Centre for Studies in British Art

Distributed by
Yale University Press, New Haven & London

Published by

The Yale Center for British Art
P.O. Box 208280
1080 Chapel Street
New Haven, CT 06520-8280
www.yale.edu/ycba

and

The Paul Mellon Centre for Studies in British Art
16 Bedford Square
London WC1B 3JA
United Kingdom
www.paul-mellon-centre.ac.uk

Distributed by

Yale University Press
P.O. Box 209040
302 Temple Street
New Haven, CT 06520-9040
www.yalebooks.com

Volume edited by Morna O'Neill and Michael Hatt
Publication coordinated by Eleanor Hughes at the Yale Center for British Art
Copyedited by Richard Slovak
Index by Nancy Wolff

Designed by Miko McGinty Inc.
Set in Garamond by Tina Henderson
Separations by Prographics Inc., Rockford, Illinois; Printed in Canada by Friesens

Library of Congress Cataloging-in-Publication Data

The Edwardian sense : art, design, and performance in Britain, 1901–1910 / edited by Morna O'Neill and Michael Hatt.
 p. cm. — (Studies in British art ; 20)
 Includes bibliographical references and index.
 ISBN 978-0-300-16335-3
 1. Arts, Edwardian. 2. Arts and society—Great Britain—History—20th century. I. O'Neill, Morna. II. Hatt, Michael. III. Title: Art, design, and performance in Britain, 1901–1910.
 NX454.5.E35E39 2010
 700.941'09041—dc22

2009040170

A catalogue record for this book is available from the British Library.
10 9 8 7 6 5 4 3 2 1

This is the twentieth in a series of occasional volumes devoted to studies in British art, published by the Yale Center for British Art and the Paul Mellon Centre for Studies in British Art.

Jacket illustrations: (front) William Nicholson, The Conder Room, oil on canvas (1910), 36 x 28 in. (91.4 x 71.1 cm). With Agnew's. (back) Film still (detail) from Georges Méliès, Le Sacre d'Edouard VII (The Coronation of Edward VII) (France, 1902). British Film Institute, National Archive.

Contents

Acknowledgments

FROM ITS VERY INCEPTION, this volume was the product of fruitful collaboration. Its topic grew out of the establishment of the Research Department at the Yale Center for British Art and a discussion among colleagues about the relationship between exhibitions and their publications. The editors are indebted to Amy Meyers, Director of the Center, for her vision in founding the Research Department and for the atmosphere of intellectual curiosity she fosters at the museum. Likewise, we are grateful to Angus Trumble, Curator of Paintings and Sculpture, for engaging in this dialogue as he plans an exhibition on art during the reign of Edward VII.

This volume was always conceived as a multiauthored book rather than a collection of essays. As such, it was developed around three workshops. At the first of these, in 2005, Christopher Breward, Lynda Nead, and Andrew Stephenson provided generous feedback and a critical perspective that was crucial for shaping the project in important ways. We would also like to thank Cassandra Albinson, Amy Meyers, Angela Sagues, Angus Trumble, and Andrea Wolk Rager for their contributions to that discussion. The discussion continued in London in 2006 and 2008, when we were fortunate enough to be guests of Christopher Breward and the Research Department at the Victoria and Albert Museum, which generously hosted two further workshops for the contributors to the volume. We are indebted to all the authors for their thoughtful engagement with the project, and we particularly thank James Ryan for his vital contributions to the 2006 event. We are grateful to Lisa Ford, Serena Guerrette, and Imogen Hart of the YCBA for the successful realization of these events, as well as Yale University student intern Alexis Krumme, who provided vital administrative and research support for the project throughout 2006–7.

We owe a great debt to the Department of Publications and Exhibitions. Julia Marciari Alexander put the project on track, and Eleanor Hughes has seen it through with admirable patience and humor. Jo Briggs contributed important assistance with research, and Anna Magliaro provided an invaluable service in securing images and captions. We also thank Richard Slovak, the book's copy editor, and Miko McGinty and Rita Jules, its designers.

Morna O'Neill and Michael Hatt

Introduction: Our Sense of the Edwardians

Morna O'Neill

Ever since George Dangerfield's classic text *The Strange Death of Liberal England* appeared in 1935, most scholarly discussions of Britain during the reign of Edward VII (1901–10) have characterized the era as one of continual upheaval, from the contentious resolution of the Anglo-Boer War in 1901 to the fiercely contested general elections in 1910.[1] Upon his ascension Edward VII ruled one-quarter of the globe, yet his sovereignty over the geographic entity known as "the British Empire" seemed less secure, and thus "Edwardian" remains a potent descriptor in historical studies, deployed to evoke the vicissitudes of political consensus or the dangers of imperial complacency. Dangerfield paid particular attention to the "Liberal crisis" of the period, first examined by the economist J. A. Hobson in his 1909 study, *The Crisis of Liberalism*.[2] The Liberal Party, the self-proclaimed "people's government," elected in a landslide in 1906, struggled to govern amid internecine debates, external pressure from Labour and Irish MPs, and legislative interference from a more conservative House of Lords—alongside the varied provocations of anarchist bombs and militant suffragettes.

The popular image of the Edwardian period, however, is that of a "golden summer," a perpetual aristocratic country-house party presided over by a playboy king. Only the advent of the First World War and the grim reality of trench warfare could disrupt this idyll.[3] The view has persisted, despite numerous historical studies that have explored the Edwardian period as one of "radical challenges to the established order."[4] Indeed, popular views of Edwardian Britain tend to the intensely nostalgic, as demonstrated by films from *Mary Poppins* (1964) to *A Room with a View* (1985), or by the extraordinary success of *The Country Diary of an Edwardian Lady* (1977), a best-selling book that launched a wide variety of merchandise, eagerly bought by audiences on both sides of the Atlantic.

This last example, which was the facsimile of the diary kept in 1906 by Edith Blackwell Holden, a teacher, reveals how this nostalgia for the long golden summer was, in part, crafted by the Edwardians themselves. They were nostalgic for their own moment, often projecting a sense of what might be lost to themselves and to

future generations. This is evident in a wide range of Edwardian art, from the impossibly picturesque cottage gardens of Helen Allingham to the knowing portraits of John Singer Sargent, an artist who understood very well his sitters' wish to project an image of perfection to the future. At the end of the film version of *Mary Poppins*, the sash of the faint-hearted suffragette Mrs. Banks becomes the tail of the kite that the family flies in Regent's Park, thus marking the end of political challenge: the suffragette is once again a mother, the father is returned to his family, and social and personal fractures are healed in an image of bliss and order. This image has its roots in the Edwardians' own mythmaking. The modern sense of the Edwardians is profoundly indebted to the Edwardians' own self-fashioning.

One of the most important attempts to revise the popular understanding of the period occurred in 1987: *The Edwardian Era*, the landmark exhibition held at the Barbican Art Gallery in London and the catalogue of the same title edited by Jane Beckett and Deborah Cherry (who are identified in the catalogue as scholars of both cultural studies and art history).[5] The exhibition set out to trouble the reputation of the era for ostentation and complacency, stating at the outset that the images of class harmony, for example, were "illusory" amid a reality of "transformation" and "confrontation." In their introduction Beckett and Cherry asked the searching questions that guided their reexamination of Edwardian visual culture: "Who had access to representation? Who had the power to represent themselves, their social group, to inscribe their gendered, class, and racial position in the imagery of the time? What were the conditions in which these images were produced, bought, and understood?"[6] Two decades later it would be easy to dismiss this project as one driven by the identity politics of the late 1980s. Yet to do so would be to overlook the necessary and important work achieved by raising these questions. As John Hoole, then curator at the Barbican Art Gallery, acknowledged in the foreword to the catalogue, *The Edwardian Era* "will in time be judged as a curious success or as a magnificent failure."[7] If the current state of scholarship on Edwardian art is an acceptable barometer, then the project was both. It changed forever the "golden summer" model of the era by bringing more recent scholarship from history and politics to bear on art history. Yet the emphasis on the power dynamics of representation overlooked the very real role that visual culture played in formulating the important questions asked by the authors. The profusion of the visual image in this period, from the proliferation of the illustrated periodical to the birth of film, created a vast archive that scholars have only begun to examine. Furthermore, most of the catalogue authors failed to distinguish between the different types of visual images in this array. Important aesthetic concerns that might have allowed the consideration of painting, for example, to question the standard narrative of early-twentieth-century British art were ignored. As Alison Light

pointed out in her perceptive critique of the exhibition and publication in *History Workshop*, there was "no recognition here of a painting as a *text*, one produced in a social situation, an ambivalent one for artists who may by no means be fully identified with their subject and who in any case can be betrayed by all sorts of unconscious perceptions."[8] We might revise this suggestion to consider paintings not as texts, but as paintings. In other words, how do art, design, and performance produced in the Edwardian period not only register these confrontations, but constitute some of the very terms of the debate?[9]

Art history has been slow to take up this challenge. The sense of crisis does not appear in most accounts of early-twentieth-century British art until 1910, when, one month after the death of Edward VII, the exhibition *Manet and the Post-Impressionists* opened at the Grafton Galleries in London. Roger Fry organized it to introduce the visual idiom of French modernism to an English audience. Critics warned viewers against the "degeneracy" and "anarchy" on display.[10] Subsequent art historical literature has focused on these outraged responses to establish the parameters of "Victorian" (those against the exhibition) and "Modern" (those who organized and supported the exhibition). In this formulation the artistic values of the late Victorian era, usually characterized as narrative and representation, predominated until 1910. They were finally overthrown, or at least challenged, by the arrival of Post-Impressionism in England. This narrative elides "Edwardian" almost entirely from art historical discourse, and it disregards vital debates over the form and meaning of art in the first decade of the twentieth century. Instead it privileges the enlightened and complex "Moderns" over the moralizing and utopian Victorians, whose values, presumably, extended well into the first decade of the twentieth century.[11] The essays in the present volume, in contrast, cut across the Victorian/Modern divide to ask what was "Edwardian" about the art of this period. Roger Fry's own sense of the Edwardian era provides an interesting case study.

Fry effectively collapsed "Victorian" and "Edwardian" in his writings from the first decade of the twentieth century. Both Ruth Livesey and Elizabeth Prettejohn, however, have demonstrated the origin of his later aesthetics in the writings of William Morris and Walter Pater, respectively.[12] Their scholarship provides a more complex picture of Fry's own aesthetic development and complicates the Manichean binary of "Victorian" and "Modern" described earlier. In "An Essay in Aesthetics," published in the *New Quarterly* in 1909, Fry distanced himself from his earlier enthusiasm for late Victorian art criticism. Although the essay signals a shift to the formalist aesthetic associated with his volume *Vision and Design* (1920),[13] at this point the theorization of "significant form" had not yet emerged.[14] He still seems to wrestle with the influence of John Ruskin in this particular essay. For example, the statement "art orders and evolves models from the observation of our actual

life,"[15] acknowledges Ruskin's dictum of "truth to nature." Fry was emphatic, however, in his rejection of Ruskin's social critique developed in texts such as *Unto This Last* (1860/62). Although "actual life" orders these artistic models, it "does so precisely by virtue of its freedom from morality, use value, means-end rationality, or any other values promoted by modernity."[16] By "modernity," Fry meant the prevailing social mores, under challenge from the enlightened artistic "modernism" that he championed. What might surprise readers today is Fry's characterization of modern values circa 1909: "morality," "use value," and "means-end rationality." The Victorian chestnuts of morality and utilitarianism coexist with a "means-ends" calculus of Edwardian imperialism and late capitalism.

In many ways the socialist Fabian Society represents the modernity that Fry derided in his essay. The political group emerged as a distinctively Edwardian organization, gaining prominence and influence over the first decade of the twentieth century, using pamphlets, statistics, and an appeal to "means-end rationality" to influence public policy.[17] Fabians pervaded the newly established London County Council, leaving their mark on the municipal government in the following decades, and the opening of the London School of Economics in 1895 (the school issued its first degrees in 1902) cemented the Fabian commitment to reform rather than revolution.[18] Yet they also realized the forces of "romanticism, culture, [and] humanism" in the socialist movement; according to future prime minister and Fabian Society member Ramsay MacDonald, writing in 1911, art constituted "the drum taps to which the steps of Socialism keep time."[19]

The artistic and political debates generated by the Fabian George Bernard Shaw's *John Bull's Other Island* (1904) is one example of the intertwined spheres of politics and culture in the Edwardian period.[20] Although William Butler Yeats commissioned the play for Dublin's Abbey Theatre, he declined to produce it; the theater could not accommodate Shaw's elaborate staging, which included plans for a hydraulic bridge and a motorcar.[21] In the play, through the motorcar and other aspects of modern life, including enthusiastic plans to build a golf course and resort in the tiny village of Roscullen, Shaw exposes the dangers for all parties in romantic stereotypes of Ireland and the Irish. The political is always cultural, and it is always personal. As the Hibernophile protagonist Thomas Broadbent declares, "I am an Englishman and a Liberal; and now that South Africa has been enslaved and destroyed, there is no country left to me to take an interest in but Ireland."[22] Throughout the play, however, Broadbent has his illusions (and stereotypes) about the essential goodness and naïveté of the Irish villagers stripped away.

Edward VII demanded a royal command performance of Shaw's "Irish play" after its run at the Royal Court Theatre in London (1904–5), during which time the Conservative prime minister Arthur Balfour (a former chief secretary for Ire-

land) managed to attend no fewer than five times.[23] The king had to satisfy himself with a "special performance" on 11 March 1905, after Shaw, asserting his socialism, declined to authorize a "command" performance.[24] Legend has it that "the King laughed so hard he broke the chair he was sitting on."[25] Edward and, according to Shaw himself, "a whole row of cabinet ministers"[26] looked to this caustic play to provide insight into Irish nationalist concerns. Shaw reflected on this popularity with his "Preface for Politicians," written in 1907 and published with subsequent editions of the play. In it he declared that his other protagonist, the Anglicized Irishman Larry Doyle, develops his "freedom from illusion" and "the power of facing facts" through "social persecution and poverty."[27] The play suggests the distinctly modern character of Doyle's experience and the lessons that might be gleaned from his imperial identity crisis.

Shaw spoke out against the German social critic Max Nordau's theories of artistic "degeneration," in a lengthy essay first published as "A Degenerate's View of Nordau" in the radical American newspaper *Liberty* in 1895 and later reprinted in pamphlet form in 1908 as *The Sanity of Art*. In his rejoinder to Nordau's view that all modern art is "diseased," Shaw pointed out in his opening paragraph that "there is nothing new in Dr. Nordau's outburst. I have heard it all before. At every new wave of energy in art the same alarm has been raised."[28] These alarms certainly included texts such as E. Wake Cook's *Anarchism in Art and Chaos in Criticism*, an invective against the defense of Impressionism put forth by "New Art Critics" such as D. S. MacColl.[29] In his essay Shaw celebrated Impressionism as one of the "Reformations"[30] he had witnessed in the fine arts, alongside the operas of Richard Wagner and the dramas of Henrik Ibsen, a concise program of Shaw's own interests.[31]

Within this context Fry's championing of Post-Impressionism took on a distinctly Edwardian cast when he replaced "modernity" with "modernism" as the cornerstone of his aesthetic philosophy. Fry did not define himself against late Victorian art and culture; rather, his aesthetic was informed by a reaction to Edwardian cultural debates. As Ruth Livesey has suggested, the later disavowal of the "Edwardian" Shaw by the "Georgian" Bloomsbury Group can be seen as a protest against "the reduction of aesthetics to a functional social good."[32] According to Fry, the purpose of art is now "adapted to that disinterested intensity of contemplation," severing the connection between modern life and modernism.[33] Just as Shaw defended Impressionism and its relation to modern life, Fry looked to the formal qualities of Post-Impressionism as "disinterested." Recent studies have contextualized Fry's modernism and sought to expand the boundaries of this formulation. David Peters Corbett and Lara Perry have argued that any definition of "modernism" should extend to all art "that grows out of and responds to modern

conditions," thus reuniting modernity with modernism.[34] For Lisa Tickner, such efforts constitute "local modernisms" that reflect a "local inflection to the web of relations that makes up the cultural field."[35] The Fabian Society is one prominent example of a "local modernism" that inflects both politics and culture. This case reminds us that artistic modernism is not merely a matter of style; rather, as the Edwardian art world demonstrates, it is also a product of politics and public debate, as well as exhibitions, publicity, and organizations.[36]

THE EDWARDIAN SENSE

This collection of essays takes "Edwardian" as a starting point to reframe art, design, and performance in Britain from 1901 to 1910, by presenting a cross section of the diverse intellectual histories of different artistic mediums: painting, sculpture, design, decorative arts, film, public spectacle, and mass media. The focus on the Edwardian "sense" works in multiple ways, to consider the visual, the spatial, and the geographic. It addresses the question of periodization to consider both contemporary conceptions—the people's sense of their own Edwardianism—and its historical afterlife. In addition, it attends to the structure of Edwardian culture. While acknowledging the familiar divisions between the highbrow world of aesthetic theory and the popular delights of the music hall, or between the neo-Baroque magnificence of central London and the slums of the East End, this volume also turns its attention to what lies between these poles: the cultural and spatial territories, such as the middlebrow or the anonymous edge of the city, that complicate our understanding of the period. The volume is divided into three sections under the broad headings of spectacle, setting, and place. Each section contains two different kinds of essays: short, focused responses to a single object or image and longer, synthesizing essays. The authors take "Edwardian" as both a historical period and a conceptual framework in revisiting 1901–10 as a periodization in art history and cultural studies.[37]

The volume opens with a consideration of spectacle. In the short-response essays, Tom Gunning, Bronwen Edwards, and Angus Trumble all evaluate film footage of the coronation of Edward VII and Alexandra as a moment that inaugurates the central concerns of the era. As Tom Gunning discusses, the conjunction of monarchy and cinema raised new questions about access and the burgeoning celebrity culture. Furthermore, the technological limitations of the medium required Georges Méliès to hire actors to perform the coronation; due to the future king's illness, however, this film ended up functioning not as a reenactment but as a pre-staging of the event. While Méliès's pre-staging brings to mind the entire

coronation ceremony as an "invented tradition," Bronwen Edwards discusses the importance of movement to the coronation, as the procession traveled through shopping and theater districts. London emerges as the capital of empire, boldly asserted by the decorative "Canadian arch." For Angus Trumble, the coronation of Edward VII provided an example of spectacle both reassuringly traditional and strikingly modern, whether from the vantage point of spectators in London or those viewing the film in Australia.

Spectacle, as it emerges in the essays that follow, marks the "modernity" of the period, albeit one without Fry's modernism. In Deborah Sugg Ryan's essay, the pageant movement emerges not only as a popular expression of community and patriotism but also as an example of the "popular modernism" that pervaded Edwardian culture, a combination of modern developments with a respect for tradition, however invented. We could configure "popular modernism" as "suburban modernity," a move suggested by David Gilbert's examination of sporting culture and the suburbs around the 1908 Olympics. In Gilbert's account the parson's daughter and tennis champion Dorothea Chambers is the standard-bearer for this type of modernity: conservative, even traditional, but still distinctly Edwardian. For Lynda Nead, the sense of being "of the moment," in terms of experience and the perception of that experience, characterizes this modernity. Motion, whether configured as "rush" or as "statis," emerges as a vital mode of Edwardian experience.

The essays in the section on setting attend to intimacy, scale, and display. Three considerations of William Nicholson's oil painting *The Conder Room* (1910, private collection) introduce this section. In her response to Nicholson's painting, Imogen Hart contextualizes the confrontation between "modernity" and "modernism" in the historiography of Edwardian art. In her evocation of a lost "Arcadia" in Charles Conder's decoration, Hart provides a new way to think about the myth of the Edwardian "golden summer." In Barbara Penner's and Charles Rice's essay, the mysterious "decoration" provided by Conder for the living room of Pickford Waller's London home suggests one way to interpret the relationship between subjects and interiors. Their discussion of the decoration as "Art Nouveau" alludes to the cosmopolitan dimension of design in this period as well as to the way in which subsequent periodization has disrupted such transnational dialogues. By interpreting Nicholson's painting through E. M. Forster's *A Room with a View* (1908), Michael Hatt suggests that both works of art come to terms with Edwardianism. While Forster's novel retains the narrative structure of social comedy, Nicholson's painting, tense and strange, dips into melancholy.

By examining the spaces of Edwardian interior decoration, the subsequent essays move beyond narrow considerations of Edwardian art to address design, decorative art, and the larger issue of a period "lifestyle." In his discussion of

Edwardian theater, Christopher Breward looks at the dynamic interaction between "fashionability" and "respectability" on the Edwardian stage. Both categories find their origins, and thus their instability, in the presentation of the interior. Origins (indeed, the origin of that evergreen "golden summer" characterization of the period) and their instability likewise permeate Christopher Reed's discussion of the Edwardian interior. For Reed, what has previously been considered a "stylistic free-for-all" in Edwardian interior decoration represents instead a search for meaning. The desire for interiors to express the ideas and ideals of their inhabitants reached its apogee in this moment of crisis.

Moving from the city to the countryside and throughout the British Empire, the essays in the final section examine nationalism, imperialism, and cosmopolitanism under the rubric of place. The introductory essays focus on George Frampton's bronze statue *Peter Pan* (1910–12), placed—not without controversy—in Kensington Gardens in London. In Anne Helmreich's reading, this statue, and its placement in Kensington Gardens, generated significant debates about the role and function of public park space. Did the commemoration of a fictional character in the park delineate a space for childish fancy in the metropolis, or did it merely indicate the commercialization of modern childhood in this period? Yet, as Gillian Beer points out, Frampton's statue presents a distinctly Edwardian understanding of childhood as central to the dynamic between man and nature. For Martina Droth, the modernity of the statue is dependent upon its materiality: Frampton seems to realize the contradictory condition of sculpture itself in his treatment of Peter Pan as something both material and imaginary. The physical placement of the sculpture (with versions in London, Liverpool, Brussels, and Newfoundland) elides the territory of empire with what Droth calls the "terra incognita" of the children's story.

The subsequent essays in this section address place as both location and affective construct. In his consideration of Edward Elgar, Tim Barringer traces a path from province to metropolis, and from metropole to empire, to disrupt the binaries that structure the composer's reputation. In particular he suggests that Elgar's visualization of a landscape aesthetic kept pace with modernity, rather than modernism. If the Edwardian period is one marked by the tension between continuity and change, then the Edwardian art world seems a particularly apt case in point. Edward Poynter remained president of the Royal Academy of Arts from 1896 until his death in 1919, while Walter Crane resumed the presidency of the Arts and Crafts Exhibition Society in 1896 (upon the death of William Morris) and held that post until his own death in 1915; however, new artistic organizations proliferated in this period and encouraged a public dialogue about modern art.[38] In his essay Andrew Stephenson suggests the cosmopolitanism of the Edwardian art world.

This account of artists' organizations, exhibitions, and patronage networks provides a powerful new way to think about "Edwardian" art, distinct from both Victorian art *and* modern art. My essay treats, as it were, the other side of cosmopolitanism and internationalism: how did these contexts influence national artistic discourse? My examination of the category "decoration" in this period indicates the extent to which Edwardian art and Edwardian politics pondered the relationship of part to whole.

Together, then, these essays reassess the divide between the Victorian and the modern, some by attending to particular "local modernisms," others by uncoupling modernity and modernism, challenging the orthodoxy that one term must entail the other. Edwardian culture is neither the last gasp of reactionary Victorianism nor the harbinger of a heroic and redemptive modernist art, but a complex and self-conscious consideration of culture and politics, often underpinned by an acute sense of being Edwardian. Just as the Edwardian period is distinctive in the transformation of the state, in the emergence of a new political landscape, or in the reconception of empire, so this volume adumbrates the distinctive qualities of Edwardian art and design, qualities that are not simply indices of political confrontation or social complacency, but are constitutive of the very terms of that debate.

Many thanks to Michael Hatt for his insightful comments on this text.

1. George Dangerfield, *The Strange Death of Liberal England* (1935; repr., New York: Capricorn Books, 1961). The historian David Powell writes that "both major parties faced the problem of maintaining internal unity while adapting their policies and organizational structures to the social and ideological challenges of the new century." David Powell, *British Politics, 1910–1935: The Crisis of the Party System* (London: Routledge, 2004), 39. Recently, scholars have suggested that the seismic cultural and societal shifts usually associated with the death of Queen Victoria, or indeed World War I, actually occurred in the 1870s and 1880s. See, for example, Margot Finn, "When Was the Nineteenth Century Where? Whither Victorian Studies?" *19: Interdisciplinary Studies in the Long Nineteenth Century* 2 (2006), http://www.19.bbk.ac.uk/issue2/index .htm (accessed 30 Dec. 2008), and Jose Harris, *Private Lives, Public Spirit: A Social History of Britain, 1870–1914* (Oxford: Oxford Univ. Press, 1993).

2. J. A. Hobson, *The Crisis of Liberalism* (1909; repr., New York: Harper & Row, 1974).

3. Juliet Nicholson, *The Perfect Summer: England 1911, Just before the Storm* (London: John Murray, 2006).

4. As the *Kirkus Review* stated of Roy Hattersley's *The Edwardians* (New York: St. Martin's Press, 2005), "It's not news to historians or even well-informed general readers that the idle ways of Edward VII and the Marlborough House Set were less representative of Edwardian Britain than the radical challenges to the established order posed by the nascent Labour Party, the suffragettes, Bloomsbury's novelists and artists or the playwrights of ideas led by George Bernard Shaw." Quoted in http://www.amazon.com/ Edwardians-Roy-Hattersley/dp/0312340125 (accessed 30 Dec. 2008).

5. Jane Beckett and Deborah Cherry, eds., *The Edwardian Era* (London: Phaidon Press and Barbican Art Gallery, 1987).

6. Beckett and Cherry, *Edwardian Era*, 14.

7. Beckett and Cherry, *Edwardian Era*, 7.

8. Alison Light, "'Don't Dilly-Dally on the Way!': Politics and Pleasure in 'The Edwardian Era,'" *History Workshop* 26, no. 1 (Autumn 1988): 158–62. Like the catalogue authors, Light points to that most Edwardian of artists, John Singer Sargent, as an interesting case study. Yet Sargent, for her, mingles "dislike" with "authority" in his portraits such as *The Acheson Sisters* (1902). Ibid., 160.

9. Especially when, as Light acknowledges, for example, one of the Edwardian artists par excellence, John Singer Sargent, "relied[d] on earlier visual codes of authority" in his portrait practice. Light, "'Don't Dilly-Dally on the Way!'" 160.

10. See Anna Gruetzner Robins, *Modern Art in Britain, 1910–1914* (London: Merrell Holberton in association with the Barbican Art Gallery, 1997), 15–45.

11. Not all accounts are positive: according to a recent study by the novelist A. N. Wilson, "after the Victorians" begins "the decline of Britain in the world." A. N. Wilson, *After the Victorians: The Decline of Britain in the World* (New York: Farrar, Straus, Giroux, 2005).

12. See Ruth Livesey, *Socialism, Sex, and the Culture of Aestheticism in Britain, 1880–1914* (Oxford: Oxford Univ. Press, 2007), esp. chap. 7, "Legacies," 193–229; see also Elizabeth Prettejohn, "Out of the Nineteenth Century: Roger Fry's Early Art Criticism, 1900–1906," in *Art Made Modern: Roger Fry's Vision of Art*, ed. Christopher Green (London: Merrell Holberton, in association with the Courtauld Gallery, Courtauld Institute of Art, 1999), 31–44.

13. Roger Fry, *Vision and Design* (London: Chatto and Windus, 1920), as discussed in Elizabeth Prettejohn, *Beauty and Art, 1750–2000* (Oxford: Oxford Univ. Press, 2005), esp. chap. 4, "Modernism: Fry and Greenberg," 157–92.

14. For significant form, see Clive Bell, *Art* (London: Chatto and Windus, 1914).

15. Roger Fry, "An Essay in Aesthetics" (1909), reprinted in Fry, *Vision and Design*, 14, and quoted in David Peters Corbett, *The World in Paint: Modern Art and Visuality in England, 1848–1914* (State College, Pa.: Pennsylvania State Univ. Press, 2005), 227.

16. Fry, "Essay in Aesthetics," 14.

17. "Gradualism" was the cornerstone of Fabian orthodoxy, a philosophy that encompasses both continuity and change. And even though the Fabians were socialists, they are still consigned to their own Edwardian garden party; according to historian Ian Britain, their "elitist" version of socialism sought to extend "their own values, tastes, and privileges, without really considered how appropriate or how desirable these things may actually be to the majority they are intended to benefit." Ian Britain, *Fabianism and Culture: A Study in British Socialism and the Arts, c. 1884–1918* (Cambridge: Cambridge Univ. Press, 1982), 6. In the Edwardian period, the "first generation" of Fabians ("the Old Gang") such as Beatrice and Sidney Webb witnessed the results of their earlier efforts, even as they were challenged by the "second generation" of members, including Eric Gill, Alfred Orage, and Holbrook Jackson.

18. For the London County Council, see Susan D. Pennybacker, *A Vision for London, 1889–1914: Labour, Everyday Life and the LCC* (London: Routledge, 1995). For a broader historical view, see Andrew Saint, *Politics and People of London: The London County Council, 1889–1965* (London: Hambledon, 1989). For the London School of Economics, see Ralf Dahrendorf, *LSE: A History of the London School of Economics and Political Science, 1895–1995* (Oxford: Oxford Univ. Press, 1995).

19. Ramsay MacDonald, *The Socialist Movement* (London: Williams and Norgate, 1911), 86.

20. Rodelle Weintraub has suggested that William Butler Yeats disapproved of the content of the play, particularly its rejection of "the idealized Kathleen O'Houlihan of the neo-Gaelic movement." See Rodelle Weintraub, "Doyle's Dream: John Bull's Other Island," *SHAW: The Annual of Bernard Shaw Studies* 21 (2001): 143–50, esp. 143.

21. Nicholas Grene, *The Politics of Irish Drama: Plays in Context from Boucicault to Friel* (Cambridge: Cambridge Univ. Press, 1999), 18–19.

22. Shaw pokes fun at the parochial sense of Irishness and its place as a "metropolitan colony" in *John Bull's Other Island*, http://books.google.com/books?id=g-SroHSpAHMC, 11 (accessed 30 Dec. 2008), and quoted

in Jordanna Bailkin, *The Culture of Property: The Crisis of Liberalism in Modern Britain* (Chicago: Univ. of Chicago Press, 2004), 34.

23. Roy Foster, "Conquering England," *History Today* 55, no. 3 (March 2005): 6–7. According to one critic, this royal patronage inaugurated "the age of Bernard Shaw." T. F. Evans, *George Bernard Shaw: The Critical Heritage* (London: Routledge, 1997), 6.

24. Foster, "Conquering England," 67.

25. David Pierce, ed., *Irish Writing in the Twentieth Century: A Reader* (Cork: Cork Univ. Press, 2000), 126.

26. Dan H. Lawrence, ed., *Selected Correspondence of Bernard Shaw* (Toronto: Univ. of Toronto Press, 1995), 61.

27. George Bernard Shaw, *John Bull's Other Island with Preface for Politicians* (New York: Brentano, 1907), vii, http://books.google.com/books?id=FGsWAAAAYAAJ (accessed 19 Jan. 2009).

28. George Bernard Shaw, *The Sanity of Art* (New York: Boni and Liveright, 1908), 21–22.

29. E. Wake Cook, *Anarchism in Art and Chaos in Criticism* (London: Cassell, 1904). For a brief overview of the New Art Critics, see Ysanne Holt, "Introduction: Visual Culture and Taste in Late-Victorian and Edwardian Britain," *Visual Culture in Britain* 6, no. 2 (Winter 2005): 1–4. For an in-depth study, see Kate Flint, "The English Critical Reaction to Contemporary Painting, 1878–1910" (PhD thesis, Oxford Univ., 1983), as well as John Stokes, "'It's the Treatment, Not the Subject': First Principles of the New Art Criticism," in *In the Nineties* (New York: Harvester, 1989), 34–52.

30. Shaw, *Sanity of Art*, 22.

31. Indeed, in general, the Fabian Society particularly championed Wagner and Ibsen, acting as "unofficial sponsors" of Harley Granville-Barker, both his work with the Elizabethan Stage Society and his later venture at the Royal Court Theatre to produce plays by Shaw and Ibsen, among others. Tracy C. David, *George Bernard Shaw and the Socialist Theatre* (Westport, Conn.: Greenwood Press, 1994), 64.

32. Livesey, *Socialism, Sex, and the Culture of Aestheticism*, 195. Alfred Orage and the Fabian Arts Group staged their own protest against Fabian utilitarianism during the reign of Edward VII. As Livesey has demonstrated, writers such as Virginia Woolf "exorcised" the influence of Edwardian politics and literature on their own work. Ibid., 195.

33. Fry, "Essay in Aesthetics," 19.

34. David Peters Corbett and Lara Perry, eds., *English Art 1860–1914: Modern Artists and Identity* (Manchester: Manchester Univ. Press, 2000), 2.

35. Lisa Tickner, *Modern Life and Modern Subjects: British Art in the Early Twentieth Century* (New Haven and London: Yale Univ. Press, 2000), 193. At the same time, Janet Wolff has pointed to the importance of a discourse of "Englishness" in this period, the sense in which a particular national identity, even with regional inflections, predominated over any sense of imperial citizenship. See Janet Wolff, *Anglomodern: Painting and Modernity in Britain and the United States* (Ithaca, N.Y.: Cornell Univ. Press, 2003), 135.

36. See Robert Jensen, *Marketing Modernism in Fin-de-Siècle Europe* (Princeton, N.J.: Princeton Univ. Press, 1994).

37. In her recent study *The Culture of Property*, Jordanna Bailkin has characterized the Edwardian period as one invested in the conjunction of art and politics, but with a difference. As she argues, for example, suffragettes were interested not only in the creation of their own art but also in the response to art. By slashing John Everett Millais's portrait of Thomas Carlyle in the National Portrait Gallery in London, they took a stand against patriarchy, Victorianism, and a type of high art that enshrines "great men." See Bailkin, *Culture of Property*, 200–202.

38. Artists came together in loose confederations such as the Newlyn Group, the Glasgow Boys, the New English Art Club, and later, the Camden Town Group, while organizations such as the International Society of Sculptors, Painters and Gravers and the Allied Artists Association organized exhibitions. At the same time, artists looked beyond the Royal Academy for training, filling classes at the Slade School and the Académie Julien in Paris, and their work appeared in British and English sections at international exhibitions such as the Venice Biennale. See Sophie Bowness, Clive Phillpot, and Sandra Berresford, eds., *Britain at the Venice Biennale, 1895–1995* (London: Arts Council, 1995).

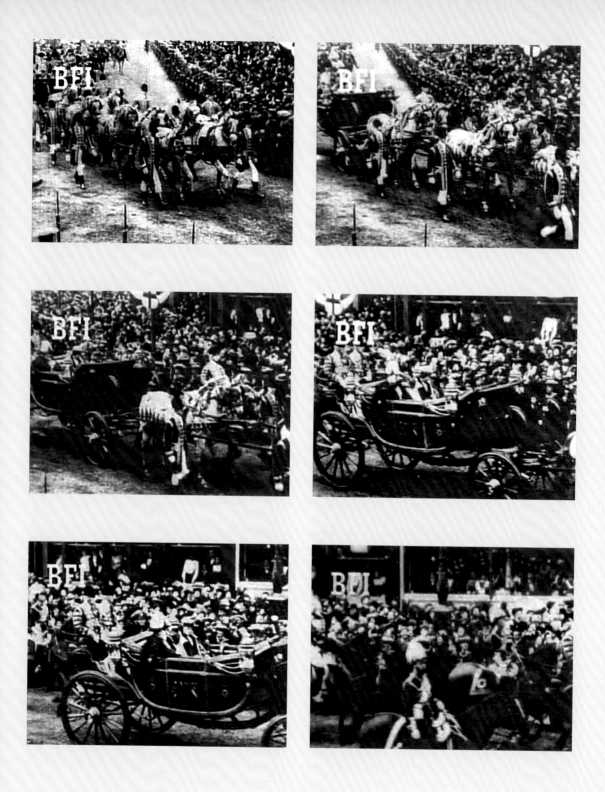

1. Film stills from *Edward VII Becomes King* (1902). British Film Institute, National Archive.

SPECTACLE

Reproducing Royalty: Filming the Coronation of Edward VII

Tom Gunning

THE HISTORY OF PHOTOGRAPHY in the nineteenth century interacts dynamically with a new culture of celebrity. Nineteenth-century photographic studios and shops not only supplied portraits for individuals who came and sat for them, but also sold photographs of celebrities for anyone who wanted to buy them. As printing technology evolved at the turn of the century and allowed reproduction of photographs in mass-circulation periodicals and newspapers, this photographic culture of celebrity moved from an artisanal process to an industrial one.[1] The commercial marketing of photographs of celebrities extended from the revered to the reviled and included figures of both enduring fame and transitory local fascination. But modern celebrity culture centered, then as now, in the worlds of entertainment and politics. Heads of state, and especially royalty, immediately became central to photographic commerce. In 1860 Queen Victoria had given permission for photographs of herself (ones that she had specifically selected) to be sold to the public, and the shop windows of photographic studios generally displayed such items for sale.

Walter Benjamin has argued that photographic reproduction undermines or abolishes the aura of the individual and unique work of art, replacing a singular moment of authenticity with the possibility of mass access and circulation. In place of authentic contact, the culture of celebrity traffics in what Benjamin referred to as the "phony spell of the commodity."[2] While the circulation of images of entertainers (and perhaps even of political leaders in governments with a democratic basis) can be seen as aids in the maintenance of popularity and charisma (although this depends in part on maintaining control of these images), the photographic circulation of the images of royalty could pose problems of an apparent lèse-majesté. Miriam Hansen has cited a description by the writer-director Berthold Viertel of a screening of films of the German kaiser in Vienna in 1910, which to her suggested the "incompatibility of the notion of a unique sovereign, ordained by divine right, with the infinite multiplication of his image by means of a camera."[3] This incompatibility of sovereignty and cinema was clearest in those regimes

that still made strong claims of divine rights, such as the czar in Russia or the Meiji emperor in Japan. As Yuri Tsivian has shown, pre-revolutionary Russian censors strictly regulated the appearance of the royal family in films and especially the manner in which films of the czar and his family could be exhibited.[4] Likewise Maki Fukuoka has pointed out that while the image of the Meiji emperor played an important role in making the cult of the emperor the foundation of a new modern state, the circumstances and protocols of displaying and circulating photographs of the emperor were strictly prescribed with the desire to keep the imperial image out of common systems of exchange.[5] As Stephen Bottomore has shown in his pioneering essay on early films of royalty, access (and even the camera distance) in shooting the films of royal personages was frequently regulated.[6]

In many ways the production and projection of motion pictures in this early era simply extended practices of still photography. In England many pioneers of motion pictures came from the photographic field. Thus shows of early cinema prominently featured images of celebrities. The Biograph Company (whose international scope included a British branch, the British Mutoscope and Biograph Company) had been one of the first companies to exhibit films of celebrities other than performers. While its chief American rival, the Edison Manufacturing Company, primarily relied on figures from the entertainment world of variety theater (acrobats like tightrope walker Juan Caicedo, dancers like the Gaiety Girls, and strongmen like Eugen Sandow), the Biograph Company had featured films of the Republican presidential candidate, William McKinley, at its premiere in 1896, and soon after it offered the first films of Pope Leo XIII. As Charles Musser first indicated, and Richard Brown and Barry Anthony have demonstrated in detail for the British branch of the company, the Biograph Company presented motion-picture shows as a form of visual newspaper, featuring images of current events and the people who shaped them.[7] Early filmmakers drew on a number of models for the technical novelty they offered to the paying public, tempering the unfamiliarity of motion pictures with familiar forms, while also accenting what this new form could offer that other mediums could not. Current events, especially the filming of arranged spectacular events, were tailor-made for the first filmmakers, and parades, funerals, state visits, and the openings of international expositions became nearly as thronged with motion-picture operators as they were with news photographers.

In Britain, as John Barnes's detailed history of the first years of British cinema makes clear, the crowning events of the Victorian era, the queen's Diamond Jubilee in 1897 and her funeral in 1901, provided defining points for early British cinema both technically and commercially.[8] Beyond the interest that early cinema showed in both celebrities and special events, the form of the parade or procession seemed particularly suited to the new medium. Further, in these public appear-

ances (and spectacles), the sovereigns had control over their appearance, a properly managed and stately context for the photographing of them; as Bottomore put it, "here the royals were presenting themselves as *they* wished to be seen."[9] In both Europe and Asia, royal processions had long been commemorated in images that mimed the progression of the event with new forms of pictorial representation, whether the series of broad-format prints measuring more than 180 feet that Albrecht Dürer used for his *Triumphal Procession* portraying the Holy Roman Emperor Maximilian I or the scroll paintings in China and Japan that frequently featured royal processions. French film theory in the 1970s stressed the *défilement*—the passage of the long moving strip of film—that underlies the cinematic apparatus.[10] As naturally unfolding forms, parades and processions would seem to be well suited to the new apparatus. In that era the form of filming such events primarily relied on a fixed camera that recorded the procession as it moved past its vantage point. Camera operators would frequently stop and restart the camera, waiting for the most interesting aspects of the parade or procession to pass (and in the early processional films I have been able to examine, these stops and starts were often refined by splicing, an early editing practice designed to condense lengthy events). Since the cameramen covering these processions were likely to take a great deal of footage (compared to the briefer events they most frequently filmed), the film feed boxes for motion-picture cameras were enlarged for the Jubilee films. Barnes also indicated that an adjustable tripod head was also introduced for filming the Jubilee, although he is not sure whether this mobile head was used to permit panning shots of the parade or simply allowed the camera to pivot in order to frame a shot before shooting.[11] The processional films I have examined contain a number of panning shots, including the footage shot of Edward VII's coronation procession, with the camera seeming to mime the turning head of a curious spectator (although by 1902, the year of the coronation, panning shots had become standard in film).

The films of the coronation procession of Edward VII (fig. 1) followed very much the pattern laid down by the previous Jubilee and royal funeral films. Dozens, if not scores, of camera operators from around the world lined the route vying (and often paying high prices) for the best vantage point, hoping for good weather and unobstructed views in which the key participants would be visible (unlike the films of the Jubilee, in which Queen Victoria's parasol had blocked many views of her). Edward had already had many encounters with the cinema. Supposedly the American-born filmmaking pioneer Birt Acres had filmed him while he was still the Prince of Wales and had even captured the future monarch in the supposedly unkingly act of scratching his head, which had led to an attack on exhibiting the film by the *Globe* (London) as "appalling publicity."[12] The prince himself held no resentment toward the new medium, however, and, according to the early

British filmmaker Cecil Hepworth, had actually halted his mother's funeral procession before Hepworth's camera, allowing Hepworth to get a splendid view of the prince on horseback.[13] The narration that now accompanies the coronation footage held by the British Film Institute refers to the shot of Edward's carriage paused in front of the camera as a "delay," as if it were unintentional, but it seems just as likely that the new monarch has again paused the procession to give the cameras a good view.

Unfortunately, the technical problems of filming the actual coronation inside Westminster Abbey remained insuperable, due to the low levels of light. Early cinema offered two possibilities for filming: exteriors in natural light or interiors in small glass-roofed studios (patterned on photographers' studios) using natural light, sometimes boosted by electrical lamps. The cavernous spaces of Westminster Abbey did not allow either source of light. But filmmakers chafed at restricting film coverage to processions taking place in exterior spaces, without any images of the elaborate rituals of actual coronation. The solution to this problem led to one of the most unusual films of royalty made in this era. Charles Urban, a dynamic early British (though American-born) filmmaker who, like most filmmaking pioneers, had filmed the Jubilee and Victoria's funeral, was determined to supplement the films he took of the coronation procession with views of the ceremony. He joined with his business associate, the French filmmaker Georges Méliès, to accomplish this. Méliès initially made films to be shown between the elaborate magical illusions presented at his theater of illusions in Paris, the Théâtre Robert-Houdin. His first films were modeled on the short actuality films of the Lumière Company showing trains arriving at stations and gentlemen playing cards. Like other early filmmakers, however, Méliès discovered the range of possibilities that filmmaking allowed, including his successful series of trick and magical films. While Urban specialized in the dominant actuality genre, Méliès was a master of the studio film, which he referred to as "artificially arranged scenes."[14] The desire to cover contemporary events in motion pictures led to the genre of reenactments, in which news events were reconstructed for the camera. Reenactments allowed filmmakers to present, for example, motion pictures portraying the military engagements in the variety of small wars that marked the turn of the century (such as the Boer War, the First Sino-Japanese War, and the Spanish-American War), where filming the actual combat was difficult (and dangerous). Although such reenactments were sometimes exhibited as if they presented unstaged realities (and were occasionally denounced as "faked," as one French journalist denounced Urban's coronation films),[15] many viewers accepted them simply as reliable representations (a bit like computer visualizations of certain news events used in reporting today, without any intention of passing as authentic records of the events).

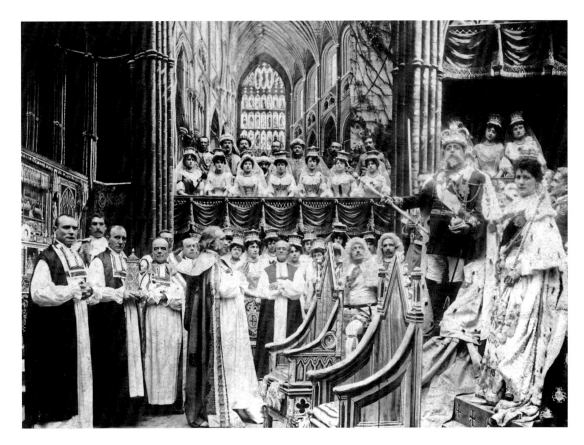

2. Film still from Georges Méliès, *Le Sacre d'Edouard VII* (*The Coronation of Edward VII*) (France, 1902). British Film Institute, National Archive.

The films of the coronation ceremony that Méliès shot in his glass-roofed studio in Montreuil were produced as a careful facsimile, the fruit of extensive research into the ceremony and its events, costumes, and arrangements (fig. 2).[16] Edward VII was played by a man identified variously as a brewer's assistant and (shades of F. W. Murnau's *Last Laugh*!) a washroom attendant with a strong physical resemblance to the monarch-to-be. Although slightly less than four minutes long in extant versions, the coronation film was among the most elaborate that Méliès had yet arranged, demanding extensive preparation. In fact, the film had to be prepared before the actual event, with the intention of exhibiting it at the Alhambra Music Hall on the evening of the coronation. As it turned out, the ceremony was delayed

by Edward's bout of appendicitis, so the simulacrum preceded the actual event by some time; even so, its exhibition was delayed to coincide with the real event.

While it is a mistake to see Méliès's film of the coronation of Edward VII as either a deliberate fraud or a knowing commentary on the modern power of images, its role as a simulacrum that actually precedes the real event can serve to indicate the ambiguities of the encounter between images of royalty and the age of mechanical reproduction, as moving images ushered in a new era of the modern monarchy.

1. For a historical discussion of this in an American context, see Eileen Michaels, "Picture-Loving: Photo-mechanical Reproduction and Celebrity in America's Gilded Age" (PhD diss., Univ. of Chicago, 2008).

2. Walter Benjamin, "The Work of Art in the Age of Mechanical Reproduction," in *Illuminations*, ed. Hannah Arendt, trans. Harry Zohn (New York: Schocken Books, 1969), 231.

3. Miriam Hansen, "Early Silent Cinema: Whose Public Sphere?" *New German Critique*, no. 29 (Spring–Summer 1983): 172.

4. Yuri Tsivian, *Early Cinema in Russia and Its Cultural Reception* (London: Routledge, 1994), 126–28.

5. Maki Fukuoka, "Totemic Aspect of the Representations of the Meiji Emperor" (unpublished essay, 1999). I thank Professor Fukuoka for sharing this with me.

6. Stephen Bottomore, "'She's Just Like My Granny! Where's Her Crown?' Monarchs and Movies, 1896–1916," in *Celebrating 1895: The Centenary of Cinema*, ed. John Fullerton (Sydney: John Libbey, 1998), 176.

7. See Charles Musser, *Before the Nickelodeon: Edwin S. Porter and the Edison Manufacturing Company* (Berkeley: Univ. of California Press, 1991), esp. 162–67, and Richard Brown and Barry Anthony, *A Victorian Film Enterprise: The History of the British Mutoscope and Biograph Company, 1897–1915* (Trowbridge: Flicks Books, 1999), esp. 189–90.

8. John Barnes, *The Beginnings of the Cinema in England, 1894–1901*, vols. 1–5 (Exeter: Univ. of Exeter Press, 1997).

9. Bottomore, "She's Just Like My Granny!" 175.

10. See, for example, Thierry Kuntzel, "Le Defilement: A View in Close-up," in *Apparatus: Cinematographic Apparatus: Selected Writings*, ed. Theresa Hak Kyung Cha (New York: Tanam Press, 1980).

11. Barnes, *Beginnings of the Cinema in England*, vol. 4, 182–98.

12. Bottomore, "She's Just Like My Granny!" 174.

13. Bottomore, "She's Just Like My Granny!" 176.

14. The best English-language accounts of Méliès remain Paul Hammond, *Marvelous Méliès* (London: Gordon Fraser, 1974), and John Frazer, *Artificially Arranged Scenes: The Films of George Méliès* (Boston: G. K. Hall, 1979). Frazer discusses the coronation film on 100–102.

15. Quoted in Frazer, *Artificially Arranged Scenes*, 101–2.

16. Jacques Malthete, *Méliès: Images et Illusions* (Paris: Exporegie, 1996), 115, reproduces a letter from Urban to Méliès detailing the research he has done about the ritual and the setting.

Edward VII Becomes King

Bronwen Edwards

THE BRIEF COMMEMORATIVE FILM tracking Edward VII's coronation parade (see fig. 1) shows glimpses of the crowds and cavalcade at sites across London: a distinctly metropolitan souvenir, kinetic and vibrant for all the heavy weight of tradition. The event is now little remembered, but it belongs to a significant cluster of spectacular ceremonial state funerals, weddings, and jubilees during the late nineteenth and early twentieth centuries that have been of much interest to historians as examples of the "invention of tradition" and "the more obviously staged and mounted dramas of imperialism."[1] Edward was well known for his love of pleasure and spectacle, having played a key role in ratcheting up the royal ceremonial toward the end of his mother's reign.[2] The short coronation film shows him playing to the crowd amid festoons and banners, the stage-managed spectacle revealing the particular inflections of national and imperial identity-making at this moment. Interestingly, the very technological limitations that confined early film coverage to outdoor scenes such as these provide insights into the role of London's street cultures in state pageantry, as well as the "routedness" of ceremonial beyond Westminster Abbey, where the king was actually crowned.

Coronations were, of course, events to be remembered as much as experienced: a way of sustaining state and imperial identity and popular allegiance. This was traditionally done through commemorative objects, written commentaries, and images. Many of these were mass-produced, such as cheap ceramics and special issues of popular magazines. Film offered a new medium for memorializing, more accessible still, yet a fragile memorial for its viewers: seen once, then residing in the imagination rather than on the mantelpiece. A sudden, serious illness meant that Edward's coronation, planned for 26 June, was postponed at the eleventh hour; a great deal of the surviving Edwardian coronation ephemera lays false trails by commemorating the aborted ceremony, rather than the actual hastily arranged coronation on 9 August. Indeed, much of the material memorializing of a coronation served to tidy its more chaotic temporal and spatial elements to create a retrospective coherence the original lacked. While this film is of the real coronation,

it sews together a disjointed and protracted series of royal processions, concealing delays, mistakes, disorderliness.

The maker of the film "fixed" events through narration and representation, pinning Edward's coronation speedily to the head of a timeline of historical dates and traditions—just like the moment of crowning frozen for posterity on the pages of the *Illustrated London News*, amid a swirl of images of coronations past. Popular media made little comment on the fact that many parts of the ceremony and procession were newly invented tradition; the effect of the pageant was clearly more valued than its historical rigor. John Bodley's contemporary commentary on this point is telling:

> The splendour of the scene, dazzling to the senses, the national pride evoked by its imposing circumstances, were well calculated to affect the calmest judgement, and to make each patriotic spectator of the stately rite feel that he or she was taking part in an august event of which the historical importance was beyond doubt.[3]

This impulse to instantaneously memorialize was understandable at this moment of potential imperial instability, as Edward VII replaced Victoria as figurehead within national and imperial imaginings.

Yet these moving images of London's streets, with the king and cavalcade processing through them, also add a kinetic dimension that is crucial to understandings of the meaning of this coronation as an event of movement and of journeys. The tracing of the ceremonial route through London on Coronation Day was the centerpiece of a much more extensive real and filmic procession by the monarch and the royal family through the nation and empire to inaugurate the new Edwardian era. Films of the procession were screened in subsequent weeks and months through a network of exhibitors at private gatherings, theaters, village halls, and function rooms across the country and empire. The procession was also a leg in a series of imperial royal tours: for example, those by members of the family to New Zealand, South Africa, and Canada in 1901. Historians have described such tours as a marking of territory, and also a means of rousing allegiances around the person of the monarch, so much more effective than illusive, generalized notions of a "British state."[4] Certainly, the processions and tours reinforced the imperial map, performing the network and the dominance of the center. But they were also occasions to showcase the visited sites, from provincial England to Toronto.

The coronation itself was London's day. The king's journey to Westminster Abbey (fig. 3) was to begin at Buckingham Palace, before he proceeded along the Mall, through Horse Guards Arch, then down Whitehall and Parliament Street.

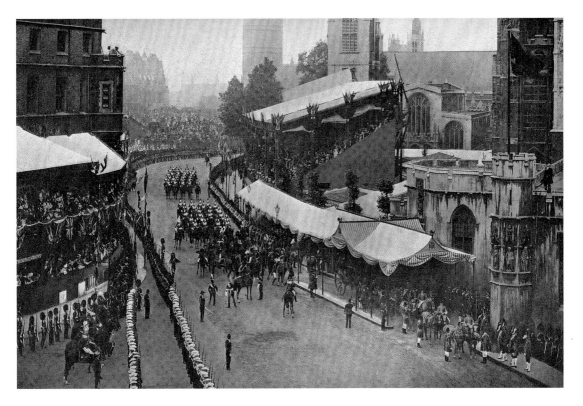

3. "On the Threshold: The Arrival of the King and Queen at Westminster Abbey," from *Black & White* 24, no. 602 (30 Aug. 1902): 235. Courtesy of the Yale University Library.

His return route to the palace went via Parliament Street, Whitehall, Cockspur Street, Pall Mall, St. James's Street, Piccadilly, and Constitution Hill, offering plenty of opportunities for the crowds to greet him. In the following days, a naval review was staged for him, and he made a second procession across London to St. Paul's Cathedral, in thanksgiving for his recovery, and to a ceremony at Temple Bar, on the historical boundary between Westminster and the City of London. It was a feature of the capital that despite notable individual sites of imperial bombast, it lacked an obvious ceremonial circuit,[5] and on this occasion the post-coronation procession was shortened due to the king's still-fragile health. In August 1902, with film and photographic media drawing the built fabric of London to the world's attention, concerns were frequently voiced about a lack of fashionable architectural splendor. Indeed, this discourse formed a backdrop to the protracted

and high-profile project for the rebuilding of Regent Street, a linchpin in future coronation routes.[6] In this film, the king is shown passing cheery contractors' hoardings—a city surprised in a state of disarray, but also a real, living city, with investment pouring into rebuilding projects that were reshaping the urban fabric piece by piece. This might justifiably be seen as a backdrop of modernity and confidence for the new monarchy.

In 1902 businesses were prepared to spend lavishly on decorations, particularly fashionable West End retailers, who were well versed in the visual vocabulary of display and spectacle. This close relationship between commerce and state ceremonial was to become a major feature of twentieth-century coronations, with ever more spectacular decorations, themed window displays, and special promotions to appeal to the influx of visitors to the capital. As coronations themselves developed their popular register, extending parades and embracing advances in moving-image technologies, it was accepted that shopping streets and theater hubs would stand in as key hosts for the expanding metropolitan procession. Regent Street, eventually completed in the late 1920s, was to be both a ceremonial route and fashionable shopping thoroughfare, housing the substantial plate-glass show windows for Liberty, Dickens and Jones, Swan and Edgar, Austin Reed. But there was unease within this arrangement: it was difficult for coronation committees to control the colorful and chaotic decorations put up by businesses, giving rise to complaints on grounds of taste.

Coronation London was a city of feint and fantasy: the processing king was met by scenes temporarily transfigured by decorations. The streets were a bright show of banners and bunting, ribbons and flower garlands, stretched over streets and strewn across the facades of London's landmark buildings, with particular attention paid to those lining the route. Decorated buildings became important tourist attractions during the summer, particularly on Coronation Night, when the "night was ablaze with illuminations and great crowds turned out into the streets."[7] The *Graphic*'s coronation number described the show in some detail:

> In the neighbourhood of Marlborough House there were dense crowds during the whole of the evening. Here the decorations were upon a bold and brilliant scale, the main lines of the large building being outlined with lamps and crystals which waved and flickered gracefully as each breath of wind played across them.[8]

Transient architectural structures, of wooden and metal frames covered with canvas and papier-mâché, also sprang up in the key spaces of coronation spectacle. Many ornate and colorful viewing stands lined the parade route, obscuring the

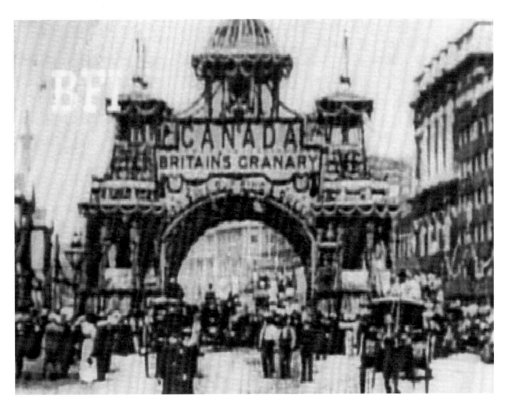

4. "Canadian Arch," film still from *Edward VII Becomes King* (1902). British Film Institute, National Archive.

facades of buildings and turning the streets of London into a theater. These were lucrative commercial ventures for such companies as the Victoria Seats Agency, as well-positioned seats commanded high prices. In the middle of Whitehall, a great arch, a gift from the people of Canada, was constructed for the procession to pass through (fig. 4). It was fitted with bundles of grain, festooned with purple and gold cloth, with "Canada: Britain's Granary / God Save Our King and Queen" emblazoned across it.[9] This decorative vocabulary drew as much on very well established urban festival cultures; architect-designed, wooden triumphal arches had long been a feature of coronations, frequently the gift of other nations.[10] But it also connected with the ephemeral architectures of international exhibitions and trade fairs, with their showy structures and signs. Again, this signaled the future of twentieth-century coronations.

The coronation event has been positioned as a significant episode of imperial boosterism, marking a new focus on the pressing need to shore up the empire.[11]

The arch's slogan was certainly a clear, if crude, comment on Canada's privileged yet still firmly subordinate ranking within the British imperial community. On the other hand, it was the most substantial, prominently placed, and striking temporary structure, much visited and debated, providing a significant place for this nation within the pageant. A great deal of the contemporary commentary was focused on all imperial aspects of the coronation. For the *Cambridge Daily News,*

> the truest and deepest significance of Saturday's great pageant was to be found in the addition which was then made to the Royal titles—"And of all the British Dominions beyond the Seas Sovereign Supreme." The new title expresses most vividly and most truly the real significance of a day unparalleled in history; it helps the imagination to a realised conception of a wider and vaster Empire than the world has ever seen, an Empire even wider and vaster than Fancy's vision has hitherto gazed upon. . . . In the crowning of Edward VII and Alexandra of England, the world has seen the symbolism of a virile and potential tree of sovereignty whose roots are bedded in the soil of England, and whose branches stretch to every clime from the tropics to the poles.[12]

In this respect, the coronation was a well-timed opportunity to recast the empire's image, and the potential of the procession to display representatives from all nations in full regalia was exploited (fig. 5).

Despite the appearance of carefully built and choreographed pageant, there was an edge to the street celebrations, so much less controllable than the indoor environment of Westminster Abbey. As shown in the film's first pre-coronation scenes, these were streets that usually pulsated with chaotic metropolitan traffic: pedestrians, bicycles, and barrows weaving in between overladen horse-drawn traffic; pavements pounded with the conflicting rhythms of sightseers, shoppers, and London's workforce. The run-up to the coronation had seen a subtle change in the makeup of the crowds. There was a surge in tourism, particularly from the outposts of the "British World."[13] Bodley particularly noted the ubiquity of khaki, as imperial troops, especially from Canada and Australia, began to gather—many fresh from the war in South Africa.[14] On Coronation Day people were packed tightly onto pavements. A cordon of imperial soldiers held them still, save for the pulse of flourished bright white handkerchiefs and black bowler hats, in a display of respectable Sunday-best civic spectatorship. The expansion of railways and publicity networks had facilitated a coronation crowd of remarkable scale and comparative diversity, becoming itself an important part of the spectacle, drawing the eye of cameramen and commentators.

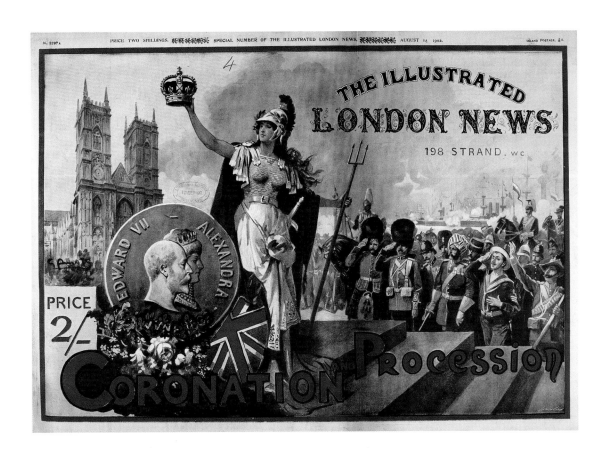

5. *Coronation and Procession*, cover image from special issue, *Illustrated London News*, 14 Aug. 1902. The Trustees of the National Library of Scotland.

Once the king's carriage had passed, the cordon relaxed, the work of the cameramen complete, and things became more chaotic, as reported in the *Sphere*:

> After the passing of the main line came a dreary interval. The crowds began to move off, and though the troops stayed they could no longer keep the line; indeed nobody seemed to know what happened. At any rate some of the royal carriages and a score of peers' coaches had to work their way through the crowd as best they could long after the King had passed.[15]

From this point on, state ceremonial was interwoven with more spontaneous popular revelry, which the *Sphere* saw threatening to spill over into the kind of disorder recently witnessed in response to military fortunes:

> London seems to have got over that lamentable outbreak of rowdyism which took over the name of "Maffeking." The police have at last mastered the mob. They made a good beginning by prohibiting "ticklers" and "squirts" and other abominations, and thereby restored the London crowd to its former condition of great good humour. On Saturday evening, for example, there was an almost total absence of rowdiness in the crowd and a minimum of shouting and singing.[16]

There was clear relief that the dangers of street culture had been contained on this occasion.

The intimacy of the medium of film highlights a lingering note of fragility around the person of the king.[17] Edward appears a patently old man, and his recent near-fatal illness would not have been far from the minds of spectators: this could so easily have been another state funeral, so soon after Victoria's. Concerns that the occasion would tire him were frequently voiced. Events were scaled down, routes shortened, and lists of attendees abbreviated as the more important members of the expectant audience—foreign royals and dignitaries—were called home and could not be expected to make a second trip.[18] While certainly not a damp squib, this was not the most memorable state event of the period, or one of the more celebrated twentieth-century coronations. It did, however, set the popular, spectacular tone that would become at once a useful tool and a bane for future monarchs on their coronations, who would be observed so much more closely by the world.

1. David Cannadine, "The Context, Performance and Meaning of Ritual: The British Monarchy and the 'Invention of Tradition,'" in *The Invention of Tradition*, ed. Eric Hobsbawm and Terence Ranger (Cambridge: Cambridge Univ. Press, 1992), 101–64, and Cecilia Morgan, "'A Choke of Emotion, a Great Heart-Leap': English-Canadian Tourists in Britain, 1880s–1914," *Histoire Sociale / Social History* 39, no. 77 (2006): 17.

2. John Wolffe, "The People's King: The Crowd and the Media at the Funeral of Edward VII, May 1910," *Court Historian* 8, no. 1 (2003): 23.

3. John Bodley, *The Coronation of Edward VII: A Chapter of European and Imperial History* (London: Methuen, 1903), 200.

4. Judith Bassett, "'A Thousand Miles of Loyalty': The Royal Tour of 1901," *New Zealand Journal of History* 11 (1987): 125–38; Phillip Buckner, "The Royal Tour of 1901 and the Construction of an Imperial Identity in South Africa, " *South African Historical Journal* 41 (1999): 326–48; and Buckner, "Casting Daylight upon Magic: Deconstructing the Royal Tour of 1901 to Canada," in *The British World: Diaspora, Culture and Identity*, ed. Carl Bridge and Kent Fedorowich (London: Frank Cass, 2003), 158–89.

5. Felix Driver and David Gilbert, "Heart of Empire? Landscape, Space and Performance in Imperial London," *Environment and Planning D: Society and Space* 16 (1998): 11–28, and Erika Rappaport, "Art, Commerce, or Empire? The Rebuilding of Regent Street, 1880–1927," *History Workshop Journal* 53 (2002): 94–117.

6. Rappaport, "Art, Commerce, or Empire?"

7. "What the Man in the Street Saw of the Pageant," *Sphere*, 16 Aug. 1902, 158.

8. *Graphic Coronation Number*, 13 Aug. 1902, 25.

9. Kenneth Munro, "Canada as Reflected in Her Participation in the Coronation of Her Monarchs in the Twentieth Century," *Journal of Historical Sociology* 14 (2001): 24–25.

10. Roy Strong, *Coronation: A History of Kingship and the British Monarchy* (London: HarperCollins, 2005), 261–63, 301–7.

11. Cannadine, "Context, Performance and Meaning of Ritual," and Strong, *Coronation*, 437–39.

12. "The Coronation Festivities in Cambridge," *Cambridge Daily News Souvenir*, Sept. 1902.

13. Morgan, "'A Choke of Emotion,'" and Angela Woollacott, *To Try Her Fortune in London: Australian Women, Colonialism and Modernity* (Oxford: Oxford Univ. Press: 2001).

14. Bodley, *Coronation of Edward VII*, 223.

15. "What the Man in the Street Saw of the Pageant," 158.

16. "What the Man in the Street Saw of the Pageant," 158.

17. Richard Brown, "'It Is a Very Wonderful Process . . .': Film and British Royalty, 1896–1902," *Court Historian* 8, no. 1 (2003): 1–22.

18. Bodley, *Coronation of Edward VII*, 238.

Coronation Streets

Angus Trumble

THE ARCHAEOLOGY OF early cinematograph footage is bafflingly obscure. For decades most sequences were cut and edited for many different uses, not always taking account of their gradual deterioration from wear and tear. Mostly we rely on hazy press advertising and other promotional tools to reconstruct the arrangement of some original reels and programs. Issues of authorship and copyright tended to be ignored on the not unreasonable basis that viable strips or stray tins of celluloid footage carried few if any indications of provenance, and in any case they found their haphazard way from commercial photographer to projectionists of varying degrees of competence, thence to semiprofessional promoters, to ad hoc distributers, and not always back again. The dangerous flammability of celluloid, combined with the rapid and inexorable decomposition of nitrate film, has further complicated matters. That so many feet have survived at all is a stroke of good fortune.[1]

This tantalizing document of the hastily rearranged coronation of King Edward VII and Queen Alexandra on 9 August 1902 (fig. 6) is no different.[2] The footage was probably spliced and reassembled into its present form—a collection of richly populated fragments—for obvious reasons of topicality at about the time of the coronation on 12 May 1937 of King George VI and Queen Elizabeth. This hypothesis is based primarily on the distinctive style of the lettering in the opening caption, as well as the text of the coolly un-effusive retrospective sound commentary. Though reined in by cut-glass diction, and accompanied by pert but hearty upright piano improvisation, this text nevertheless drips with coronation-year nostalgia: "London in nineteen two. This is what the streets looked like then. The gay, dignified Edwardian decade has begun."[3]

The present film consists of six brief sequences, commencing with a panning shot up Broad Sanctuary from the end of Victoria Street, bracketed at first by the Clock Tower of the Palace of Westminster and the bell towers of St. Margaret's. The camera then slowly scans the enormous temporary public viewing platform erected on Broad Sanctuary; passes the spindly iron framework for a long and

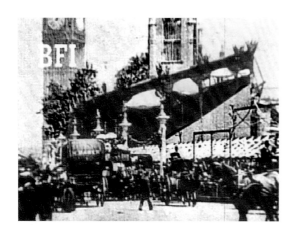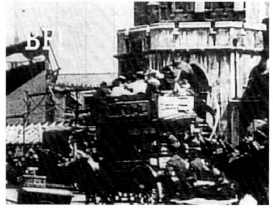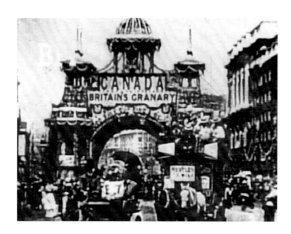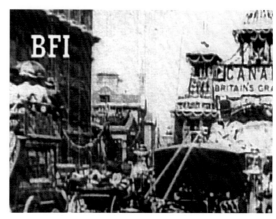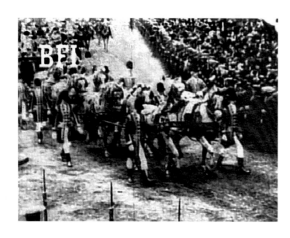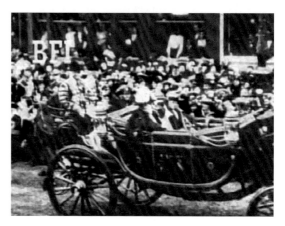

6. Film stills from *Edward VII Becomes King* (1902). British Film Institute, National Archive.

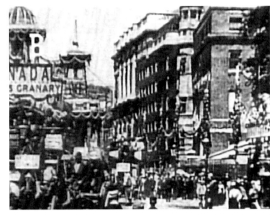

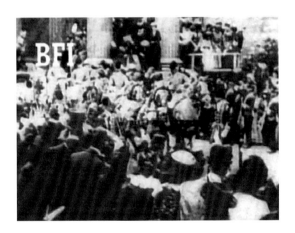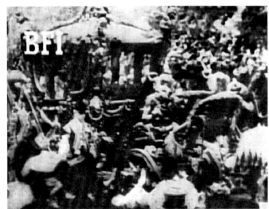

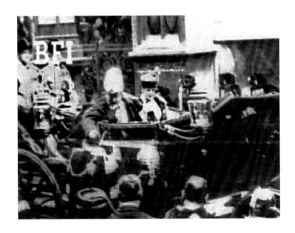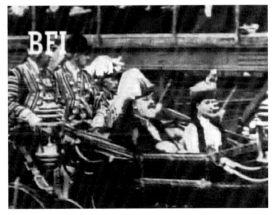

as-yet-unfinished entry canopy leading to the side of the temporary annex erected over the west door of Westminster Abbey; and turns gradually inward toward the Sanctuary itself, in which the base and lower shaft of the column of Gilbert Scott's Crimean Memorial are clearly visible.[4] Crude wooden barriers, putatively for crowd control, lie in disorderly piles against the few available walls.

The second sequence, looking north toward Trafalgar Square—Nelson's column is clearly visible—proffers the vista of an equally congested Whitehall, spanned or, more accurately, blocked by the riotously vulgar commemorative arch, swagged, draped, and turreted, loudly trumpeting Canada's role as the imperial breadbasket. The unabashed promotional tag "Canada: Britain's Granary / God Save Our King and Queen" was devised by William Thomas Rochester Preston, commissioner of emigration for Canada, who supervised the work on behalf of the Canadian Department of the Interior, and its expedient tone was tactfully overlooked in most press reports.[5] The camera tripod was evidently positioned not too far north of the Banqueting House, right in the middle of the street.

Then follows a brief glimpse of the coronation procession itself, evidently shot in the vicinity of Horse Guards Parade, Admiralty Arch, the Mall, and St. James's Park (in the background). Here we see the king after his coronation, wearing the old Imperial State Crown, accompanied by the queen, riding side by side in the enormous 1762 Gold State Coach en route to Buckingham Palace, flanked by liveried footmen in powdered wigs, grooms, Beefeaters, and gentlemen-at-arms, and escorted by members of the Household Cavalry.

The last three sequences (one of which is spliced in the middle, for brevity) show the king and queen being driven to St. Paul's Cathedral the next day in a glossy black, open barouche mounted with four large polished lanterns. There they attended a service of thanksgiving for the king's recovery from emergency surgery for appendicitis, the severe illness that made it necessary to postpone the coronation ceremonies originally scheduled for 26 June. The middle portion records at quite close quarters the brief presentation and return to the Lord Mayor of the city sword at Temple Bar that marked the king's passage from Westminster into the City of London. The last was apparently shot after the service at St. Paul's, from a tight spot on the northwest side of London Bridge.

Perhaps the most unexpected aspect of these rare glimpses of the streetscape of London in 1902 is the curious mixture of decorations, ceremonial, chaos, advertising, dirt, and surprising personal habits. Private coaches and hansom cabs are not particularly scarce in the first two "scenes," but these sequences are liberally punctuated by top-heavy horse-drawn public omnibuses. Approximately four thousand of these were operating in central London at this date, usually over-crowded, and much picked over by thieves. These and numerous other commercial

vehicles are mostly covered in advertisements for (inter alia) the Society for Promoting Christian Knowledge (SPCK); the "Palace," in other words, the Palace Theatre of Varieties in Cambridge Circus (originally built in 1891 as an opera house for Richard D'Oyly Carte); Bragg's Charcoal; Singer's Sewing Machines; Oxo Extract of Meat; Ogden's Cigarettes; Thorougood's Family Ales; Nestlé's Milk; (R. S.) Colman's Mustard (of Norwich); Hudson's Soap (of Liverpool); Red Maid Soap; and Heaton's Glycerin and Borax Dry Soap.

The footage of the coronation procession and the next day's procession to St. Paul's naturally bristles with heraldic emblems and militaria, apparently endless low-slung floral swags, and ample bunting decorated with the shield and arms of the City of London. Yet even in the final sequence, just when London Bridge was being ingeniously widened without closing it to either street or river traffic, placards affixed to the freshly welded seventy- to eighty-ton horizontal steel girders stretching out above the heads of the king and queen cheerfully take credit for the remarkable job of construction: "Pethick Bros.' Quarry [Stone Merchants, Builders & Contractors of Plymouth]" and "The Patent Shaft and Axletree Company, Bridge Builders, Wednesbury [in the West Midlands]." It seems likely that with brilliant commercial opportunism the subcontractors, J. H. and W. Bell of Liverpool, carefully positioned these for the camera beforehand.[6]

Universally hat-wearing pedestrians and onlookers, meanwhile, scale walls and scramble over plinths and bollards; perch nonchalantly on the ledges of upper stories; and mingle chaotically, even dangerously, with barrow boys and errand runners, very familiar-looking London bobbies, and heavy horse-drawn traffic clattering over rough paving stones. They crane from opened windows, and they press against shop windows, including that of a very large "coffee and chocolate" establishment, perhaps in Aldwych. Men generally cluster into groups of men; women and children congregate separately. Pedestrian couples seem remarkably scarce.

It is in the foreground detail, mostly glimpses of people straying untidily and obliviously into frame, that one observes the most intriguing hints toward vanished custom and usage—the more telling, it seems, for their benign triviality. Many large black umbrellas regularly double as parasols, for example. And as the Gold State Coach passes St. James's Park, all men remove their hats, and most wave them high in the air, while women excitedly flutter their scarves and white handkerchiefs. In the head-craning jostle, there are a few leisurely boaters and at least one raffish fedora, but mostly demotic bowlers. Slightly to the left, however, isolated by a barely detectable cordon sanitaire of empty space, are three gentlemen companions: one actually seated, another with a pair of racing binoculars slung over the shoulder of his well-cut morning coat, the third and nearest to the camera

evidently far more interested than the other two in the approaching cavalcade. As the king and queen pass, they lift their rigid, shiny black silk toppers. Each cradles the brim most curiously in the palm of his gloved right hand, then proceeds to wave it (crown held upper- or outermost) with a slight, indeed barely perceptible, back-and-forth rocking motion of the wrist alone, a gesture so hemmed in by restraint that it could hardly be visible to anyone or anything other than the lens of a conveniently placed camera immediately adjacent. In fact, the man with the binoculars lets the top hat slip out of his hand, and it falls under the feet of his next-door neighbor. You sense in the case of these fastidious young men that the shared obligation to salute the sovereign argues comically with an innate disinclination to engage in any crowd activity outside the Royal Enclosure at Ascot, or even to wave with vigor. Here is far more than a residue of carefully self-administered class differentiation. It is the bowlers and handkerchiefs that raise the louder and more plausible cheer.

Just as the Canadian arch acts as a powerful imperial prompt, this film (and others like it) brought the coronation to the colonies. On 1 January 1901, the newly federated Commonwealth of Australia came into existence, a prudently negotiated and much more promising echo of the 1867 Confederation of Canada—at least from the point of view of the Colonial and Foreign Offices and the wool trade.

The Cinématographe arrived early in the Australian colonies and stimulated a remarkable local efflorescence of pioneering work, led somewhat counterintuitively by the Salvation Army in Melbourne, under whose aegis some of the earliest and most ambitious documentary films were made, commencing with *Soldiers of the Cross* (1900).[7] In May 1903 "Seajayk," the Sydney correspondent of the *Northern Territory Times and Gazette*, breathlessly reported to the residents of Darwin the arrival at the Arcades of the Mutoscope, "a new kind of peep show, in which pictures on the cinematograph principle are exhibited." The Mutoscope, "a cast-iron frame with glass eye holes, a slot in which you place a penny, and a handle at the side which you turn . . . presented to your vision a moving picture, the subjects being of infinite variety and calculated to suit all tastes." The Mutoscope was evidently competing well with other Sydney attractions such as *Dick Whittington* at the Theatre Royal; *Are You a Mason?* at the Palace; *A Woman of Pleasure* at the Lyceum; "'Thornton' in the evergreen comedy of *Charley's Aunt* at the Criterion"; *The Battle of Gettysburg* at the Cyclorama; and, finally, Fitzgerald's Circus at Belmore Park—at least several of which also incorporated motion-picture entertainments.[8]

As in England, the local public was well accustomed to seeing footage of royal occasions, as in 1897, when the impresario Carl Hertz and his assistant Mademoiselle D'Alton presented the following farewell program in Perth:

THE GLORIOUS PROCESSION of the QUEEN'S DIAMOND JUBILEE. Her Majesty the Queen actually bowing and acknowledging the plaudits of the people of Perth, seated in the Royal Carriage drawn by her famous Eight Cream Ponies, which nightly causes a perfect blizzard of Loyal and Acclamative Enthusiasm. FOR THE LAST TIME IN PERTH. GOOD-BYE to Queen Driving to St. Paul's. GOOD-BYE to Colonial [Boer War] Contingent. GOOD-BYE to Queen's Life Guards. GOOD-BYE to Dragoons at St. Paul's. GOOD-BYE to Blue Jackets and Cannons. GOOD-BYE to Royal Princes at St. Paul's. GOOD-BYE to Carriages Returning Home.[9]

There is, sadly, no evidence that the present film of Edward's coronation was ever screened in Australia, although it is certain that comparable footage, shot by other cinematographers under similar circumstances, was eventually absorbed into the variety entertainments in many thriving local theaters. These were generally marketed under viceregal patronage, for example, *Princess Maud's Marriage in London* (the future Queen Maud of Norway, on 22 July 1896), which was enthusiastically supported by the governor of Queensland, Lord Lamington, and widely advertised in Brisbane on that basis.[10] These films, and others, reminded Australian audiences of their role within the empire and provided a context for their own vice-regal ceremonial. It is an unremarked aspect of ceremonies on the scale of Edward VII's coronation, captured in these conveniently portable moving pictures, that the psychic distance between colonial or dominion outpost and the imperial capital was far narrower than the 4,700 miles that separated London from Vancouver, British Columbia, or the 6,000 to Cape Town and Hong Kong, or indeed the 11,700 to Wellington, New Zealand. If communities of British settlers in each of these and other possessions could for the time being conceive of the royal dramatis personae as actually acknowledging their own plaudits, locally rendered (even when not prompted to do so by advertisements placed by Hertz and others), we may safely conclude that, as a substitute for the gossamer threads of the transcontinental telegraph, the lumbering fleet of the Peninsular and Oriental Steam Navigation Company and the merchant marine, the decidedly mixed bag of Colonial Office representatives, even the wide distribution of the illustrated London weeklies and monthlies, the burgeoning medium of cinema constituted an imperial binding agent far more powerful, and with much greater potential, than all the others combined.

1. Anthony Slide, *Nitrate Won't Wait: A History of Film Preservation in the United States* (Jefferson, N.C.: McFarland and Co., 1992), passim; Vanessa Toulmin, *Electric Edwardians: The Story of the Mitchell & Kenyon Collection* (London: British Film Institute, 2006), 3–4; Geoffrey O'Brien, "First Takes: A Hundred Years Ago at the Movies," *New Republic* 212, no. 24 (12 June 1995): 33–35.

2. For the preparation of the ceremony itself, and the "enhanced" role of Lord Esher in planning it, see Roy Strong, *Coronation: A History of Kingship and the British Monarchy* (London: HarperCollins, 2005), 469–80.

3. This footage may also be associated with a program entitled *Royal Remembrances* (apparently released in 1929), or else fragments harvested from the coronation of King Edward VII by the cinematographer Cecil Hepworth, although by its very nature sequences of this kind may ultimately derive from either one, or both, or even a hitherto undocumented cinematographer working in robust competition. See Frances Dimond, *Developing the Picture: Queen Alexandra and the Art of Photography* (London: Royal Collection Publications, 2004), 175.

4. Angus Trumble, "Gilbert Scott's 'Bold and Beautiful Experiment,' Part I: The Tomb of Sir Charles Hotham in Melbourne," *Burlington Magazine* 142, no. 1161 (Dec. 1999): 747.

5. "Royal Annexe and Canadian Arch," *Architects' Magazine* 2, no. 21 (July 1902): 170. Preston's title seems to have been "commissioner of immigration" almost as often as "commissioner of emigration," but his roles were indivisible. He also found time to write *The Life and Times of Lord Strathcona* (London: E. Nash, 1914).

6. "London Bridge," *Times* (London), 24 Nov. 1902, 2, reprinted as "Widening London Bridge: A Work of Engineering and Historical Interest," *New York Times*, 30 Nov. 1902.

7. John Tulloch and Paul Washington, "Film Industry," in *The Oxford Companion to Australian History*, ed. Graeme Davison and others (Melbourne: Oxford Univ. Press, 1998), 253.

8. *Northern Territory Times and Gazette*, 8 May 1903, 3.

9. *West Australian* 13, no. 3,622 (5 Oct. 1897): 1.

10. *Brisbane Courier*, 11 June 1897, 2.

Spectacle, the Public, and the Crowd: Exhibitions and Pageants in 1908

Deborah Sugg Ryan

> By eleven o'clock the High Street was packed with crowds that whiled away their time with staring at flags and decorations. But it was not until 1.0 p.m. that there began to flow, always towards the Pageant Ground, a stream by which that week, among the inhabitants of Merchester, will always be best remembered; a stream of folk in strange dresses—knights in armour, ladies in flounces and ruffs, ancient Britons, greaved [*sic*] Roman legionaries, monks, cavaliers, Georgian beaux and dames.
>
> It appeared as if all the dead generations of Merchester had arisen from their tombs and reclaimed possession of her streets. They shared it, however, with throngs of modern folk, in summer attire, hurrying from early luncheons to the spectacle. In the roadway near the Pageant Ground crusaders and nuns jostled amid motors and cabs of commerce.[1]

THIS ACCOUNT OF a fictional "Merchester" pageant by the novelist Arthur Quiller-Couch in his *Brother Copas* (1911) was based on his own experience as a writer and actor—or pageanteer, in contemporary parlance—involved with the 1908 Winchester National Pageant. Quiller-Couch's description of the anticipation of the pageant as the crowds gathered in the streets and mingled with pageanteers, creating a spectacle of past and present, is a common trope in eyewitness accounts of pageants in Edwardian Britain. Boundaries became blurred between the spectators and the spectated.

Distinctive forms of public display and spectacle emerged in Edwardian Britain. Commercial exhibitions and historical pageants were spectacular events that were part of a modern mass culture of popular entertainments and consumer experiences, including other visual forms such as the cinema and the department store.[2] As S. Michael Halloran has written on the rhetoric of spectacle, the audience, in gathering to witness events such as pageants, became part of the spectacle. Furthermore, he argued that the pageant was "a public gathering of people who have come to witness some event and are self-consciously present to each other as

well as to whatever has brought them together."[3] H. V. Nelles has described the 1908 Quebec tercentenary pageants, which were organized by the British pageant master Frank Lascelles, thus:

> Even the unwilling were drawn in one way or another by the crowds, parades and booming spectacles. It was an entertainment, of course, but it was entertainment with an intent, or rather intentions. Spectators were drawn in at many points of access, becoming in the process participants as well as observers.[4]

This Edwardian sense of spectacle as "lived experience"[5] contrasts with Guy Debord's later situationist characterization of the spectacle as a displacement of lived experience.[6] Thus the discussion of Edwardian popular spectacle that follows has an emphasis on the interaction between performers and audience.

Popular spectacles in the Edwardian period, such as exhibitions, pageants, and the cinema, all relied on large casts and mass audiences. The growth of these commercialized forms of leisure depended on the development of mass society in the first decade of the twentieth century, in which populations became more urban and affluent, transgressing traditional class and gender boundaries.[7] The possibility of the extension of the vote led to debates about citizenship. As Richard Butsch has argued, there were huge anxieties about the behavior of the masses—in the form of the crowd.[8] This was powerfully expressed in Gustave Le Bon's book *The Crowd* (1895), which continued to have an impact on the social sciences into the twentieth century. According to Le Bon, people in crowds witnessing an event or listening to a speaker were irrational and lost their individuality, reason, and will, becoming swept up in collective emotions and acting with one mind. The notions of rational and independent citizenship and the behavior of the masses as a responsible public were more desirable. Such studies of crowd psychology also incorporated contemporary ideas about social and racial hierarchies: the lower classes, women, and certain races and nationalities were thought of as more primitive and more likely to behave as a crowd. Furthermore, it was widely thought, those most susceptible to behaving as a crowd should be excluded from the responsibilities of citizenship.[9] Thus, while the organizers of popular spectacles of Edwardian Britain might have desired their audiences to behave as a public, audiences often appropriated spectacular events for their own ends and behaved as a crowd.

Spectacle, deriving from both high and popular culture, was a major part of leisure activities in Edwardian Britain. Examples of the spectacular in fine art include tableaux vivants and history and narrative painting.[10] Edwardian visitors to museums and art galleries could participate in the spectacle of the exhibition.[11]

There were distinctively spectacular forms of theater in Edwardian Britain (see the essay by Christopher Breward in this volume), including pantomimes and a revival of Roman and Shakespearean plays. Henry Irving and Herbert Beerbohm Tree produced elaborate stage productions influenced by the spectacular effects that Dion Boucicault and Charles Kean pioneered, as well as by the phenomenal success of *Peter Pan*, the Drury Lane Theatre pantomimes of Augustus Harris, panoramas, and dioramas.[12] In addition to these, Edwardians could view lantern-slide lectures,[13] waxworks, fairs, circuses, magic shows, balloon ascents, sideshows, and street entertainers.[14] Even while on the street, Edwardians experienced a mass of advertising material, such as posters and leaflets, on walls, shop windows, and elsewhere.[15] Women had the department store, and men had the spectacle of professional sport, such as boxing, cricket, and soccer—and in 1908 the Olympic Games, which attracted huge, largely male crowds (see the essay by David Gilbert in this volume). Everyday life was treated as a kind of spectacle in the Edwardian sense.

Motion-picture shows were a particularly Edwardian spectacular phenomenon. Before 1908 films were frequently presented as attractions or sideshows.[16] Filmmakers such as the early film company Mitchell and Kenyon recorded Edwardians making spectacles of themselves on weekends and public holidays in parks, pleasure gardens, and rivers.[17] Thus the spectators of "the cinema of attractions" were part of the spectacle, as both subject and audience. The popular historical pageants and exhibitions that were staged in Edwardian Britain also became subjects for the cinema of attractions. The attraction of the pageant films, as their publicity material made clear, was for pageanteers to recognize themselves and their friends in the on-screen spectacle, via the new technology of the cinema, not to watch a historical narrative.[18]

It is hard to fit the huge range of spectacular experiences available to Edwardian audiences into one essay. Concentrating on the particularity of commercial exhibitions and pageants, however, will demonstrate that they were unique kinds of spectacular visual culture, with their own conventions and technologies. The rest of this essay will examine exhibitions and pageants in 1908. This year marked the pinnacle of public spectacle in the Edwardian period, encompassing the Franco-British Exhibition and the Olympic Games, both at what became White City in Shepherd's Bush, West London, and also an extraordinary number of commercial exhibitions, including the first Daily Mail Ideal Home Exhibition. For the fourth year running, local historical pageants were staged across England, spreading to Scotland and even Canada. In addition, the suffragettes put public spectacle to political ends in a series of spectacular parades. The use of spectacle, however, was not simply a top-down hegemonic process, despite its utilization by the state and

various organizations for purposes of propaganda, in the coronation (see the essays by Tom Gunning, Bronwen Edwards, and Angus Trumble in this volume) and other spectacular events. As Alison Light has pointed out, faced with "the staggering spectacle of the coronation . . . with all the sumptuous excess of a displayed Empire," we need to "gauge the appeal of such imagery."[19] Thus the focus of this essay is the interplay between the Edwardian sense of spectacle and spectatorship.

EXHIBITIONS

In 1908 the *Daily Mail* (London) proudly announced: "It has been the custom to speak of 1851 as Exhibition Year; the name will be henceforth have to be applied to 1908."[20] The development of a circuit of exhibition venues in London and the rest of Britain suggests that there was a thriving commercial culture of exhibitions in Edwardian Britain.[21] Under the subhead "twenty-five great shows," the *Daily Mail* explained that "Exhibition Year" would include the Franco-British Exhibition at White City and the Hungarian Exhibition at the Earl's Court exhibition center as well as its own very first Ideal Home Exhibition at the Olympia exhibition center's Great Hall, all in West London. The range of exhibitions that the article in the *Daily Mail* listed was extraordinary. It said that visitors to the Olympia exhibition center in March could see the Heavy Motor Exhibition and the Business Exhibition, while those interested in lace, postage stamps, or tobacco could go to the Royal Horticultural Hall. In April the Clothing, Outfitting, and Allied Trades Exhibition took place, as did the Sociological Society's Toy Exhibition. In May both the Franco-British and Hungarian exhibitions opened, along with the Municipal, Building and Health Exhibition, Chemists' Exhibition, What to Do with Our Girls Exhibition, the Royal Navy and Military Tournament (not strictly an exhibition, but it appeared as such in the *Daily Mail*), and the Mexican Exhibition at the Crystal Palace. In June the Orient in London exhibition was staged at the Royal Agricultural Hall, the Home Arts and Industries exhibition at the Royal Horticultural Hall, and the Horse Show (the definition of exhibition seemed to include all spectacular events) at Olympia.[22] Later in the year, the Medical, Cookery, Waring's (a furniture company), Confectioners', Grocers', and Brewers' exhibitions were held at various London venues.[23]

Newspapers advertised and reported on exhibitions of all kinds, whether they were intended for the public or not. This may have been partly for the benefit of readers employed as sales representatives in the appropriate trades, but the interest went beyond this. Indeed, the public was so keen on exhibitions that individuals arrived uninvited to trade fairs that were not intended for them. It is surprising

how few of these exhibitions are remembered, even though some of them were annual events and have very long histories.[24]

One of the masters of spectacle in the Edwardian period was the Austro-Hungarian-born entrepreneur Imre Kiralfy. He acquired the leases for the Olympia and Earl's Court exhibition centers in 1891 and 1893, respectively, and put on a "conjunction of spectacle entertainment, informative exhibitions, and 'Midway.'"[25] Kiralfy and his brother Bolossy, who had worked together on a spectacle series in the United States in the 1870s and 1880s, staged several rival performances in London that they termed "spectacles" or "pageants."[26] Imre's first major success, *Nero, or the Fall of Rome*, was held at Olympia in 1889. It had huge sets and hundreds of actors, animals, and extras "orchestrated into what was essentially a tableau-vivant of special effects."[27] Not to be outdone, Bolossy staged his own spectacles, including *The Orient; Or a Mission to the East* at Olympia in 1894, described as "a mammoth and original spectacle and water pageant, in two acts and five tableaux."[28] Imre Kiralfy's exhibitions frequently included ethnographic villages, which could be seen as living pageants. He developed his White City exhibition venue for his Franco-British Exhibition in 1908 and went on to stage a number of exhibitions there until 1914. His exhibitions were essentially commercial ventures motivated by profit rather than simply imperialist propaganda.

At least ten and a half million people visited Kiralfy's Franco-British Exhibition.[29] It occupied a site of 140 acres, housed in the specially built and descriptively named White City. This architectural fantasy consisted of twenty palaces, seven huge pavilions, and the largest machine hall ever built, set amid landscaped ornamental gardens, courts, and vistas, spectacularly lit at night with novel "illuminations." Visitors, ferried in swan-shaped gondolas through canals, "Rialto-like" bridges, and a huge artificial lake, became part of the spectacle of the exhibition.[30]

The success of the Franco-British Exhibition depended on attendance numbers and revenue from gate admissions. Kiralfy introduced large-scale leisure facilities, such as sideshows, amusement rides, cafés, and restaurants, modeled on those he had seen in St. Louis and Chicago, and drew as well on techniques from theater, such as tableaux vivants, and from his experience with fairgrounds, which had not been used in British exhibitions before. There was an open-air theater capable of holding three thousand spectators, where a two-hour "Alfresco Spectacular" entitled *Our Indian Empire* was staged with a cast of hundreds of Indians and Ceylonese and a wide variety of wild animals, explaining how the British civilized India.[31] Kiralfy aimed to "combine the extraordinary nature of his previous ventures with the cultural respectability of a Great Exhibition."[32]

The Franco-British Exhibition represented, as Paul Greenhalgh has argued, a "discernable shift from philanthropic involvement with education to mass enter-

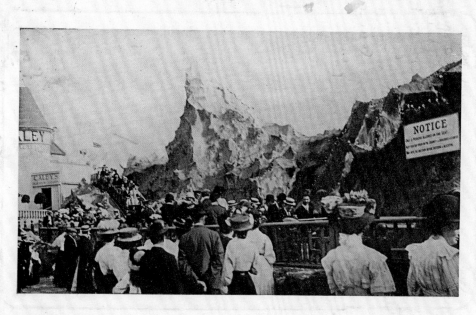

SCENIC RAILWAY Franco-British Exhibition London, 1908

7. "Scenic Railway: Franco-British Exhibition, London, 1908," postcard. Courtesy of David Gregory, Postcards of the Past.

tainment."[33] A commentator on the following year's Imperial International Exhibition noted:

> The instructive part of the exhibition appears to be in rather an embryonic condition, but Mr Kiralfy knows his public. And his public prefer Biplanes, and Water-whirls and Witching-Waves, and Wiggle-woggles, and Flip-flaps to all the instruction in the world.[34]

The Flip-Flap was a huge pincer-like ride that swung visitors above the ground at great height. There was also a Canadian toboggan run, a Pathé Brothers cinematograph, and a Stereomatos slide show with special effects. Another popular attraction was the scenic railway. A postcard of the ride (fig. 7) is interesting, because it seems to be a snapshot of a crowd actively participating in the exhibition by watching and queuing for the scenic railway, swept up in collective pleasure, in contrast

to the individual public citizens peopling the landscape of official views of the exhibition. On the back of the postcard, a visitor to the exhibition wrote: "I went on the spiral railway, it is a terrible thing! and is supposed to be very dangerous. I sat in front with the driver and he asked me if I would like to go fast, I said 'Yes,' and we did!!"

On Friday, 9 October 1908, the first Daily Mail Ideal Home Exhibition opened at Olympia on the heels of the Franco-British Exhibition, which had closed after a run of five months.[35] The timing was certainly effective; by the time the Ideal Home Exhibition closed on Saturday, 24 October, it had attracted some 160,000 visitors.[36] Most of the themes of the various sections of the Ideal Home Exhibition had been seen before at international exhibitions and trade fairs.[37] Moreover, the scale of the Ideal Home Exhibition, housed in the Olympia exhibition center's single Great Hall, paled into insignificance beside the Franco-British Exhibition's vast site at White City. What was unique about the Ideal Home Exhibition was its sole emphasis on the home.

In an advance notice for this first Ideal Home Exhibition, the *Daily Mail* declared:

> This Exhibition will be the first of its kind to be held in this country. It will be a revelation to the British public. It will demonstrate in the most striking manner what is being provided in every direction for the betterment of the home.[38]

The Ideal Home Exhibition shared many of the conventions and features of international exhibitions in its model dwellings and displays of ingenious machinery. It succeeded because it built on forms of spectacular entertainment to which the public was already well accustomed. Many of the exhibitors at the first Ideal Home Exhibition would also have participated in trade fairs such as the Building Trades Exhibition, which had been held annually since 1895. The Ideal Home Exhibition differed from such fairs in that it was primarily intended for the public. So the claim that it was "the first of its kind" would appear to have some substance.

The Ideal Home Exhibition linked consumer desires, retailing, manufacturing, and leisure by seeking to explain the "modern ways of domestic life" in displays of suburban modernity.[39] Home became the center of new forms of consumption in Edwardian Britain. In the Edwardian sense, it was the place that provided not just shelter, but also space to project desires and fantasies (see the essay by Christopher Reed in this volume). A photograph of the first Ideal Home Exhibition (fig. 8) shows visitors perusing stands bearing several well-known names, including J. S. Fry & Sons and Bird's Custard. Visitors were encouraged to interact with the

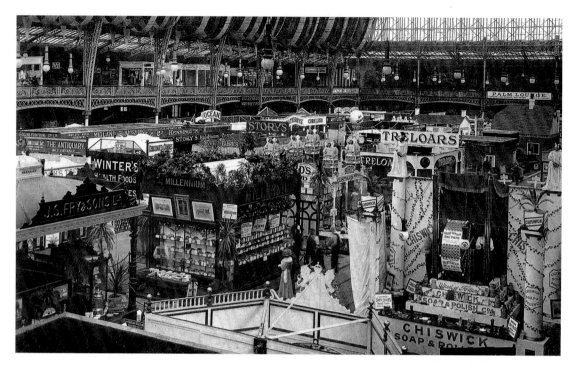

8. "View of the First Daily Mail Ideal Home Exhibition" (1908), from Deborah S. Ryan, *The Ideal Home through the Twentieth Century* (London: Hazar, 1997), 23.

exhibits. The Millennium stand in the foreground, for example, featured an "Ideal Loaf" competition, which was judged by visitors to the stand.

There is no doubt that the organizers of the Ideal Home Exhibition aimed it at women. The *Daily Mail*'s proprietor, Alfred Harmsworth, Lord Northcliffe, had long recognized that women were important consumers and had launched the *Daily Mirror* in 1903 as a women's newspaper. He said the *Daily Mail*'s magazine page "ought to be almost entirely feminine. It ought, I think, to be a women's page without saying so."[40] And so its contents appealed to the feminine sphere, concentrating on fashion, cookery, homemaking, and romantic stories. Thus, in the buildup to the 1912 Ideal Home Exhibition, the *Daily Mail* declared that "all the world and her husband flocked to the last two 'Ideal Home' Exhibitions, and will do so again next month."[41] The Ideal Home Exhibition portrayed a feminine and domestic world of goods, to which men were merely appendages.

The notion of the "ideal home" invoked both orderly angels in the house and also wanton, free-floating consumer desires. This point was exploited by suffrag-

ettes who staged an intervention into the 1908 Ideal Home Exhibition. The *Daily Mail* reported this "suffragette invasion":

> A party of suffragettes put in an appearance at the exhibition during the afternoon. Ascending to the second floor, they stood bareheaded, and spoke to the large crowd that quickly assembled on the lawn below. The two speakers . . . explained that they came to the exhibition because many women had no homes and because elementary rights were denied to women who made the homes. After a certain amount of oratory the ladies consented to retire.[42]

The incident was played down, buried in a column headed "Ideal Home Record" that reported the attendance of titled aristocratic "ladies" at the exhibition. Under the subhead "growing interest in the model nursery," the "support and interest of women of all walks of life" was reported. This was surely a deliberate juxtaposition of, on the one hand, honorable and orderly "ladies" and the identification of women as mothers—who could be thought of as constituting a suitable public face of womanhood—with, on the other hand, the unladylike and unmotherly behavior of suffragettes, raising fears of the female crowd. Immediately after the account of the "suffragette invasion," there was a report of the prizewinners in the competitions for basketwork, wood carving, and "coloured embroidery in material suitable for furniture purposes," reinforcing respectable feminine virtues of home crafts.[43]

In 1908, when there were enormous changes in the social, economic, and political structure of Britain, the suburban modernity of the Ideal Home Exhibition presented an Edwardian sense of stable femininity and peaceful domesticity that harnessed the latest modern developments yet respected the traditions of the past. The *Daily Mail* frequently underlined this by juxtaposing reports of the steady femininity and placid atmosphere of the exhibition with the disorderly behavior of suffragettes, hunger marchers, and the unemployed. With empire in decline and anxieties about the future of the race and nation, much importance was attached to the home as a site of citizenship. It was also a site of dutiful consumption where women were responsible for the making of the citizens of the future.

By 1908 exhibitions of all kinds had become an established form of entertainment, which, though educational, were motivated primarily by commerce and profit. The success of these exhibitions depended on both willing exhibitors and an enthusiastic audience. The Franco-British Exhibition drew on the language of imperial and civic education from Victorian exhibitions aimed at civilizing the public. It also drew on technologies calculated to appeal to the crowd's Edwardian sense of the pursuit of leisure and pleasure.

PAGEANTS

In Edwardian Britain a new tradition of historical pageants was invented. Pageants are particularly apt exemplifications of the Edwardian sense. May Morris called for the revival of pageantry and the masque in a speech at the Royal Society of Arts in 1902.[44] This reinvention can be seen as part of what Mark Girouard has called the "return to Camelot": an Edwardian taste for events combining chivalry, patriotism, and imperialism.[45] Indeed, the illustrated postcards and drawings for the "books of words"—as the souvenir volumes of printed and bound scripts were usually called—that accompanied pageants bear a striking resemblance to romanticized depictions of medieval life by artists such as Walter Crane (see the essay by Morna O'Neill in this volume).

Louis Napoleon Parker founded the modern pageant movement when he staged the Sherborne Historical Pageant in 1905.[46] Shortly afterward he too gave a speech at the Royal Society of Arts about his new genre. Significantly, Imre Kiralfy was present in the audience.[47] Parker was the first to use the word "pageant" to describe an outdoor community drama. He originally used the term "folk play" to describe his production, but it aroused little interest.[48] He turned to the word "pageant" to describe an event that he summarized as follows:

> A festival of Thanksgiving, in which a great city or a little town celebrates its glorious past, its prosperous present, and its hopes and aspirations for the future. It is a Commemoration of Local Worthies. It is also a great Festival of Brotherhood; in which all distinctions of whatever kind are sunk in a common effort. It is, therefore, entirely undenominational and non-political. It calls together all the scattered kindred from all parts of the world. It reminds the old of the history of their home, and shows the young what treasures are in their keeping. It is the great incentive to the right kind of patriotism: love of hearth; love of town; love of country; love of England.[49]

Parker defined the Edwardian pageant as an outdoor folk play or community drama. The ideal pageant, as an American writer formulated it in 1914, was "a drama of which the place is the hero and its history is the plot."[50] At least forty pageants were subsequently staged in Britain before the outbreak of World War I. Pageantry was not a static genre, however; it was continuously refined and redefined.[51]

By 1908 the *Times* (London) newspaper index required a full column to itemize articles dealing with a dozen or more English pageants, whereas only two years earlier it had contained no references to pageants of any kind.[52] In 1907 *Punch* magazine commented on the "acute" outbreak of "pageant mania": "Can you cite

LIVING ON REPUTATION.

Britannia (*among the Pageants*). "QUITE RIGHT OF THEM TO SHOW PRIDE IN MY PAST; BUT WHAT WORRIES ME IS THAT NOBODY SEEMS TO TAKE ANY INTEREST IN MY FUTURE!"

9. Edward Linley Sambourne, *Living on Reputation*, engraving, from *Punch*, 1 July 1908, 11. Yale Center for British Art, Paul Mellon Collection.

any other country where it is impossible to walk out of doors without colliding into a pageant?"[53]

Punch regarded this preoccupation with the past as an evasion of the responsibilities of the present toward the future. This view is pointedly expressed in the cartoon *Living on Reputation* in 1908 (fig. 9), in which Britannia (among the Pageants) remarks: "Quite right of them to show pride in my past; but what worries me is that nobody seems to take any interest in my future."[54] As Paul Readman has argued, in Edwardian Britain great emphasis was placed on the continuities of past and present at a time of great change, and there was a genuine popular desire

to learn about the past.[55] Pageants were certainly an effective means of so doing. Moreover, they could be read as nostalgic, antiquarian, self-consciously traditional (albeit an invented tradition), and inherently conservative. This was certainly Parker's intention:

> This modernising spirit destroys all loveliness and has no loveliness of its own to put in its place, it is the negation of poetry, the negation of romance. . . . This is just precisely the kind of spirit which a properly organised and properly conducted pageant is designed to kill.[56]

But to see pageants as "a protest against 'modernity'" is an oversimplification.[57] Bill Schwarz has pointed out that "the emergence of a popular modernism also coincides with the deepening idea of English traditionalism."[58] As he suggested, "The dynamic and recurring inventiveness of tradition may precisely have required a popular and carnivalesque projection of modernity and of the future in order to sustain the idea of the past."[59] The modernity of Edwardian pageants was not necessarily located in their subject matter but in their spectacular and participatory nature, which was dependent on modern mass society.

In the summer of 1908, the public could attend several different pageants across England, including ones in Dudley, Winchester, Chelsea, Gloucestershire (at Cheltenham), Pevensey, Dover, and King's Lynn.[60] There was also a Scottish National Pageant of Allegory, Myth and History, held on the grounds of the Scottish National Exhibition in Edinburgh.[61] A Pageant of London was originally planned for 1908, but it was not staged until 1911, after a series of delays.[62]

At least five individuals worked actively as pageant masters and were paid for their services in Edwardian Britain, with some amassing fame and fortune in the process.[63] The Dover Pageant was Louis Napoleon Parker's fourth, preceded by pageants in Sherborne (1905), Warwick (1906), and Bury St. Edmunds (1907).[64] He went on to stage six more between 1909 and 1918. It is significant that some of the pageant masters had previously worked on Henry Irving's spectacular productions of Shakespeare and were experienced actor-managers. The master of the Gloucestershire pageant was George Procter Hawtrey, an actor and playwright.[65] This was his first pageant, and he went on to stage the National Pageant of Wales in Cardiff in 1909 and the Chester Pageant in 1910. The master of the Winchester pageant was F. R. (or Frank) Benson, an actor-manager who had worked for Irving. Benson founded a well-known repertoire company in 1883 that performed all but two of Shakespeare's plays and was responsible for twenty-six of the annual Shakespeare festivals at Stratford-upon-Avon.[66] He was master of the 1907 Romsey Pageant and went on to organize the Army Pageant at Fulham Palace, West London,

in 1910.[67] The Chelsea Historical Pageant in 1908 was staged in that part of London by the actor and stage manager John Henry Irvine.[68] The painter, sculptor, writer, and actor Frank Lascelles was a pageant master who had a huge hit in 1907 with the Oxford Historical Pageant, the first he staged. An accomplished Shakespearean performer,[69] he had worked with Irving and with Herbert Beerbohm Tree at His Majesty's Theatre, London, between 1904 and 1906[70] and had also appeared on stage with Irvine.[71] Like Irving and Tree, each of the pageant masters had to be meticulous about every aspect of a production, combining its various aspects into a single vision.

Lascelles was no imitator of Parker. His pageants were distinctive spectacles rather than dramas, relying more on visual effects than the spoken word.[72] Lascelles himself, reflecting on the development of modern pageantry in his Oxford (1907) and Quebec (1908) pageants, stressed the "effect upon the eye . . . when great scenes of a country's history are visualised . . . the massing and blending of colours."[73] Lascelles's Oxford pageant was witnessed by Mark Twain and the American pageant master Ellis Paxson Oberholtzer, and it had a huge influence, arguably greater than Parker's, on the development of the historical pageant movement in the United States, notably on Oberholtzer's own Philadelphia Pageant in 1908.[74] Lascelles was invited to organize the pageants for the Quebec tercentennial celebrations in 1908, using the Plains of Abraham as his ground, to sublime effect, and restaging the 1759 battle of Quebec with a cast of four thousand, including Native American pageanteers.[75] This was widely regarded by American pageant masters as the pinnacle of "pageantitis." Lascelles was also master of the delayed Pageant of London.[76] He was the most prolific pageant master in Britain, staging some twenty-two pageants between 1907 and 1932.

Edwardian pageants were performed outdoors, usually in a place of historical interest where events staged in the pageants had actually taken place. For Hawtrey, ideally "the ground must not be overlooked; or if it is, it should be possible without great expense to mask out those places from which a view can be obtained gratis."[77] The Dudley, Pevensey, and Winchester pageants in 1908 took place on the grounds of their respective castles. Irvine had to make some compromises with the location of his Chelsea pageant, which was performed in the old Ranelagh Gardens: "It has not, it is true, the wide vistas that have added so much to some of the Pageants in the Provinces, but the players and the scenes were so artfully disposed upon it that there was no sense of smallness or limited distances."[78] Hawtrey had to make even more compromises for the location of his Gloucestershire pageant in Cheltenham: "Some difficulty was felt because the town is not one that possesses many historical associations. In each episode we have to assume that the scene represents a different locality. This demands a certain imagination on the

part of the audience."[79] Thus the members of the audience, though remaining seated in one place, were active spectators, having to reimagine the actual place before them to form different historical manifestations of that place and other places as well.

Edwardian pageants told the history of places in scenes, or episodes, usually from Roman times until the eighteenth century—the recent past was thought too controversial. Thus Chelsea started with the Romans crossing the Thames at Chelsea in 53 B.C. and ended with the tenth episode depicting the Royal Fete at Ranelagh Gardens in 1749.[80] Dudley began with an episode depicting Penda the Strong, last of the pagans and king of Mercia, in Dudda (the ancient name for Dudley), A.D. 656, and concluded seven episodes later with Charles II accompanied by Dud Dudley (a son of Lord Dudley), who had discovered a way to make iron using "pit cole" (or coke, derived from coal using a process that he invented, like that used to turn wood to charcoal), in 1660.[81] Winchester, consisting of nine episodes, began with the coming of the Romans in A.D. 43 and ended with Charles II visiting Winchester on May Day in 1665.[82] The majority of pageants seemed to have a scene of Elizabeth I visiting their location; this was certainly the case for Dudley and Chelsea. Some also included interludes, masques, or allegories; Chelsea had a children's masque of Edmund Spenser's *Faerie Queene* and also narrative links spoken allegorically by Thames and Tide, meeting at Chelsea's Riverside.[83]

The scenes of histories of towns were intended to invoke pride in place, civic virtues, and citizenship among both pageanteers and audience. Accounts by pageanteers, however, often reveal other motivations. For example, a diary kept by a young woman who acted in the 1911 Pageant of London reveals interborough rivalries and a delight in the opportunities afforded to meet members of the opposite sex.[84] Pageanteers relished the opportunities that dressing up presented, and they often wore their costumes in their everyday jobs and for weeks after the pageant ended.[85]

There was also an implicit nationalism and imperialism in Edwardian pageants, particularly invoked by the scenes set in Elizabethan England. Furthermore, the town in question was often depicted as the center of the British Empire. For example, the Dover pageant had a finale with Dover represented as a mother figure surrounded by her forty-four American and colonial daughters (fig. 10), a common feature of many pageants.

Crucial to the success of pageants were their huge casts of actors, averaging five thousand people. Indeed, the casts of thousands sometimes threatened to outnumber their similarly large audiences. The logistics of recruiting willing and able pageanteers caused huge problems for pageant masters. It was certainly the case that although Parker believed idealistically that aristocrats should play serfs

10. "All the Dovers, Pageant of Dover" (1908). Courtesy of the Dover Pageant Society. Women representing towns named Dover from all over the British Empire participate in a parade at the pageant.

and vice versa, many of the most prominent parts were bagged by local elites. Some well-to-do pageanteers evidently traveled around the country to appear in one pageant after another.[86] A 1907 *Punch* cartoon, *In the Movement*, depicts a man in medieval costume and mounted on a horse, being addressed by a young woman in costume (fig. 11). It was accompanied by the following text:

> Wench. "Do you paj much? I was wondering if you'd help us at Pipley later on."
>
> Varlet. "My dear lady, I'm absolutely booked up for the season. Let's see. I'm Oliver Cromwell at Land's End on Friday; Perkin Warbeck in the Isle of Man on bank holiday; Titus Oates in the Scillies on the 10th; and then Ethelred the Unready in Shetland. Sorry. No go."[87]

But pageanteers were not just from the leisure classes. Hawtrey was sensitive to the question of where to recruit pageanteers, commenting that "it is never very easy to obtain all the men that are required. Mr. Louis Parker, the inventor of Pageants, has succeeded in persuading the inhabitants to close the shops during the afternoons when the performances were taking place."[88]

Pageanteers actively contributed to the spectacle of the pageant by making their own costumes, which was desirable—indeed, necessary—given tight budgets. Many displayed great ingenuity. For example, a "young woman of Dover

IN THE MOVEMENT.

Wench. "Do you pay much? I was wondering if you'd help us at Pipley later on."

Varlet. "My dear lady, I'm absolutely booked up for the season. Let's see. I'm Oliver Cromwell at Land's End on Friday; Perkin Warbeck in the Isle of Man on Bank Holiday; Titus Oates in the Scillies on the 10th; and then Ethelred the Unready in Shetland. Sorry. No go."

11. J. L. C. Booth, *In the Movement*, engraving, from *Punch*, 31 July 1907, 73. Yale Center for British Art, Paul Mellon Collection.

turned rejected halfpenny 'bowler' hats into splendid 'steel' helmets, at a cost of twopence-halfpenny apiece; 'chain armour' was made from thick twine, knotted and 'metalized' at a very small cost."[89] Hawtrey, working on the Gloucestershire pageant, thought that Parker's insistence on pageanteers supplying their own costumes was detrimental, causing such low attendance at his rehearsals that it threatened the pageant. In a letter to the pageant committee, he complained that 671 people out of 2,347 pageanteers "have not attended a single rehearsal," that he had been "repeatedly told at rehearsal by those present that their friends are staying away because they will not pay for their dresses," and that he believed "most strongly that the performers are not the people out of whom we ought to make

money. We are conferring no benefit on the town by taking the shillings of working girls, and sending the money away to London, whence not a penny will ever return."[90] In his treatise on how to stage a pageant, he expanded on this belief: "Those who are able to provide their own costumes and who wish to do so are to be encouraged and thanked. But no performer, either rich or poor, ought to be pressed to pay."[91]

Most pageants contained little in the way of spoken words, relying instead on spectacular staging and dancing. Pageants depended on the primacy of the ocular. Many of the larger pageants used specially composed music, to great effect.[92] Eyewitness accounts tend to focus on pageants' "visible spectacle" rather than "verbal exchanges," despite the scripts being reproduced in full in the pageants' books of words.[93] As S. Michael Halloran has noted, "It seems highly unlikely that actors in the dramatized scenes of the pageant could have been heard by more than a tiny fraction of the huge and widely dispersed audience."[94] This was certainly the case for a reviewer of the Chelsea Historical Pageant in the American magazine *Nation*:

> A pageant, by its series of pictures and eloquent movements, should explain itself with no more words than are absolutely indispensable. Besides, the noblest and most poetic dialogue must lose in the open air, where speakers either cannot make themselves heard at all, which was the case with so many at Chelsea, or else have to labor so hard in the endeavor, that the beauty, or meaning, of their words is lost in the ugliness of the effort.[95]

The disjointed, episodic nature of pageants and the very long time it took to stage them—performances typically lasted at least half a day, with long breaks between scenes—meant that the emphasis, like that of the cinema of attractions, was on visual spectacle and what Tom Gunning has termed "temporality" rather than narrative effects.

Pageant audiences, as Halloran has noted, like those who attended showground spectacles, were active participants rather than passive observers.[96] A souvenir postcard of the Dudley pageant (fig. 12) shows the "earl and distinguished company witnessing the pageant." Looking around at the action and at one another, the spectators are clearly part of the spectacle, so much so that they are worthy of being commemorated. Close inspection reveals the behavior of the seated pageant audience. In the front rows, the well-dressed spectators are clearly following the pageant in the book of words, many of them looking down rather than out toward the spectacle. Some of them are looking at one another, however, and may even be talking. This is especially the case in the rows farthest from the

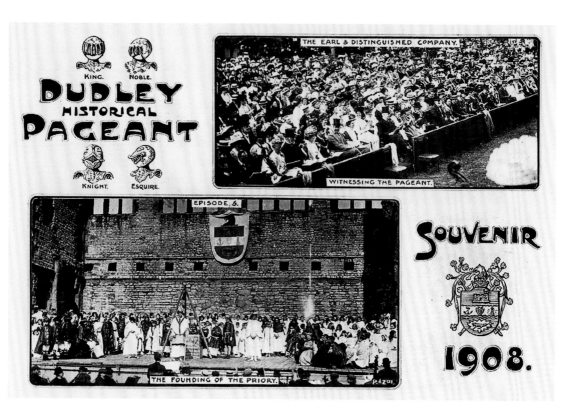

12. "The Earl & Distinguished Company Witnessing the Pageant" and a scene, "The Founding of the Priory," from the Dudley Historical Pageant, postcard (1908). Collection of Deborah Sugg Ryan.

action. Perusal of the souvenir handbook reveals that the photograph on the postcard has been cropped. There can be seen, behind a railing, a standing audience, clearly lacking in the finery of the seated spectators. None of them appear to be reading. Their field of vision includes not only the pageant; they are also looking at the spectators in front of them who could afford the more expensive seats, as well as at one another. Furthermore, many of the cast members would have been looking out for their friends in the audience. Indeed, the photograph is taken from the performers' point of view. Thus the pageant spectacle operated at a number of different levels, blurring the boundaries between spectators and spectated. The spectacle worked both ways.

Photography played an important role in recording pageants, both in official views, on postcards and in souvenir publications, and in snapshots taken by pageanteers and audience members. As James Ryan and Nicola Thomas have com-

mented on the Delhi Durbar of 1903, "Photography was used to record and enhance its appeal as modern spectacle." This was not just through commercial and official photographers, but also through the people in the audience wielding their own cameras, "turning viewers into image-makers." This, in turn, led to multiple viewpoints of and perspectives on modern spectacle, "an approximation of an active and varied engagement with the visual scene."[97]

This begs the question of how the audience behaved. The long time taken for performances, the breaks between episodes, and the complex entrances and exits of the huge casts meant that the audience's concentration was often disrupted. Spectators not only talked to one another, but also they called out to their friends in the pageant and their friends called to them, disrupting the illusion of the spectacle—to the annoyance of pageant masters. They also ate. Hawtrey complained, "A great mistake was made at Cheltenham in this matter of refreshments. The contractor . . . was allowed to sell refreshments while the performance was going on, and the tramping backwards and forwards of waiters soliciting orders was intolerable."[98] Thus they behaved as an unruly crowd rather than a civic public.

Pageanteers also acted as an out-of-control crowd, to the exasperation of pageant masters, who wanted historical illusions to be maintained. The American pageant master Ellis Paxson Oberholtzer has complained that "a very common nuisance is the habit on the part of performers of laughing and signalling to their friends as they pass. . . . Still others, as they pass out behind the trees into their camps, will shout until the welkin rings with the echoes of their unruliness."[99] Furthermore, Halloran argued that it is possible for the lived experience of the audience to overwhelm the pageant "like a dramatic performance in which the splendour and animation of those in the audience attracts more attention than the doings on stage, transforming the play into a side-show entertainment."[100]

The souvenir postcard for the Dudley pageant (see fig. 12), or rather the uncropped image that appears in the souvenir book, seems to suggest that quite a wide social mix attended the pageant. These were, after all, intended to be civic events to bring communities together, not high-society functions. There certainly were issues about the costs of seats, however, which might have prevented some from attending. Hawtrey was particularly concerned about ticket prices:

> All Pageants hitherto have made the most astounding mistake in the matter of prices charged for seats. . . . In my opinion there should be accomodation [sic] for large numbers at one shilling. . . . It is instructive to remember what took place at the Olympic Games last summer, where high prices were originally charged in the Stadium, with the result that thousands of seats were empty every day.[101]

Furthermore, G. K. Chesterton, who acted in Lascelles's English Church Pageant at Fulham Palace in 1909, commented:

> The only objection to the excellent series of Pageants that has adorned England of late is that they are too expensive. The mass of the common people cannot afford to see the Pageant; so they are obliged to put up with the inferior function of acting in it.[102]

Although Chesterton's point is satiric, it does raise the possibility that the opportunity to act in the pageant also gave pageanteers the opportunity to view it.

Edwardian pageant audiences were not just local or even British. Special pageant trains were laid on to bring visitors from other parts of Britain. Edwardian pageants were tourist attractions for visitors from overseas, especially the colonies and dominions and the United States. Hawtrey certainly marketed his pageant outside Gloucestershire: "After the Welsh, the most likely fish to angle for are American and Colonial visitors."[103] The American historian of pageantry Robert Withington (a friend of the genre's founder, Louis Napoleon Parker), writing in 1920, noted that English pageants usually fell in the holiday season, to take advantage of summer weather, and many Americans attended them.[104] The Winchester pageant was marketed as a tourist attraction by the "Atlantic Union," a club for "the various English speaking peoples." The Atlantic Union even produced a map, headed "City of Winchester . . . Cradle of the Anglo-Saxon Race," which placed Winchester at the center of the United Kingdom.[105] American towns were also frequently represented, for instance at Dover (see fig. 10).[106] The American press frequently wrote about English pageants; thus, according to Withington, "both countries have profited as the bonds between them have been strengthened."[107]

Although the pageants became tourist commodities, the question of profit was a controversial one. Hawtrey declared that "a Pageant should be produced for its own sake, and not for the sake of profit."[108] Pageants were largely conceived of as charitable events that would instill civic virtues and citizenship in an orderly public. Pageants were, however, subject to commercial exploitation and the spectacle of advertising. Manufacturers and retailers readily grasped the possibilities for placing commodities in pageants.[109] For example, an advertisement for the motor-car manufacturers Coxester & Sons in the program for the Oxford Historical Pageant includes a photograph of pageanteers in Elizabethan costume inside one of the company's motorcars.[110] The Gloucestershire pageant went even further than this. Its souvenir book contained advertisements for special pageant commemorative merchandise such as spoons, matchboxes, cigarette cases, and ink bottles.[111]

Moreover, souvenirs did not just consist of official merchandise. *Punch* lampooned a "belle Americaine" souvenir hunter:

> Every inch of table, sofa, chair and mantelpiece space was covered with litter. . . . On looking more closely I saw that to each was affixed a card bearing a name and date.
>
> I picked one up and read it: "The Dover Pageant, July 28," it read: "Louis N. Parker's cigar stump."
>
> "Ah!" she said, "that's one of my bulliest souvenirs. Wasn't it lucky to get that? Won't it make some of the others just mad with jealousy?"[112]

This also points to the cult of celebrity and personality of the pageant master.

But what of the higher purpose of pageants? According to Richard Butsch, the pageant movement aimed to instill pageanteers and public alike with "a citizenship of civic pride and social order. It envisaged a well-behaved mass of citizens guided by an enlightened elite."[113] Michael Woods has argued that pageants promoted discourses of continuity and community that sought to reinforce the position of the local elite at a time of political instability and to protect conservative hegemony.[114] Arthur Quiller-Couch gave, in Robert Withington's words, a "semi-ironic, semi-appreciative view of pageantry" in his *Brother Copas*:

> Here, after all, thousands of people were met in a common pride of England and her history. Distort it as the performers might, and vain, inadequate, as might be the words they declaimed, an idea lies behind it all. These thousands of people were met for a purpose in itself ennobling because unselfish. As often happens on such occasions, the rite took possession of them, seizing on them, surprising them with a sudden glow about the heart, tears in their eyes. This *was* history of a sort. Towards the close when the elm shadows began to stretch across the green stage, even careless spectators began to catch this inflection of nobility—this feeling that we are indeed greater than we know.[115]

Pageants were not just invented by the pageant masters and committees of local worthies that organized them, however, but also by their pageanteers and those who watched them. For all the intentions of organizers for pageant audiences to behave as a public, they indulged in crowd behavior.

CONCLUSION

This essay suggests that the Edwardian sense of spectacle depended on the opportunities afforded by increased mass leisure. While spectacle was often intended as a means to inculcate civic values and a sense of citizenship, with audiences and participants alike ideally envisaged as a public, the truth was often very different. The mass spectacles of Edwardian Britain are difficult to capture and evoke accurately. The experiences of participants and viewers are particularly hard to re-create. Simply to read spectacle as a top-down hegemonic process, however, is inadequate. The invention of tradition was, as Raphael Samuel has said, "a process rather than an event . . . something which people made for themselves."[116] Thus this essay has been concerned with the agency and transgressions of the public, considering the ways in which they behaved as a crowd.

A further example of this is the Edwardian suffragette campaign, which was quick to utilize and subvert the techniques of mass spectacle, mindful as the suffragettes were of the novelty and shock value of women behaving en masse as a crowd rather than a public.[117] On 13 June 1908, a huge demonstration in London by the National Union of Women's Suffrage Societies drew on spectacle in the form of striking publicity material and nearly a thousand richly embroidered banners. As Lisa Tickner has commented, "With elegant sleight of hand, women responded to the accusation that they were 'making a spectacle of themselves' by doing precisely that, in full self-consciousness and with great skill and ingenuity."[118] Between ten and fifteen thousand women from all over Britain arrived on special trains, joined by representatives from the United States, continental Europe, and India.[119]

The suffragettes drew directly on the symbolism of the historical pageant movement. For example, in a demonstration on 1 March 1910 in London, suffragettes carried a banner declaring: "From Prison to Citizenship" (fig. 13). Some 617 of them held wands tipped with silver broad arrows, each representing the conviction of a suffragette. Dressed in white, the women were strikingly similar to the way in which "daughters of empire"—towns from the colonies and dominions named after English towns in pageants such as the one at Dover (see fig. 10)—were represented, although with arrows rather than tridents or flags. This similarity was even more apparent on 17 June 1911, when forty-eight thousand women from twenty-eight women's organizations marched in the Women's Coronation Procession in London, with floats, banners, music, and historical costumes rivaling those of the official coronation procession. This seven-mile-long procession subverted the spectacles of popular entertainment and propaganda such as pageants. According to Tickner, this was "the most spectacular, the largest and most triumphant, the most harmonious and representative of all the demonstrations in the cam-

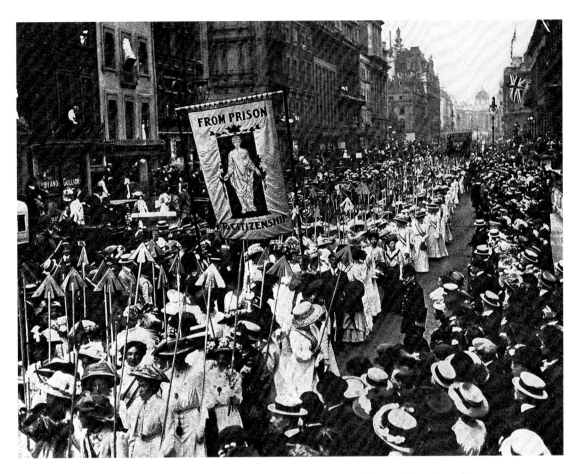

13. "Suffragette Demonstration, London" (1 March 1910). Time & Life Pictures / Getty Images.

paign. . . . It reached the limit of public spectacle not just as a political device, but as a practical possibility."[120] This was the finale of the suffragettes' Edwardian spectacular campaign; they never organized in this way or on such a scale again. Perhaps after this time, public spectacle in the Edwardian sense had become too commonplace and too entrenched in commercialized leisure—and women had become too visible in the treatment of everyday life as spectacle—to shock.

Much of the research for this essay was conducted during an extended research trip to The Huntington Library, Art Collections, and Botanical Gardens, San Marino, California, during which I benefited greatly from the help of the librarians; Amy Meyers, then curator of American art and now director of the Yale Center for British Art; and the insights of my fellow readers. At the time I was a research fellow at the University of Ulster, and I am grateful for the support of Keith Jeffery and Bob Welch. I would also like to thank the staff at the New York Public Library Theatre Collection for their help with sources. Finally, this essay could not have been written without the support and critical insights of James R. Ryan.

1. Arthur Thomas Quiller-Couch, *Brother Copas* (London: J. W. Arrowsmith, 1911), 327.

2. See Leo Charney and Vanessa S. Schwartz, eds., *Cinema and the Invention of Modern Life* (Berkeley: Univ. of California Press, 1995); Geoffrey Crossick and Serge Jaumain, eds., *Cathedrals of Consumption: The European Department Store, 1850–1939* (Aldershot, UK: Ashgate, 1999); Erika D. Rappaport, *Shopping for Pleasure: Women in the Making of London's West End* (Princeton, N.J.: Princeton Univ. Press, 2000); and Rosalind H. Williams, *Dream Worlds: Mass Consumption in Late Nineteenth-Century France* (Berkeley: Univ. of California Press, 1982).

3. S. Michael Halloran, "Text and Experience in a Historical Pageant: Towards a Rhetoric of Spectacle," *RSQ: Rhetoric Society Quarterly* 31, no. 4 (Fall 2001): 5.

4. H. V. Nelles, *The Art of Nation-Building: Pageantry and Spectacle at Quebec's Tercentenary* (Toronto: Univ. of Toronto Press, 1999), 168.

5. Halloran, "Text and Experience," 6.

6. Guy Debord, *Society of the Spectacle* (Exeter: Rebel Press, 1987).

7. Peter Bailey, *Leisure and Class in Victorian England: Rational Recreation and the Contest for Control, 1830–1885* (London: Methuen, 1987); Bailey, *Popular Culture and Performance in the Victorian City* (Cambridge: Cambridge Univ. Press, 1998); and Hugh Cunningham, *Leisure in the Industrial Revolution* (London: Croom Helm, 1980).

8. Richard Butsch, *The Citizen Audience: Crowds, Publics and Individuals* (London: Routledge, 2008), 11.

9. Butsch, *Citizen Audience*, 34.

10. See Kenneth McConkey, *Memory and Desire: Painting in Britain and Ireland at the Turn of the Twentieth Century* (Aldershot, UK: Ashgate, 2004); Martin Meisel, *Realizations: Narrative, Pictorial and Theatrical Arts in Nineteenth-Century England* (Princeton, N.J.: Princeton Univ. Press, 1983).

11. For an account of the audience as part of the spectacle of exhibitions, see Helen Rees Leahy, "'Walking for Pleasure'? Bodies of Display at the Manchester Art Treasures Exhibition in 1857" *Art History* 30, no. 4 (2007): 545–65.

12. Irving's and Tree's productions of Shakespeare took liberties with the bard's text. They used overblown emotion, high drama, flamboyant acting, and large choreographed crowds in spectacular settings designed by leading painters such as Edward Burne-Jones. They had a particularly dramatic deployment of space, combined with spectacular lighting effects and specially composed atmospheric music. See Jeffrey Richards, *Sir Henry Irving: A Victorian Actor and His World* (London: Hambledon, 2005), 219.

13. John M. Mackenzie, ed., *The Victorian Vision: Inventing New Britain* (London: V&A Publications, 2003).

14. Richard D. Altick, *The Shows of London* (Cambridge, Mass.: Harvard Univ. Press, 1978).

15. The first purpose-built department store in Britain was Selfridges, which opened in 1909. Gordon Selfridge encouraged women to come and look without any obligation to buy. Selfridges' doors were open until 8:00 P.M., and its windows were illuminated until midnight. It was "considered one of the great show sights of London, like Westminster Abbey, which all visitors from the provinces and abroad would expect to see." See Mica Nava, "Modernity's Disavowal: Women, the City and the Department Store," in *Modern Times: Reflections on a Century of English Modernity*, ed. Mica Nava and Alan O'Shea (London: Routledge, 1996), 51.

16. Tom Gunning argues that in the display of film by showmen at this time, "the cinematic gesture of presentation" was more important than narrative and storytelling in what he terms "the cinema of attractions." See Tom Gunning, "'Now You See It, Now You Don't': The Temporality of the Cinema of Attractions," in *Silent Film*, ed. Richard Abel (London: Athlone, 1996), 73. See also Gunning, "The Cinema of Attractions:

Early Cinema, Its Spectator, and the Avant-Garde," in *Early Cinema: Space Frame Narrative*, ed. Thomas Elsaesser (London: BFI, 1990), 52–62, and Gunning, "An Aesthetic of Astonishment: Early Cinema and the [in]Credulous Spectator," in *Film Theory and Criticism*, ed. Leo Braudy and Marshall Cohen (Oxford: Oxford Univ. Press, 1999), 818–32.

17. Vanessa Toulmin, *Electric Edwardians: The Films of Mitchell and Kenyon* (London: British Film Institute, 2008).

18. See Deborah Sugg Ryan, "'Pageantitis': Frank Lascelles' 1907 Oxford Historical Pageant, Visual Spectacle and Popular Memory," *Visual Culture in Britain* 8, no. 2 (2007): 67. The later cinematic epics of D. W. Griffith and Cecil B. DeMille must have drawn on Edwardian historical pageants, with scenes of huge casts reminiscent of pageant spectacles. It is also likely that, in turn, epic films influenced pageants. This point is echoed in publicity photographs of pageant directors Frank Lascelles and Louis Napoleon Parker bellowing through megaphones, curiously reminiscent of depictions of silent-film directors.

19. Alison Light, "'Don't Dilly-Dally on the Way!': Politics and Pleasure in 'The Edwardian Era,' *History Workshop: A Journal of Socialist and Feminist Historians* 26, no. 1 (Autumn 1988): 159.

20. *Daily Mail* (London), 13 May 1908, 3.

21. Shortly after the Great Exhibition in 1851, the Crystal Palace was moved from Hyde Park to Sydenham. It hosted rose shows, pigeon and poultry shows, goat shows, rabbit shows, and cat and dog shows; electrical, aeronautical, mining, transport, photographic and art exhibitions; and trade fairs, spectacles, musical performances, and fireworks displays. This gives some indication of the scope of exhibitions that existed in Edwardian Britain. See Patrick Beaver, *The Crystal Palace, 1851–1936: A Portrait of Victorian Enterprise* (London: Hugh Evelyn, 1970), and Christopher Bernard Hobhouse, *1851 and the Crystal Palace* (London: John Murray, 1950). Kelvin Hall in Glasgow and Bingley Hall in Birmingham crop up regularly as venues in exhibition and trade-fair manuals. See Hugh A. Auger, *Trade Fairs and Exhibitions* (London: Business Publications, 1967), 9. Imperial exhibitions were held in Bradford (1904) and Wolverhampton (1907). Missionary societies also held exhibitions all over the country. The London Missionary Society and Church Missionary Society took their exhibitions to Manchester, Liverpool (Picton Hall), Birmingham, and "smaller towns in the provinces." See A. E. S. Coombes, "'For God and for England': Contributions to an Image of Africa in the First Decade of the Twentieth Century," *Art History* 8, no. 4 (Dec. 1985): 454.

22. *Daily Mail* (London), 13 May 1908, 3.

23. Arnold Rattenbury, *Exhibition Design: Theory and Practice* (London: Studio Vista, 1971), 9.

24. There was also a Mining Exhibition at Olympia in 1908. See F. A. Fletcher and A. D. Brooks, *British Exhibitions and Their Postcards*, vol. 1, *1900–1914* (East Boldon, UK: privately printed, 1978), 20.

25. B. E. Gregory, "The Spectacle Plays and Exhibitions of Imre Kiralfy, 1887–1914" (PhD thesis, Univ. of Manchester, 1988), 6. Events included *Savage South Africa*, which blended stage performances and exhibitions where visitors could wander among semi-naked Africans. The performers later appeared in an 1899 film by the Warwick Trading Company, enacting a real-life event from the Matabele Wars between Africans and British infantry earlier in the 1890s. See British Film Institute, *Screenonline*, http://www.screenonline.org.uk/film/id/725486/ (accessed 26 Sept. 2008).

26. Barbara M. Barker, ed., *Bolossy Kiralfy: Creator of Great Musical Spectacles: An Autobiography* (Ann Arbor, Mich.: UMI Research Press, 1988).

27. Paul Greenhalgh, *Ephemeral Vistas: The Expositions Universelles, Great Exhibitions and World's Fairs, 1851–1939* (Manchester: Manchester Univ. Press, 1988), 90. This was followed by *Venice in London* (1891–93); *Columbus* (1892–93); *America* (1893); *India, a Grand Historical Spectacle* (1895–96); *Our Naval Victories, an American Naval Spectacular* (1898), and *China, or the Relief of the Legations* (1901).

28. Bolossy Kiralfy, *The Orient; or, A Mission to the East: A Mammoth and Original . . . Spectacle and Water Pageant, in Two Acts and Five Tableaux* (London: Olympia, 1894). His other productions included *Constantinople, or the Revels of the East: A Grand Spectacle, etc.*, also at Olympia in 1894.

29. See Paul Greenhalgh, "Art, Politics and Society at the Franco-British Exhibition of 1908," *Art History* 8, no. 4 (Dec. 1985): 434.

30. Greenhalgh, "Art, Politics and Society," 435.

31. Greenhalgh, *Ephemeral Vistas*, 92.

32. Greenhalgh, "Art, Politics and Society," 442.

33. Greenhalgh, *Ephemeral Vistas*, 44.

34. *Times* (London), 21 May 1909, quoted in Greenhalgh, *Ephemeral Vistas*, 44.

35. See Deborah S. Ryan, *The Ideal Home through the Twentieth Century* (London: Hazar, 1997).

36. "Fifty Years of Success: The Story of the *Daily Mail* Ideal Home Exhibition, 1908–1958," *Daily Mail Ideal Home Exhibition Catalogue* (London: Daily Mail, 1956), 56. The exhibition celebrated its centennial in 2008.

37. The sections were Construction, Decoration, Lighting and Heating, Sanitation, Ventilation, Furniture, Recreation, Hygiene and Cleaning, Food and Cookery, and Garden and Accessories. See *Daily Mail* (London), 25 March 1908, 1.

38. *Daily Mail* (London), 30 April 1908, 1.

39. Foreword, *Daily Mail Ideal Home Exhibition Catalogue*, 7. See also Deborah S. Ryan, "The Daily Mail Ideal Home Exhibition and Suburban Modernity, 1908–51" (PhD thesis, Univ. of East London, 1995).

40. Lord Northcliffe to Thomas Marlowe, 10 March 1909, Northcliffe Papers, British Library (London), Add. MSS 62198, fol. 29.

41. *Daily Mail* (London), 18 March 1912, 5.

42. Quoted in Deborah S. Ryan, "All the World and Her Husband: The Daily Mail Ideal Home Exhibition, 1908–39," in *All the World and Her Husband: Women in Twentieth-Century Consumer Culture*, ed. Maggie Andrews and Mary M. Talbot (London: Cassell, 2000), 10.

43. Ryan, "All the World and Her Husband," 10. The *Daily Mail* was a great supporter of the campaign by Lady Aberdeen (Dame Ishbel Maria Gordon, Marchioness of Aberdeen and Temair), influenced by the Arts and Crafts movement, to revive "home industries" to provide employment for women, including crafts such as wood carving, which might have been traditionally thought of as masculine; she organized a lace exhibition in 1908 at the Royal Horticultural Hall. J. T. Herbert Baily, ed., *Daily Mail Exhibition of British and Irish Lace Held at the Royal Horticultural Hall, Vincent Square, Westminster, March 9–14 1908* (London: Daily Mail, 1908).

44. May Morris, "Pageantry and the Masque," *Journal of the Society of Arts* 50, no. 2588 (27 June 1902), 670–77.

45. Mark Girouard, *The Return to Camelot: Chivalry and the English Gentleman* (New Haven: Yale Univ. Press, 1981), 2, 8, 13.

46. For an account of the origins of the Edwardian pageant movement, see Robert Withington, *English Pageantry: An Historical Outline*, vol. 2 (Cambridge, Mass.: Harvard Univ. Press, 1920), 194–230. The emerging historiography tends to treat all modern pageants, irrespective of their authorship and direction, as a single, unified genre. It has been heavily and uncritically reliant on the work of Withington, an American historian at Harvard University and friend and champion of Louis Napoleon Parker; Withington coined the adjective "Parkerian" in 1915 to categorize the modern pageant. See David Glassberg, *American Historical Pageantry: The Uses of Tradition in the Early Twentieth Century* (Chapel Hill: Univ. of North Carolina Press, 1990); Joshua D. Esty, "Amnesia in the Fields: Late Modernism, Late Imperialism, and the English Pageant-Play," *ELH*, 69, no. 1 (Spring 2002), 245–76; Peter Merrington, "Masques, Monuments, and Masons: The 1910 Pageant of the Union of South Africa," *Theatre Journal* 49, no. 1 (1997): 1–14; Paul Readman, "The Place of the Past in English Culture c. 1890–1914," *Past and Present* 186, no. 1 (Feb. 2005): 147–200; Mick Wallis, "Delving the Levels of Memory and Dressing Up in the Past," in *British Theatre between the Wars, 1918–1939*, ed. Clive Barker and Maggie B. Gale (Cambridge: Cambridge Univ. Press, 2000); Akiko Yoshino, "Between the Acts and Louis Napoleon Parker—the Creator of the Modern English Pageant," *Critical Survey* 15, no. 2 (2003): 49–60. For a critique, see Ryan, "'Pageantitis.'"

47. Louis N. Parker, "Historical Pageants," *Journal of the Society of Arts* (22 Dec. 1905): 146.

48. See Robert Withington, *English Pageantry: An Historical Outline*, vol. 1 (Cambridge, Mass.: Harvard Univ. Press, 1918), xix. See also Withington, *English Pageantry* 2:196–98.

49. Louis N. Parker, *Several of My Lives* (London: Chapman and Hall, 1928), 279.

50. Arthur Farwell, "Community Music-Drama," *Craftsman* 26 (July 1914): 422.

51. For an account of the development of the pageant movement in the United States, see Glassberg, *American Historical Pageantry*. See also Deborah S. Ryan, "Performing Irish-American Heritage: The Irish Historic

Pageant, 1913," in *Ireland's Heritages: Critical Perspectives on Memory and Identity*, ed. Mark McCarthy (Aldershot, UK: Ashgate, 2005).

52. Nelles, *Art of Nation-Building*, 145.

53. Charles L. Graves, *Mr Punch's History of Modern England*, vol. 4 (New York: Frederick A. Stokes, 1922), 60.

54. *Punch*, 1 July 1908, 11.

55. Readman, "Place of the Past."

56. Parker, *Journal of the Society of Arts*, 143.

57. Withington, *English Pageantry*, 2:24.

58. Bill Schwarz, "Englishness and the Paradox of Modernity," *New Formations*, no. 1 (Spring 1987): 153.

59. Schwarz, "Englishness and the Paradox of Modernity," 153.

60. *Souvenir of the Dudley Historical Pageant* (Dudley: E. Blocksidge, 1908); *Winchester National Pageant: The Book of the Words, and Music* (Winchester: Pageant Committee, 1908); Christopher Wilson, *Winchester National Pageant . . . Held in the Grounds of Wolvesey Castle, on June 25th, and the Five Following Days. The Book of the Words and Music* (Winchester: Warren & Son, 1908); Paul Readman, "Commemorating the Past in Edwardian Hampshire: King Alfred, Pageantry and Empire," in *Southampton: Gateway to Empire*, ed. Miles Taylor (London: I. B. Tauris, 2007); Ernest Bucalossi, *The Chelsea Historical Pageant, 1908: Book of Words—with Illustrations and Selections from the Music* (Chelsea: Chelsea Pageant Committee, 1908); George Procter Hawtrey, *Gloucestershire Historical Pageant, at Cheltenham, July 6, 7, 8, 9, 10, 11, 1908, etc.* (Cheltenham: Norman Bros., 1908); James Richard Dear, *The Book of the Music of the Pevensey Pageant . . . July 20, 21, 22, 23, 24 & 25, 1908* (London: Weekes & Co., 1908); W. de B. Wood, *The Episodes of the Pevensey Historical Pageant* (Eastbourne, UK: V. T. Sumfield, 1908); and *Pevensey Historical Pageant in the Grounds of Pevensey Castle, Monday, July 20, to Saturday, July 25, 1908. Official Souvenir* (Tunbridge Wells, UK: Percy Lankester, 1908); Louis Napoleon Parker, *The Dover Pageant, July 27, 28, 29, 30, 31, August 1, 1908. Invented and Arranged by L. N. Parker* (Dover: Grigg & Son, 1908); Harry James Taylor, *The Dover Pageant . . . 1908 . . . Book of the Music, the Words Chiefly Written by J. Rhoades, the Music Chiefly Written by H. J. Taylor, etc.* (London: Weekes & Co., 1908); and *The "Dover Times" Book of Pageant Pictures. The Dover Pageant, July 27th to August 1st, 1908* (Dover: Dover Printing & Publishing Co., 1908). King's Lynn appears in "A Chronological List of the More Important English Pageants Ending with the Year 1911," *American Pageants Association Bulletin*, no. 5 (15 July 1914). See also Holcombe Ingleby, *The Shade of a Pageant: King's Lynn, 1908* (Cambridge: Bowes & Bowes, 1908).

61. *The Scottish National Pageant of Allegory, Myth and History: To be Held in the Grounds of the Scottish National Exhibition, 13th June 1908, in Aid of the Scottish Children's League of Pity* ([Edinburgh]: F. and E. Murray, 1908).

62. Deborah S. Ryan, "Staging the Imperial City: The Pageant of London, 1911," in *Imperial Cities: Landscape, Display and Identity*, ed. Felix Driver and David Gilbert (Manchester: Manchester Univ. Press, 1999), 117–35.

63. Ryan, "'Pageantitis,'" 64.

64. Yoshino, "Between the Acts."

65. Hawtrey, *Gloucestershire Historical Pageant*.

66. "Benson, Sir Frank (Robert)," *Who Was Who: 1929–1940* (London: Adam & Charles Black, 1940), 96; F. R. Benson, *My Memoirs* (London: Ernest Benn, 1930); and John Parker, "Benson, Sir Francis Robert ('Frank')," *The Dictionary of National Biography: 1931–1940*, ed. L. G. Wickham Smith (Oxford: Oxford Univ. Press, 1949), 71–72.

67. *Army Pageant: The Book of the Army Pageant, Held at Fulham Palace* (London: Sir Joseph Causton & Sons, 1910).

68. Philip A. Hunt and Neil A. Flanagan, *Biographical Register 1880–1974* (Oxford: Corpus Christi College, Univ. of Oxford, 1988), 142.

69. Deborah S. Ryan, "'The Man Who Staged the Empire': Remembering Frank Lascelles in Sibford Gower, 1875–2000," in *Material Memories: Design and Evocation*, ed. Jeremy Aynsley, Christopher Breward, and Marius Kwint (Oxford: Berg, 1999).

70. Edward Gordon Craig, Irving's son, described Tree's productions as "weighty and astonishing efforts in

glorious spectacular pageant." See Edward Gordon Craig, *Henry Irving* (London: J. M. Dent and Sons, 1930), 96. The stage became a series of living pictures, with the text embellished and explicated through visual spectacle, unified by the single vision of the actor-manager who directed the production. Although the Lyceum Theatre in London closed two weeks after its spectacular coronation reception, its legacy exerted a huge influence on the productions of Edwardian pageant masters.

71. J. P. Wearing, *The London Stage: A Calendar of Plays and Players*, vol. 1, *1900–1907* (London: Scarecrow Press, 1981), 330.

72. Ryan, "'Pageantitis.'"

73. C. R. Peers, ed., *The Book of the English Church Pageant, Fulham Palace, June 10–16, 1909* (London: Eyre and Spottiswoode, 1909), 26.

74. Ryan, "'Pageantitis,'" 77.

75. Nelles, *Art of Nation-Building*.

76. Ryan, "Staging the Imperial City," 117–35.

77. George P. Hawtrey, "How to Stage a Pageant," Univ. of North Carolina at Greensboro, University Archives and Manuscripts, George P. Hawtrey Papers, MSS 162.

78. "The Chelsea Pageant," *Nation* 87, no. 2245 (1908): 58.

79. George P. Hawtrey, foreword, *Book of Words of the Gloucestershire Pageant* ([Cheltenham], 1908).

80. Bucalossi, *Chelsea Historical Pageant*.

81. *Souvenir of the Dudley Historical Pageant*. See also Kevin Hillstrom and Laurie Collier Hillstrom, *Industrial Revolution in America*, vol. 1, *Iron and Steel* (Santa Barbara, Calif.: ABC-CLIO, 2005), 31.

82. *Winchester National Pageant: The Book*.

83. Bucalossi, *Chelsea Historical Pageant*.

84. Ryan, "Staging the Imperial City," 128–31.

85. Ryan, "'Pageantitis,'" 76.

86. Ryan, "'Pageantitis,'" 75.

87. *Punch*, 31 July 1907, 73.

88. Hawtrey, "How to Stage a Pageant."

89. Withington, *English Pageantry*, 2:205.

90. George P. Hawtrey, letter to Gloucestershire Historical Committee, 10 June 1908, Univ. of North Carolina at Greensboro, University Archives and Manuscripts, George P. Hawtrey Papers, MSS 162.

91. Hawtrey, "How to Stage a Pageant."

92. Jeffrey Richards, *Imperialism and Music: Britain 1876–1953* (Manchester: Manchester Univ. Press, 2001), 188–94.

93. Halloran, "Text and Experience," 11.

94. Halloran, "Text and Experience," 11.

95. "Chelsea Pageant," 58.

96. Halloran, "Text and Experience," 5–17.

97. James R. Ryan and Nicola J. Thomas, "Landscapes of Performance: Staging the Delhi Durbars," in *Power and Dominion: Photography and the Imperial Durbars of British India*, ed. J. Codell (New York: Alkazi Books, 2010).

98. Hawtrey, "How to Stage a Pageant."

99. E. P. Oberholtzer, "Historical Pageants in England and America with Practical Suggestions for Similar Spectacles," *Century* 80, no. 48 (July 1910): 426–27.

100. Halloran, "Text and Experience," 6–7.

101. Hawtrey, "How to Stage a Pageant."

102. G. K. Chesterton, *The Uses of Diversity* (London: Methuen, 1920), 126.

103. Hawtrey, "How to Stage a Pageant."

104. Withington, *English Pageantry*, 2:204.

105. Map entitled "City of Winchester. National Pageant June 25–30 & July 1, 1908. Cradle of the Anglo-Saxon Race," New York Public Library, Theater Collection, Pageants: England 1908: Clipping.

106. *Book of Words of the Dover Pageant* ([Dover], 1908), 69.

107. Withington, *English Pageantry*, 2:204.

108. Hawtrey, "How to Stage a Pageant."

109. For a discussion of the link between visual spectacle, advertising, and commodities, see Thomas Richards, *The Commodity Culture of Victorian England: Advertising and Spectacle, 1851–1914* (London: Verso, 1991).

110. Ryan, "'Pageantitis,'" 76–77.

111. *Souvenir of the Gloucestershire Historical Pageant* (Cheltenham, 1908).

112. *Punch*, 26 Aug. 1908, 158.

113. Butsch, *Citizen Audience*, 76.

114. Michael Woods, "Performing Power: Local Politics and the Taunton Pageant of 1928," *Journal of Historical Geography* 25, no. 1 (Jan. 1999): 57–74.

115. Quoted in Withington, *English Pageantry*, 2:204.

116. Raphael Samuel, *Theatres of Memory*, vol. 1, *Past and Present in Contemporary Culture* (London: Verso, 1994), 17.

117. During this period, women were increasingly visible in the streets as consumers of new dream worlds of mass consumption in department stores. This environment positioned consumers as audiences to be entertained by commodities; selling became "mingled with amusement," and the "arousal of free-floating desire is as important as immediate purchase of particular items." See Williams, *Dream Worlds*, 67. Suffragettes turned the spectacle of consumption to their own ends; for example, specially designed merchandise in the suffragette colors of purple, white, and green was sold at department stores.

118. Lisa Tickner, *The Spectacle of Women: Imagery of the Suffrage Campaign, 1907–14* (London: Chatto and Windus, 1987), 81.

119. Tickner, *Spectacle of Women*, 80, 86.

120. Tickner, *Spectacle of Women*, 122.

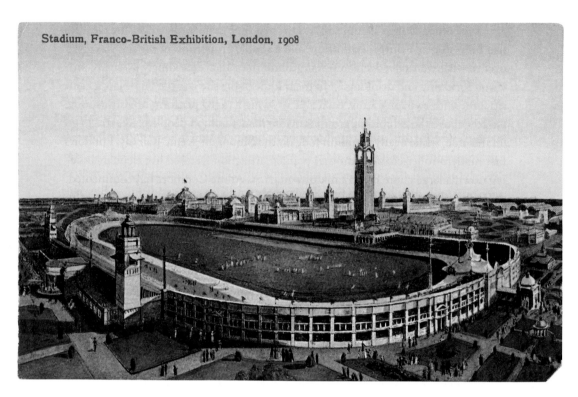

Stadium, Franco-British Exhibition, London, 1908

14. "Stadium, Franco-British Exhibition, London, 1908," postcard. Museum of London. James Fulton's proposed design for the stadium (not completed in this form), depicted below a pink "sunset" sky.

international exhibitions. These events were played out in front of relatively small crowds around large, open playing fields. The 1908 Olympics at White City featured the first modern multisports stadium and proved that there was a mass audience for these games. In total, well over three hundred thousand people paid to watch the Olympics, while as many again saw the marathon raced in suburban London. William Grenfell, first Baron Desborough, chairman of the British Olympic Association, had volunteered London as host city in the summer of 1906, when Rome withdrew after the eruption of Mount Vesuvius. By January 1907 an agreement had been reached with Kiralfy for the use of the White City site, by which the Franco-British Exhibition committee was to provide the entire built infrastructure in return for 75 percent of the turnstile receipts.[21] The first stanchion was erected on 31 July 1907, and the stadium was completed by early June 1908.[22]

The White City stadium was the largest one anywhere at the time, in terms of both capacity and physical size. It needs to be understood in the context of the rise in sporting spectatorship that was such a feature of the late Victorian and Edward-

ian periods. This was led by football (soccer), although cricket, horse racing, and rugby also attracted significant crowds. The first Football Association Cup final in 1872 was watched by fewer than two thousand people. By the early twentieth century, crowds of forty thousand were common at professional matches in northern England and Glasgow, and more than one hundred thousand attended the cup final of 1901, held in the Crystal Palace area of south London.[23] Stadium design and technology, as well as methods of crowd control, struggled to keep pace with the demands of increasing numbers. Ibrox Park in Glasgow was the first giant purpose-built football venue, completed in 1900 with a capacity of just under eighty thousand.[24] Ibrox was made up mostly of vast timber terraces supported on steel columns, a system that its engineer, Archibald Leitch, adapted from recently erected American baseball parks. Ibrox operated successfully—until its first capacity crowd at the Scotland-England match of 1902. Twenty-six people were killed and more than five hundred injured when wooden joists split under the weight of the crowd.[25]

The White City stadium was designed in the aftermath of the Ibrox disaster, shifting to a new technology combining a steel framework and reinforced concrete for the construction of its terraces. Although James Fulton drew up architectural plans for the stadium, it was fundamentally an engineering project undertaken by the Scottish firm of Finlay and Company.[26] The stadium was curved at both ends, at its extremes one thousand feet long by six hundred feet wide. The terraced platforms, formed from two-inch-thick concrete slabs reinforced by patent indented steel bars, were supported by rolled-steel joists carried by braced, latticed columns of steel.[27] Fulton's original designs featured a Baroque pavilion building and a partially faced exterior to the stadium (fig. 14). Kiralfy was anxious to limit spending on the Olympics, and the finished stadium was much simpler and sparer (fig. 15). For some contemporaries the effect of raw engineering structures abutting the exhibition architecture was "neither brilliant nor suitable."[28] Others, such as Robert Carden writing in the *Architectural Review*, used the stadium, and particularly the clean lines of its interior and its overall scale and ambition, as a riposte to the fussy facades of the Franco-British Exhibition:

> The Stadium is, beyond all manner of doubt, the one building calculated to impress the beholder with a sense of majestic grandeur. The splendid rising lines of the seats are wholly wonderful as they diminish into a hazy mist of curves fading away into the distance. It is a lasting object-lesson on the futility of much that we are pleased to call "architectural grandeur." . . . It boasts no architectural features; the steel is still gaunt and unclothed; but there are few who will deny that it runs some of our architectural "conceptions" very

15.　"White City Stadium in London, Venue for the 1908 Olympics" (1908). Getty Images, Hulton Archive.

close. From the Stadium, with its impressive lines, we may learn that effect does not depend on the amount of disposal of ornament. It is the rhythm of proportion and perspective that triumphs in the steel and concrete Stadium, just as it does in the marble Sala della Ragione of Palladio in Vicenza. It is vast, splendid, monumental: it is the great achievement of the Franco-British Exhibition, and of the Engineering profession.[29]

Carden's comments are indicative of a strand in British architecture that was not merely looking toward the new technologies of steel and concrete for formal solutions to the challenges presented by mass society, but was tentatively embracing the aesthetic power of functional design. The building of the Olympic stadium coincided with the foundation of the Concrete Institute, as well as the first major debates on the use of the material at the Royal Institute of British Architects, while the Hennebique system for reinforced concrete was demonstrated at the Franco-British Exhibition in a spectacular unsupported spiral staircase.[30] While Britain lacked the kind of direct intellectual and aesthetic precursors of modernism that were developing in other European countries, there was a developing practical commitment to what Alan Powers has described as "modernity without modernism."[31]

Such pragmatic architectural functionalism could be seen as a part of a much broader Edwardian movement for "National Efficiency." Developing as a response to the humiliations of the Boer War, to particular revelations about the physical state of recruits to the army, and to a more general sense of national and imperial malaise, the National Efficiency movement appealed to different constituencies,

including Liberal imperialists and reforming socialists.[32] While the idea of efficiency was a powerful element in Edwardian culture, becoming what one contemporary described as "the hardest worked vocable in politics," widespread calls for the implementation of sound managerial principles and technocratic expertise could have contradictory results.[33] Such was the case with the Olympic stadium. The positive response to its fit-for-purpose design was necessarily combined with an acceptance, even celebration, of the aesthetic force of the mass crowd. For the *Architect and Contract Reporter*, although the stadium was clearly designed "for use and not for artistic effect . . . when the sixty thousand seats and the standing room are crowded to their utmost during the Olympic games, the magnificent spectacle of humanity removes all desire to criticise non-architectural effects."[34] The large crowd, however, and particularly the culture of "spectatorism," was distinctly troubling for some Edwardian sensibilities, particularly those that seized upon any possible connections between forms of mass culture and both physical and moral decline. In *Scouting for Boys*, published in the year of the Olympics, Robert Baden-Powell famously criticized the effects on young males of watching football, in terms that stressed the impact of the mass crowd: "I have seen thousands of boys and young men, pale, narrow-chested, hunched up miserable specimens, smoking endless cigarettes, numbers of them betting, all of them learning to be hysterical as they groan and cheer in panic in unison with their neighbours."[35]

In Baden-Powell's comments, there are strong echoes of *The Crowd*, Gustave Le Bon's essay on mass psychology and behavior, first published in English in 1896, with its emphasis on the crowd's "impulsiveness, irritability, incapacity to reason, the absence of judgment and of the critical spirit, and the exaggeration of the sentiments."[36] In Britain the vast crowds associated with what became known as "Football Fever . . . the infection of the working classes" were sources of elite anxiety.[37] This extended beyond worries about passivity and the degenerating effects of "spectatorism" to include concerns, in an age of industrial unrest and syndicalism, that huge terraces of standing working-class men in a state of "exaggerated sentiment" were a potential threat to the established order.[38] The Olympic stadium provoked a rather different reaction, because it was designed for a different kind of mass spectatorship that reflected the developing social geography of the metropolis. Whereas the largest contemporary football ground in London, at Chelsea's Stamford Bridge, had only five thousand seats in a capacity of some ninety thousand overall, the Olympic stadium had more than fifty-two thousand seats, perhaps as much as half of its intended capacity.[39] This, of course, was due in part to the different character of the sports; the Olympics were spread over two weeks, with daylong sessions, rather than the relatively brief and intense experience of a football match. The design of the stadium, however, also indicated that this was

to be a cross-class event, with the organizers anticipating large attendance from those willing to pay up to ten shillings to sit in the stands, as well as those paying a shilling to stand on the terraces at either end.[40] Hierarchy and order were built into the White City stadium.

On the final days of the Olympic Games, and particularly on the day of the marathon, 24 July 1908, when the gates were shut early and the stadium was deemed to be filled to capacity, the crowd approached this ideal of a continuous, yet socially graded, wall of spectators (fig. 16).[41] On other days that were less well attended, the effect was rather different. It poured with rain for the first week of the Olympics, and only about forty thousand attended even the opening ceremony on 13 July. Contemporary photographs of the first week show a strangely polarized crowd: the terraced sections at the ends were often relatively full (and frequently under a sea of umbrellas), separated by huge empty spaces along the bends up to the covered seating areas at the side of the running and cycling straightaways. *Punch* magazine's satire of the first week contrasted the proliferation of events and the number of competitors with the absence of spectators:

> The Olympic arena seethed with officials, unofficials and competitors. On the cinder track the demi-semi-finals of the 109.36 yards sprint, and the 29th heat of the 4.05 miles race were being worked off concurrently. . . . My eye ran over the vast empty spaces in the part reserved for spectators. "Ah!" I thought, "if only the public could change places with the occupants of the arena, what a magnificent gallery it would be!"[42]

This was not so much a consequence of apathy, or even the malign effects of the British weather, as it was the demands of the working week for all but a small number of potential spectators.[43] On the first Saturday of the Olympics, there was a crowd of more than sixty thousand, and the organizers were forced to relieve dangerous overcrowding on the standing terraces.[44] It was also the case that the organizers and designers of the London Olympics were working without precedent. With the need for heats and qualifying competitions, all modern Olympic Games have been marked by times when the main stadiums have been relatively empty. The London Olympic organizers, however, were also almost too ambitious in their physical model for a modern mass sporting spectacle. By the interwar period, Olympic complexes had moved to the template of an athletics arena in a wider sports park, with most sports taking place away from the main stadium itself. For the 1908 Olympics, however, although sports such as rowing and tennis did take place elsewhere, the underlying model was to bring as many sports as

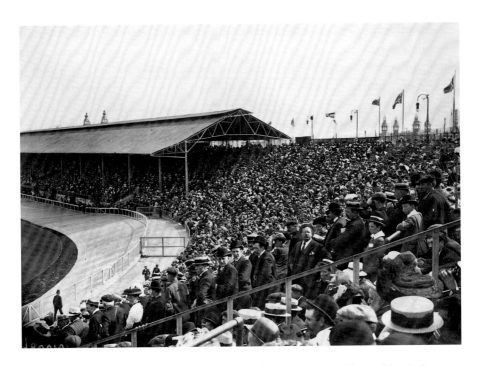

16. "Spectators Filling the Stands at White City Stadium for the 1908 London Olympics" (1908). Getty Images, Hulton Archive.

possible into a single enormous space. Thus, in addition to the track and central football field, the White City stadium boasted "a vast concrete swimming bath, built just inside the running track, 109 1/2 yards long by 50 ft. wide with a depth of 12 ft. in the middle for high diving."[45] Events such as wrestling, gymnastics, and, somewhat worryingly, archery also took place inside the stadium. The arrangement meant that the running track was one-third of a mile in length (535 meters rather than the now standard 400 meters), and spectators were pushed back farther from the action by a banked concrete cycling track that was 640 yards long and 35 feet wide. While undoubtedly impressive when full, this made it difficult for the crowds to engage with the action, particularly for some of the field sports, which "were impossible to follow from the amphitheatre."[46] The longest sight lines to the middle of the arena were about 150 meters, significantly farther than those for twenty-first-century Olympic stadiums.

For Coubertin, the gigantism of the London Olympics was a troubling challenge to his Olympic ideals, and his views on the modern sports crowd were largely negative. In 1910, reflecting on the London games, he argued that the Olympics should not be organized as a mass spectator event, adding that "technically, the

presence of too large a crowd with a predominantly non-sporting composition is harmful to sport. The ideal spectator of a sports event is a resting sportsman who is interrupting his own exercise to follow the movements of a comrade more skilled or better trained than himself."[47] Coubertin also criticized the mass crowd on aesthetic grounds: not only was "a large modern crowd ugly in silhouette and color," but also it was "not easy to make everything it needs to contain it tolerable to the eye—grandstands, enclosures, barriers, turnstiles etc."[48] His alternative was to suggest ways to make the Olympics more suitably elite, by selling some tickets at high prices and distributing the remainder "with tact and intelligence to those who could not pay."[49] Instead of the mass crowd, Coubertin imagined an elite crowd of the rich and the sportingly deserving, numbering no more than ten thousand in total, and arranged on lawns and open grassy terraces rather in grandstands.

If the Stockholm games in 1912 were to come somewhat closer to Coubertin's ideal of a compact, elite Olympics, the London games demonstrated the power of marketing and set a model for commercially based and spectator-dominated events that later Olympics were to follow.[50] The London Olympics also indicated that Coubertin's assumed separation between elite sportsmen and a nonsporting mass was a gross oversimplification. The growth of the middle classes, and particularly the clerkly classes, in late Victorian and Edwardian Britain was accompanied by what has been described as the "great sports craze."[51] By the early 1900s, participation in some form of sporting activity was possible for a widening middle-class constituency, and the new suburbs to the west of the capital were the heartlands of these developments.[52] In this dynamic social environment, sport became an important way in which complex distinctions of class and status were expressed, but it was significant that this resulted in a richly stratified sporting culture that catered to a wide range of incomes. Sports as diverse as golf, rugby, cycling, hockey, lawn tennis, rowing, bowls, badminton, and table tennis were part of this sporting boom. While cricket was notable for its wide cross-class following and participation, and football was increasingly associated with the urban working classes, the sports that blossomed in the new suburbia tended to have more tightly defined social meanings and boundaries. These distinctions were strongly grounded in the way that sporting clubs became mainstays of the associational culture of middle-class suburban life. John Lowerson has suggested that what was developing was a diverse popular sporting culture, rather than an undifferentiated mass phenomenon.

What this meant was that the potential audience for the Olympics was large, socially stratified, and importantly knowledgeable and enthusiastic about sports, with many active participants. As a multisport event, the games had an appeal to a broad spectrum of metropolitan and suburban society. They also showed the growing complexity of popular attitudes toward the nature of competitive sport.

Lord Desborough and the British Olympic Association went to great lengths to define and defend the amateur principles of the Olympic Games. The pages of regulations about permissible expenses and each participant's allowed competitive history, however, indicate the difficulties of converting an amalgam of Coubertin's reimaginings of Hellenic values and a patrician ideology of English gentlemanly amateurism into a viable code for increasingly international and democratic sport.[53] Beyond the debates around the terms "amateur" and "professional" were cultural disputes over the extent to which sportsmen should set out to win, particularly through physical preparation, practice, coaching, and aggression. The smug hypocrisy of an elite Victorian amateurism that idealized the supposedly effortless superiority of its race and class (and often bleated about ungentlemanly conduct in defeat) was transformed in its translation into popular middle-class sport. Here, as particularly in golf, such "gentlemanly" values could be codified in the rules and become an expected and monitored part of the performance of socially aspirational behavior. The proliferation of leagues, ladders, tournaments, and trophies in the club structure of suburban sport, however, indicated just how much organized competition and the will to win (albeit politely) had become an integral part of this sporting culture. The regular complaints about the evils of "shamateurism" and "pot-hunting" in the amateur sports journals were indicative of the harder edge to suburban recreational pleasures.

Such changes were personified in the figure of the Olympic women's tennis champion of 1908, Dorothea Lambert Chambers. In truth, the Olympic Games were neither the greatest challenge nor the greatest triumph in her long career. With the competition held not at White City but at Wimbledon, Chambers easily beat Dora Boothby, 6–1, 7–5, winning the small, all-British tournament without losing a set in her four matches. Coubertin was famously hostile to women in sport, considering their participation to be an affront to both ancient ideals and the natural order. Female track-and-field athletes were not admitted until the 1928 games, and they did not achieve full parity until the first women's marathon in 1984. Nevertheless, in 1908 women participated in both lawn tennis and archery, both considered sufficiently "decorous" to be safe for women.[54] Part of this sense of the safety and appropriateness of tennis was undoubtedly connected to a perception of this being almost a domestic sport, "a game that has so majestically received the hall-mark of suburban gentility."[55]

In addition to the Olympic gold, Chambers won the Wimbledon singles title seven times between 1903 and 1913, and she was also the losing finalist in both 1919 and 1920. She is now perhaps best remembered for the epic Wimbledon final against Suzanne Lenglen in 1919, which Chambers lost 10–8, 4–5, 7–9, after holding two match points. The match has been treated as a turning point, not just between

two sporting generations (Chambers was forty-one years old, Lenglen twenty), but also in the whole culture of women's sport, as a "visible emancipation of women on the tennis court."[56] In this contrast Chambers is often represented as the epitome of Edwardian backwardness and a supposedly conservative prewar sporting culture (fig. 17). Besides the difference in age, the contrast worked through bodily appearance and the material culture of sporting dress. Chambers was a strong-jawed, well-built woman, while Lenglen fitted (and indeed helped to establish) the slighter, fashionable body shape of the young interwar woman. Lenglen appeared "as a vision of modernity in a short-sleeved, loose, white tennis frock which barely reached her calves, worn with white stockings . . . and most importantly, without corset."[57] On the contrary, the "only concession that Mrs Lambert Chambers had made to the passing of time since 1903 was that her long-sleeved blouse was open at the neck and her long skirt just a trifle shorter."[58] Such contrasts in attire were reinforced by a certain kind of cultural geography: Lenglen stood for a new, sophisticated, internationalized order of celebrity (for which being young, attractive, and French suited perfectly), while Dorothea Chambers was the "vicar's daughter from Ealing," a product of a passing age of polite pastimes on manicured suburban lawns.[59]

While it was certainly true that Chambers was the second daughter of the vicar of St. Matthew's Church, Ealing Common, and had learned her early tennis skills on the vicarage lawn, the resulting sportswoman was far removed from stereotypes of what she described as the "garden-party pat-ball game."[60] Dorothea Douglass, as she was before her marriage to a local merchant, was a prime example of what Alison Light has characterized as "conservative modernity," embodying dramatic change inside an outer surface of dress and manners that stressed continuity with the past.[61] In terms of dress, she was unwilling or unable to break with the conventions for long, corseted skirts, but she insisted that the skirt should be unpleated and comfortably clearing the ankles, and that the shirt should be plain, without "frills or furbelows." Above all, clothing should allow "free use of all your limbs; physical action must not be impeded in any way by your clothing."[62] In relation to other aspects of the game, however, Chambers's ideas indicated a much more unambiguous commitment to aggressive competition. Her best-selling publication of 1910, *Lawn Tennis for Ladies*, began with a direct attack on the idea that athletic sport was unwomanly, or potentially injurious to health, and continued by suggesting that photographs of women in action should be judged by different aesthetics from those of ordinary poses:

> In fact, I think it is more interesting to see a girl not absolutely immobile. I
> prefer that she should show some signs of excitement, that her muscles

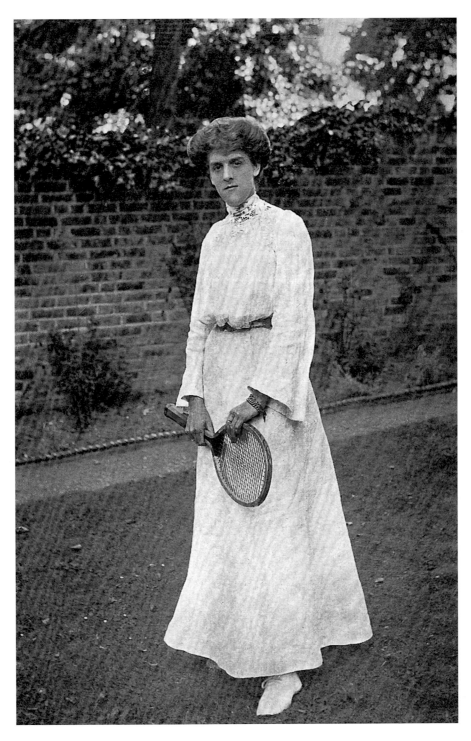

17. "Portrait of Dorothea Lambert Chambers," from G. W. Hillyard, *Forty Years of First-Class Lawn Tennis* (London: Williams & Norgate, 1924), opp. 156. Courtesy of the Yale University Library.

should be strained and her face set. This has a very real pleasure of its own, and I do not think it unsightly.[63]

Chambers was a firm advocate of the superiority of the overhead serve, encouraging women to use the shot properly and to full effect. In addition to advice on equipment and the correct execution of the most important strokes, *Lawn Tennis for Ladies* included a chapter on what was effectively the sporting psychology of winning in tournament play. Chambers had little to say about social pleasantries, but much to say about the efficacy of mental rehearsal of tactics, as well as about complete mental and bodily absorption in the quest for victory: "you *must* lose yourself in the game—eye, mind, and hand all working together."[64]

Chambers departed strongly from the Corinthian culture of elite amateurism in advocating intensive practice. This, she stressed, had developed during her suburban childhood environment, with the encouragement of her father. Far from its common use as a signifier of gentility and passivity, it was the vicarage garden that incubated this sporting potential, which then flourished in the competitive culture of the suburban tennis club. Chambers described imaginary childhood games with dolls and animals as opponents, and later repeated practice against one of the vicarage walls. This developed into the repetitive technique by which she systematically made sure that each of her strokes were "passed through the mill and assiduously exercised until perfection came."[65] The vicar squeezed a tennis court between the gooseberry bushes in the back garden, taking up most of the available space. Douglass joined the Ealing Common Tennis Club as a junior, playing regularly against men and winning the club handicap as an eleven-year-old, the first of three successive victories.

Suburbia was more than a passive setting for the development of this talent and sporting attitude; it was an active agent in the making of new sporting practices and cultures. Pierre Bourdieu is distinctive among social theorists in taking sport seriously. While part of his work concentrates on the cultural and symbolic capital of sporting activity, and thus relates directly to the position and proper performance of tennis and other sports in London's intensely stratified Edwardian suburbia, his concept of habitus emphasizes the linkages between social (and indeed spatial) environments and embodied practices.[66] Bourdieu stressed the ways in which practices are learned through repetition and habit, along with how bodies come to express social position through their actions and modes of appearance.[67] Yet, while he used the learning of sporting skill as a central example of the formation of habitus, Bourdieu's analysis failed to give a full account of acquisition and the generative capacity of embodied learning.[68] Tellingly, the example of the childhood and adolescence of Dorothea Douglass indicates the way that the changes

in the physical environment created possibilities for new embodied practices, which in turn changed the expectations and meanings of women's sporting activities; the endless thumps of ball against garden wall, or her training drills at the local tennis clubs, were a product of the new microgeographies of the suburbs.

One notable absence from the 1908 Olympics was the American tennis player May Sutton, who had taken the physicality of the women's game to new levels in winning Wimbledon in 1905 and 1907. Chambers described her 1906 victory over Sutton at Wimbledon as her finest, considering the fearsome power of her opponent. In the other athletic events at the White City stadium, however, American competitiveness was all too evident. Not including the rather shambolic tug-of-war contest, the Americans won sixteen track-and-field gold medals to Britain's seven. This severely strained British claims for some kind of natural sporting superiority. Although some people such as Theodore Cook, one of the organizers of the games, still claimed "that athletic traditions are in our blood, and that athletic framework is constantly being bred into the best of our boys," there was a growing sense of crisis in British sporting achievement.[69] In its review at the end of the games, the *Sporting Life* defiantly sifted through the statistical evidence of the full range of sports (many of which had no or very limited foreign competition) to refute the "general chorus as to British degeneracy in athletic sports."[70] One response to American success turned back to the codes of elite amateurism, shifting the snobberies that were so significant in policing the class boundaries of domestic sport into the increasingly politicized domain of international sport. The Americans were criticized for their win-at-all-costs attitude and for the meticulousness of their preparation—in short, for entering what *Truth* described as "the cad zone of sporting development."[71] Americans in the crowd were also criticized for their shouting, singing, and displays of sporting triumphalism.[72] Writing in the *Illustrated London News* on the "general stream of exciting events at the Stadium," G. K. Chesterton commented that "the American is a bad sportsman because he is a good Jingo. . . . One American phrase constantly recurred: 'our boys were in to win'. Which means: 'This is sport to you, but death to us—death or immortality.'"[73]

This insouciant belief in the superiority of British values over foreign "caddishness" was hard to sustain, not least in the face of international criticism of the partiality of the British officials. Many competitors shared the opinions of James Sullivan, secretary of the American Athletic Union, that the British judges were "unsportsmanlike and absolutely unfair" and that their "real aim was to beat the Americans," and the British Olympic Association was forced after the games to defend the standards of officiating.[74] A different kind of reaction to relative failure demonstrated the way in which the Olympics had become a part of broader international rivalry and nationalist and imperial politics. Sport was clearly an

important element in British cultural imperialism, but it could also become the focus of anxiety about Britain's position in the world, as well as about imperial decline.[75] The Olympic performance reinforced a strong strand of Edwardian sentiment in the lasting aftermath of the Boer War, an admixture of National Efficiency and loose social Darwinism. The comparison with American thoroughness was taken by the National Efficiency movement as further evidence of wider British lack of competitiveness, as well as the degradation of Victorian values of amateur purity into plain amateurishness, unsuited to the challenges of the modern world.[76]

Coupled to the broader concern for efficiency was a more specific sense of physical or even racial decay.[77] The sense of threat to Britain's supremacy from the rapidly modernizing economies of the United States, Germany, and even Japan extended beyond the comparison of industrial productivity or political cultures, to include concerns about physical deterioration that grew out of the alarming statistics of the Boer War recruitment campaigns.[78] While the wider Franco-British Exhibition sought to reinforce and reinterpret the racial hierarchies of empire for a mass public, within the stadium there was troubling evidence of weakness. Although the 1904 report of the Physical Deterioration Committee set up by the government after the Boer War had dismissed the more alarmist versions of racial decline, it did contribute to the wider culture of concern, particularly through its criticisms of working-class urban conditions. But while both social reformers and eugenicists debated the condition of the working classes and their relationship with the metropolis, the sense of malaise also extended to include the negative effects of middle-class suburban expansion on the nation. In such debates sport held a contradictory position: excessive sporting fanaticism (and hence distraction from the higher callings of national and imperial needs) was a cause of decline, yet sporting failure, particularly in the raw metric of athletic events, was also symptomatic of that decline. Many, such as the liberal imperialist C. F. G. Masterman, writing in *The Condition of England* (1909), identified decline with a soft new suburban culture:

> Those who are intimate with modern phases of suburban life think that they can detect a slackening of energy and fibre in a generation which is much occupied with its pleasures. . . . The veterans who remember the strenuous existence of Victorian England [complain] that the whole newer time thinks that it has little to do but to settle down and enjoy the heritage which has been won. The young men of the suburban society, especially, are being accused of a mere childish absorption in vicarious sport and trivial amusement.[79]

The biggest shock to national morale and esteem came in the marathon of 1908. Long-distance running, despite its Victorian associations with the professional "pedestrianism" circuit, was held as a particularly powerful embodiment of supposedly British characteristics of pluck and determination; in early July, before the Olympics, there was great confidence in the sporting press that "Britain seems sure of the long-distance events."[80] For Theodore Cook, "the Marathon Race produced perhaps the greatest disappointment felt by British athletes in these Games; for, like the Greeks at Athens, we had scarcely imagined the possibility of a foreign victory."[81] Beyond the drama of the finish, the race was a humiliating defeat for the British and a triumph for the Americans, with the winner, John J. Hayes (after Pietri's disqualification), followed by compatriots in third and fourth places. There were no British runners in the first ten places.

Even before the race, the marathon and its route had been the subject of qualms about the nature of the Olympic Games and their relation with suburban culture. The patrician paper *Truth*, which feared that the Olympics were an overly desperate attempt to disprove British degeneracy, was particularly scathing that the marathon, rather than running through the heart of the imperial capital, was to be "a semi-circular tour of suburban London."[82] The route ran from Windsor Castle to Shepherd's Bush through Uxbridge, Ruislip, Harrow, Wembley, and Willesden. This was Edwardian contested terrain, the locus of fears about the unrestrained growth of the metropolis and its impact on people, nation, and empire. For the contemporary town-planning movement, the twin evils were central overcrowding and unrestrained growth of the suburban outskirts; the marathon connected precisely those unconstrained developments that lay outside of what architects and planners were increasingly suggesting should be an ordered, controlled, and circumscribed London.[83] The *Illustrated London News* seemed distinctly equivocal about the proper way to illustrate this new London. Its preview for the Olympic marathon used photographs and line drawings, including images both of remnants of rural Middlesex and of the suburban and edge-city landscape on the route to White City (fig. 18).[84] What was more certain was that the Olympic marathon as an event, rather than as a demonstration of British endurance, was a stunning success, as hundreds of thousands of enthusiastic suburbanites lined the streets in well-ordered crowds.

The marathon returned to the West London suburbs the following year, in what was an explicit attempt to correct the national failings of the Olympics. The *Sporting Life* offered a £500 trophy for a repeat race, organized by the Polytechnic Harriers Club. As the paper put it, "Britishers especially have cause to throw themselves heart and soul into the success of this Marathon, for the opportunity is now afforded them to regain their lost prestige for pluck and endurance, and the

18. "Marks for Marathon Runners: The Mile Posts in the Twenty Six Mile Course from Windsor to the Stadium" (detail), from *Illustrated London News*, 18 July 1908, 91. Courtesy of the Yale University Library.

honour of being the best long-distance racing men in the world."[85] The police asked for the revised route not to be publicized widely, to keep down the numbers of spectators, but large crowds were still present to watch Harry Barrett, an electrical technician from Hounslow (just off the route), restore some lost national pride with a new record for the distance.[86]

Besides the gratitude of the nation (at least as expressed in the popular press), Barrett's reward was the trophy for a year and an 18-carat gold medal to keep. Indeed, the runners were competing "for prizes never before given to amateurs in England or elsewhere."[87] In its form the Sporting Life Trophy was conventional enough, if disturbingly large and heavy.[88] Like the Olympic trophy won by Hayes the previous year, it was topped by a statuette of Pheidippides running (fig. 19). The whole trophy, nearly five feet in height, was an over-the-top confabulation of Edwardian Baroque forms, with its solid silver Corinthian columns, further statuettes of Victory and Fame, and laurel-festooned silver panels and scrolls of honor.

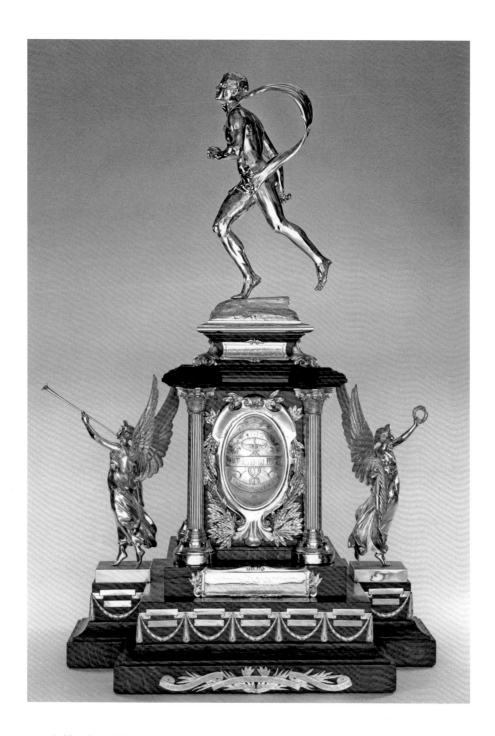

19. Goldsmiths and Silversmiths Company of Regent Street, *Sporting Life Trophy* (1909). Museum of London.

Yet for all its attention to "classical" detail, what the Sporting Life Trophy represented was the triumph of a new order, both in sport and in wider Edwardian culture. Despite the attempts to keep the Polytechnic race at least nominally amateur, this was now an event with valuable prizes, sponsored lavishly by the daily "yellow press" so despised by denigrators of suburban life such as Masterman and Crosland; an event where the makers of Oxo and Bovril fought advertising wars to show that they were the energy drink of champions; an event whose trophy formed the centerpiece for promotional displays in West End department stores; and an event watched annually by thousands of spectators in the period before World War I. Like the well-drilled and muscled body of Dorothea Lambert Chambers beneath her corseted skirt, and the giant concrete bowl set among the plasterboard Beaux-Arts, Baroque, and orientalist pavilions of White City, the Sporting Life Trophy was a sign of the Janus-faced character of Edwardian modernity and the significance of its suburban heartlands.

1. Pierre de Coubertin, *Mémoires Olympiques* (Lausanne, Switzerland: Bureau International de Pédagogie Sportif, 1931), 123, translation in Martin Wimmer, *Olympic Buildings* (Leipzig: Edition Leipzig, 1976), 27.

2. *Franco-British Exhibition London 1908 Official Guide* (London: Bemrose and Sons, 1908), 7.

3. Pierre de Coubertin, *Une Olympie Moderne* (Paris: Imprimerie Jattefaux, 1910), translation in Wimmer, *Olympic Buildings*, 209.

4. For London population figures from decennial censuses of population, aggregated to provide populations for the 1888 County of London area and the post-1963 Greater London area, see Ben Weinreb and Christopher Hibbert, *The London Encyclopaedia* (London: Macmillan, 1983), 614. Comparative urban populations are taken from Tertius Chandler, *Four Thousand Years of Urban Growth: An Historical Census* (Lewiston, UK: St. David's Univ. Press, 1987).

5. See Alan Jackson, *Semi-Detached London: Suburban Development, Life and Transport, 1900–39*, 2nd ed. (Didcot, UK: Wild Swan, 1991), 1.

6. Jerrold Walker, *Highways and Byways of Middlesex* (London: Macmillan,1909), quoted in Jackson, *Semi-Detached London*, 17.

7. T. W. H. Crosland, *The Suburbans* (London: John Long, 1905).

8. Robert Carden, "The Franco-British Exhibition 1," *Architectural Review* 24, no. 140 (July 1908): 32–37, quote at 33.

9. Charles Dickens, *Our Mutual Friend* (1864; repr., London: Nonesuch, 1938), 36.

10. John Carey, *The Intellectuals and the Masses: Pride and Prejudice among the Literary Intelligentsia, 1880–1939* (London: Faber and Faber, 1992), 53.

11. H. G. Wells, *Kipps* (1905; repr., London: Fontana Collins, 1961), 240.

12. Georg Simmel, "The Metropolis and Mental Life" (1903), reprinted in *Simmel on Culture: Selected Writings*, ed. David Frisby and Mike Featherstone (London: Sage, 1997), 184.

13. Paul Greenhalgh, "Art, Politics and Society at the Franco-British Exhibition of 1908," *Art History* 8, no. 4 (Dec. 1985): 434. Another estimate puts attendance at about 8.4 million visitors. See Fred Hawthorn and Ronald Price, *The Soulless Stadium: A Memoir of London's White City* (Upminster, UK: 3-2 Books, 2001), 11.

14. "The Franco-British Exhibition," *Builder* 94 (27 June 1908): 734. See Paul Greenhalgh, *Ephemeral Vistas: The Expositions Universelles, Great Exhibitions and World's Fairs, 1851–1939* (Manchester: Manchester Univ. Press, 1988), 44, for a discussion of the shift of international exhibitions toward popular entertainments in the late Victorian and Edwardian periods.

15. "Elephants Shooting the Chute at the Franco-British Exhibition," *Illustrated London News*, 4 July 1908, 1.

16. Annie E. Coombes, *Reinventing Africa: Museums, Material Culture and Popular Imagination* (New Haven: Yale Univ. Press, 1994), 191–92.

17. "The Franco-British Exhibition," *Building News* 93 (13 Sept. 1907): 346–47, and J. Nixon Horsfield, "The Franco-British Exhibition of Science, Arts and Industries," *Journal of the Royal Institute of British Architects* 15, 3rd ser. (1908): 546–56.

18. "Architecture at the Franco-British Exhibition," *Builder* 94 (9 May 1908): 531–33.

19. "Architecture at the Franco-British Exhibition," 532.

20. "Franco-British Exhibition Supplement," *Sketch*, 1 July 1908, 3.

21. "The Olympic Games," *Times* (London), 30 March 1907, 10.

22. Theodore Andrea Cook, *International Sport: A Short History of the Olympic Movement from 1896 to the Present Day, Containing the Account of a Visit to Athens in 1906, and of the Olympic Games of 1908 in London, Together with the Code of Rules for Twenty Different Sports and Numerous Illustrations* (London: Archibald Constable, 1909), 16.

23. John Arlott, "Sport," in *Edwardian England*, ed. Simon Nowell-Smith (London: Oxford Univ. Press, 1964), 447–86.

24. Simon Inglis, *Engineering Archie: Archibald Leitch—Football Ground Designer* (London: English Heritage, 2005), 19.

25. Inglis, *Engineering Archie*, 21.

26. "The Franco-British Exhibition," *Building News* 93 (23 Aug. 1907): 238–39.

27. "Engineering at the Franco-British Exhibition," *Builder* 95 (18 July 1908): 61–62.

28. "Architecture at the Franco-British Exhibition," 533.

29. Robert Carden, "The Franco-British Exhibition II," *Architectural Review* 24, no. 142 (Sept. 1908): 108–11, quote at 111.

30. "Engineering at the Franco-British Exhibition," 62.

31. Alan Powers, *Britain: Modern Architectures in History* (London: Reaktion, 2007), 15.

32. G. R. Searle, *A New England? Peace and War, 1886–1918* (Oxford: Clarendon, 2004), 304.

33. A. G. Gardiner, *Prophets, Priests and Kings* (London: Alston Rivers, 1908), 211.

34. "A Brief Survey of the Franco-British Exhibition," *Architect and Contract Reporter* 80 (17 July 1908): 37.

35. Robert Baden Powell, *Scouting for Boys* (London: C. Arthur Pearson, 1908), 297–98.

36. Gustave Le Bon, *The Crowd: A Study of the Popular Mind* (New York: Macmillan, 1896), 17.

37. H. F. Abell, "The Football Fever," *Macmillan's Magazine* 89 (1903), quoted in Derek Birley, *Land of Sport and Glory: Sport and British Society, 1887–1910* (Manchester: Manchester Univ. Press, 1995), 229.

38. See Camiel van Winkel, "Dance, Discipline, Density and Death: The Crowd in the Stadium," in *The Stadium: The Architecture of Mass Sport*, ed. Michelle Provoost (Rotterdam: NAI Publications, 2000), 12–36.

39. Estimates of the overall capacity of the stadium varied wildly between about 100,000 and 150,000, reflecting various estimates about how tightly packed the terraces could be. The official figure for the number of seats in the original design was 66,288. Cook, *International Sport*, 159. The *Sporting Life*, however, indicated that 51,200 seats could be bought by the public for the Olympic events, with a further 1,040 seats in reserved boxes. *Sporting Life*, 10 July 1908, 4.

40. *Sporting Life*, 13 July 1908, 1. After disappointing attendance, prices were dropped for the second week, which, combined with improved weather, saw crowds increase dramatically.

41. While most estimates were of a marathon-day crowd of more than eighty thousand, one put the total at one hundred thousand, with twenty thousand more turned away. *Daily Mail* (London), 25 July 1908, 5.

42. "The Great Little Games," *Punch*, 22 July 1908, 56.

43. As *Truth* pointed out, the public "cannot take holidays every day in the week" to watch the games. *Truth*, 22 July 1908, 187.

44. *Sporting Life*, 20 July 1908, 8.

45. Cook, *International Sport*, 12.

46. *Sporting Life*, 20 July 1908, 6.

47. Coubertin, *Olympie Moderne*, 215.

48. Coubertin, *Olympie Moderne*, 215.

49. Coubertin, *Olympie Moderne*, 215.

50. Birley, *Land of Sport and Glory*, 226.

51. John Lowerson, *Sport and the English Middle Classes, 1870–1914* (Manchester: Manchester Univ. Press, 1993), 25.

52. Lowerson, *Sport and the English Middle Classes*, 15.

53. See Cook, *International Sport*, for a detailed listing of the amateur regulations.

54. Birley, *Land of Sport and Glory*, 221.

55. *Baily's Magazine*, Nov. 1907, 387.

56. Catherine Horwood, "Dressing Like a Champion: Women's Tennis Wear in Interwar England," in *The Englishness of English Dress*, ed. Christopher Breward, Becky Conekin, and Caroline Cox (Oxford: Berg, 2002), 45–60, quote at 48.

57. Horwood, "Dressing Like a Champion," 48.

58. Mark Pottle, "Chambers, Dorothea Katharine Lambert (1878–1960)," *Oxford Dictionary of National Biography* (Oxford: Oxford Univ. Press, 2004).

59. Horwood, "Dressing Like a Champion," 47; see also Richard Holt, *Sport and the British: A Modern History* (Oxford: Clarendon, 1989), 127, for similar claims about the gentility and social character of suburban Edwardian tennis.

60. Dorothea Lambert Chambers, *Lawn Tennis for Ladies* (London: Methuen, 1910), 4.

61. Alison Light, *Forever England: Femininity, Literature and Conservatism between the Wars* (London: Routledge, 1992).

62. Chambers, *Lawn Tennis for Ladies*, 14.

63. Chambers, *Lawn Tennis for Ladies*, 12.

64. Chambers, *Lawn Tennis for Ladies*, 39.

65. Chambers, *Lawn Tennis for Ladies*, 16.

66. For his discussion of sport and social distinction, see Pierre Bourdieu, *Distinction*, trans Richard Nice (Cambridge, Mass.: Harvard Univ. Press, 1984), 211–13.

67. Pierre Bourdieu, *Language and Symbolic Power*, trans. Gino Raymond and Matthew Adamson (Cambridge: Polity, 1991), 86–89.

68. For an exposition and sympathetic critique of Bourdieu's work related specifically to the issue of sporting skill, see Greg Noble and Megan Watkins, "So How Did Bourdieu Learn to Play Tennis? Habitus, Consciousness and Habituation," *Cultural Studies* 17 (2003): 520–38.

69. Cook, *International Sport*, 91.

70. *Sporting Life*, 27 July 1908, 6.

71. *Truth*, 9 Sept. 1908, 598.

72. See Birley, *Land of Sport and Glory*, 224–25.

73. *Illustrated London News*, U.S. ed., 15 Aug. 1908, reprinted in G. K. Chesterton, *Collected Works*, vol. 27, *The Illustrated London News, 1908–1910*, ed. L. J. Clipper (San Francisco: Ignatius Press, 1987), 162.

74. Quoted in Birley, *Land of Sport and Glory*, 225.

75. For a discussion of sport and cultural imperialism, see Allen Guttman, *Games and Empires: Modern Sport and Cultural Imperialism* (New York: Columbia Univ. Press, 1994), and Claude Hurtebitze, "Géopolitique de la Genèse, de la Diffusion et des Interactions Culturelles dans la Culture Corporelle et le Sporte," in *Géopolitique du Sport*, ed. Borhane Errais, Daniel Mathieu, and Jean Praicheux (Besançon: Université de la Franche-Comté, 1990).

76. Holt, *Sport and the British*, 274–75.

77. For example, Arnold White, one of the instigators of the National Efficiency movement in his book *Efficiency and Empire* (1901), moved toward a more explicitly eugenic position during the decade. See Dan Stone, *Breeding Superman: Nietzsche, Race and Eugenics in Edwardian and Interwar Britain* (Liverpool: Liverpool Univ. Press, 2002).

78. Searle, *New England?* 305.

79. C. F. G. Masterman, *The Condition of England* (London: Methuen, 1909), 90–91.

80. *Sporting Life*, 1 July 1908, 1.

81. Cook, *International Sport*, 220.

82. *Truth*, 22 Jan. 1908, 3.

83. See, for example, Paul Waterhouse, "The Laying-Out of London" (report of a paper to the Architectural Association), *Architect and Contract Reporter* 78 (20 Dec. 1907): 393–95.

84. "Marks for Marathon Runners: The Mile Posts in the Twenty Six Mile Course from Windsor to the Stadium," *Illustrated London News*, 18 July 1908, 90–91.

85. *Sporting Life*, 2 April 1909, 8.

86. *Sporting Life*, 10 May 1909, 6.

87. *Sporting Life*, 8 May 1909, 6.

88. The trophy was used for the Polytechnic Marathon from 1909 to 1961. Now known as the Chris Brasher Sporting Life Trophy, it is used for the London Marathon. Its weight is more suited to the physique of heavyweight boxers or rugby forwards than that of a typical marathon runner. See www.ianridpath.com/polymarathon/trophy.htm for details.

The Age of the "Hurrygraph": Motion, Space, and the Visual Image, ca. 1900

Lynda Nead

IN WHAT SENSE "EDWARDIAN"?

F ROM ITS INCEPTION the intellectual aim of this collection of essays has been
to bring the Edwardian period back into focus for art and cultural history. The
assumption behind this objective is that the Edwardian has somehow lost its his-
torical specificity, its hard edges, and has fallen into obscurity between the two great
megaliths of historical periodization: "Victorianism" and "modernism." To what
extent, however, is it possible to refer to an Edwardian sense of space, or Edwardian
visuality? Is there a period, somewhere between the death of Victoria in 1901 and
the general elections of 1910 and coinciding with the monarchy of Edward VII, that
can be described as distinctly different from the social and cultural formations that
went before and after it? Raymond Williams put the matter this way:

> What we are defining is a particular quality of social experience and relation-
> ship, historically distinct from other particular qualities, which gives the
> sense of a generation or of a period. The relations between this quality and
> the other specifying historical marks of changing institutions, formations,
> and beliefs, and beyond these the changing social and economic relations
> between and within classes, are again an open question.[1]

In this essay I will argue that there was indeed a distinctive perception and
experience of space and visuality in the first years of the twentieth century, but that
it drew on ideas and meanings that had taken shape at least throughout the second
half of the nineteenth century and that continued to develop well after World War I.
Again, Williams provided a lucid and useful terminology for analyzing this kind
of historical process. It is difficult to believe that his *Marxism and Literature* is now
more than thirty years old. In its adherence to a Marxist model of base, superstruc-
ture, and ideology, it seems to belong to a very different and vanished world of
cultural analysis; however, in its move beyond these templates and its sensitive

engagement with cultural forms and styles, it remains a classic work of cultural analysis. In his chapter "Dominant, Residual, and Emergent," he considered the "internal dynamic relations" that characterize any historical moment.[2] This means addressing not only the dominant, or hegemonic, forms of culture, but also those elements that have been formed in the past but are actively drawn into the present, as well as those that represent new phases and forms within the dominant culture.[3] This model allows us to produce a more fluid and dynamic model of cultural history, in which a period, or epoch, does not have to be entirely autonomous from those before or after it; it may be folded backward or forward and possess elements that belong to the past and that inform the future. In this way it is possible to use the term "Edwardian sense" to describe a historical character or quality that differentiated itself from nineteenth-century Victorianism but that, at the same time, drew on many elements of that epoch, and that set in play a range of practices, ideas, and forms that continued to play an effective part in the years after the period itself had come to an end.

Working through this conceptual framework, this essay will examine the relationships between movement, space, and the visual image in the years around the reign of Edward VII. It will consider the ways in which technologies of transport and image reproduction enabled a different form of visual perception that was explicitly discussed in publications of the period. It is easier, perhaps, to describe the historical construction of space or perception than it is to evoke their *experience*, but in the textual attempts to find a language for new ways of looking at objects and views, and the hesitant acceptance of different perspectives, or the retreat into familiar sights, something of the nature and quality of that experience may be grasped.

For James Hissey, the author of a number of motoring guidebooks to Britain, the motorcar offered diverse forms of speed and vision. In his 1908 guide, *An English Holiday with Car and Camera*, he relished certain journeys,

> meander[ing] about in a car in as leisurely a fashion as though you were driving a horse. . . . We meant to see and enjoy the country we passed through, not to obtain fleeting and soon-forgotten visions of it.[4]

Elsewhere in the book, however, he described how

> the spirit of speed took possession of us, the fascination and the frenzy of speed for speed's sake; the rush through the air, mocking the bird in its flight. . . . We were intoxicated with a new-born freedom. . . . "Distances, changes, surprises" greeted us in rapid succession as we sped along over the wild, sweeping wolds.[5]

The title of Hissey's book should also not go unnoticed; the experience of touring in the Edwardian period was a conjunction of mechanized transport and mechanized vision. The car and the camera were brought together to create an experience of movement and vision that embraced picturesque views and vistas consumed at a leisurely pace and the rapid succession of images created by speed. This was, as Hissey termed it, the age of the "hurrygraph":[6] of impressions created at high velocity, but equally of conventional landscapes created by loitering.

RUSHING AND LOITERING: THE BICYCLE AND THE MOTORCAR

It is a maxim of histories of modernity that mechanization and urbanization changed the pace and experience of life, which in turn created new forms of visual representation and perception. Life in the early twentieth century became faster, so the argument goes, and this new velocity found its visual analogue in blurred images viewed from behind the windshield of a speeding car or the continuous movement of film stills projected at twenty-four frames per second. There are two assumptions within this argument that may be challenged: first, that the change in the speed of daily life was one of acceleration, of an increase in the velocity of everyday experiences. And second, that there is a synergy between this perception and lived experience, heralding what might be called "machine vision."

To a degree and in general terms, these claims are historically supportable and reasonably accurate characterizations of late-nineteenth-century social life and viewing practices, but I would like to unravel this equation between modern mechanized life and modern machine vision further in order to present a more nuanced account of the comprehension of cultural life and spatial experience at the end of Victoria's reign and in the early twentieth century than has thus far been offered. Strolling and sketching, cycling and hand-camera photography, motoring and filming, were all ways in which mechanized motion and visual technologies were intertwined in this period. Residual and emergent forms of representation coexisted and gave meaning to the comprehension of urban and rural space.

The starting point for this narrative might be a full-page color image in the special issue of the *Illustrated London News* published to celebrate Queen Victoria's Diamond Jubilee in 1897 (fig. 20). Framed by an elaborate decorative border, punctuated with vignettes of great Victorian men, six tableaux at the center of the page depict how life has changed in the sixty years of Victoria's reign. Arranged in tiers of two contrasting images and separated by horizontal bands with rows of circular piercings, the scenes resemble fragments of film. Within the page itself,

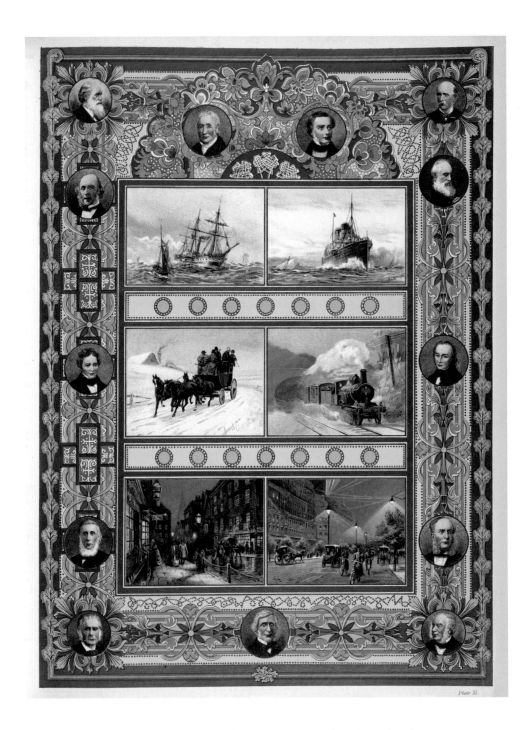

20. *Her Majesty's Glorious Jubilee. 1897*, published by the proprietors of the *Illustrated London News*
(St. Albans: Oxford Smith and Co., 1897). Museum of London.

the illustrator uses two distinctive styles of representation: one, the decorative border, archaic, conservative; the other, the film strip, a new technology (the first public film exhibition had taken place in 1895), signifying modern progress. The scenes represent progress during the years of Victoria's reign in terms of the transformation in modes of transport: from sailing boats to steamships; horse-drawn coaches to railway locomotives; and, finally, walking to bicycling and motorcars (1897 is really the earliest moment that a motorcar might have been included in this urban scene). The final pair of images is particularly interesting, since the transformation of the street is also defined in terms of the changes in lighting and in communication. Movement, electric light, and communication: the three essential components of modern life and of modern visual culture. That final image of the street in 1897 may not be as straightforward as it first appears, however, and it might depict more than it intends to. Pedestrians, cyclists, horses, and motorists demonstrate a range of velocities under a roof of rays of light and telegraph wires. The picture is not simply an illustration of monolithic technological progress during Victoria's reign, but a more complex evocation of the diversity of modern life and movement in the last years of the nineteenth century. The single space of a city street could be experienced at a walking pace or at the varying speeds of horse-drawn carriage, bicycle, and car. None of these alone represented the pace of life in 1897; instead, the image makes clear that all of these forms of movement created the tempo of urban life at the end of the nineteenth century.

With movement and space come specific forms of looking and comprehension. Developments in modes of transport in the nineteenth century were met with changes in forms of photographic technology. Cameras became lighter and more portable, tripods were abandoned, and the introduction of the hand camera made photography a ubiquitous part of everyday life at the turn of the century. For many writers on photography in this period, the hand camera seemed to be perfectly designed for vision on the move (fig. 21). Articles with such titles as "Cycling and Photography" appeared regularly in the photographic press, and advertisements for camera makers addressed their products to "tourists and bicyclists." Camera models with names such as the "Instantograph" could be attached by clips to any part of the bicycle, allowing men and women to travel to new subjects that could be easily transformed into photographs. As one writer observed in 1896, "I know not which to be most thankful for, the bicycle which takes me to, or the camera that taught me to take [an] interest."[7]

Hand-camera technology and bicycles appeared to offer the perfect match for a growing amateur market, keen to move and to make images. Ernest Bowden's *Pocket Guide to Cycling* (1896) included a section on photography for cyclists, which also recommended rational dress for women.[8] And Walter D. Welford, one of the

21. Advertisement from *Amateur Photographer*, 21 Aug, 1885,
iv. British Library.

most prolific writers on the hand camera in this period, also happened to be the
editor of *Cycling: A Monthly Magazine* and the *Wheelman's Year Book*. The synergy
between the two technologies seemed to sum up the nature of contemporary life at
the end of the century. As one article, entitled "Spirit of the Times" and published
in *Photography*, stated: "The number of photographers amongst cyclists is one of
the features of the times."[9] The interdependence and co-popularity of the two forms
of moving and looking led one commentator in the *Photographic News* to coin the
term "Photo-Cycling" to express "the inter-suitability of the two pastimes, and the
added pleasure the adoption of one gave to the pursuit of the other."[10]

What these sources make clear is that the histories of movement and vision
are closely interrelated in the years leading up to and including the Edwardian
period. The experience of space was formed out of the experience of modes of
traveling and technologies for seeing. Country and city, rural lane and urban
street, tradition and renovation, were all mediated through the wheels of transport
and the lenses of cameras.

The bicycle and the hand camera provide one case study of the relationship between motion and the visual image at the end of the nineteenth century; perhaps the motorcar and the motion-picture camera provide a different instance of this synergy. In the mid-1890s, the motorcar and the cinematograph both made their formal public debut. In 1895 the Lumières mounted the first public exhibition of their Cinématographe, and within months other inventors were coming up with their own versions of moving pictures. In 1896 in Britain, legislation acknowledged the triumph of the automobile by abolishing the requirement that all vehicles using public roads should be preceded by a person on foot; the speed limit was raised to twelve miles per hour, and in November 1896 the first London-to-Brighton run was organized on what was to become known as "emancipation day," to celebrate the passing of the act into law.

The motorcar in this period offered a new type of subjectivity: privileged, individualistic, and phenomenological. Early drivers spoke of the physical pleasures of motorized speed and the almost human connection between driver and machine. The automobile offered individual motorists the freedom to choose when and where they traveled and the pace and tempo of their journey. Every writer in these early years agreed that the natural environment of the motorcar was thus the countryside rather than the city, the open road rather than the congested street. To this extent the motorcar was seen as a rural adventure machine, and its pleasures were intimately connected to those of a newly emergent national identity based on the rediscovery and preservation of the British countryside.

Set free in rural England, motor driving offered a changed visual perception, a different way of seeing, but is it possible to define this shift as a move from a panoramic to a cinematic aesthetic, as Jean Baudrillard and others have claimed?[11] For all those who celebrated the exhilaration of speed, there were others who loved the motorcar for its varied motion and its creation of leisurely, individualized travel. Motoring was varied and capricious: leisurely exploration was punctuated with euphoric episodes of speed, and it was the capacity for all of these styles of motion that was the special charm of the motorcar in these years. For motoring enthusiasts such as Rudyard Kipling, the motorcar was a kind of time machine, allowing the motorist to explore both space and time. Driving through the English countryside was a journey into the past:

> The car is a time-machine on which one can slide from one century to another at no more trouble than the pushing forward of a lever. . . . In England the dead, twelve coffin deep, clutch hold of my wheels at every turn, till I sometimes wonder that the very road does not bleed.[12]

What is clear is that different forms of travel created distinct modes of vision. High speeds did not suit the static aesthetic of the picturesque; the tempo of the modern pastoral required seeing the landscape as a sequence of moving pictures. Speed turned the countryside into what Hissey described as "hurrygraphs"— indistinct impressions that rendered the picturesque utterly redundant. This was the world of motorized travel and vision in the late Victorian and Edwardian periods: the world of hand cameras and motion pictures. But the move to cinematic vision was slow to develop and probably belongs to the period after World War I rather than to the Edwardian era, which remained a world in which the train and the pedestrian, the horse-drawn cart and the motorcar, coexisted, both in the cities and in the countryside.

RUSHING AND LOITERING: THE PEDESTRIAN

The Edwardian metropolis continued the uneven process of physical growth and economic and commercial development that had characterized it during the reign of Victoria. Concern about the older, inefficient areas of the city persisted after 1900 alongside episodic attempts at modernization and improvement. What was most distinctive about the capital in this period, however, was its position as the administrative and cultural heart of the empire, and it was this aspect of London life that gave it a claim to being the capital of the early twentieth century. Debates about the nature of modern urban life can also be framed in terms of the concepts of residual, dominant, and emergent, set out by Raymond Williams. While many elements of the city in about 1900 had been established in preceding decades, new technologies such as the motorcar and telegraph were undoubtedly changing the appearance and experience of metropolitan life. What was distinctive about the city in these years, therefore, was the specific conjunction of residual and emergent forms and the coexistence of older spaces and paces alongside new locations and variations of urban movement.

Film footage of large public events such as the funeral of Victoria and the coronation of Edward convey the spectacular side of the urban crowd in the period; other sources, however, offer a different experience of occupying the city and moving through its spaces. If Kipling described the motorcar as a kind of rural time machine that allowed motorists to rediscover the nation's past and its traditions, other writers saw the pedestrian as an urban time traveler, able to walk away from the busy thoroughfares of the emergent imperial city and rediscover the picturesque past of London. As the author of *Picturesque London* explained:

Often has been described the aspect of the overwhelming tide of busy men,
all hurrying and crowding and pushing past at a brisk speed; the carriages,
waggons, carts, incessantly moving in a crowded procession; the hum and
roar in the ears. . . . But more pleasing is the picturesque irregularity, and
windings and curves of the bye-streets or alleys.[13]

The peculiar nature of the city in this period, however, was not simply that it con-
tained new and old, busy and secluded, spots, but that these residual and emergent
spaces were in such close proximity that the experience of one could not be disen-
tangled from the experience of the other. As Emily Cook, the author of a number
of guides to the metropolis in this period, wrote in 1902:

What is so strange to the inexperienced wanderer among London byways is
the manner in which bits of ancient garden, fragments of old, forgotten
churchyards, isolated towers of destroyed churches, deserted closes, courts
and slums of wild dirt and no less wild picturesqueness, suddenly confront
the pedestrian, recalling incongruous ideas, and historical associations puz-
zling in their very wealth of entangled detail. The "layers" left by succeeding
eras are thinly divided.[14]

Both Kipling and Cook see the historical past as embedded in the roads and build-
ings of country and city; it is as though modernity is merely the most recent
chronological membrane and can easily be scraped away to reveal the layers of past
existences on which it is constructed.

Cook sought and found personalities and social relations even in the busiest
parts of the metropolis. In Piccadilly she observed and illustrated two sandwich-
board men stopping to smoke a pipe together; in Cheapside, perhaps one of the
busiest streets in the city at this time, she chose a shoeblack, bending to polish the
boots of a city gentleman (fig. 22).[15] Elsewhere in her guides, sightseers stop a
policeman and are given directions; in further examples, the author and her illus-
trator concentrate on incidents that show social interaction and stasis in the midst
of the city. Genre and anecdote take precedent over the image of the city as a place
of anonymous crowds and relentless rush.[16]

Filtered through the writings of Charles Baudelaire and Georg Simmel, the
urban crowd and the anonymous passerby have become standard tropes of narra-
tives of modern life in the second half of the nineteenth century and the first
decade of the twentieth.[17] Other urban personalities also peopled accounts of the
city in the Edwardian period, however, and bring a different quality to the history
of urban space, movement, and the visual image at this time. The pavement artist

plane-tree costs a year in mere lodging ! Wandering northward
from Cheapside down any of the crowded City lanes with

The Shoeblack.

their romantic names, through the mazes of drays and waggons
—where porters shout over heavy bales, and pulleys hang from
upper " shoots "—you may find, in a sudden turn, small oases

22. "The Shoeblack," from Mrs. E. T. Cook, *Highways and
Byways in London* (London and New York: Macmillan and Co.,
1902), 11. Courtesy of the Yale University Library.

makes a regular appearance as a new type of urban beggar from about the 1870s
(fig. 23).[18] Both men and women were occupied as "open air pastellists," reflecting
the increased access of women to diverse forms of formal art education in the
second half of the nineteenth century (fig. 24).[19] Creating art on the streets, the
pavement artist is a subversion of the official culture of the late-nineteenth-century
art schools and galleries. The visual image appears but is only temporary; the street
becomes a gallery and the crowd a static viewing public, but merely for a short
period. The work of the pavement artist becomes a commodity for a time but can
never finally be bought and sold like a work of art on canvas. Much of the literature
about pavement artists comments on the proximity of their work to great art in
the metropolitan galleries and speculates on the possibility that, in another exis-

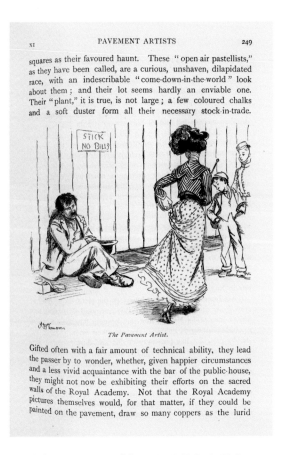

squares as their favoured haunt. These " open air pastellists," as they have been called, are a curious, unshaven, dilapidated race, with an indescribable " come-down-in-the-world " look about them ; and their lot seems hardly an enviable one. Their "plant," it is true, is not large ; a few coloured chalks and a soft duster form all their necessary stock-in-trade.

The Pavement Artist.

Gifted often with a fair amount of technical ability, they lead the passer by to wonder, whether, given happier circumstances and a less vivid acquaintance with the bar of the public-house, they might not now be exhibiting their efforts on the sacred walls of the Royal Academy. Not that the Royal Academy pictures themselves would, for that matter, if they could be painted on the pavement, draw so many coppers as the lurid

23. "The Pavement Artist," from Mrs. E. T. Cook, *Highways and Byways in London* (London and New York: Macmillan and Co., 1902), 249. Courtesy of the Yale University Library.

tence, these individuals might have been great artists whose work could be seen in major collections. The significance of these figures, however, is that they work outside of such institutions and markets and create still images in public places that turn the "crowd" into an audience for art.

In her article "The *Flâneur*, the Sandwichman and the Whore: The Politics of Loitering," Susan Buck-Morss analyzed the urban characters of Baudelaire and Walter Benjamin as forms of urban resistance to the financial and social hegemony of modernity.[20] As loiterers, Buck-Morss argued, they become "a condemnation of capitalism." Heedless of the rhythms and priorities of the modern city, they create their own irreverent temporality and urban style: "The loiterer refuses to submit to industrial social controls. Loiterers ignore rush hour; rather than getting somewhere,

Apart from the Royal Academy, there are other institutions which make bids for public favour in various ways. Among the closer corporations are the Royal Society of Painters in Water Colours; the Royal Institute, in Piccadilly; the Royal Society of British Artists, in Suffolk Street; the New Gallery, in Regent Street, and many other smaller galleries which from time to time hold exhibitions. These are almost invariably interesting.

In the nature of things, the inevitable trend of human aspirations, sometimes an amateur who has the advantage, or, from the point of view of art, the disadvantage to possess more of this world's goods than his fellow artists, trumpets himself forth with what is known as a "one-man" show. Generally this is done for personal advertisement. There are, however, many artists who eschew the perils of public competition, and are content to display their work under their own conditions in the atmosphere and arrangement which suit their individual fancy.

Judging by the extremely inferior statues which are scattered about London, it might be naturally assumed that the English knew not the art of sculpture. There is, however, a younger school of sculptors which is very promising.

A LADY PAVEMENT ARTIST.

The initial expense of making a large piece of sculpture is heavy, and by the time it is complete there is rarely much profit for the sculptor. The cost of marble or bronze is considerable. There are the workmen to be paid—for, of course, the rough-hewing of the marble is not done by the sculptor

SCENE PAINTING.

16

24. "A Lady Pavement Artist," from Gilbert Burgess, "Artistic London," in *Living London: Its Work and Its Play, Its Humour and Its Pathos, Its Sights and Its Scenes*, ed. George R. Sims, vol. 1 (London: Cassell and Co., 1902–3), 121. Courtesy of the Yale University Library.

they hang around. . . . Instead of pursuing private ends they enjoy (the public) view."[21] Modernity's loiterers embody Karl Marx's concept of "heroic laziness."

It is difficult to specify the precise form of politics represented by urban loitering in this period, other than a disinterested neglect of the priorities of modern industrialization and a slovenly disregard of social class. The figure who embodies this lazy political subversion more than any other in Edwardian London is the loafer. Lacking the skills of disinterested observation that characterize the flaneur and free from the labor that defines the prostitute and the sandwich man, the loafer opposes simply by loafing around on street corners and by informally neglecting the economies of work and leisure constructed in the modern metropolis. In this way the loafer, rather than the flaneur, may be said to symbolize the "heroic laziness" described by Marx.

In George R. Sims's fortnightly magazine series, *Living London* (1901–3), the loafer appears regularly in a number of different versions. The aim of the publication was to present in text and image the "flesh and blood" of London during the reign of Edward VII. The etymology of the word "loafer" is possibly from the German verb *laufen*, "to saunter," and it has come to mean to spend time idly. By the mid-1830s it was generally applied to a petty thief, but through the nineteenth century it gradually lost its association with any form of action and signified a more general type of layabout. The loafer has none of the analytical edginess of modernity's heroic observer, the flaneur; he is defined solely in terms of time spent unproductively; he lacks any power of social analysis; and rather than suffering from that paradigmatic malaise of modern life, neurasthenia, the loafer is so relaxed that he can barely stand upright. Whereas the flaneur is a figure of modern leisure, the loafer is the symbol of contemporary idleness.

In 1901 *Living London* carried an article devoted to "Loafing London," in which the author, Arthur Morrison, identified a range of specialist forms of loafing, including "the park loafer, the theatre loafer, the sporting loafer, the market loafer," each of whom has a particular style and characteristics (fig. 25).[22] What they all have in common, however, is that they are "content to merely loaf."[23] The most indolent type of loafer is the park loafer: "he will not even stand up to loaf. Indeed he will not often even sit. He lies on the grass and sleeps, embellishing the best of the London parks with a sprinkle of foul and snoring humanity."[24] As loafers require walls, posts, and benches to keep them erect, it is unsurprising that George Sims noticed that on "London Street Corners," "the loafer is to be found . . . in all his glory night and day."[25]

The qualities of the loafer and the pavement artist are not exclusive to London life in the 1900s, but they do point toward what was distinctive about motion, space, and the visual image during the Edwardian period. No longer Victorian

for a sovereign about you?" Probably the victim hadn't. "Dear, dear, what a pity! (and he really was sorry, as you will soon see). Come, lend me five shillings then, quick!"—perhaps with some hazy reference to a cabman waiting round the corner. The victim, thus taken with a rush, would weakly produce the coins, which the "tapper" would instantly seize, with hasty thanks, and vanish. On the other hand, if the change were forthcoming, it was better business still. "Thanks, awfully—eighteen, twenty—quite right. Why

are often very impressive with green young journalists, who regard them as veterans of the profession, and are "tapped" with great freedom; and their complexions are the product of external dirt and internal Scotch whisky.

The Fleet Street loafer is often observed to merge into the sporting loafer. There are many about the neighbourhood who are, or who call themselves, bookmakers' runners; though they are rarely observed to run. And there are many who are Fleet Street

THE MARKET LOAFER.

where—what—where did I put—oh, there, I'll give you the sovereign to-morrow!" And the "tapper" would be gone round the corner in a flash, leaving the "tappee" standing staring and helpless on the pavement.

This sort of thing cannot endure for long, and the growing seediness of hat and coat makes operations in Pall Mall increasingly difficult. Club porters get uncivil, too, and victims grow warier. So the loafer declines on Fleet Street, and smaller "taps." But of course there are Fleet Street loafers who have never loafed anywhere else. Some came years ago to take the profession of journalism by storm, but have not begun storming, or even journalising, yet. These

loafers by locality, but sporting loafers by predilection. Not that they are expert in any sport, unless the "tapping" and "prossing" already mentioned be called sports. But they frequent the neighbourhood of the sporting papers, and are learned in spring handicaps. They do not wear tall hats, old or new, and their clothing is apt to be tighter about the legs than common, and to show signs of original loud tints.

The sporting loafer is by no means confined to Fleet Street, and he is often identical with the cab-stand loafer. The cab-stand loafer is a dingy and decayed imitation of the cabmen upon whom, it is to be presumed, he lives. He is like most loafers, a parasite

25. "The Market Loafer," from Arthur Morrison, "Loafing London," in *Living London: Its Work and Its Play, Its Humour and Its Pathos, Its Sights and Its Scenes*, ed. George R. Sims, vol. 1 (London: Cassell and Co., 1902–3), 360. Courtesy of the Yale University Library.

and not exactly modern, they are precisely Edwardian, a conflation of residual and emergent forms of urban characterization. They also suggest that the period may offer a useful revision of prevailing accounts of modernity in the early twentieth century, in which rush and social control are replaced, partly at least, by loitering and sketching. The "age of the hurrygraph" was as much about stasis and hanging about as it was about speed and productivity.

1. Raymond Williams, *Marxism and Literature* (Oxford and New York: Oxford Univ. Press, 1977), 121.

2. Williams, *Marxism and Literature*, 121.

3. Williams, *Marxism and Literature*, 22.

4. James John Hissey, *An English Holiday with Car and Camera* (London: Macmillan and Co., 1908), 8.

5. Hissey, *English Holiday*, 337.

6. Hissey, *English Holiday*, 162.

7. G. Sullivan, "Cycling and Photography," *Amateur Photographer*, 22 Aug. 1896, 449. See also "The Camera on Wheels," *Amateur Photographer*, 4 Dec. 1885, 587–88, and an advertisement for the Pocket Kodak, *Amateur Photographer*, 8 May 1896, xvi.

8. Ernest M. Bowden, *The Pocket Guide to Cycling*, 2nd ed. (London: Hay Nisbet and Co., 1896), 111.

9. "Spirit of the Times," *Photography*, 8 Aug. 1889, 458.

10. "Photo-Cycling," *Photographic News*, 28 April 1899, 267.

11. Jean Baudrillard, *The System of Objects*, trans. James Benedict (London and New York: Verso, 1996).

12. Rudyard Kipling, letter, Cape Town, April 1904, quoted in A. B. Filson Young, *The Complete Motorist* (London: Methuen and Co., 1904), 286.

13. Percy Fitzgerald, *Picturesque London* (London: Ward and Downey, 1890), 195.

14. Mrs. E. T. [Emily Constance] Cook, *Highways and Byways in London* (London: Macmillan and Co., 1902), 10.

15. Cook, *Highways and Byways*, 6–11.

16. Cook, *Highways and Byways*, 34, 85, 293, 415. See also Lynda Nead, *The Haunted Gallery: Painting, Photography, Film c. 1900* (New Haven and London: Yale Univ. Press, 2008), chap. 3.

17. See, for example, Charles Baudelaire, "The Painter of Modern Life" (1863), in *The Painter of Modern Life and Other Essays*, trans. and ed. Jonathan Mayne (New York: Da Capo Press, 1964), 1–40, and Georg Simmel, "The Metropolis and Mental Life" (1903), reprinted in *The Sociology of Georg Simmel*, ed. Kurt H. Wolff (New York: Free Press, 1964), 409–24.

18. See the *Graphic*, 5 Sept. 1874; "The Pavement Artist," *Young Folks Paper*, 14 Sept. 1889; "Round the Studios," *Funny Folks*, 1 April 1893; *Hearth and Home*, 21 Oct. 1897; Cook, *Highways and Byways*, 249.

19. See "A Lady Pavement Artist," in *Living London: Its Work and Its Play, Its Humour and Its Pathos, Its Sights and Its Scenes*, ed. George R. Sims, vol. 1 (London: Cassell and Co., 1901), 121.

20. Susan Buck-Morss, "The *Flâneur*, the Sandwichman and the Whore: The Politics of Loitering," *New German Critique* 39 (Autumn 1986): 99–140. See also Walter Benjamin, *The Arcades Project*, ed. Rolf Tiedemann, trans. Howard Eiland and Kevin McLaughlin (Cambridge, Mass., and London: Belknap Press / Harvard Univ. Press, 1999).

21. Buck-Morss, "*Flâneur*, the Sandwichman and the Whore," 136.

22. Arthur Morrison, "Loafing London," in Sims, *Living London*, 1:357.

23. Morrison, "Loafing London," 361.

24. Morrison, "Loafing London," 362.

25. George R. Sims, "London Street Corners," in *Living London: Its Work and Its Play, Its Humour and Its Pathos, Its Sights and Its Scenes*, ed. George R. Sims, vol. 2 (London: Cassell and Co., 1902), 87.

26. William Nicholson, *The Conder Room*, oil on canvas (1910), 36 x 28 in. (91.4 x 71.1 cm). With Agnew's.

SETTING

The Conder Room

Imogen Hart

THE CONDER ROOM is an unsettling picture (see fig. 26). Its first challenge arises as soon as we seek to establish whose reflection appears in the glass covering the painting that is depicted in the center of the image. If we try to see it as a reflection of Pickford Waller, who is seated in the foreground, we discover that the shape of his head differs from that of the reflected head, while the long, slender neck in the reflection hardly matches Waller's collared throat and lowered chin. This observation might lead us to consider the standing woman—Pickford's daughter, Sybil Waller—as the reflected figure. Yet while the line of the figure's neck looks more comparable to Sybil's, the two seem to face in opposite directions, and the reflected figure appears to be seated.

This raises the double question of who else the reflection might correspond to and where that person might be positioned. The third obvious candidate is the artist himself, especially since William Nicholson incorporates a self-portrait into some of his other paintings. If, however, we consider one such painting from the same year, *A Young Nobleman Surveys the City*, we see that the two reflections are comparable neither formally nor spatially. The *Young Nobleman* reflection is clearly male, with a visible white collar and cropped hair, whereas the *Conder Room* reflection's gender is more ambiguous. Meanwhile, the glass in the *Young Nobleman* is parallel to the picture's surface, and thus appears to reflect back the image of the viewer's (and the artist's) space. In contrast, the glass in *The Conder Room* is set at an oblique angle relative to the picture's surface, so that it is unclear whether, and how, it would reflect objects in our space. This also seems to rule out the possibility that the reflection, in its vagueness, corresponds to the viewer. The spatial logic of the image, insofar as we can identify one, suggests that the reflected figure is positioned beyond the left boundary of the picture, since the glass faces in that direction. That is also where the light originates, and the figure—appearing as it does in silhouette—seems to be positioned between the light and the reflective glass, perhaps in a window seat.

If so, the figure's identity remains a mystery. We might speculate that this is Waller's wife, who is otherwise conspicuously absent from this father-and-daughter

27. Edouard Manet, *A Bar at the Folies-Bergère*, oil on canvas (1882), 37⅞ x 51¼ in. (96 x 130 cm). The Courtauld Gallery, London.

portrait. In this case the image has the potential to become a "problem picture," since restricting the presence of the lady of the house to nothing but a reflection raises questions of domestic intrigue.[1] Yet Nicholson has made it impossible for us to resolve such speculations. The picture seems to be arranged so that we cannot fully explain the reflection. This calls to mind Edouard Manet's *A Bar at the Folies-Bergère* (1882; fig. 27), whose famously illogical reflections have been the subject of endless analysis.[2]

The comparison with the Manet painting draws our attention to another ambiguity in the Nicholson. One of the key questions raised in the *Bar*, thanks to the disconcerting reflection, is the nature of the relationship between the barmaid and the reflected man.[3] Once we start scrutinizing the spatial arrangement of *The Conder Room*—thanks, again, to the puzzling reflection—we realize that the relationship between Pickford and Sybil is represented rather curiously. They seem strangely distant from each other, even though their proportional scale suggests they are close together. Compositionally, father and daughter are at odds: neither seems aware of the other, and their attention is focused in opposite directions. Indeed, the stretched skin on Sybil's neck and the folds on Pickford's imply that each is straining to avoid looking at the other.

A comparison with another Nicholson portrait, *The Earl of Plymouth and Family* (1908; fig. 28), emphasizes the sense of separation in *The Conder Room*. Here, the man of the house is once again in the foreground, looking out, while his female kin are further embedded in the domestic space. Yet at least one male family member is recessed even further into the interior, and all the figures confront the viewer's gaze, which brings them together as a group. In contrast, Pickford and Sybil seem almost to belong to different compositions, as though a painting of Pickford on his seat has been appended to a picture of Sybil in the Conder room.[4] This impression is intensified by the way the viewer is positioned. We could almost fall over Pickford's seat, which forces its way into our space, making the painting's lower left-hand corner feel cramped. Yet when we look at Sybil's portion of the painting, our viewing position changes and we appear to observe her from a privileged distance.[5] Though small, the patch of carpet in between the figures works to separate Pickford's outward-reaching impact—chair, elbow, and gaze—from our encounter with Sybil. We can contemplate her unself-consciously because nothing from her space seems to share ours.

We could assign this compositional disparity to a mistake on Nicholson's part. Such an approach would be consistent with Sybil Waller's view. She wrote that the picture was "not such a complete success as most of his previous work," attributing the aberration to a six-month hiatus in the painting's manufacture while Nicholson suffered a "nervous breakdown."[6] Other contemporaries seem to have been

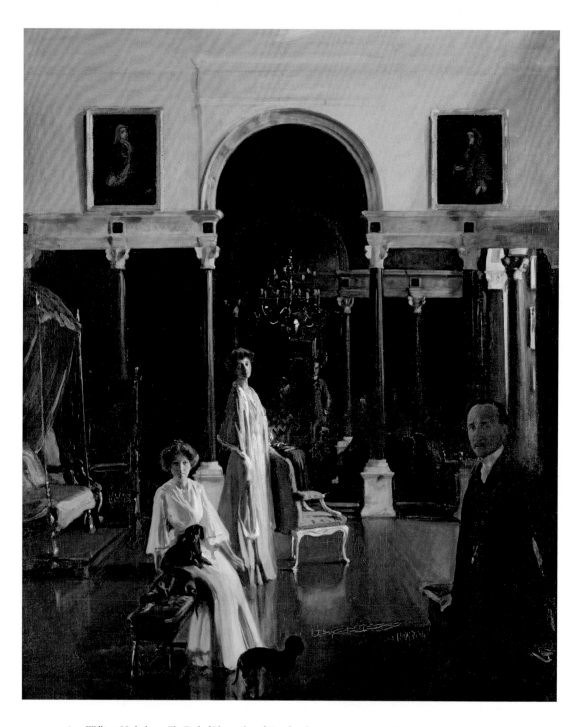

28. William Nicholson, *The Earl of Plymouth and Family*, oil on canvas (1908), 59⅛ x 49 in. (150 x 124.5 cm). Private collection.

similarly disappointed by the picture. One anonymous reviewer remarked, "*The Conder Room* of Mr. Nicholson hardly established a place for him in this show such as he has normally held."[7]

It is possible that the ambiguities in *The Conder Room* stem from errors of judgment. Yet Manet's *Bar* famously received similar criticism from those who saw its puzzling composition as evidence of painterly incompetence, and we have learned to approach such views skeptically.[8] There is an argument for treating Nicholson differently, however. Most accounts insist that the artist detested verbal analysis of his works, that "theorizing was alien to him," and, in the words of his son Ben Nicholson, that he *"merely wanted to paint"* (italics Nicholson's).[9] Some recent scholars have challenged this assumption that discursive analysis of Nicholson's images inherently misunderstands their context.[10] Nevertheless, the caution against verbalizing around Nicholson's paintings is still a potent one.

London in 1910 is famous for Virginia Woolf, Post-Impressionism, and the introduction of "modern" European art to a British audience. Manet's *Bar*, which was displayed at Roger Fry's 1910 exhibition, *Manet and the Post-Impressionists*, is part of that story, whereas *The Conder Room* is not.[11] The modernist trajectory's bias toward a certain type of "avant-garde" European art may persuade us that looking for meaning in *The Conder Room*'s compositional confusion is inappropriate, whereas doing the same thing with Manet's *Bar* is consistent with that artist's habit of crafting deceptive visual jokes.[12] By challenging this prejudice, we may expand the interpretive possibilities of an encounter with *The Conder Room*. As Sanford Schwartz has observed, Nicholson's relish for painting includes a fondness for visual tricks.[13] It would not, therefore, be inconsistent of him to have developed a disconcerting composition for *The Conder Room*.

With this in mind, let us return to the two questions I have raised. Why are father and daughter so distinctly separate, and what is the meaning of the reflection? We may get further with these questions if we consider the painting's title. *The Conder Room* is less a portrait than a picture about the experience of being in the Conder room. The large silk Charles Conder painting in the picture, in whose protective glass the reflection is visible, is known as *A Decoration* (fig. 29). It is a good example of the type of painting in which, according to John Rothenstein, "Conder created an Arcadia peopled by dreamy, capricious figures who lead lives of luxurious idleness."[14] *A Decoration* depicts an entirely female world suspended in space, a world protected from the reality of industrialized and modernized London—except, perhaps, for the outfits. Rothenstein goes on to claim that "so highly civilized were the English ruling classes, and so seemingly secure in the possession of fabulous wealth and power, that such an Arcadia seemed almost within their grasp."[15]

29. Charles Conder, *A Decoration*, watercolor on silk (1894–1904), 88¼ x 50 in. (224 x 127 cm). National Gallery of Australia, Canberra.

30. James Abbott McNeill Whistler, *Symphony in White, No. 2: The Little White Girl*, oil on canvas (1864), 30⅛ x 20⅛ in. (76.5 x 51.1 cm). Tate, London.

Its depiction of a room full of Conder pictures, particularly *A Decoration*, may be the key to *The Conder Room*. We are distanced from Sybil's world, which could almost be the "Arcadia" Rothenstein identifies with Conder's world. Sybil's gaze is hard to read: she seems to look neither down at the terrier nor far enough to the right to contemplate the reflection of the mysterious figure or herself. Her gaze is introspective in a more complete sense than that of the figure in James Abbott McNeill Whistler's *Symphony in White, No. 2: The Little White Girl* (1864; fig. 30),

whose apparent reverie is in fact made relatively legible by her expressive reflection, and by the accompanying narrative of Algernon Swinburne's poem.[16] Such clues are absent from *The Conder Room*. Sybil is unfathomable, like Manet's barmaid with her famously unreadable expression.[17] In her unself-conscious demeanor, her idle patting of the terrier, and her luxurious outfit, Sybil could be the counterpart of one of Conder's figures.

If Sybil is part of that dreamy world evoked in *A Decoration*, Pickford is not— or he is not quite. Abutting the picture plane, he is on the boundary with the real world, and his attention could be on that world. Yet he is still less self-conscious than the head of the family in *The Earl of Plymouth*.[18] Like Sybil he refuses to look directly at the viewer. We feel that he could lose himself in the "luxurious idleness" of Edwardian privilege if he wanted to.

All this is complicated, finally, by the reflection. *The Conder Room* differs crucially from Manet's *Bar* in that the reflection is superimposed on a painting, rather than appearing in a mirror. Via the reflection, *A Decoration* declares itself as an object. It is not an Arcadia, or an alternative reality; it is a painting, covered in prosaic glass, so that, far from drawing the viewer into its illusory dreamland, the image is partly obscured by reflections. Sybil is not capable of entering into that land. The joke is that the reflected figure does, at first glance, become one with the Arcadian space; yet, in doing so, the reflection proves that such a thing is impossible. The glass brings *A Decoration*'s viewer back down to earth. *The Conder Room* thus plays with the idea of the Edwardians as, on the one hand, having access to a "luxurious" "Arcadia" while, on the other, negotiating the uncompromising reality of material, and modern, existence.

1. See Pamela M. Fletcher, *Narrating Modernity: The British Problem Picture, 1895–1914* (Aldershot, UK: Ashgate, 2003).

2. See Novelene Ross, *Manet's Bar at the Folies-Bergère and the Myths of Popular Illustration* (Ann Arbor, Mich.: UMI Research Press, 1982), and Bradford R. Collins, ed., *Twelve Views of Manet's Bar* (Princeton, N.J.: Princeton Univ. Press, 1996).

3. See Carol Armstrong, "Counter, Mirror, Maid: Some Infra-thin Notes on *A Bar at the Folies-Bergère*," in Collins, *Twelve Views*, 25–46, esp. 33, 37, and Griselda Pollock, "The 'View from Elsewhere': Extracts from a Semi-Public Correspondence about the Visibility of Desire," in Collins, *Twelve Views*, 278–313, esp. 282–83.

4. For *The Earl of Plymouth and Family*, see Sanford Schwartz, *William Nicholson* (New Haven and London: Yale Univ. Press, 2004), 87–88.

5. See Schwartz, *William Nicholson*, 102, 165, and Sanford Schwartz, "The Speck in the Distance, or Rethinking William Nicholson," in *The Art of William Nicholson*, by Colin Campbell and others (London: Royal Academy of Arts, 2004), 13–19, esp. 13, 14.

6. Sybil Waller's "unpublished memoirs," cited in *William Nicholson Painter: Paintings, Woodcuts, Writings, Photographs*, ed. Andrew Nicholson (London: Giles de la Mare, 1996), 106.

7. "The International Society's Tenth Exhibition," *Studio* 50 (1910): 24.

8. See T. J. Clark, *The Painting of Modern Life: Paris in the Art of Manet and His Followers* (Princeton, N.J: Princeton Univ. Press, 1986), 240–43.

9. A. Nicholson, *William Nicholson Painter*, 12; Lillian Browse, *William Nicholson* (London: Rupert Hart-Davis, 1956), 27; and Ben Nicholson, quoted in Schwartz, *William Nicholson*, 220; see also Robert Nichols, *William Nicholson* (Harmondsworth, UK: Penguin Books, 1948), 8–9.

10. See Schwartz, *William Nicholson*, and Merlin James, "Words about Painting," in Campbell, *Art of William Nicholson*, 21–33.

11. Peter Stansky, *On or About December 1910: Early Bloomsbury and Its Intimate World* (Cambridge, Mass.: Harvard Univ. Press, 1996), esp. 194–95.

12. See Browse, *William Nicholson*, 27, and Schwartz, *William Nicholson*, 93.

13. See Schwartz, *William Nicholson*, 161.

14. John Rothenstein, *The Life and Death of Conder* (New York: E. P. Dutton & Co., 1938), xiv.

15. Rothenstein, *Life and Death of Conder*, xiv.

16. See David Park Curry, *James McNeill Whistler: Uneasy Pieces* (Richmond: Virginia Museum of Fine Arts and Quantuck Lane Press, 2004), 196, 314–15.

17. See Ross, *Manet's Bar*, 2, 10, 85; Clark, *Painting of Modern Life*, 250–51; Armstrong, "Counter, Mirror, Maid," 40–41; and Pollock, "'View from Elsewhere,'" 282–83, 302–3.

18. See Schwartz, *William Nicholson*, 88.

The Conder Room: Evidencing the Interior's Dissolution

Barbara Penner and Charles Rice

WILLIAM NICHOLSON'S 1910 PAINTING *The Conder Room* (see fig. 26) exhibits a compelling strangeness. The painting is a hybrid of two genres— the interior view and the portrait—and these appear to be in tension. On the one hand, there is the room decorated with the artist Charles Conder's work, the centerpiece being his large watercolor on silk, entitled *A Decoration* (ca. 1904; see fig. 29). On the other hand, there is the collector of Conder's work, Pickford Waller, depicted, with his daughter, Sybil, before *A Decoration*.[1] The occupants seem uneasy in the setting the room provides. Decorated room, painting, and subjective experience do not cohere.

We have a specific interest in investigating this work. Many architectural historians use portraits of families "at home" as evidence of the domestic interior and its inhabitation (figs. 31 and 32). This move is usually authorized by the belief that works such as *The Conder Room* establish a direct and visible correspondence between subjects and their interiors; when sitters are represented inhabiting their own space (as opposed to the artist's studio), it is expected that something fundamentally truthful about their psychology, character, and taste will be revealed. Yet, we will argue, portraits and interior views rarely furnish evidence of inhabitation in this straightforward way. Indeed, *The Conder Room* testifies to the perils of such an approach. It tells precisely of the failure of the interior and its decorations to reflect character transparently or to tell a life story.[2]

This failure is conveyed through several surprising features of the work, which, together, confound our expectations of a typical "at home" portrait. For instance, given that a choice was made to site the portrait in the Conder room (a choice explicitly flagged by the picture's title), we might reasonably expect Conder's work to feature in the painting. Instead, we find that it has been effaced. A reflection in the glass frame erases the detail of *A Decoration*; there is some sense of the effect of its colors, but nothing of the subject matter, which has been described as "a painted summary of a summer's day."[3] Nicholson apparently had no desire to record the interior's decoration. Instead, he used *A Decoration* to capture the

31. Ernest Gall, "Robert and Joanna Barr Smith at Auchendarroch, Mount Barker, Adelaide Hills" (1897). State Library of South Australia.

spatiality of the room beyond the field of view implied by his canvas. The glass frame of *A Decoration* turns the work into a reflecting screen that makes present the window illuminating the room. This reflection allows Nicholson to attempt to paint the space of the room, rather than simply a corner of it.

To some extent, these spatial games are what we would expect from Nicholson in this period. The art historian Sanford Schwartz has emphasized that, at this time, influenced by the contemporary portrait painter William Orpen and old masters such as Diego Velázquez, Nicholson was preoccupied with reflectivity and with trompe l'oeil visual games that confuse the relationship between foreground and background.[4] Yet another potential influence might be considered. In *The Conder Room*, the carefully constructed angle of view bears a resemblance to photographically constructed interiors popular at about the time Nicholson was painting, such as those produced by the prolific H. Bedford Lemere in England (figs. 33 and 34).[5] Photographic views would often try to maximize available reflections in a room so as to depict spatial

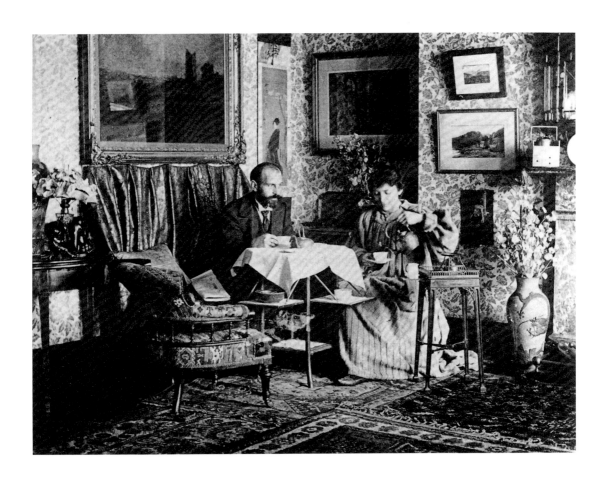

32. "Hermann and Anna Muthesius at the Priory, Hammersmith" (1896). Collection of Eckart Muthesius.

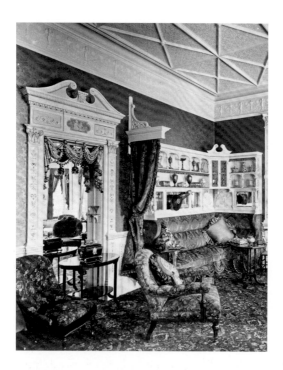

33. H. Bedford Lemere,
"The Drawing Room, 118
Mount St., London" (detail)
(1894). English Heritage,
National Monuments Record.

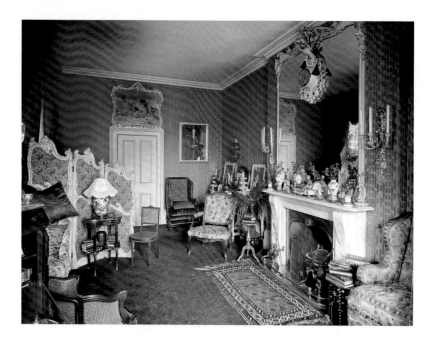

34. H. Bedford Lemere, "The Boudoir, 3 West Halkin St., London" (1891). English Heritage,
National Monuments Record.

extent more fully, while avoiding the inclusion of windows within the frame. In a photographic sense, *A Decoration* serves to reflect but also dampen the direct light coming through the window, allowing an even "exposure" across the entire canvas.

Nonetheless, it is clear that Nicholson's motive in extending our view into the room is not purely technical. At the left-hand edge of *A Decoration*, it is possible to see the silhouette of a figure, perhaps a young woman, who is seated in front of the window, gazing into the room. Her presence has the curious effect of stabilizing the composition at the same time as it enhances its narrative tension. It stabilizes the composition through a complex act of triangulation: our ghostly figure's pose echoes Pickford Waller's and gives Sybil Waller's gaze a potential focus. Yet even as it sets up this formal connection across the threshold of visible and reflected space, it underscores the bizarre nature of the scene. Pickford and Sybil pose with almost theatrical rigidity. While Nicholson generally preferred depicting his sitters in profile, here their necks seem unnaturally contorted by the effort not to look at each other or at the decorative work that gives the painting its name.

With its effacements and disjunctions, the scene in *The Conder Room* contradicts contemporary notions of how interiors ought to be experienced. Conder himself was present at the "birth" of Art Nouveau as a distinct style, having been commissioned by Siegfried Bing to decorate a boudoir in Bing's Paris exhibition of 1895 at La Maison de l'Art Nouveau. His decorations on silk, of the type that Waller would later collect, did not arouse a great deal of interest at the time of the exhibition, nor did they sell. In 1904, however, he received a significant commission for the decoration of a room in the Holland Park house of the Australian-born industrialist Edmund Davis.[6] In the course of discussing Conder's project for Davis in the *Studio*, T. Martin Wood articulated how decoration should ideally affect its inhabitants:

> Mr. Conder's work decorates in the highest sense of the term. By his panels the eye is engaged, the intelligence aroused, but only to a point; a story is told, a drama is enacted in them which is never finished. There is a purpose about the actions of the figures which evades us, an anecdote in each of the panels that escapes us, and this elusiveness gives us rest—the restfulness which is to be demanded of perfect decoration.[7]

But Nicholson's *The Conder Room* does not depict the "restfulness" that unified decoration should call forth. Instead, through the acute, if unspecific, sense of drama unfolding in the room, the painting tells a very different and decidedly less restful story about the effect of Conder's decoration. In this context it is useful to recall a critique of Art Nouveau and Jugendstil made by the Viennese architect Adolf Loos. In 1900 he published a satirical article entitled "The Poor Little Rich

Man," in which he described how a rich man commissions a fashionable architect to create an entire "artistic life" for himself through a unified interior decorative scheme. Upon its completion, however, the man feels immediately constricted by the totality of the scheme. On the occasion of the man's birthday, his family gives him gifts, and the man seeks the advice of the architect on how they should be placed appropriately in the interior. The architect becomes irate, suggesting that the man should not accept such "traces" because he has been "completed" by the architect's artistic vision. The man realizes he is no longer able to have a developing relation to the world of things, or indeed to his family.[8]

Walter Benjamin has described this moment of constriction as the "liquidation" of the interior, as well as its simultaneous "consummation" and "shattering."[9] Through the nineteenth century, the interior had increasingly become the privileged site for the formation of the bourgeoisie's identity; this relationship was mediated through objects that left a trace in the interior. When Art Nouveau and Jugendstil emerged to take hold of the design of the interior in the name of ensuring a "proper," "artistic" life, the interior in Benjamin's account became a space of a tyranny that left its own mark on the inhabitants. Far from acting as a container of subjectivity in a Bachelardian sense, something that gathers and shelters its occupants, the interior ends by denying them such comfort.

Where do these speculations leave us in terms of the matter of evidence initially posed at the beginning of this essay? As we have seen, *The Conder Room* is not a faithful depiction of Conder's work, nor does it depict the sort of inhabitation Waller might have thought ideal. This illuminates the dangers of treating such representations as if they are transparent windows onto ways of living in times past, a tendency that still dominates in writings about the interior.[10] Yet we would maintain that the painting *is* testimony of a certain sort. Rather than using the backdrop to convey the characters of his sitters, Nicholson's interior portrait depicts how subjectivity and the interior can come apart, highlighting potential incongruities in the relationship between self-identity, the interior, and its decoration. The elusiveness of the *Conder Room* painting also allows us to glimpse a broader paradox that characterizes Edwardian interiors and spatial relations generally. Even as the Art Nouveau or Aesthetic interior was being affirmed through portraiture and photography as one of the most privileged and stable signifiers of bourgeois identity and taste, it was also becoming a contested representational field, shaped by occupants, decorators, artists, and their representations without cohering into the stable referent of any. Rather than a portrait of the bourgeois interior's triumph, *The Conder Room* testifies to its dissolution. In the end the painting remains a mystery, but an undeniably productive one for working through the complexities of Edwardians' relationships to their interiors and their subsequent interpretations.

1. Anne Gray, *The Edwardians: Secrets and Desires*, exh. cat. (National Gallery of Australia, Canberra, 2004), 156.

2. For this approach to considering representations of the interior, see Barbara Penner and Charles Rice, eds., "Constructing the Interior," special issue, *Journal of Architecture* 12, no. 4 (2004), and Charles Rice, *The Emergence of the Interior: Architecture, Modernity, Domesticity* (London: Routledge, 2007). For questions of the art historical interpretation of paintings of interiors, see Susan Sidlauskas, *Body, Place and Self in Nineteenth-Century Painting* (Cambridge: Cambridge Univ. Press, 2000).

3. Gray, *Edwardians*, 156.

4. Schwartz devoted two chapters to this theme in his monograph on Nicholson. Sanford Schwartz, *William Nicholson* (New Haven and London: Yale Univ. Press, 2004), 92–108, 149–67.

5. See especially the work of H. Bedford Lemere in Nicholas Cooper, *The Opulent Eye: Late Victorian and Edwardian Taste in Interior Design* (London: Architectural Press, 1976).

6. Ann Galbally and Barry Pearce, *Charles Conder*, exh. cat. (Art Gallery of New South Wales, Sydney, 2003), 139–40. It is important to note that Davis's Conder room was an "all of a piece" commission, the framing of the painted silk decorations being held within the satin wood veneer surfacing the walls of the room. Waller's Conder room was created through Waller's own collection of Conder's works. Davis's room thus conforms more strongly to the Art Nouveau ideal that nothing could be added to or taken away from a decorative scheme that was total.

7. T. Martin Wood, "A Room Decorated by Charles Conder," *Studio* 34 (1905): 205. Wood does not use labels such as Art Nouveau, Jugendstil, or Aesthetic; he writes in more general terms about decoration as "art," approximating the "age of Watteau."

8. Adolf Loos, "The Poor Little Rich Man," in *Spoken into the Void: Collected Essays 1897–1900*, trans. Jane O. Newman and John H. Smith (Cambridge, Mass.: MIT Press, 1982), 125–27.

9. Walter Benjamin, *The Arcades Project*, ed. Rolf Tiedemann, trans. Howard Eiland and Kevin McLaughlin (Cambridge, Mass., and London: Belknap Press / Harvard Univ. Press, 1999), 9, 20.

10. Although methodologies from a range of disciplines that study the visual representation of the interior have developed in more critical ways in recent years, the results have been inconsistent. Compendiums of such work still consider the interior to be a stable idea existing over a long historical period. See, for example, Jeremy Aynsley and Charlotte Grant, eds., *Imagined Interiors: Representing the Domestic Interior Since the Renaissance* (London: V&A Publications, 2006).

A Room with a View: William Nicholson's
The Conder Room

Michael Hatt

IN E. M. FORSTER'S 1908 NOVEL, *A Room with a View*, the complex social comedy of class and sex is set in motion when the heroine, Lucy Honeychurch, and her chaperone, Miss Bartlett, take over the rooms of Mr. Emerson and his son George in the Pensione Bertolini. As she examines her new accommodation, Miss Bartlett closes the shutters and sees, "pinned up over the wash-stand, a sheet of paper on which was scrawled an enormous note of interrogation."[1] The question mark stuck to the wall has an unpleasant effect on Miss Bartlett: she finds it "menacing, obnoxious," and her instinct is to destroy it, although, in a typical instance of forensic Forsterian insight, she remembers that it belongs to the young man and so carefully unpins and stores the sheet of paper. In William Nicholson's painting *The Conder Room* (see fig. 26), created two years after the publication of Forster's novel, a large decorative panel on the wall performs an analogous function. While it may not share the explicitly and brutally existential significance of George Emerson's question mark—we learn later that he is pondering whether he should live or die—it intends a similarly interrogative mood that extends across the fictive space of the painting and into that of the viewer. I want to suggest that Nicholson's painting is a complement to Forster's comedy: both novel and painting ask what it is to become an Edwardian, with comic and melancholy answers, removing or retaining the mark of interrogation.

The Conder Room shows Pickford Waller and his daughter, Sybil, in the drawing room of their house at 27 St. George's Road, Pimlico. The room is so named on account of the large decorative panel by Charles Conder, a painting on silk entitled *A Decoration* (see fig. 29), which dominates the scene. Waller, the principal figure in the portrait, and a patron of both Nicholson and Conder, was a successful businessman. The success of his father's building firm, R. & J. Waller, allowed him to develop an interest in art. Waller became not only a collector of James Abbott McNeill Whistler, Charles Hazelwood Shannon, and Conder, but also a member of their circles, and his Pimlico home revealed an orthodox but sophisticated aestheticist taste. Here in the drawing room, Conder's decoration is juxtaposed with Japanese

prints and fans, while the dining room at 27 St. George's Road included the ubiquitous William Morris wallpaper and Waller's collection of blue and white china.

The Conder Room reveals not only aesthetic but also social aspirations. Waller's choice of Conder was preceded, and most probably provoked, by a famous room that Conder had decorated for the South African mining magnate Edmund Davis in 1904.[2] Davis was also in the circle of Charles Ricketts—indeed, it was he who introduced Waller to Shannon—and it was through this network that Davis met Conder and became an enthusiastic collector of his fans and silk paintings. In the late 1890s, Davis built an Arts and Crafts home in the Holland Park area of London, largely to house his art collection. For the drawing room, Davis commissioned ten large grisailles from Conder, watercolors on silk, in the artist's characteristic ancien régime manner. An account of the room in the *Studio* in April 1905 saw the decorative scheme as compromised: the proportions of the room and its wood paneling were at odds with Conder's painting and thus failed to provide a coherent interior.[3]

Waller's Conder room was a deal less extravagant, but it represented similar ambitions and similar incoherence. Conder deploys a decisively Rococo palette in *A Decoration*, painted in pinks, beige, and orange-browns, with areas of blue and lilac. The use of silk is similarly resonant of late-eighteenth-century luxury, not only in the image but with the object itself representing the fabrics and textures of a *fête champêtre* by Antoine Watteau or Jean-Baptiste-Joseph Pater. The image is of four women in an enclosed garden, and within that scene is an oval medallion in which a second scene is portrayed, this one of three figures, closer to the viewer and in front of a Renaissance-style townscape. We are in mythological Cythera, but a polite Cythera complete with latticed fencing and careful planting. One might make a comparison with Edward Burne-Jones's scenes of medieval fantasy in terms of the setting, the compositions, and the dreamy atmosphere; however, Conder is self-consciously avoiding the seriousness of Burne-Jones. *A Decoration* aims to be as purely decorative as possible, and the format, complete with swags and bows, challenges the viewer to find anything more than pleasure.

Nicholson was aware of the ironies generated between Conder's painting and his own. He did all he could to disrupt the relationship between room and view, as well as to create an awkwardness similar to that perceived by the critic of Davis's drawing room: the mismatch between room and view, between the dream of stepping back into the eighteenth century and the uncooperative reality of the present. The figures in the room are stiff, socially and physically, whereas the women in Conder's panel are as relaxed as can be. While the easy, elegant poses of the women are hard to see in Nicholson's transcription, they are figured by the Baroque curves, the motile lines, captured by his brush. Similarly, the proximity of the figures in the silk panel, the sense of touch as body reclines against body, or as silk and flesh

brush against each other, is so very different from the sense of distance between Waller and Sybil. Nicholson emphasized this difference yet further by technical means: the dry surface of his painting is the antithesis of Conder's thin and fluid washes. Nicholson used powdery scumbling and heavily loaded brushstrokes to give a sense of materiality, even to shadows and space. In every way, Nicholson attempted to counter the style and significance of the Conder painting, to create a visible distance between what we might dream and what we experience, between promises held out by imagination and the failure of reality to deliver on those promises. All that is most characteristic of the Conder panel is obliterated by Nicholson. It is, indeed, a melancholy complement to Forster's comedy.

There is, as a consequence, an undeniable strangeness to the picture. The space itself, so beautifully analyzed by the other essays in this volume, appears both crowded and empty. While the arrangement of objects and bodies seems a poor fit in the strange dimensions and plan of the room, there is a curious lacuna created by the height of the room, the angle of viewing, and the reflection of further space in the glass surface of the Conder panel. There is no real sense of how the Pickford Wallers occupy this world, in either literal or metaphoric terms. More than space, though, the use of light and shadow represents the mismatch between fantasy and reality, between the view into the imagination and the room itself, insistently in the present. This is characteristic of Nicholson's work, with extremes of reflected light and impenetrable shadow in his still lifes, for instance, often providing the same interrogative strangeness. Waller's face is in shadow, and the light on the back of his head reveals his white hair and baldness. Sybil both turns into shadow and casts a bizarre shadow herself. Her shadow, like that of the cabinet at the far left of the canvas, stains the wall, a further mark of interrogation in the tense juxtaposition of decorative panel and the stilted half-light of the drawing room. This use of shadow draws our attention to the fact that *The Conder Room* is a painting in which everyone turns away: Sybil turns her head; the dancer in the Japanese print echoes the gesture; Waller himself turns. Nicholson's characteristic mode of quiet irony is in force here: the painting resembles a conversation piece, and yet the silent atmosphere is the very opposite of the sociability prescribed by the conversation piece. Sybil, ignoring both the outside and the fantasy image, engages with the family dog, a Forsterian touch in the way that the possibilities of the world and of the imagination are displaced by banality. As for Waller, he is waiting for something, the body tense, pulling away from the back of the chair. Again, Nicholson presents him as the very opposite of the reclining, easeful bodies of the women in *A Decoration*. Just as the painting shows a conversation piece that fails to converse, so Nicholson's framing of the Conder is such that the aspiration to Edwardian splendor and glamour, to neo-Rococo bliss, is dulled and barred.

The light is equally disruptive. Bright sunlight streaming in from the window hits the glazed surface of the Conder panel, which becomes a glassy screen in which we see a reflection of the room, the fireplace, and a seated figure (and it is uncertain whether this is Waller himself or a third figure). This area of reflection forms a barrier, becoming nearly tangible given Nicholson's use of paint with a texture almost of scumbling. This is the fulcrum of the painting, a non-form where two worlds collide: the world of the room and London beyond, and the fantasy world of Conder's painting. At the surface, on the picture plane, they are confused, one reflected in the other, each obscured by the other. In *The Conder Room*, the silk panel is denied to the viewer as a route to a fantasy world; the surface becomes an impenetrable barrier, its glazing no longer something through which the eye, and hence the imagination, might travel. Transparency is turned into opaque reflection, ruthlessly returning us to the awkward disposition of bodies in the drawing room and its curious spatial character. It is as if the silk painting, promising the possibility of an aesthetic escape, is drowned out by the noise of the world.

If we wish to search for something distinctively Edwardian in Nicholson's painting, something more than the mere date of its production, a return to the analogy with Forster's comedy may help us. *A Room with a View* and *The Conder Room* are both about rooms and both about views. In the novel Lucy Honeychurch's liberation is symbolized by the shift from a search for the prescribed view to an understanding that there are other, unknown views offering greater possibility. Thus, she begins with the tourist view from a *pensione* window, the view as instructed by a guidebook, whether John Ruskin or Karl Baedeker, or the authorized view seen in a photograph; however, when she and her party travel up into the hills around Fiesole to see Florence as painted by Baldovinetti, she ends up witnessing something quite different and experiences an alternative way of living her life, flying in the face of convention, albeit unexpectedly. Back in Sussex she starts to find more in the view over The Weald, learning that the unauthorized view may offer something that the prescribed one cannot.

This is not a question of a choice between life and art, between experience and escape, but a choice about how one brings them together: Forster contrasts a modern understanding of life and art as mutually enriching with nineteenth-century norms that set the two in opposition. This is symptomatic of Edwardian mythmaking. No sooner was Queen Victoria dead than this mythmaking began, as J. B. Priestley pointed out in his marvelous account of the Edwardians.[4] While Priestley's concern was high society, a similar process took place elsewhere on the social ladder, a process of caricaturing Victorian life, a bid to be decisively Edwardian that necessitated the reimagining of Victorian Britain as dour and repressive. In *The Soul of a Bishop*, H. G. Wells's doubting protagonist famously ponders that

Victoria's death has been understood as if "some compact and dignified paper-weight had been lifted from people's ideas, and at once they had begun to blow about anyhow."[5] (Nicholson's famous 1897 woodcut of Victoria, showing her as an immovably black and solid object, is a fine visual analogue to Wells's metaphor.)

Forster, too, invents both Victorian and Edwardian in his novel, casting them as stuffy and spirited, respectively, both in the narrative of *A Room with a View* (and one need only compare Lucy and Miss Bartlett) and through his style. His self-conscious and gently vicious adumbration of rooms and views, of class and sex, of folly and freedom, is evidence that he has also made himself into an Edwardian. It is a style in which ideas blow about, if not anyhow, then at least with controlled abandon. This proposed sense of freedom, of fluttering papers and new forms of self-narration, is quite at odds with Nicholson's portrait of the Wallers. While Lucy Honeychurch discovers how she might find a new view, the figures in *The Conder Room* remain caught between art and the open window. They do no more than turn away to the room itself, as if trapped in the space. There is no connection between the view into Rococo fantasy and the view into modern London, only incoherence where light hits glass and the transparent becomes the illegible. If Forster's comedy moves his characters from one point to another, Nicholson's painting represents an impasse. This is not to say that Forster reveals to us the Edwardians and Nicholson the remains of the Victorians. Rather, each offers representations of how people imagined themselves to be Edwardian, to narrate their own mythology, and how this process might succeed or be stalled.

Indeed, Nicholson's painting alerts us to the modern mythmaking that has long since become orthodoxy. Sybil Pickford Waller, later in life, remarked that this portrait of her family was more about Nicholson than about her family; the strangeness was projected onto the scene by the artist. There is no doubt that Nicholson's characteristic irony and melancholy inform the painting more than the taste of his patron. He transforms the Conder panel from escapist beauty to portentous mark of interrogation. While Forster's injunction was to "only connect the prose and the passion,"[6] in *The Conder Room* the prose of Pimlico and the passion of the Rococo imagination remain resolutely unconnected.

1. E. M. Forster, *A Room with a View* (Harmondsworth, UK: Penguin Books, 2000), 12.
2. For a fuller description of Davis's house, see Ann Galbally, *Charles Conder: The Last Bohemian* (Melbourne: Melbourne Univ. Press, 2002), 256–59. My comments are based on Galbally's very useful account.
3. T. Martin Wood, "A Room Decorated by Charles Conder," *Studio* 34 (1905).
4. J. B. Priestley, *The Edwardians* (Harmondsworth, UK: Penguin Books, 2000), 56.
5. H. G. Wells, *The Soul of a Bishop* (London: Cassell, 1917), 25.
6. E. M. Forster, *Howards End* (1910; repr., Harmondsworth, UK: Penguin Books, 2000), 188.

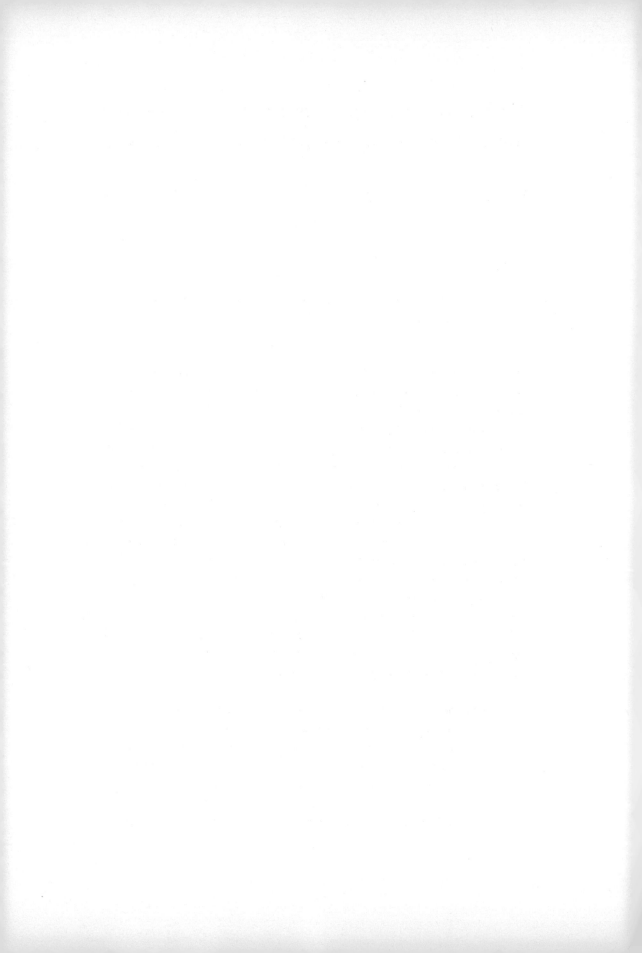

"At Home" at the St. James's: Dress, Decor, and the Problem of Fashion in Edwardian Theater

Christopher Breward

> Nice plays, with nice dresses, nice drawing rooms and nice people are indispensable; to be un-genteel is worse than to fail.
>
> —George Bernard Shaw

IN HIS PREFACE TO *Three Plays for Puritans* (1901), George Bernard Shaw deftly offered both a swift dismissal and a sharp acknowledgment of the rising status of what would become known as the "drawing-room drama" in Edwardian thought and experience. His crisp appraisal of this largely forgotten theatrical subgenre opens up a space for considering the simultaneous articulation of dress and the interior as a key relationship in the formation of a characteristically popular and "middlebrow" fashion culture in Britain, as well as their loaded representation on the early-twentieth-century London stage as a lens through which the fashionable sensibilities of Edwardian audiences might be further analyzed (figs. 35 and 36). For Shaw the lens was not a flattering one: in his work as a theater critic during the 1890s, he recorded a London stage "awash with sensuousness in the form of ritualised Shakespeare, sham Ibsen and voyeuristic musical farce."[1] This produced a flow of mediocre productions sustained by consumers who craved little more than vulgar spectacle, a hypocritical flattering of their own pretensions to good manners, and "substitute sex."[2] Like much commentary of the time, Shaw's characterization of the market may well have carried misogynistic and anti-Semitic overtones, but it hit the target with typical acuity:

> In the long lines of waiting playgoers lining the pavements outside our fashionable theatres every evening, the men are only the currants in the dumpling. Women are in the majority; and women and men alike belong to that least robust of all our social classes, the class which earns from eighteen to thirty shillings a week in sedentary employment, and lives in lonely lodgings or in drab homes with nagging relatives. These people preserve the innocence of the theatre: they have neither the philosopher's impatience to get

AFTER THE PLAY

" Did you enjoy the piece ? "
" No ; I couldn't see the stage for the coiffeur
of the lady in front of me ! "

13

35. John Hassall, *After the Play*, plate 13 from souvenir program,
Special Morning Performance in Aid of the Re-building Fund of Royal National
Orthopaedic Hospital (3 Dec. 1908). Theatre Collections, Victoria and
Albert Museum, London.

to realities (reality being the one thing they want to escape from), nor the
longing of the sportsman for violent action, nor the full-fed, experienced,
disillusioned sensuality of the rich man, whether he be gentleman or sport-
ing publican. They read a good deal, and are at home in the fool's paradise
of popular romance. They love the pretty man and the pretty woman, and
will have both of them fashionably dressed and exquisitely idle, posing against
backgrounds of drawing room and dainty garden; in love, but sentimentally,
romantically; always ladylike and gentlemanlike. Jejunely insipid all this, to
the stalls, which are paid for (when they are paid for) by people who have

36. "Miss Marion Terry as Lady Claude Derenham in Mollentrave on Women," from *Sketch*, supplement, 15 March 1905, 8. Courtesy of the Yale University Library.

their own dresses and drawing rooms, and know them to be a mere masquerade behind which there is nothing romantic, and little that is interesting to most of the masqueraders except the clandestine play of natural licentiousness. The stalls cannot be fully understood without taking into account the absence of the rich evangelical English merchant and his family, and the presence of the rich Jewish merchant and his family. . . . All that can be fairly said of the Jewish influence on the theatre is that it is exotic, and is not only a customer's influence but a financier's influence: so much so, that the way is smoothest for those plays and those performers that appeal specially to the Jewish taste. English influence on the theatre, as far as the stalls are concerned, does not exist, because the rich purchasing-powerful Englishman prefers politics and church-going: his soul is too stubborn to be purged by an avowed make-believe. When he wants sensuality he practices it: he does not play with voluptuous or romantic ideas. . . . He demands edification and will not pay for anything else in that arena. Consequently the box office will never become an English influence until the theatre turns from the drama of romance and sensuality to the drama of edification.[3]

The romance and sensuality of late Victorian and Edwardian popular theater have, of course, attracted significant attention from cultural historians in recent years; both the theater's role in promoting powerful versions of fashionable femininity, through the figure of the celebrity actress, and its links to the commodity culture of the department store and to the luxury trades of the West End have provided fertile ground for the arguments of Joel Kaplan and Sheila Stowell, Peter Bailey, and Erika Rappaport in particular.[4] But the focus here has tended to fall on the spectacular form of musical comedy, exemplified most vividly by the productions held at the Gaiety Theatre, off the Strand, under George Edwardes's management during the 1890s. These borrowed from the older theatrical traditions of pantomime, music hall, and burlesque, drawing on the fantastical, satirical, and sexualized appeal of each to create a new kind of performance premised on the idea that the glamour of contemporary metropolitan life constituted a fitting platform for escapism directed primarily at a huge and largely untapped lower-middle-class female audience. The incorporation of fashionable dressing into the dramatic scenario was an important element in the success of such plays, and when the Gaiety premiered its first example, *The Shop Girl*, in 1894, the press reaction certainly focused on its well-regulated but inconsequential modishness. Commenting on the character of the leading actress, the critic for the *Theatre* stated that "one is tempted to forget that she is anything more than a lay figure, intended for the exhibition of magnificent costumes. In this respect, however, she merely fulfils the

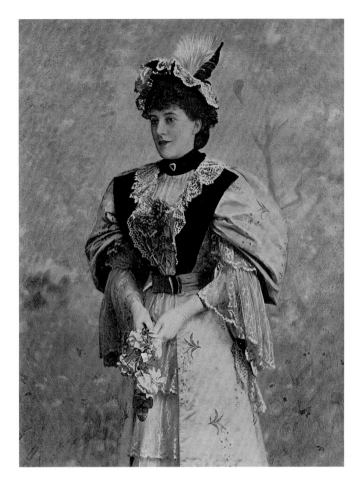

37. "Miss Maud Hobson" (ca. 1895). Collection of Christopher Breward.

law of her being."[5] An earlier Edwardes production, *In Town*, staged at the Prince of Wales Theatre in 1892, had set the precedent for a form of theater whose primary function was the promotion of contemporary trends through locating the action in the effervescent milieu of London's theater land. Its reviewer in the *Players* devoted a great deal of print to a description of the wardrobe (fig. 37):

> Some very, very smart frocks are worn by the "chorus ladies of the Ambiguity Theatre" in the first act, Miss Maud Hobson being well to the fore in the way of style and presence. Her dress . . . is quite of the smartest I have seen for some time. The skirt, which is made in a demi-train, lined underneath (and seen only when the wearer moved) with pale pink silk, was composed

of a beautiful shade of dove coloured silk—over this was worn a bodice of the richest purple velvet, designed in a new and very quaint manner. . . . The eyes of many of the female portion of the audience grew large with envy as they watched this creation . . . move about the stage.[6]

Significantly, the writer did not stop at a description of stage dress, but went on to note the mantle of a member of the audience "made of turquoise poult de soie, and lined all through with the same material in a most delicate peach colour." Such synergy was clearly novel, adding weight to the claims of another reviewer that the play "embodies the very essence of the times in which we live."[7]

And yet, this very celebration of contemporaneity—achieved largely through costume design and clever commercial tie-ins—also limited the comedies, leaving them open to charges of superficiality and manipulation that for the social historian Peter Bailey brackets them to those broader regimes of fin de siècle modernity that included the routines of the office and the factory production line, as well as the parade-ground drills and stock-market speculations of military and economic imperialism. The fashionable stage confection was then another regulatory device, controlling unruly desires and encouraging unthinking consumption among the widest possible audience—but also, as Bailey suggested, offering important psychological compensations; to borrow his words,

> within a generation . . . London women came to use the greater range of cheap consumer goods available in ways that not only followed the promptings of popular fashion and femininity but realised a more independent sense of self. Although a blithely manipulative mode, musical comedy may have stimulated such new imaginative gains for women in a more overtly sexualised identity that was no longer merely hostage to the designs of men.[8]

Bailey thus credited the musical comedy of the 1890s as an important conduit for the emergence of new, more assertive feminine subject positions, linked to the performative potential of consumer culture whose implications would become much more evident in the 1920s through the figure of the flapper. But in essence, although its appeal was undoubtedly formidable, we should not lose sight of the fact that the nature of the genre itself was fairly haphazard and unsophisticated— less a self-conscious attempt at theatrical innovation or social progressivism than a blatant case of managerial opportunism and creative prostitution. Aside from the gorgeous contemporary costumes, musical comedy was marked by predictably romantic and coy plotlines, stereotypical characterization, lushly sentimental but derivative scoring, and plenty of colorful, crowd-pleasing ensemble scenes; settings

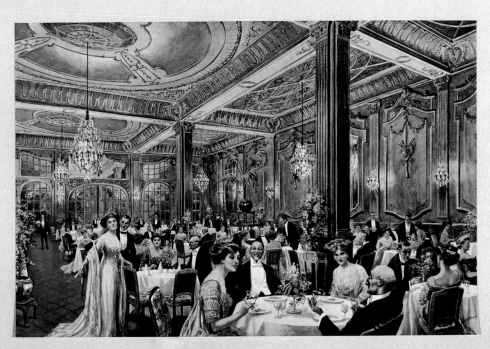

THE LOUIS XIV. RESTAURANT,
PICCADILLY HOTEL, REGENT STREET, LONDON.

38. *The Louis XIV Restaurant, Piccadilly Hotel, Regent Street, London*, plate 1 from souvenir program, *Special Morning Performance in Aid of the Re-building Fund of Royal National Orthopaedic Hospital* (3 Dec. 1908). Theatre Collections, Victoria and Albert Museum, London.

tended to a broad-brush and overblown approximation of the familiar haunts of the fashionable—ballrooms, park promenades, restaurants, and department stores—that would have served equally well as backdrops for the more louche vaudeville offerings of the Empire theater in Leicester Square (fig. 38). Henrik Ibsen it was not—and as Shaw pointedly noted:

> If I despised the musical farces, it was because they never had the courage of their vices. With all their laboured efforts to keep up an understanding of furtive naughtiness between the low comedian on stage and the drunken undergraduate in the stalls, they insisted all the time on their virtue and patriotism and loyalty as pitifully as a poor girl of the pavement will pretend to be a clergyman's daughter.[9]

Across town, on the edges of Green Park, the actor-manager George Alexander and his wife, Florence, were pioneering a parallel form of presentation whose carefully considered constitutive parts represent perhaps a more profound, or at least self-reflexive, commentary on the formations of fashionable taste in early-twentieth-century London (figs. 39 and 40). In their minutely observed studies of the genteel sensibility under stress, we may perhaps find fertile ground for tracing the manner in which stage representations of dress and the interior produced a powerful conception of metropolitan modernity that deserves closer scrutiny than the extant literature has so far provided.[10]

The St. James's Theatre, which became the epicenter of drawing-room drama following Alexander's appointment in 1891, had flourished as the West End's westernmost playhouse since its erection in 1835. Sandwiched between Pall Mall and St. James's Street on the south side of Piccadilly, its proximity to the Royal Household, to club land, and to the residences of the upper ten in Belgravia and Mayfair earned it an aristocratic reputation by association (fig. 41). Such associations were not lost on the new management, and although the theater had fallen out of fashionability for some years, Alexander pursued a policy of understated gentility that stood in vivid contrast to the overtly entrepreneurial approach of Edwardes and his peers in the commercial theaters of the Strand. His three key management principles stressed the promotion of British and colonial over foreign productions, well-balanced dramatic characterizations in preference to the reification of the celebrity actor, and the maintenance of "perfectly cogged and oiled wheels back and front of the curtain" to ensure maximum audience comfort. An overriding sense of decorum linked all three desiderata, and as the historian of the theater Barry Duncan has suggested, the organization behind the scenes stripped back the usual association of thespian affairs with bohemian chaos, opting instead for the polished efficiency of the modern hotel or luxury liner: "Back stage, carpets, mostly overlaid with white drugget, lined all corridors and departments. Stage-hands were attired in white overalls with cuffs coloured to denote their duties, cotton gloves and white soft shoes. . . . Visitors were banned from dressing rooms which were at one time reached by a staircase for ladies and another for gentlemen."[11]

Alexander's first new play at the St. James's was a piece by the young Sydney-born playwright C. Haddon Chambers that had premiered recently in New York. *The Idler* opened on 26 February 1891 and set the template for the drawing-room plays that would follow. The action proceeded over four days through three acts: the first in Sir John Harding's quarters in Kensington Palace Gardens, the second in Mrs. Cross's apartment, and the third in Mark Cross's rooms in Piccadilly. The theatrical raconteur Walter Macqueen-Pope recounted the narrative in his history of the theater of 1958:

It was drawing room drama alright. Mark Cross, a rich young man, makes an unhappy marriage and leaves his unfaithful wife. Although still married he falls in love with a young girl. He has the decency to go to America and there leads a wild life among the miners, making a great friend of one of them, "Gentleman Jack." News of his wife's death brings him home. He goes to the girl he loved, only to find she has married John Harding MP. . . . No other than his old acquaintance "Gentleman Jack!" Sir John has not told his wife about his past, which includes killing a man in a drunken bout and fleeing the consequences. The dead man's brother is in England seeking revenge on the killer, and Cross warns Harding about this. In due course the brother, Simeon Strong, calls on both men and lays his plans. Seeing a chance to win the girl he loved, Cross plans to get her to his chambers and possess her, in return for saving her husband. Lady Harding, who loves her husband, sees no way out. Cross obtains a written promise from Strong that he will let Sir John alone. When Lady Harding visits him and he attempts to seduce her, her appeal to his better nature brings out the latent good in him, and he is allowing her to depart when her husband arrives and puts the worst construction on the situation. He demands a duel between Cross and himself. . . . Strong turns up and stops this. Lady Harding convinces her husband of this and they go away together. Cross decides to commit suicide—a worthless idler only causes trouble in the world. But his mother, whom he dearly loves, comes to see him. He puts away his revolver and orders his servant to pack for a long journey. Whither will he travel? "God knows!" he says as the curtain falls.[12]

There was, of course, much here reminiscent of mid-Victorian melodrama, but it is also possible to discern the emergence of some of the distinctive characteristics associated with Edwardian theater, as outlined by the theater historian Joseph Donohue. These included, he wrote, the promotion of a new ethical realism that went hand in hand with the apotheosis of late-nineteenth-century verisimilitude in settings, costume, and decor: "a realism that views society in its social and moral aspects as a matrix of moving and shifting values, rather than as an essentially monolithic conglomeration of persons and classes all with fixed attributes. . . . An insistent, restless desire to see things for what they really are and name them accordingly"—setting them in meaningful context. This was accompanied by "a continuing love of fantasy . . . a heightened appreciation of and appetite for pleasure—hedonistic, intellectual, innocent or guilty," bracketed with "an enthusiastic idealism that vents itself . . . in visions of a new theatre and even a new audience . . . ; a strong re-orientation towards [the present and] the future [and] a

39. Lizzie Caswall Smith, "Sir George Alexander," bromide postcard print (ca. 1905), 4¾ x 3¼ in. (12 x 8.2 cm). National Portrait Gallery, London.

40. "Mrs. George Alexander with 'Pan,' a Favourite," from *Play Pictorial* 17, no. 101 (1911): 48. Courtesy of the Yale University Library.

41. "The St James Theatre, London," from *Sketch*, 25 March 1896, 374. Theatre Collections, Victoria and Albert Museum, London.

quasi-teleological sense of progress towards a goal."[13] That such a goal could be manifested in the dressing of sets and actors was a new proposition, and one that the critics of *The Idler* were quick to identify. Macqueen-Pope cited the "well-known journalist" A. W. Bean:

> The action on the part of our managers in placing the furnishing of their stage interiors in the hands of competent men, proves that they are making an effort, and with success, to enable us to escape from the opprobrium of

being a people without taste. Some of us, especially the ladies, dress better than we used to do—often the result of seeing a model costume on the stage. The next step in the same direction is to furnish better—to better dress our dwellings. Hence the appreciation of art furniture and its accompanying decorations. For instance, who can visit the Idler at the St James's Theatre and come away without their artistic perceptions receiving improvement? The charming set in the second scene, arranged in the Louis Seize style, shows a strong contrast to the sumptuous chambers of Mark Cross in the last act, so artistically arranged by the firm of Messrs F. Giles and Co., whose setting of this scene in antique oak furniture will be much appreciated by those who see the play, and especially those whose financial positions will enable them to carry out in their own houses such elegant designs.[14]

All of this polish was made possible by the rise of the actor-manager, whose promotional skills were made manifest in the suave figure of Alexander. He had risen from a fairly humble middle-class background as the son of a Reading commercial traveler to work as a leading man under Henry Irving at the Lyceum in the 1880s before finding wider success and a degree of infamy as the producer of Oscar Wilde and Arthur Pinero in the 1890s. "Hierarchically and organizationally," the theater historian Ian Clarke suggested, "the commercial Edwardian Theatre was dominated by the actor-managers. They leased and managed the building, chose the plays and controlled their production, and usually acted a leading role. A consequence of the extent of this organisational control was an ability throughout the period to embody and create the tone of the theatre as a social institution."[15] For the St. James's Theatre, this tone was firmly established only after 1900, following a complete refurbishment in February of the same year. The correspondent of the *Sketch* noted:

> The brand new St James's Theatre, a blaze of crimson and gold as regards colour . . . looked very handsome indeed when filled with a brilliant first night audience on February 1st. . . . We all rose to accord fullest sympathy to the National Anthem, in the chorus of which joined with special heartiness the best gowned lady in the house—a graceful and captivating Irish girl sitting just in front of me in the dress circle. The suave lines of that . . . white silk dress fitted the figure most exquisitely, and I am sure that the maker must be a woman of genius.[16]

His observations could not have accorded more perfectly with those of Henry James, who simultaneously recorded the impression that "the theatre in England is a social

luxury and not an artistic necessity. . . . The audience is well dressed, tranquil, motionless, it suggests domestic virtue and comfortable homes; it looks as if it had come to the play in its own carriage, after a dinner of beef and pudding."[17]

Thus in the images created by managers such as Alexander, both the front and the back of the proscenium, a simulacrum of the Edwardian social experience based on the concept of politeness was maintained, which was both "suitably flattering and acceptable to the bulk of the theatre-going public."[18] And as Clarke argued, "despite the image-making, the social image was partly founded on fact. For most of the nineteenth-century, the acting profession had not genuinely been received into polite society, but, by the Edwardian age, it had been so successfully assimilated that this . . . relatively new-found social position and respectability affected a whole range of assumptions about the nature and function of theatre as an institution and about the drama it presented."[19] At the core of these assumptions lay the thorny issue of what constituted a respectable lifestyle and how this might be conveyed through the problematic but highly modern concept of fashionability. Although the evidence for the way that these concerns were represented on stage is by nature ephemeral and patchy, the material is rich enough to yield new insights. Having sketched in the broader developmental and institutional contexts that gave rise to such concerns, I'd like to consider in a little more detail how they were practically resolved at the St. James's during the first two decades of the twentieth century.

Kaplan and Stowell, in their groundbreaking analysis of the relationship between fashion and theater during the 1880s and 1890s, bluntly characterized the provision of stage costumes, both by couture companies such as Redfern, Worth, and Paquin and by more obscure Mayfair dressmakers, as part of

> a cynical collusion of stage, shop and society press . . . facilitated by a new wave of independent designers determined to break the monopoly of estab- lished houses. . . . In London, where Worth's influence had been felt at one remove, the stage became the principal marketplace in which his authority was tested by rivals who had neither the prestige nor resources of their Parisian counterparts.[20]

At the St. James's Theatre, this process was clearly seen at play in the contributions made by the West End dressmakers Mesdames Savage and Purdue, who between 1892 and 1897 costumed thirteen productions, including Wilde's *Lady Windermere's Fan* (1892), Pinero's *The Second Mrs Tanqueray* (1893), and H. A. Jones's *The Masqueraders* (1894). Once their names, prominently displayed in programs and discussed in the reviews, were in broader circulation among society, it is notable that

Savage and Purdue curtailed the stage work and concentrated on the lucrative drawing-room commissions that allowed them in due course to call themselves "Court Dressmakers." The playhouses had simply functioned as secondary show-rooms, "with London's leading ladies serving as living mannequins."[21]

After 1900 the situation seems to have shifted, with a more concerted effort by the theater's management to harness all aspects of production toward producing a coherent account of the play's setting. This left fewer opportunities for ambitious dressmakers to use the St. James's as a personal career platform and no doubt owed much to the contribution of Florence Alexander, who was described in the *Sketch* of 1901 as "one of the best dressed women in London. . . . Not a play, especially a modern play, goes on to the St James's stage the costumes of which have not been suggested or decided upon by this able actor-manager's very able wife."[22] Her crucial creative role and its place in a more cohesive design process, which incorporated consideration of dress and setting in tandem, are also alluded to by the set and costume designer W. Graham Robertson, who recalled in his memoirs that

> work was very pleasant at the St James's. Alexander and I, as old friends, were able to discuss matters comfortably. Florence Alexander, his wife, was always of immense help, and she and I used to make secret and illicit raids upon the sacred "wardrobe" where we often found just what we wanted ready to our hand.[23]

Their concern for producing a convincing mise-en-scène was first tested through Robertson's contribution to Alexander's 1897 production of *As You Like It*, for which, he remembered, "I was most conscientious over the dresses, and the forest scenes looked really rustic; nothing but russets, browns and greens—what a tailor would call 'gent's heather mixture.'"[24] The final "masque of Hymen" offered the opportunity for an expensive, high-aesthetic sensory overload:

> Flower-decked children danced, demure white maidens swung their garlands, it was a picture of Spring in the faint pure tints of primrose and anemone. Then came a burst of colour. A coven of little crimson-robed cupids fluttered in on peacock wings shooting golden arrows, tipped with red roses, and finally the beautiful golden figure of Hymen emerged from the misty blue deeps of the wood. I had certainly attained my riot of colour, the gentle hues of the opening wiped out by the rush of crimson, the crimson effaced in its turn by the only colour that will efface crimson—orange—and orange against its complementary blue, which doubled its effect.[25]

But a striving after elegant effect and nuanced mood was not restricted to Shakespeare. The modern drawing-room plays that earned the St. James's Theatre its reputation were the focus of similarly intense labor, whose function was usefully described by the French critic Georges Bourdon, writing on the English theatrical trades in 1903:

> What they try to achieve in the mise-en-scène is not so much the representation, in a form as precise as possible, of material objects that will confer value as a sign of art. They are pre-occupied less with establishing a décor that will constitute a faithful image of nature than with giving adequate symbolic expression to the nature of the characters who inhabit it. The job of painters and carpenters is not to restore nature itself: they evoke environments, they create "atmosphere," they confer thought and a voice on décor, they make of it a living, speaking character, they impose it on the spectator's mind, they send across the auditorium the soul of the work itself, elusive but still present.[26]

Bourdon's generalized account of the communicative role played by the set in conveying narrative, character, and mood is supported four years later by the research of the Italian critic Mario Borsa, who in interviewing Pinero noted,

> I had under my eyes "the author's copy" of several of his plays and the stage directions in these were quite as long as the texts. Pinero not only gives a most minute description of each scene, going so far as to describe the colours of the stuffs used to cover the chairs and sofa, not only does he indicate every step and every movement of the actors and the actresses, but he even suggests their very gestures. . . . If you were to first read the author's copy of one of his plays, and then go to see it produced upon the stage, your first feeling would be one of displeasure; for you would imagine yourself to be seeing wooden puppets, moved about by means of invisible threads of wire by the guiding hand of Pinero![27]

Pinero was not alone in setting exacting and lavish standards of representation; for example, the stage directions set by Somerset Maugham for the decoration of Lady Grayston's country-house drawing room in the play *Our Betters* (1915) are similarly prescriptive:

> It is a sumptuous double-room, of the period of George II, decorated in green and gold, with a coromandel screen and lacquer cabinets; but the coverings of the chairs, the sofas and the cushions show the influence of Bakst and the

Russian Ballet; they offer an agreeable mixture of rich plum, emerald green, canary and ultra-marine. On the floor is a Chinese carpet, and here and there are pieces of Ming pottery.[28]

Scraps of evidence from the program notes, production photographs, and reviews of the series of productions held at the St. James's between the turn of the century and World War I are testament to the genre-defining dictums of Maugham and Pinero that (to use Pinero's words) "wealth and leisure are more productive of dramatic complications than poverty and hard work . . . [and] if you want to get a certain order of ideas expressed or questions discussed, you must go pretty well up in the social scale";[29] in addition, that in order to set a convincing context for such ideas it would be necessary for actor-manager, playwright, costume mistress, property buyer, and scene painter to work together to an unprecedented degree.[30] Thus the program note for the play *Saturday to Monday*, staged in April 1904, states that "the dining room scene was painted by Mr Walter Hann and the Garden Scene by Mr Hawes Craven, the furniture was by Wiseman and Butcher of 7 High Street Kensington and the dresses by Madame Frederick, 14 Grosvenor Place and Marshall & Snelgrove, Ladies Hats by Mme Elise, 33 New Bond Street."[31] That autumn a revival of *Lady Windermere's Fan* necessitated a wider trawl for costumes, with the following result:

> The gowns and cloaks worn by Mesdames Braithwaite, French, Lewis and Hamilton designed and made by Madame Frederick. . . . Miss Terry's gowns by Madame Hayward, New Bond Street, Miss Coleman's gowns by Marshall and Snelgrove, Oxford Street, the other gowns by Mme Brown, 169 Knightsbridge and Mrs Evans. Hats by Mme Elise. . . . The furniture by Wiseman and Butcher and Ernest Renton, King Street St James.[32]

Such retailers reoccur with regularity, furnishing the decor of *Mollentrave on Women* by Alfred Sutro, *John Chilcote MP* by Katherine Cecil Thurston, and *The Man of the Moment* by Alfred Capus (all 1905), although for the latter, "Mme le Bargy's dresses were provided by the Maison Doucet, Rue de la Paix, Paris"[33] (fig. 42).

Pinero's *His House in Order* (February 1906), with its dresses by Mme Hayward and Mme Purdue, scenery by Joseph Harker from decorations designed by Percy MacQuoid, and furniture by Waring's, Bailey's, Lyon's, and Ernest Renton, elicited a telling review by Edith Waldemar Leverton in a commemorative edition of the *Play Pictorial*, which cleverly segued observations of fashionable life before, during, and after the play to suggest the unbroken continuum of taste between audience and production that Alexander so desired (fig. 43):

42. "Mme Simone le Bargy in *The Man of the Moment*," from *Sketch*, supplement, 12 July 1905, 4. Courtesy of the Yale University Library.

THE FINDING OF COMPROMISING LETTERS WRITTEN BY MAJOR MAUREWARDE TO THE LATE MRS JESSON

NINA: "What's this, Derek?" DEREK: "Oh, that's poor mamma's. I s'pose it was hers. I'm going to ask father."
NINA: "Where did you find it?" DEREK: "In the boudoir, underneath the boards at the bottom of the cupboard."

NINA: "I had no suspicion I should light upon anything disagreeable." HILARY: "Disagreeable?"
NINA: "Anything *she* had meant to hide. It didn't occur to me —underneath the floor, in her sanctum—?"

43. "Scenes from *His House in Order*," from *Play Pictorial* 8, no. 48 (1906): 70–71. Courtesy of the Yale University Library.

"Say!" exclaimed my American friend, "guess I'm about tired of Musical Comedy, can't you give me something with pure drama in it, and no Bernard Shaw." "Certainly" I responded with alacrity "there's the Immortal Pinero, George Alexander, Irene Vanbrugh and 'His House in Order,'" . . . We first of all repaired to that delightful restaurant the Dieudonne, with its . . . delicate mural decorations, and its incomparable little dinners. . . . Between the courses I had leisure to observe the pretty gowns worn by the many pretty women. Lady J who always displays such exquisite taste in frocks had selected one in hydrangea mauve silk, the skirt bearing a wide-border of silk embroidery in a design of forget-me-nots in their natural colouring. Close by was one of our best beloved actresses in a gown of Irish lace slashed over an underskirt of white chiffon and laced across by silver cords. . . . In due course we settled ourselves comfortably in our stalls. Before the curtain rose I had leisure to admire a very fascinating lady in front with the prettiest coiffure imaginable, one mass of tiny curls and a white aigrette waving above a small diamond tiara.

Finally, describing the costumes of the play itself, Leverton was drawn to

> the rebellious wife in a wonderful creation of pink silk mousseline, the skirt clinging and trailing in graceful folds, the bodice displaying an under-blouse of pure white with cape-like sleeves of Irish lace. . . . A veritable dream gown this, and one to make every true woman sigh with envy. . . . "I'm real glad that idiot of a husband gave the Ridgeley family the 'skipoo'" remarked my companion, as he lighted a homeward cigar. "Say, but Pinero is a dandy writer." I sighed! I was thinking of that pink frock![34]

A final example of theatrical fashion journalism from a *Play Pictorial* (November 1910), commemorating the play *The Eccentric Lord Comberdene* by R. C. Carton, takes the elision between experience and its representation to its extreme:

> The lounge of the Imperial Hotel, Shingelford Bay . . . shows us some elegantly dressed lady visitors, who wander in and out of the hall in a most natural manner, entertaining visitors at afternoon tea. . . . It is a rather restless mise-en-scène and seems without any apparent object, for few of the ladies . . . play any part in the story. But the dresses are pretty and form a varying background to the male and female characters in the rather melodramatic plot. There was a lady visitor to the hotel who wore a very attractive gown of white cloth, with a shawl-like mantlet, and the movement of this mannequin was quite refreshing as she came and went. . . . The deck of the Morning Star looked rather inviting at first, but when the yacht started and got away the movement was so realistic that more than one bad sailor amongst the audience looked ready for the stewardess. . . . Such is life, or rather such is stage life![35]

On a superficial reading, this, then, was the sum contribution of a dramatic form that George Bernard Shaw famously dismissed as "a tailor's advertisement making sentimental remarks to a milliner's advertisement in the middle of an upholsterer's and decorator's advertisement,"[36] a jolly and well-engineered conduit for the commodification of life, which sat securely within the dominant, highly materialistic mind-set of the Edwardian middle classes (fig. 44). Yet within this skillful placement of contemporary dress and furniture, this concerted play with their performative possibilities—intended to produce that crowning accolade of "niceness"—so bitterly dismissed by Shaw, I would suggest there are valuable lessons to be learned, both about the role played by theatrical methods in the con-

44. Advertisements from *Play Pictorial* 8, no. 51 (1906): ii–iii. Courtesy of the Yale University Library.

struction of fashionability and about the embedding of the idea of fashion in certain conservative theatrical forms. As Ian Clarke has observed:

> The desire for "nice" plays, over and above its creation of a social tone, entailed a more fundamental ideological affiliation. "Nice" plays could only be those which demonstrated and endorsed a non-objectionable subject-matter and morality. The successful plays of the serious commercial theatre were almost inevitably conservative in matters of social conduct and sexual morality. The success of the drama depended not only on a congruity of taste between providers and consumers, but on a congruity between the ideological foundations of the Edwardian theatre, ramified by notions of a stable social structure and concepts of correct behavior, and the ideological construction of the drama itself.[37]

There is a reactionary reciprocity here that deserves further analysis, not just in the realm of theater, but as a marker of middlebrow aspirations in the history of modern English visual and material culture more generally: in the home, the shop, the novel, and latterly through film. For we can certainly be sure that whether these signs occurred through the prism of fashion or the interior, they will always have been fetchingly, expensively, and appropriately dressed—and nowhere more so than on the Edwardian stage.

The epigraph is from George Bernard Shaw, preface to *Three Plays for Puritans* (Harmondsworth, UK: Penguin Classics, 2000), 15. Also cited in Ian Clarke, *Edwardian Drama: A Critical Study* (London: Faber and Faber, 1989), 5.

1. Michael Billington, introduction to Shaw, *Three Plays for Puritans*, vii.
2. Billington, introduction.
3. Shaw, preface, 8–10.
4. Joel H. Kaplan and Sheila Stowell, *Theatre and Fashion: Oscar Wilde to the Suffragettes* (Cambridge: Cambridge Univ. Press, 1994). See also Peter Bailey, *Popular Culture and Performance in the Victorian City* (Cambridge: Cambridge Univ. Press, 1998), and Erika D. Rappaport, *Shopping for Pleasure: Women in the Making of London's West End* (Princeton, N.J.: Princeton Univ. Press, 2000).
5. Raymond Mander and Joe Mitchenson, *Musical Comedy: A Story in Pictures* (London: Peter Davies, 1969), 18–19.
6. Mander and Mitchenson, *Musical Comedy*, 13.
7. Mander and Mitchenson, *Musical Comedy*, 13.
8. Peter Bailey, "Naughty but Nice: Musical Comedy and the Rhetoric of the Girl, 1892–1914," in *The Edwardian Theatre: Essays on Performance and the Stage*, ed. Michael R. Booth and Joel H. Kaplan (Cambridge: Cambridge Univ. Press, 1996), 55.
9. Shaw, preface, 14.
10. Two recent exceptions from the field of art history are Lisa Tickner, *Modern Life and Modern Subjects: British Art in the Early Twentieth Century* (New Haven and London: Yale Univ. Press, 2000), and Pamela M. Fletcher, *Narrating Modernity: The British Problem Picture, 1895–1914* (Burlington, Vt.: Ashgate, 2003). For earlier explorations of the fashion-related arguments developed in this essay, see also Christopher Breward, *Fashioning London: Clothing and the Modern Metropolis* (Oxford: Berg, 2004), and Breward, "Ambiguous Role Models: Fashion, Modernity and the Victorian Actress," in *Fashion and Modernity*, ed. Christopher Breward and Caroline Evans (Oxford: Berg, 2005), 101–21.
11. Barry Duncan, *The St James's Theatre: Its Strange and Complete History, 1835–1957* (London: Barrie & Rockliff, 1964), 218–19.
12. William Macqueen-Pope, *St James's: Theatre of Distinction* (London: W. H. Allen, 1958), 112–13.
13. Joseph Donohue, "What Is Edwardian Theatre?" in Booth and Kaplan, *Edwardian Theatre*, 14–16.
14. Macqueen-Pope, *St James's*, 114.
15. Clarke, *Edwardian Drama*, 1.
16. *Sketch*, 7 Feb. 1900, 103.
17. Henry James, *The Scenic Art*, ed. A. Wade (London: Hart-Davis, 1949), 100–101.

18. Clarke, *Edwardian Drama*, 1.

19. Clarke, *Edwardian Drama*, 1.

20. Kaplan and Stowell, *Theatre and Fashion*, 8–10.

21. Kaplan and Stowell, *Theatre and Fashion*, 8–10.

22. Henry Chance Newton, "Mr and Mrs George Alexander at Home and Out," *Sketch*, 23 Jan. 1901, 23.

23. Walford Graham Robertson, *Time Was: The Reminiscences of W. Graham Robertson* (London: Quartet, 1981), 267.

24. Robertson, *Time Was*, 261.

25. Robertson, *Time Was*, 261.

26. Georges Bourdon, "The English Theatre 1903," cited in Booth and Kaplan, *Edwardian Theatre*, 29.

27. Mario Borsa, *The English Stage of Today* (London: John Lane, 1907), 82.

28. Michael Booth, "Comedy and Farce," in *The Cambridge Companion to Victorian and Edwardian Theatre*, ed. Kerry Powell (Cambridge: Cambridge Univ. Press, 2004), 136.

29. Booth, "Comedy and Farce," 135.

30. Further work needs to be completed on the luxury trades of London (many of which contributed to the designs for St. James's Theatre productions) during this period. Some important work has been achieved tracking the network of court and society dressmakers in the 1890s and 1910s. See, for example, Amy de la Haye, Lou Taylor, and Eleanor Thompson, *A Family of Fashion: The Messels: Six Generations of Dress* (London: Philip Wilson Publishers, 2005).

31. All programs are held in the Theatre Collections, National Archive of Art and Design, Victoria and Albert Museum, London.

32. Theatre Collections, National Archive of Art and Design.

33. Theatre Collections, National Archive of Art and Design.

34. Edith Waldemar Leverton, *Play Pictorial* 8, no. 48 (1906): 78.

35. Edith Waldemar Leverton, *Play Pictorial* 17, no. 101 (1910): 46.

36. George Bernard Shaw, preface to *Three Plays for Puritans*, 15.

37. Clarke, *Edwardian Drama*, 8–9.

Enduring Evanescence and Anticipated History: The Paradoxical Edwardian Interior

Christopher Reed

O N THE EVIDENCE OF FICTION, the paradigmatic Edwardian interior was both domestic and disappearing. Vita Sackville-West's novel *The Edwardians* opens (after ruminating over the arbitrary nature of periodization, an issue that troubles virtually every commentator on the Edwardians[1]) "on Sunday, July the 23rd, nineteen hundred and five," that is, smack-dab in the middle of the Edwardian era. The plot that follows is a series of flights from the Edwardian interior. The hero is introduced fleeing to the roof of his family manse: "he escaped; sprang upstairs through the rich confusion of staircases and rooms; and finally reaching the attics pushed his way out through a small door." This escape presages the narrative arc of the novel, in which this young embodiment of British aristocracy learns to slough off social norms and expectations, finally achieving emancipation—with rather obvious symbolism—at the coronation of George V. (In an ancillary plot, his sister also achieves liberation slightly earlier in 1910.) From Sackville-West's perspective in 1930, when *The Edwardians* was published, the clichés of the Edwardian summer—"a world where pleasure fell like a ripened peach for the outstretching of a hand"—masked a culture stultified in hypocrisy and snobbery.[2] Edwardian life, symbolized by the Edwardian interior, was something best abandoned, even at the risk of climbing out onto uncomfortable and dangerous rooftops.

In contrast, E. M. Forster's *Howards End*, written during the Edwardian age, presents the Edwardian interior not as a trap to escape from, but as a vanishing paradise. Forster evoked the architectural transformation of London in seismic terms: rising "promontories" replace "estuaries" of "older houses," destroying domestic-scale London while the "shallows" of capital-S Suburbia "washed more widely against the hills of Surrey and over the fields of Hertfordshire."[3] Amid all this, the Schlegel sisters face eviction from their London house so the landlord can erect blocks of flats, "expensive, with cavernous entrance halls, full of concierges and palms." That pretentious interior marks an opposite extreme from poor Leonard Bast's furnished "semi-basement," which "struck that shallow makeshift note that is so often heard in the modern dwelling place. It had been too easily gained,

and could be relinquished too easily." If, in Forster's conclusion—as heavy-handedly symbolic as Sackville-West's—the Schlegels are restored to a timeless idyll at Howards End, where all their old furniture just happens to fit "extraordinarily well," this denouement is more wish than prediction. "All the signs are against it now, but I can't help hoping, and very early in the morning in the garden I feel that our house is the future as well as the past," asserts Margaret in the book's final chapter.[4] Whether seen by mid-century as actively rejected or experienced at the time as tragically slipping away, the fictional Edwardian interior is characterized by its imminent demise.

Loss of the home was a powerful symbol during a decade when, measured against inflation, real wages fell, the gap between rich and poor widened, and analysis of tax statistics suggests that "the famous middle class of literature and reminiscence turns out to be largely a matter of aspiration, imitation and snobbery [as] a third of the population was trying to live in a way that only a seventeenth of the population could live."[5] In C. F. G. Masterman's canonical 1909 study, *The Condition of England*, the three middle-class values of "Security," "Sedentary occupation," and "Respectability" were symbolized by "the miles and miles of little red houses in little silent streets."[6] Anxieties concerning those values were symbolized among the Edwardians as threats to the home. A Conservative and Unionist Party poster entitled "An Englishman's Home" showed a middle-class family being turned out of their house by the budget of 1909, and numerous anti-suffrage posters depicted the chaotic domestic interiors resulting from vote-seeking females.[7] In actuality, poverty could easily mean having no home. Charles Booth's *Life and Labour of the People of London*, a revised edition of which was published in 1902–3, found 40,000 of those he called the poor and the "very poor" living in "common lodging houses," hotels or boarding houses, and 96,000 in institutions, mainly workhouses.[8] According to Booth, 1 million Londoners, out of the city's population of 4.5 million, had inadequate housing.[9]

Yet despite Edwardians' anxieties—real and imagined—about the evanescence of their homes, a great many Edwardian domestic interiors are still around. Almost a million houses were built during the first decade of the twentieth century in England, Scotland, and Wales, and, as a recent restoration guide points out, Edwardian terraces and villas remain "such a ubiquitous type of housing, we take it for granted."[10] Far from embodying a uniquely British sensibility, moreover, the Edwardian house was a successful export, inspiring householders and designers internationally through illustrated journals, such as the *Architectural Review*, the *Studio*,[11] and *Country Life*, as well as books like Hermann Muthesius's influential *Das Englische Haus*, published in Berlin in 1904. One paradox of the Edwardian domestic interior, therefore, is that anxiety over its disappearance inspired a vast

and enduring roster of examples. A related irony is that—unlike the neo-Baroque institutional architecture in which the Edwardians confidently housed their institutions of imperial administration—their apparently evanescent domestic designs defined a lasting global norm. Indeed, it could fairly be said that, although the British Empire is today little more than a memory, the sun never sets on neighborhoods where Edwardian modes of domestic design remain a living ideal.

The intensity of Edwardians' anxiety helps to account for the salient qualities of their interiors: their extreme variety and their various extremes. Consider their range, starting with the "English Baroque" or "Wrenaissance" styles exemplified in Aston Webb's Britannia Royal Naval College, Dartmouth (1905), which has been well analyzed as a "supercharged family home" for middle-class sons aspiring to an aristocratic grandness exceeding "their own family domesticity."[12] At the other end of the spectrum from this exaggerated aristocratic mode was the ostentatiously vernacular. Edwin Lutyens's "expression of every joint and dowel" has looked to later commentators like "an unnecessary over-exaggeration of the scale of exposed timbers," while the encyclopedic replication of local varieties of vernacular decoration in Edward S. Prior's (again) overscale Home Place, Kelling, near Holt, Norfolk (1903–5), with its barnlike central hall, now strikes historians as "seemingly crazy" and "making the house look as though it is covered with a very old Fairisle pullover that had been knitted by an imbecile child."[13] Further down the economic ladder, in cities throughout Britain, street after street of suburban terrace houses were cluttered with carpentry, tile, and plasterwork—not to mention furniture, pictures, and bric-a-brac—in a frantic effort to signal historical precedents, usually Tudor and Jacobean. Meanwhile, among the avant-garde, the fantastically extenuated proportions of the Glasgow designers' chairs contrasted with their massively buttressed exterior walls. Despite repeated calls from Edwardian reformers and experts for simplicity and discipline in interior design, exaggeration and eclecticism were the anxious order of the day.[14]

What has been called the "stylistic free-for-all" of Edwardian architecture is evidence of a conceptual unity among designers and patrons, who shared a desire—one might even say a compulsion—to signify.[15] One writer for *Country Life* proclaimed that "we are at liberty to ransack the centuries for the architectural expression which best represents our outlook on life and manners." Architects, in his view, sought

a fresh expression of the chosen outlook in the same language, but in new phrases. Architecture can no more invent a new style than literature can create a new language. Just as a modern writer will abjure the precise imitation of Elizabethan forms, though he may seek to express as richly and

strongly the spirit of his day out of a vocabulary but little changed, so does the architect set his skill to solve new problems with old materials.[16]

More critically, Roger Fry indicted the quest by Edwardian house builders for "the pearl of romance" that led them to dive

> now here, now there, now into the Romanesque, now into Gothic, now into Jacobean, now into Queen Anne. They have brought up innumerable architectural "features" which have been duly copied by machinery, and carefully glued on to the houses, and still the owners and the architects, to do them justice, feel restless, and are in search of some new "old style" to try.

Fry reported that Edwardian style-diving no longer went on "with the old zest for and hope of discovery, but rather with a languid indifference and with evident marks of discouragement." In contrast, he defended the strikingly individual house he designed in 1908–9 by asking, "What if people were just to let their houses be the direct outcome of their actual needs, and of their actual way of life[?]" He argued, "Instead of looking like something," such houses "would then be something." Despite his ideal of an architecture of ontological purity, however, when Fry explained the look of the double-height "house-place" with its factory-scale windows that was the center of his own house design, he fell back on a desire for his architecture to speak in terms of stylistic precedents: "I hate Elizabeth rooms with their low ceilings. . . . I love the interiors of the baroque palaces of Italy."[17]

Fry's analysis of his own domestic interior was caught between two contradictory ideals: one for architecture as signification, the other for architecture that could simply *be*. The latter closely anticipated the rhetorics of Le Corbusier and his followers who, after World War I, promoted what ultimately became accepted as "modern" design. By mid-century, architectural historians' consensus in favor of functionality provoked assessments of Edwardian design as undisciplined, crazy, idiotic—even immoral in its suggestion of "a bogus antiquity."[18] By the end of the twentieth century, however, postmodernist reinvigoration of ideas of design as signification challenged the ideology that blank walls are more functional than decorated ones (although blankness may, of course, signify functionality). From the postmodernists' perspective, Edwardian designers returned as important forerunners because of, rather than despite, their investment in the language of ornament: Charles Jencks's manifesto on postmodern architecture cites Lutyens as an important source for Robert Venturi.[19] And it is worth noting that Fry's fundamentally Edwardian presumption that architecture is language emerged most explicitly in his rejection of Corbusian modernism when he encountered it in the

1920s. Sounding strikingly like *Country Life*'s Edwardian writer, Fry objected to what he called Le Corbusier's "gadgett style" precisely because it failed as language. In a Queen Anne interior, Fry explained, "the mouldings at the base and the top of the wall were equivalent to saying a wall <u>which</u> rises from the ground and <u>which</u> supports the ceiling. The mouldings give us the power of using a relative clause whereas in the modern interior we are reduced to a kind of pidgin English with no possibility of syntax."[20] In short, even those who struggled against Edwardian design conventions assumed, first and foremost, that buildings signified. Their interiors constituted—although the Edwardians would never have used this terminology—a semiotic field.

The linguistic analogies proposed by both Fry and *Country Life* reveal how profoundly Edwardian designers differed from later modernists. It was not simply that Edwardian architecture should signify, but that such signification took place in a temporal context that was not the timeless utopia of modernist futurity, but a history composed of past, present, and future. Thus, it was not only novelists who tuned the interior to nostalgic key. When, in the introduction to their influential *Art of Building a Home* (1901), architects Barry Parker and Raymond Unwin exhorted architects to pay more attention to interiors, they looked toward the immediate future: "If, when designing a house, the architect were bearing in mind the effect each room would have when finished and furnished, his conceptions would be influenced from the very beginning, and his attitude towards the work would tend to undergo an entire change." This attitude, however, was premised on projections of memory. Parker and Unwin urged the artist to "leave his easel pictures, and paint on our walls and over the chimney corner landscapes and scenes which shall bring light and life into the room; . . . paintings which our children shall grow up to love, and always connect with scenes of home with that vividness of a memory from childhood which no time can efface." They exhorted architects to imagine the spaces they created as settings to be remembered, concluding with a flourish, "Let us have . . . rooms which can form backgrounds, fitting and dignified, at the time and in our memories, for all those little scenes, those acts of kindness and small duties, as well as the scenes of deep emotion and trial, which make up the drama of our lives at home."[21] For Edwardian designers and dwellers alike, the meanings of the Edwardian home proposed a future that cherished an ideal of the past.

This dynamic clearly animates *Country Life*'s presentation of Lutyens's Deanery Garden, at Sonning in Berkshire, a country house commissioned by the magazine's proprietor, Edward Hudson, although his identity was obscured in the description of this "house of a man with a hobby—viz., rose-growing and wall-gardening." The article, apparently written by Hudson, opens, "We can imagine a

poet some four or five years ago" fantasizing about the "the building as it stands today" rising from the "ancient boundary walls whereon herbs and flowers grew, fragrant and old-fashioned" on the site.

> He looked and dreamed and wondered what sort of house they could possibly have enclosed, and though there was little to guide his fancy, the situation and certain traditions that linger about the place suggested at least that it had been a residence for learned scholars and ecclesiastics, who doubtless paced its walks and avenues, thinking out ideas that may be enshrined in dusty medieval quartos now worth their weight in gold.

With the completion of the house, "The poet's dream came true." In the present the past is frankly fantasized—there are no claims for historical accuracy here. And the article, which is structured as a guided tour of the property, repeatedly rehearses the experience of visitors in the future whom the house will prompt to more imaginary remembering. In the dining room, to take one example, "the beams still bear the adze marks of the carpenter, and thus we are brought face to face, as it were with the craftsman."[22] The storytelling quality of Lutyens's design is implicit his biographer's assertion that "Deanery Garden . . . may be called without overstatement a perfect architectural sonnet . . . : its theme, a romantic bachelor's idyllic afternoons beside a Thames backwater."[23]

Interior design was not the only way that Edwardians fused memory, fantasy, and history, as evidenced by the pageants discussed in the essay by Deborah Sugg Ryan in this volume. Interiors, however, were central to three interrelated and distinctly Edwardian arenas of individual investment in the past: the vogue for antiques, the vast increase in the scale of department stores, and the rise of mass-circulation illustrated journals. In the proliferating antique shops, as in the period-room displays in the larger stores (which sold both antiques and reproductions), shoppers were encouraged to make personal selections among historical styles using criteria that were explained and rehearsed in new journals addressed to patrons and practitioners alike. Both *Country Life*, which has a reasonable claim to be the first "life-style" magazine, and the professional journal *Architectural Review* were founded in 1897. The popularity of these illustrated magazines, which presented eclectic historical precedents as useful case studies in interior design, contrasts with the fate of another magazine founded in 1897, the *House*, which struggled until it expired in 1903 to find readers for its mid-Victorian exhortations to employ experts and avoid experimentation.[24] Although they represent opposite ends of the spectrum in terms of both readership and stylistic allegiance (*Country Life* being associated with consumers of the neo-Tudor, the *Architectural Review*

with producers of the neo-Baroque), these successful magazines were allied in their interpellation of readers as active participants in design discourses rooted in the past.

Country Life trained its readers to relish old rural buildings, with a strong emphasis on domestic architecture ranging from the lowly cottage to the grandest castle. The first article in the first issue of 1901 begins, "It is no easy matter to discover by analysis whence comes the charm of those pleasant old houses that are still to be found in most of the rural districts of England,"[25] and it is juxtaposed with Harold Begbie's poem "To the New Century," which figures the entire world as a cozy country interior:

> Come in, come in Sir Stranger! yes, here are sounds of mirth,
> Ah! not so bad a hostel is this old inn, the Earth;
> The fire is blazing brightly, the punch is on the brew;
> Move up there in the ingle; come friend, here's room for you.[26]

Exploring grander houses, *Country Life* sustained its emphasis on the nostalgic narratives they evoked. Yanwath Hall, "A Border Home of the Fourteenth Century," was described as "a kind of Rip Van Winkle of a house, only hundreds of years more antique than the sleeper of the Catskills. . . . A strange old place altogether, much as though a knight in armour had survived to turn up among a lot of khaki-dressed staff officers, his armour a little rusty, and his equipment spare and decidedly out of date, but otherwise not altogether different from the soldiers of to-day."[27] At Broughton Castle readers were invited to identify with the anonymous author who found that "it would have been pleasant to linger over the Great Hall, with its splendid example of an early decorated ceiling, where Cromwell's coat hangs on the wall opposite the hearth, a silent witness of luxurious comfort to which Cromwell's age was a stranger."[28]

The professionalizing rhetorics of the *Architectural Review* abjured such overt fantasy, dismissing parallels between architecture and literature and condemning "architectural fantasy in house building" while calling for a "new realism" that awaits "the new light of the twentieth century."[29] But the *Review* also sniffed at what it called "novelty" and harked earnestly to "the middle ages and the early Renaissance, when men were content to work in common on the accepted forms of the period."[30] In lushly illustrated features running over several issues, the *Review* regularly examined historical precedents ranging from the Hagia Sophia to "Ecclesiastical Architecture in Ireland," as well as details like antique vernacular lead-pipe heads. The *Review* marked the occasion of a meeting of the International Congress of Architects in London in July 1906 by publishing a 112-page history of English

architecture from the medieval (this section written by Edward Prior) to the "Later Renaissance," followed by thirty-eight more pages of photographs of "Work by Living Architects" echoing these styles.

The understanding of architecture as a dialogue with and about history, which animates publications as different as *Country Life* and *Architectural Review*, suggests that, beneath their stylistic variations, Edwardian interiors are not as different as they appear. To return to the binary observed above between neo-Baroque and Tudoresque interiors, we find that both were theorized as a return to a properly English architectural history.

Advocates of the Edwardian neo-Baroque asserted a British neoclassical legacy running back through Inigo Jones, John Vanbrugh, and especially—as wittily encapsulated in the "Wrenaissance" epithet—Christopher Wren.[31] As befit its ecclesiastical and palatial prototypes, the Edwardian Baroque was paradigmatically conceived for large institutional buildings. Both architects and critics treated the interiors of such buildings as incidental to their imposing exterior aspect.[32] As a result, although architects by default designed the insides of Edwardian institutional buildings, this function was hardly acknowledged, let alone thought through.[33] One consequence was insides that looked like outsides; the interiors of buildings that housed Edwardian institutions often looked like facades. A particularly telling example is Lutyens's London headquarters for *Country Life*, built in 1904. The choice of Wrenaissance style for this building is itself evidence of how powerfully the idea of urban administration was signified by the neo-Baroque, for in 1904 both Lutyens and *Country Life* were strongly associated with the Tudor-style domestic vernacular.[34] Asserting institutional grandeur, Lutyens, in the vestibule of *Country Life*'s office building, jumbled together elements associated with facades—columns, brackets, and balustrade—ineffectively screening a modest staircase behind a stack of Baroque exterior elements (fig. 45).

The importance of such stylistic signification for Edwardian householders is exemplified in the fraught history of Little Thakeham, in Storrington, West Sussex, a country house begun in 1901 in red brick but razed mid-construction, when its owner decided on a new look and made Lutyens his new architect.[35] Despite the house's Tudor-style exterior, "internally the air is Palladian and one feels that Wren had walked that way," as *Country Life* put it.[36] The cavernous hall exemplifies what Peter Inskip has called Lutyens's passion for "fictitious history": a combination of styles from various periods to create the impression that his houses evolved over centuries. Here the library mantel follows Wren, while the parlor fireplace imitates the massive hearths of medieval kitchens, as if the room had been remodeled from an ancient structure. The entrance hall presents itself as, again in Inskip's words, "a fragment of a half-completed Baroque remodeling,"[37] flooded with outdoor

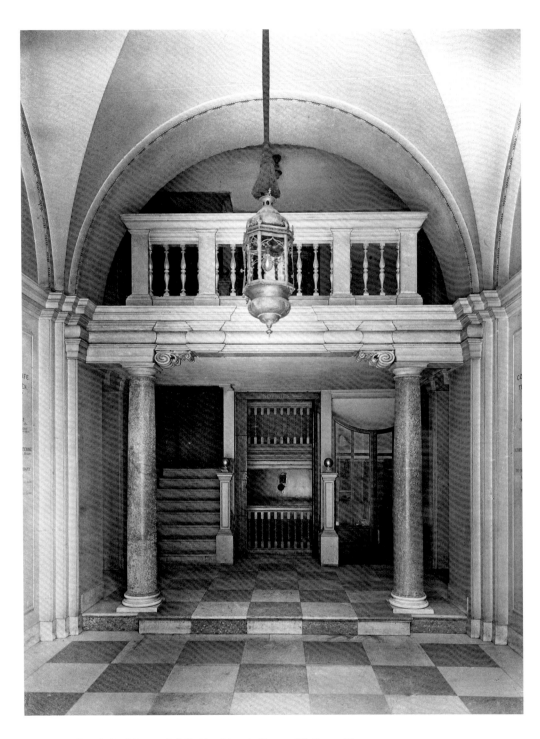

45. "Vestibule of Country Life Building" (1904). Country Life Picture Library.

light (and, in winter, undoubtedly with cold) by a massive two-story bay window. The spatial disorientation created by the complex play with landings and levels in this space complements the Baroque detailing: segmented arches, overscale keystones, and rusticated quoins suggestive of exteriors combine for an effect that a recent commentary calls "masterful but bewildering."[38] This effect of an indoor-outdoors is augmented by balconies with wrought-iron railings overlooking the room from the floor above, including one situated illogically—though not without precedent—directly over the fireplace (fig. 46).[39]

More sensibly, most classicizing Edwardian houses drew on eighteenth-century domestic interiors, creating the Edwardian vogue for Adam-style rooms (the reference is to the brothers Robert and James Adam). The classicizing architects' disinclination to theorize interior design, however, meant that Edwardian discourses about the interior continued to draw from the values and vocabularies of the Arts and Crafts movement, which, during the Victorian era, had worked from the inside out with particular focus on the home and its inhabitants. Often trumpeting their "amateur" status and identifying themselves as dwellers in, rather than just designers of, homes, Arts and Crafts practitioners from William Morris on challenged the architectural establishment's emphasis on monumental buildings and indifference to interiors by using vocabularies (both verbal and visual) that privileged domesticity, Britishness, and comfort. The result was that Edwardian tastemakers' rejection of the Tudor and Gothic styles preferred by the Arts and Crafts Victorians, in favor of neoclassical precedents, left untouched fundamental ideologies about the nature of the interior, and especially the domestic interior. Visually this is manifest in the ubiquitous oxymoron noted by Alastair Service of "the inglenook and cosy corner built in Neo-Georgian . . . style."[40]

The Edwardian Wrenaissance, therefore, did not so much supplant as augment the range of vocabulary with which the interior could speak.[41] Speculative builders continued to appeal to householders with features, such as dados, that design reformers insisted were no longer used.[42] And rooms in the Arts and Crafts style continued to be designed, advertised, and written about throughout Edward's reign. In 1910 the *Studio* saw out the Edwardian era still awarding prizes for the design of Arts and Crafts inglenooks and praising houses built with local materials and "based upon the general lines suggested by" local vernaculars.[43] In contrast to subsequent accounts of Edwardian design that cast the neoclassical "new" against the Arts and Crafts "old," the *Studio* consistently presented the Tudor-style vernacular as a progressive alternative to "a deplorable tendency to fashion new houses out of the relics or ruins of old styles," condemning "the followers of the old, classic Renaissance, still very numerous in our midst."[44] Mackay Hugh Baillie Scott, a particular favorite of the *Studio*, presented his houses as the work of a "modern

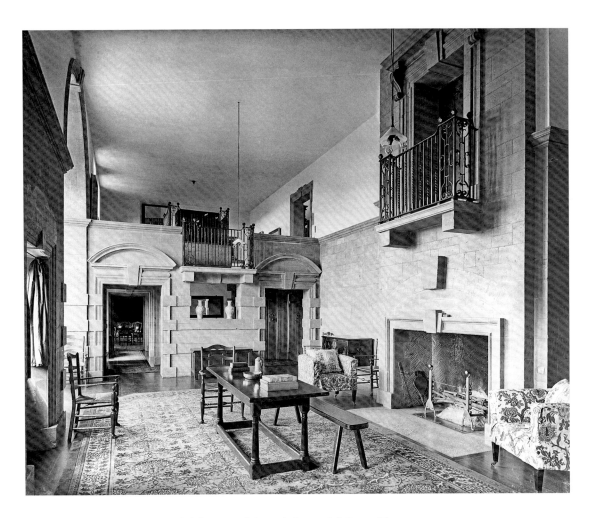

46. "The Hall, Little Thakeham House" (1902–3). Country Life Picture Library.

designer" joining in a progressive revolt "against the sordid ugliness of the Victorian house," but also as "looking backward to earlier types of plans for suggestions."[45] He inveighed against what he mocked as the Wrenaissance's antediluvian "Webb-ed foot" (an allusion to Aston Webb) in a 1910 speech that asserted, "The study of Greek temples will do little to enable us to fit ourselves to deal with small houses. . . . We should study the old cottages and farmhouses and forget the grand manner."[46]

47. Mackay Hugh Baillie Scott, "Yellowsands," from *Studio* 28 (1903): 186, no. 187. Courtesy of the Yale University Library.

Where Baillie Scott was at his most Edwardian, however, was in his descriptions of how his houses signified. About Yellowsands, he wrote, "In a house so named one might expect to find that all things had suffered a sea change, and that its decoration should tell us something of those who go down to the sea in ships." Thus, "the stones which form the floor of the terrace are gathered from the beach," the influential hexagonal hall "suggests a ship in the form of its plan," and "the carving is of that Runic kind which was suggested by the interlacing of cordage, and the walls are hung with sailcloth" (fig. 47).[47] Even his gardens were treated as interiors that offered an emotional narrative: "As in a dramatic entertainment, apartments of the garden, full of tragic shade, are followed by open spaces where flowers laugh in the sun. . . . By such devices the art of man arranges natural forms to appeal in the strongest way to the human consciousness."[48]

Figurative or symbolic elements, of the kind described by Baillie Scott, turned interiors into sign systems. The simplest of these elements might be the heart motif, favored by Charles F. A. Voysey and other Arts and Crafts designers. Voysey embraced Edwardian ideas of interior design as language—"You must choose your hall furniture and ornaments as carefully as you choose the first words to a stranger on his arrival," he instructed readers of the *Studio*. Even those who objected to Voysey's designs accepted the premise that decoration signified: H. G. Wells notoriously insisted on transforming one of Voysey's heart-shaped letter plates into a spade, for he declined "to wear his heart on his front door."[49] Stained glass and tile offered obvious sites for such symbolism. The newly inexpensive stained-glass windows—themselves suggestive of the sanctity of the home—that replaced Victorian plate glass were festooned with representations of the flowers that, in theory anyway, adorned the gardens outside. Bathroom tiles often had nautical or waterway themes. A wide variety of machine-milled "fitments"—especially screening woodwork for wide doorways and for the landings that supplanted the Victorian straight run of stairs—allowed middle-class householders to experiment with eclectic combinations of motifs and styles.[50] Edwardians also welcomed the invention of wallpapers with motifs specific to children's rooms. Even more specific among examples of the Edwardian penchant for signification are the stained-glass window designed by George Bernard Shaw in 1909–10, which represents—in Tudor style—the founding of the Fabian Society, and Lutyens's cartographic overmantels—sometimes attached to weather vanes—depicting maps of the house or region (figs. 48 and 49).[51]

Mottoes and murals—often combined—provided the clearest opportunities for signification. Mottoes were usually inscribed in or near the hearth, although *Country Life* praised Charles Eamer Kempe's windows painted with captioned scenes from poems by Alfred Tennyson and Walter Scott.[52] A mid-Edwardian

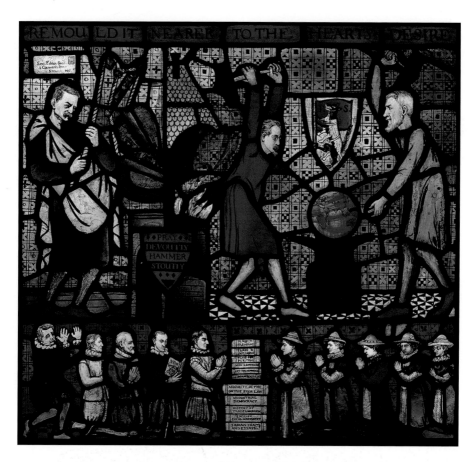

48. George Bernard Shaw, designer, and Caroline Townshend, fabricator, *The Fabian Society Window, "Pray Devoutly, Hammer Stoutly,"* stained glass (1909–10), 31⅞ x 30 in. (81 x 76 cm). Beatrice Webb House, Dorking, Surrey. The identities of some of the figures are debated, but the upper register shows the economist Sidney Webb (husband of Beatrice) and Edward Reynolds Pease, the society's secretary and the author of a history of the Fabians, helping to build a new world. The lower register portrays Shaw in the left corner and his wife, Charlotte Payne-Townshend, in the right.

addition to the Law Society's quarters in Chancery Lane featured windows embellished with "the arms of the various Inns of Court" along with Conrad Dressler's thirteen-panel ceramic reliefs representing "Justice, Human and Divine," emphasizing, appropriately, the Human.[53] Murals by specialists such as Arild Rosenkrantz adorned restaurants like Claridge's and Simpson's, were illustrated in the *Studio*, and found their counterparts in private homes.[54] For a 1903 house outside Leeds, the designer James Gibson embellished the entrance hall with a War of the Roses

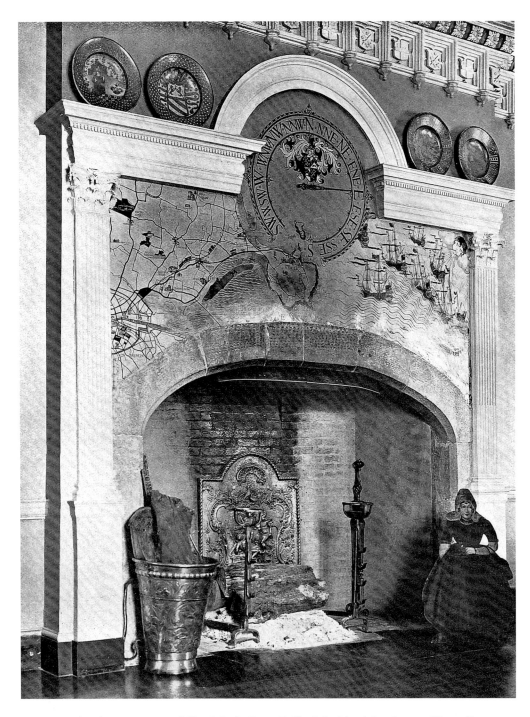

49. Edward Lutyens, overmantel, Howth Castle, County Dublin, Ireland (1910), from Lawrence Weaver, *Houses and Gardens by E. L. Lutyens* (London: Offices of "Country Life" [etc.], 1913), 273. Dartmouth College Library.

theme: two painted panels depicting *The Quarrel in the Temple Gardens* and *The Battle of Bosworth Field* were complemented with Yorkshire and Tudor roses inlaid into the woodwork, embroidered on tapestries, woven into the border of the carpet, and molded into the plaster frieze.[55] Whether referencing a room's function or its location, all of these schemes cast their signifying systems in typically Edwardian historical terms.

The semiotic function of decoration could also be storytelling for its own sake, however. This, according to the artist T. Martin Wood, writing in the *Studio*, was the accomplishment of Charles Conder's 1904 painted decorations in Edmund Davis's house—the so-called Conder room (see the essays by Imogen Hart, Barbara Penner and Charles Rice, and Michael Hatt in this volume). "Looking to them we are not called upon to look into our memory for history, and we are not put out of court in the matter of subject by ignorance of their legend, we are not teased with symbolism," Wood opined.

> There is a purpose about the actions of the figures which evades us, an anecdote in each of the panels that escapes us, and this elusiveness gives us rest—the restfulness which is to be demanded of perfect decoration. Every time these panels engage the eye, the brain returns to them and to the indolent task of unraveling their story, seeking from them stimulus to its own fancy.[56]

Wood's analysis makes explicit the fundamental dynamic of the Edwardian interior as a signifying practice—he compares the Conder room to "the writings of a scholar in which there comes to the surface a knowledge of many times"[57]—that is less about facts concerning the past than about historical fantasies deployed in the present. This returns our attention to the Edwardians, the makers and users of these rooms for whom the look of the interior was deeply significant of identity. Such associations were especially intense in domestic interiors, which, Deborah Cohen has argued, were infused with new ideals of individualism. Whereas Victorian rooms signified the abstract "moral state" associated with "character," as Cohen put it, Edwardian interiors signified a far more individualistic idea of "personality."[58]

Period sources abound in evidence of the Edwardians' belief in the self-expressive domestic interior. Foreigners marveled over what Muthesius, in *Das Englische Haus*, called the "great store that the English still set by owning their home," and he tied this to their "powerful sense of the individual personality. The Englishman sees the whole of life embodied in his house."[59] The individual's choice of styles for decoration expressed a personal relationship to various periods in history, as explicated in a typical passage from a *Country Life* book on Lutyens's designs:

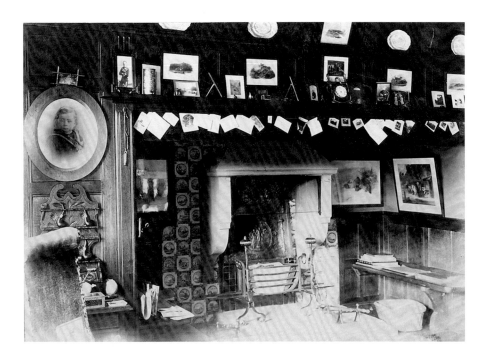

50. "Ote Hall" (ca. 1900). Victoria and Albert Museum, London.

> If we are moved by the ascetic strength of monastic life in the early Middle
> Ages, we shall be greatly touched by the pure splendours of Cistercian build-
> ings. If we are touched by the awakened humanism of the early Renaissance,
> we shall rejoice in the age of Inigo Jones. Perhaps the intellectual march and
> broadening civilisation of the eighteenth century chiefly attract us: then the
> quiet shape of its domestic building will most satisfy.[60]

More specific features were even more individually self-expressive. Families dis-
played craftwork created in the home or by relatives along with pictures—whether
prints, paintings, or photographs—and other souvenirs of travel or residence
abroad, often to overwhelming effect (fig. 50). What strikes viewers today—as it
did at the time—about William Orpen's 1907 painting of William Nicholson's
family in their Bloomsbury dining room is the profusion of pictures crowding the
yellow walls, far outnumbering the four solemn-faced children. The *Studio's*

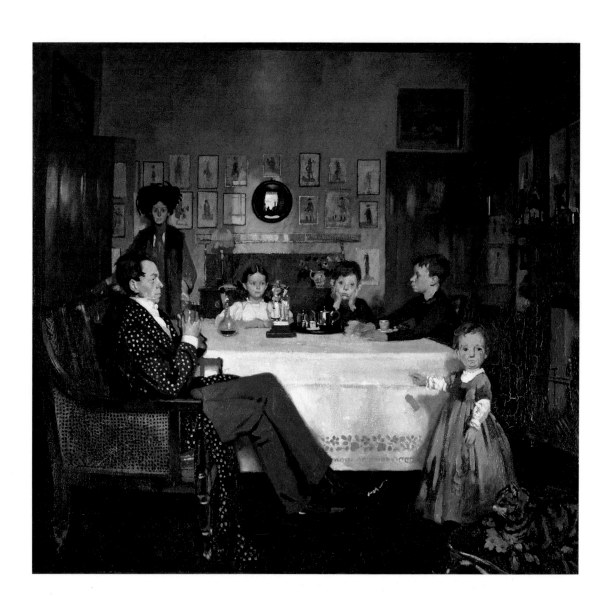

51. William Orpen, *A Bloomsbury Family*, oil on canvas (1907), 34⅛ x 36⅛ in. (86.5 x 91.5 cm). Scottish National Gallery of Modern Art, Edinburgh.

reviewer noted that "scarcely any of the faces show the intimate touch of sympathy which the painter extends to the reflections in the candelabra and the glass of the picture frames" (fig. 51).[61] If, as historians propose, "clutter reached its highest density in Edwardian times," despite experts' warnings to avoid visual excess, this *horror vacui* responded to even stronger exhortations that rooms should express their inhabitants.[62]

If, however, householders courted experts' disapprobation—and, perhaps, the satiric eye of an artist such as Orpen—through over-expression, they also ran risks of revealing more than they intended. "Show me your room, and I will tell you what you are," warned the advice columns in the *House* in 1898.[63] Discussing "the use of mottoes and maxims in connection with the decoration of a house," Baillie Scott opined that "when decoration becomes articulate in the writing on the wall it affords us a better opportunity of judging of the character of its owner," and he advised that "the reticence of the average Englishman . . . will suggest that they should be somewhat cryptic and disposed in such decorative ways as not to be too readily deciphered by the casual observer."[64] This note of caution returns to the themes of anxiety with which this essay began. Self-expression risked self-exposure, especially in a middle-class culture of regular at-home entertaining and among Edwardians, who honed their skills of observation through popular "problem pictures," in which the settings offered clues to the precise social echelon of the protagonists and the secrets of their family dramas.[65] Riskier than Baillie Scott's "casual observer" was the too-observant reader of rooms epitomized by that figure of Edwardian fascination, the detective. Sherlock Holmes was revived in the Edwardian *Return of Sherlock Holmes* stories to read interiors—a scratch on a tabletop, little piles of dirt, scratches on a lock, ashes on the floor—as insightfully as he read people's appearances.[66]

Even if householders were not trying to cover up a crime, the prospect of being read through one's room could arouse anxiety. The *Studio*'s encomiums to successful interior designs created by artists such as Conder for men like Davis—"a true 'patron' of the arts in the best sense of the word"—were shadowed by the specters of "tasteless or unappreciative owners."[67] Admonishing readers to redress the regrettable fact that "there is no individuality and no variety in the ornamentation of our homes," the *Studio* advised householders to turn to artists for help: "Cannot you realise that a really fine scheme of decoration can only be imagined by a great artist, and is not to be bought across a counter?"[68] Artists, as exemplary individualists, were credited with creating properly expressive homes. The *Studio* ran features on the houses of Anatole France ("a home as unique as its possessor," its furnishings "all eloquent with history and souvenir"), of Louis Comfort Tiffany ("the skilful subtlety of his expression reveals a sensitive and a sympathetic personality"),

and of the sculptor George Frampton ("every room shows something of this individuality, something that marks the house as his and that of no other artist," including an eclectic "drawing room with its pictures and furniture of many styles . . . in complete harmony").[69] Yet Baillie Scott condemned "the modern villa with its 'artistic' furnishings and decorations" as itself "the result rather of a blind concession to the demands of convention than a deliberate and personal choice of things loved and chosen for their own sake," and the *Studio* was condescending about "people who are cursed with the conviction that they ought to pose as people of taste."[70] .

What separated the artistic (which was good) from the "artistic" (which was bad)? When was taste simply a "pose"? If the Scottish designer George Logan, analyzed by the *Studio*, could be praised because "he avoids the lazy practice of relying on precedent for justification," yet chastised (in the same sentence) for "his apparent straining after originality," what hope did the average householder have of successfully accomplishing the convoluted ideal articulated in the architect Halsey Ricardo's "Principles of Modern Decoration" (1903), which advised that "'art' in our homes must be a synthesis, the ingredients of which need lay no claim to art or to the exhibition of any personal feeling," so that a visitor would feel "the works of art, affectionately chosen . . . gave a further and amiable sidelight into the character of his host."[71] No wonder Edwardian readers flocked to Sherlock Holmes's antithesis, the crook Raffles, invented by E. W. Hornung, Arthur Conan Doyle's brother-in-law. Raffles's rooms successfully mask their inhabitant with duplicitous reproductions of Pre-Raphaelite paintings suggesting that "the man might have been a minor poet instead of an athlete of the first water," a disjunction that reminds the narrator "of yet another of his many sides"—occasioning, of course, another tale of undetected crime carried off by disguise and impersonation.[72]

No wonder, too, that the Edwardian interior, as it appeared in fiction, seemed, as in Sackville-West's *The Edwardians*, an obligation so onerous that it had to be escaped or, as in *Howards End*, an ideal so fugitive that it could not be sustained. Individualism, the quality that Edwardians looked to interiors to signify, was an ever-receding ideal, fundamental to middle-class identity under capitalism, yet increasingly impossible to enact in a culture dominated by mass-produced objects and mass-mediated imagery. This paradox is captured in that definitive feature of the Edwardian interior, the inglenook, the prime site of the individualized leisure that marked the educated middle class. *The British Home of Today* (1904) quoted the architect John Cash explaining: "How comfortable a retreat the fireplace may be is realized only by those who have whiled away an hour or two in some deeply recessed ingle, on a broad cushioned seat with high, restful, sloping back, and close at hand a few shelves of books."[73] More fundamentally, however, inglenooks con-

noted, to quote *Cassell's Household Guide*, "the modern hatred of the expected," that is, individuality—or, rather, the modern oxymoron of a conformist individuality that defers to the expectation of eschewing the "expected."[74] This paradox, because it is as relevant now as a century ago, lies at the heart of another: the persistence into our own day of the evanescent Edwardian interior. Today what seems dated are the modernists' claims to functionality and truth to materials in a timeless present where being and seeming are one and aspirations for individualism cede to "the spirit of living in mass-production houses" (to quote Le Corbusier). With modernist interiors now cast as one "retro" design option among many, the historical language of Edwardian interiors, even—maybe especially—when frankly fantastical, seems to speak again to our desire, in the present, to signify individual identities that incorporate memory and futurity. We echo the Edwardians in the hope voiced by Margaret Schlegel in *Howards End* that "our house is the future as well as the past."

1. Much of what I describe as characteristic of the Edwardians extends trends from the 1890s that continued into the 1910s.

2. Vita Sackville-West, *The Edwardians* (1930; repr., New York: Viking, 1958), 2–3, 7.

3. E. M. Forster, *Howards End* (1910; repr., New York: Random House, 1921), 8, 15, 107. Elsewhere in *Howards End* (47), Forster used other metaphors to make the same point: "bricks and mortar rising and falling with the restlessness of the water in a fountain, as the city receives more and more men upon her soil."

4. Forster, *Howards End*, 8, 48, 273, 339.

5. Peter Laslett, *The Listener*, 28 Dec. 1961, quoted in Marghanita Lasky, "Domestic Life," in *Edwardian England*, ed. Simon Nowell-Smith (London: Oxford Univ. Press, 1964), 142. Lasky reported, "In 1901 there were seven million households in England and Wales. Only 400,000 people declared their income for tax purposes at more than £400 a year, and income tax, which started on incomes of £160 a year, was paid by fewer than a million people." Lasky, "Domestic Life," 142. For an overview of this topic, see T. R. Gourvish, "The Standard of Living, 1890–1914," in *The Edwardian Age: Conflict and Stability, 1900–1914*, ed. Alan O'Day (London: Macmillan, 1979), 13–34.

6. C. F. G. Masterman, *The Condition of England* (London: Methuen, 1909), 70.

7. Jane Beckett and Deborah Cherry, eds., *The Edwardian Era* (London: Phaidon Press and Barbican Art Gallery, 1987), 18, and Lisa Tickner, *The Spectacle of Women: Imagery of the Suffrage Campaign, 1907–14* (Chicago: Univ. of Chicago Press, 1988), 218–19, pl. xv.

8. R. J. Minney, *The Edwardian Age* (Boston: Little, Brown, 1964), 138.

9. Alastair Service, *Edwardian Interiors: Inside the Homes of the Poor, the Average and the Wealthy* (London: Barrie and Jenkins, 1982), 23.

10. Service, *Edwardian Interiors*, 9, and Helen C. Long, *The Edwardian House: The Middle-Class Home in Britain, 1880–1914* (Manchester: Manchester Univ. Press, 1993), 2.

11. It should be noted that, unlike the other magazines listed here, the *Studio* also regularly published Continental interiors, disseminating these models both within Britain and throughout the Anglophone world.

12. Quintan Colville, "The Role of the Interior in Constructing Notion of Class and Status: A Case Study of Britannia Royal Naval College, Dartmouth, 1905–1939," in *Interior Design and Identity*, ed. Susie McKellar and Penny Sparkes (Manchester: Manchester Univ. Press, 2004), 118.

13. Peter Inskip, "Lutyens' Houses," in *Edwin Lutyens*, ed. David Dunster, Architectural Monographs 6 (1979; repr., London: Academy Editions, 1986), 10. For Home Place, see Richard Fellows, *Edwardian Architecture: Style and Technology* (London: Lund Humphries, 1995), 147, and Roderick Gradidge, quoted in Gavin Stamp and André Goulancourt, *The English House 1860–1914: The Flowering of English Domestic Architecture* (Chicago: Univ. of Chicago Press, 1986), 39.

14. The tendency of institutionalized art and design history to emphasize the voices of would-be reformers is tartly—but aptly—rebuked by the historian Deborah Cohen: "A waste-paper basket fashioned from an elephant's foot betrays the aspirations of its Edwardian owners; a decorous C.F.A. Voysey wallpaper pattern that never went into production, by contrast, tells us chiefly about what museums have considered worthy design." Cohen, *Household Gods: The British and Their Possessions* (New Haven: Yale Univ. Press, 2006), xv.

15. The quoted phrase is from Fellows, *Edwardian Architecture*, 8. Lenora Auslander has argued that the meanings attached to various design styles in Germany and Britain were more various than in France, where the unique "French experience of the Revolution" created more specific associations with historical moments that styles evoked. Auslander, *Taste and Power: Furnishing Modern France* (Berkeley: Univ. of California Press, 1996), 259.

16. Lawrence Weaver, *Houses and Gardens by E. L. Lutyens* (London: Country Life, 1913), vii–viii.

17. Roger Fry, "A Possible Domestic Architecture" (1917), reprinted in *Vision and Design* (London: Chatto and Windus, 1920), 273–74, 276.

18. Stamp and Goulancourt, *English House*, 39.

19. Charles A. Jencks, *The Language of Post-Modern Architecture*, 5th ed. (New York: Rizzoli, 1987), 87, 88. Jencks's early and influential taxonomies of postmodernism return repeatedly to what he called "the central role of communicating with the public" using "art, ornament, and symbolism." Ibid., 6–7.

20. Roger Fry, unpublished lecture, ca. 1932, Modern Archives, King's College, Cambridge (1/129). For Fry's antagonism to International Style modernism, see my *Bloomsbury Rooms* (London: Yale Univ. Press, 2004), 251–53.

21. Barry Parker and Raymond Unwin, *The Art of Building a Home* (London: Longmans, Green, 1901), iv–vi.

22. "A House and Garden," *Country Life*, 9 May 1903, 602–11, quotations from 602, 606.

23. Christopher Hussey, *The Life of Sir Edwin Lutyens* (London: Country Life, 1950), 95.

24. Cohen, *Household Gods*, 32–33, 57–59; see also Deborah Cohen, "Why Did *The House* Fail?: Demand and Supply Before the Modern Home Magazine, 1880s–1900s," *Journal of Design History* 18, no. 1 (2005): 35–42.

25. P. Anderson Graham, "Old Houses in Kent and Sussex" (review of *Old Cottages and Farmhouses in Kent and Sussex*, photographed by W. Galsworthy Davie), *Country Life*, 5 Jan. 1901, 5. The success of *Country Life* must have influenced the *Studio*'s decision in 1904 to start a regular feature, "Recent Designs for Domestic Architecture," focusing on rural manors and cottages.

26. Harold Begbie, "To the New Century," *Country Life*, 5 Jan. 1901, 7.

27. "Yanwath Hall, Westmorland, A Border Home of the Fourteenth Century," *Country Life*, 25 July 1903, 126.

28. "Broughton Castle, Banbury," *Country Life*, 20 Jan. 1901, 112.

29. [Arthur] Beresford Pite, "Modern House Design," *Architectural Review* 8 (July–Dec. 1900): 153–55.

30. S. S. G., "Notes," *Architectural Review* 19 (Jan.–June 1906): 21–22.

31. Lynne Walker has argued that in Britain, worrisome Continental associations with the Baroque were eased by the Entente Cordiale, which allied Britain and France in 1904; see Walker, "Heart of Empire / Glorious Garden: Design, Class and Gender in Edwardian Britain," in Beckett and Cherry, *Edwardian Era*, 117–18.

32. C. F. A. Voysey, in a 1911 lecture to the Design Club, put this distinction pithily: "Renaissance is a process by which plans and requirements are more or less made to fit a conception of a more or less symmetrical elevation, or group of elevations. The design is conceived from the outside of the building and worked inwards. Windows are made of a size necessary to the pleasant massing of the elevation, rather than to fit the size and shape of rooms. The Gothic process is the exact opposite; outside appearances are evolved from internal fundamental conditions; staircases and windows come where most convenient for use." For Voysey this was what gave medieval architecture "a soul." Quoted in John Brandon Jones, "C. F. A. Voysey," in *Victorian Architecture*, ed. Peter Ferriday (London: Jonathan Cape, 1963), 273.

33. Such attitudes followed the professionalization of architecture, which widened the hierarchical distinction between those who designed buildings and those who furnished them, leaving the design of interior spaces unaddressed. Although the *Architectural Review* illustrated interiors, it rarely deigned to discuss them. So fixated on this outside-in approach was the *Review* that it complained about Parker and Unwin's *Art of Building a Home*: despite the "ingenious" plans and copious illustrations of interiors, the *Review* stated, "It is a pity that the authors do not give a few more views of the outside of their houses; as it is we are left a little in the dark as to the measure of success they have achieved in the application of their principles." Ernest Newton, "The Art of Building a Home," *Architectural Review* 11 (Jan.–June 1902): 36. The *Review* was much more condescending to books that treated the interior as a topic: for example, an anonymous review of *The Apartments of the House*, by Joseph Crouch and Edmund Butler, in *Architectural Review* 9 (Jan.–June 1901): 239–40. The *Studio*, in contrast, complained about "the almost universal practice of making the decoration of a room, or a building, a kind of afterthought," and it heralded the rare instances of collaboration between architect and designer; see, for example, A. L. Baldry, "A Notable Decorative Achievement by W. Reynolds Stephens," *Studio* 34 (1905): 3. The exemplary attention given to the interiors—especially the plasterwork—of Wrenaissance buildings in Richard Fellows, *Edwardian Civic Buildings and Their Details* (Oxford: Architectural Press, 1999), far exceeds that of period sources.

34. *Country Life* published features on more than twenty Lutyens houses, in contrast to the *Architectural Review*, which featured only two. See Daniel O'Neill, *Sir Edwin Lutyens: Country Houses* (New York: Watson-Guptill, 1981), 42–43.

35. Jane Brown, *Lutyens and the Edwardians: A English Architect and His Clients* (New York: Viking, 1996), 78–81.

36. Weaver, *Houses and Gardens by E. L. Lutyens*, 183.

37. Inskip, "Lutyens' Houses," 27, 48; illustrations in Weaver, *Houses and Gardens by E. L. Lutyens*, figs. 181–186. Lutyens's admirers strained to justify this hall, which, it is acknowledged, "can only be used as a public room. If such planning is to be judged on economic grounds it obviously fails, for a large proportion of the cubic space is, as an economical planner would say, wasted. Waste, however, is a relative word, and takes no account of aesthetic purpose. If the disposition of the hall, etc., at Little Thakeham had been devised for a hotel where every cubic foot of space had to earn a dividend, it would manifestly have been bad planning. As it was for a private house, the owner of which wanted to secure a distinct and distinguished architectural effect, it was not only good but brilliant planning." Weaver, *Houses and Gardens by E. L. Lutyens*, 106.

38. Service, *Edwardian Interiors*, 61.

39. Richard Norman Shaw's 170 Queen's Gate (1887–88), often cited as his breakthrough into neoclassicism, also features a balcony over the fireplace; illustrated in Andrew Saint, *Richard Norman Shaw* (New Haven: Yale Univ. Press, 1976), 247.

40. Service, *Edwardian Interiors*, 64; see illustration, 62. Compare the illustration of an inglenook in a house designed by Holland W. Hobbis, *Studio* 40 (1907): 124.

41. Claims for the newness of the Edwardian neoclassical tend to hang on Lutyens's conversion in about 1906, or more precisely on Voysey's condemnation of Lutyens's discovery of the "High Game" of classical architecture for leading a new generation of architects astray. See Stamp and Goulancourt, *English House*, 42. In peering through the dust kicked up by this clash of titans, however, it is clear that the Wrenaissance had encroached on domestic design even before the Edwardian era and even in the bucolic suburbs that were the heartland of Tudor-style cottages. Alastair Service has reported, "By 1900, many neo-Georgian house designs were appearing in the architectural magazines and in the architectural section of the Royal Academy summer exhibition." Service, *Edwardian Architecture* (London: Thames and Hudson, 1977), 172. For illustrations of typical neo-Georgian domestic interiors of about 1902, see Service, *Edwardian Interiors*, 102, 103. More prominent early examples include Leonard Aloysius Stokes's Yew Tree Lodge in Streatham Park (1898–99), for which see Stamp and Goulancourt, *English House*, 202–3; and John Belcher's 1901 Cornbury Park, Oxfordshire (1901), for which see Mark Girouard, *Life in the English Country House* (London: Yale Univ. Press, 1978), 310, and *Architectural Review* 13 (Jan.–June 1903). In 1897 Reginald Blomfield published *A History of Renaissance Architecture in England*, followed by *A Shorter History of Renaissance Architecture in England* in 1900, cementing his reputation among the most eminent and erudite architects associated with the Wrenaissance. Although he is today remembered primarily for his commercial and institutional buildings, Blomfield described domestic architecture as "the most attractive part of an architect's work." Quoted in Fellows, *Edwardian Architecture*, 141. Blomfield deployed his signature neoclassical style in the country house Caythorpe Court, Lincolnshire (1901). See Service, *Edwardian Interiors*, 113.

42. Long, *Edwardian House*, 144.

43. "'The Studio' Prize Competitions," *Studio* 50 (1910): i; "Recent Designs in Domestic Architecture," *Studio* 49 (1910): 135–36.

44. "Some Recent English Designs for Domestic Architecture," *Studio* 25 (1902): 113, 114; the first quote is repeated almost exactly in the feature of the same title in *Studio* 33 (1904): 128. Competitive claims to embody progress characterize modern art and design movements generally and are often rather uncritically adopted by historians, although evolutionary schemas invariably flatten out the complexity of the historical moment and obscure what are actually ideological contests. The latter is especially clear in the case of Edwardian domesticity, where designers like Charles Rennie Mackintosh and Mackay Hugh Baillie Scott, who are dismissed as old-fashioned in accounts that progress to the British Wrenaissance, are exactly the British architects heralded in accounts that progress to the Bauhaus.

45. M. H. Baillie Scott, "A Country Cottage," *Studio* 25 (1902): 88, 89.

46. Quoted in James D. Kornwolf, *M. H. Baillie Scott and the Arts and Crafts Movement: Pioneers of Modern Design* (Baltimore: Johns Hopkins Univ. Press, 1972), 402.

47. M. H. Baillie Scott, "'Yellowsands.'—A Sea-side House," *Studio* 28 (1903): 189.

48. M. H. Baillie Scott, "A Cottage in the Country," *Studio* 32 (1904): 124.

49. C. F. A. Voysey, "Remarks on Domestic Entrance Halls," *Studio* 21 (1900): 244. The anecdote about Wells is recounted in Jeremy Cooper, *Victorian and Edwardian Decor from the Gothic Revival to Art Nouveau* (New York: Abbeville, 1987), 195.

50. Hilary Hockman, *Edwardian House Style: An Architectural and Interior Design Source Book* (Devon: David and Charles, 1994), 111; Long, *Edwardian House*, 165.

51. For Shaw's window, which was recently recovered, having been stolen in 1978 from the Beatrice Webb house, see the London School of Economics press release "A Piece of Fabian History Unveiled at LSE," www.lse.ac.uk/collections/pressAndinformationOffice/newsAndEvents/archives/2006/FabianWindow. For Lutyens's overmantels, see Weaver, *Houses and Gardens by E. L. Lutyens*, 33, 241–42, 274, figs. 58, 412.

52. "Stained Glass in House Decoration," *Country Life*, 23 May 1903, 666–69.

53. "Current Architecture," *Architectural Review* 19 (Jan.–June 1906): 120–28.

54. Rosenkrantz's depiction of Old King Cole, captioned, "Was it not a Dainty Dish to set before a King," at Simpson's was illustrated in the *Studio* 40 (1907): 124. Similar decorations of medieval scenes adorn the area above the dado in the dining room of 9 Hyde Park Terrace, London, illustrated as the work of the architect J. Leonard Williams, in the *Architectural Review* 18 (July–Dec. 1905): 149. The *Review* in 1904 initiated a series to promote the use of murals by architects; see Walter Bayes, "Architecture and Painting I.—The Return of the Prodigal," *Architectural Review* 16 (July–Dec. 1904): 195–201.

55. "Some Recent Designs for Domestic Architecture," *Studio* 33 (1905): 313.

56. T. Martin Wood, "A Room Decorated by Charles Conder," *Studio* 34 (1905): 205.

57. Wood, "Room Decorated," 205.

58. Cohen, *Household Gods*, xii; see also 84–86, 124–25, 134–36.

59. Hermann Muthesius, *The English House*, trans. Janet Seligman (New York: Rizzoli, 1979), 7.

60. Weaver, *Houses and Gardens by E. L. Lutyens*, xxiv.

61. T. Martin Wood, "The New English Art Club's Exhibition," *Studio* 44 (1908): 136.

62. Service, *Edwardian Interiors*, 36; see also 74, 100–103, and Cohen, *Household Gods*, 127–30, 141.

63. "Penelope," "Illustrated Answers to Correspondents," *House* 20, no. 4 (Oct. 1898): 80, quoted in Cohen, *Household Gods*, 138–40.

64. Baillie Scott, "'Yellowsands,'" 191–92.

65. Pamela M. Fletcher, *Narrating Modernity: The British Problem Picture, 1895–1914* (Burlington, Vt.: Ashgate, 2003), 76.

66. Arthur Conan Doyle, *The Return of Sherlock Holmes*, in *The Complete Sherlock Holmes* (New York: Doubleday, n.d.), 599–600, 614, 621; these stories were originally published in 1903–4.

67. Wood, "Room Decorated," 202, and W. R. Watson, "Some Recent Scottish Domestic Fittings and Decorations," *Studio* 27 (1902): 109.

68. "The Lay Figure: On Domestic Decoration," *Studio* 32 (1904): 182.

69. Frederick Lawton, "The Home of Anatole France as Depicted by Pierre Calmettes," *Studio* 42 (1907): 211–15; Samuel Howe, "An American Country House," *Studio* 42 (1908): 294–96; and "Recent Designs in Domestic Architecture," *Studio* 49 (1910): 213, 217.

70. Baillie Scott, "'Yellowsands,'" 186, and "The Lay Figure: On the Decoration of Houses," *Studio* 36 (1905): 192.

71. "A Glasgow Designer: The Furniture of Mr. George Logan," *Studio* 30 (1903): 202, and Halsey Ricardo, "The Principles of Modern Decoration," *The World: A Journal for Men and Women*, 30 June 1903, 1126. I am grateful to Deborah Cohen for providing me with +this document.

72. E. W. Hornung, *The Amateur Cracksman* (New York: Charles Scribner's Sons, 1899), 13. In addition to the specifics of his various crimes, Raffles's fundamental crime was also a kind of extreme class mobility, in which this "amateur cracksman" (a phrase strongly associated with gentlemen cricketers, as opposed to working-class professionals) could pass for anyone from a duke to dustman.

73. W. S. Sparrow, ed. *The British Home of Today: A Book of Modern Domestic Architecture and the Applied Arts* (London: Hodder & Stoughton, 1904), quoted in Cooper, *Victorian and Edwardian Decor*, 225.

74. *Cassell's Household Guide to Every Department of Practical Life: Being a Complete Encyclopedia of Domestic and Social Economy*, quoted in Long, *Edwardian House*, 35.

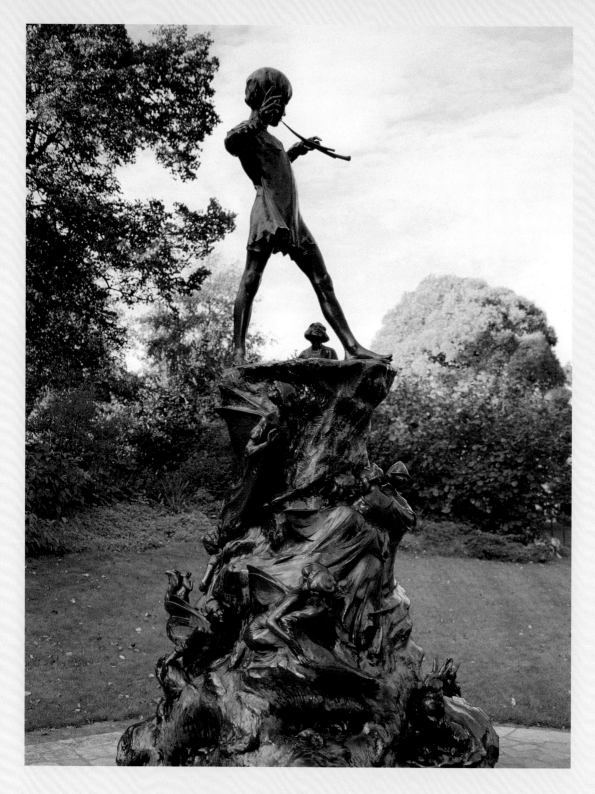

52. George Frampton, *Peter Pan*, bronze (1912). Kensington Gardens, London.

PLACE

Peter Pan and the Role of Public Statuary

Anne Helmreich

> For Peter Pan looks like being the child-legacy of the Edwardian era as Alice
> was of the age of the great Victoria.
>
> *—Pall Mall Gazette*

T HE *PALL MALL GAZETTE*'s prediction, occasioned on the display of the
model of George Frampton's statue of Peter Pan destined for Kensington
Gardens (fig. 52), was in tune with the overwhelming success of J. M. Barrie's play
Peter Pan, or the Boy Who Would Not Grow Up, first performed on 27 December 1904,
and borne out by the critical response to Frampton's statue, erected in 1912. Peter
Pan continues to cast a long shadow: Frampton's statue has evolved into a pilgrimage
site for tourists of all ages, and Barrie's tale of Peter Pan certainly has proved resilient,
given new life by theatrical productions, peanut butter, and Walt Disney.

Frampton's statue is indicative of both the "New Sculpture" movement and a
pronounced change in Kensington Gardens, first built as a royal garden but, by
the Edwardian era, reimagined as a public park (fig. 53). The statue also became a
lightning rod for debates in the popular press about the role of public statuary in
the modern age. Such discussions indicate that the transformation of Kensington
Gardens, while seemingly inexorable, was not without resistance.

Peter Pan was the invention of Barrie, a Scottish playwright and novelist, who
recalibrated the ancient mythical figure of Pan for the modern age of nurseries
and fairy tales. Peter Pan, whose commercial potential was not fully realized until
Frampton's statue was well ensconced in the popular imagination, was nonetheless
a serial phenomenon. He first appeared in several chapters of Barrie's novel *The
Little White Bird; or, Adventures in Kensington Gardens* (1902), which became the
basis of the children's novel *Peter Pan in Kensington Gardens*, with illustrations by
Arthur Rackham (1906), as well as the 1904 play, and he reappeared in the novel
Peter and Wendy (1911).

Barrie reinforced the links between Peter Pan and Kensington Gardens on
the dedication page to the published play, when he rhetorically asked "the Five"

(presumably the five young boys of the Llewellyn Davies family, whom he had befriended), "We first brought Peter down, didn't we, with a blunt-headed arrow in Kensington Gardens?"[1] Barrie rendered the gardens central to the story with his address to readers in the opening to *Peter Pan in Kensington Gardens*: "You must see for yourselves that it will be difficult to follow Peter Pan's adventures unless you are familiar with the Kensington Gardens." Wittily describing the locale from a child's point of view, he noted that this London landscape was "bounded on one side by a never-ending line of omnibuses." Furthermore, "the Gardens are a tremendous big place, with millions and hundreds of trees"; the Broad Walk "is as much bigger than the other walks as your father is bigger than you"; and the Serpentine has "a drowned forest at the bottom of it." Here, in the Serpentine, is an island, populated by all the birds who will "become baby boys and girls"; Peter Pan is the only human permitted there.

In this narrative, echoed by Rackham's illustrations, Peter Pan is a baby, seven days old, when he is lured out of his window by the trees of Kensington Gardens. On the advice of the large black bird Old Solomon Caw, Peter Pan comes to reside on the island, soon returning to a quasi state of nature as birds take pieces of his nightgown "to line their nests" and Peter "hid the rest." He takes up the panpipe but is still inconsolably sad because he is no closer to his desired gardens as a castaway on the island. Moreover, "how he longed to play as other children play, and of course there is no such lovely place to play in as the Gardens." Later in the narrative, Barrie underscored the desirability of the gardens by informing readers, "Long ago children were forbidden the Gardens."[2] Once children were admitted, he continued, so was the magic of fairies, who "dress exactly like the flowers, and change with the seasons, putting on white when lilies are in and blue for bluebells, and so on"—a fanciful notion with roots in late Victorian texts such as Walter Crane's illustrated *Flora's Feast: A Masque of Flowers* (1890) and John Ruskin's exegesis of the flower painters Kate Greenaway and Helen Allingham in *The Art of England* (1883–84). Childhood, in these narratives, is akin to a pastoral state, unspoiled by materialism and adult cares and tinged with nostalgia.

Barrie's claim that children were forbidden from the gardens was a bit of dramatic license that nonetheless had some factual basis inasmuch as the original landscape was intended as a pleasure garden, a space for adults rather than children. Lucy Trench has aptly described Kensington Gardens as "a 'layered' landscape, in which the early Georgian formal garden is overlaid with the decorative features of a Victorian park."[3] The gardens were intended to accompany Kensington Palace, an expansion of Nottingham House commissioned from Christopher Wren. The formal Dutch gardens on the south side of the house were removed by Queen Anne, who commissioned Henry Wise to create an expanded landscape by

53. Map of Kensington Gardens and Hyde Park (detail), from *The Blue Guides, Appendix, Cabs, Omnibuses, Tramways & Underground Railways and Plans of London with Street Index* (London: Muirhead Guide-Books Limited, 1918), opp. 16. Courtesy of the Yale University Library.

encompassing one hundred acres from Hyde Park and thus allowing for a deer park and, closer to the house, a wilderness and sunken garden. Charles Bridgeman, hired by Queen Caroline, reworked (perhaps in collaboration with William Kent) the broad landscape he inherited from Wise, replacing "the paddock with a *patte d'oie* of radiating, tree-lined *allées*" and creating a series of water features—"the Long water"—culminating in the Serpentine.[4] A ha-ha (a ditch with a retaining wall) divided the private garden from Hyde Park, which was nonetheless visually assimilated to the fabric of Kensington Gardens.

With Queen Victoria's decision to reside at Buckingham Palace, Kensington Gardens were opened to the public and, as Trench puts it, the "character of the gardens gradually changed."[5] Most visible was the construction around the gardens of iron railings (to which Barrie's balloon lady desperately clings in order to remain earthbound), as well as a bandstand and other markers of public use, such as lavatories.

Public accessibility, however, was limited by the gates, locked nightly in the Victorian and Edwardian eras. Barrie reportedly had a key to the gardens, which, according to the *Glasgow Evening News*, "enables him to roam in them after they are officially closed. It is a privilege possessed by no one else except commissioners of works and people of that sort, and it is strange that the extremists in Parliament have had nothing to say on the subject."[6] This same news report was among the first to name Barrie as the patron of the statue of Peter Pan recently commissioned from George Frampton.[7]

Peter Pan, as a fictional character, released Frampton from any obligation of portraiture, and Frampton reported to the *Morning Leader* (London) that he "had three models, and I took the best from each. The coat is the coat Peter wore in the play." He rejected the conception of Peter as a baby that was promulgated in *Peter Pan in Kensington Gardens* in preference for the youth of the play; the site for the statue, however, adhered to the book as it was "where Peter Pan landed from his barque on the Serpentine."[8]

Familiarity with Peter Pan makes it difficult for viewers today to recognize the statue's innovation. Frampton clearly did and orchestrated a publicity campaign for the statue, which enjoyed general approbation, with the exception of at least one prominent critic (as discussed below). In 1910 Frampton cultivated many critics by opening his studio to reporters in order to share a small-scale model of the statue, vividly described in press accounts.[9] In 1911 a full-scale model was exhibited at the Royal Academy annual exhibition, and on that occasion both artist and reporters remarked on perhaps its most unusual feature: the lack of a traditional base. The *Birmingham Dispatch* observed that as a result, "The children who come to see it, near where they now feed the ducks, need not regard it as a statue but as

some delicate, graceful thing that belongs to them."[10] Frampton, in an interview for the *Morning Leader*, explained that he omitted a pedestal so that the statue would appear "that it has simply grown out of the ground."[11] Such earthy connections were to be reinforced by a planting of flowers, "in a natural way," around the base. The label "natural" suggests a reference to the gardener and designer William Robinson, who had challenged the prevalent system in public gardens of planting brightly colored exotics and hybrids and instead advocated utilizing hardy perennials arranged in imitation of nature, a practice described in his *English Flower Garden* (1883), republished in numerous editions in the late Victorian and Edwardian periods and taken up by the designer-writer Gertrude Jekyll.

The foundation of Frampton's work, modeled to resemble gnarled tree roots, suggests an entire ecosystem, its surface populated with fairies, scampering rabbits, sniffing mice, flirtatious squirrels, perambulating snails, and Caw, nearly hidden in a recess in the tree. A quality of dynamic energy, reinforced by the flowing gowns of the fairies, carries through the slim figure of Peter Pan, who strides forward, arms raised and pipe to lips, as a fairy lifts herself, smilingly, to his platform atop the lopped tree trunk.

The notion that the statue would appear to emerge from the ground and echo, albeit imaginatively, motifs found in nature binds boy and nature together, a sentiment compatible with nineteenth-century notions that children are closer to nature than adults. Both nature and child, in their ideal state, are pure and unadulterated, according to such rhetoric. As Ruskin declared, in his lecture on Allingham and Greenaway, "The radiance and innocence of reinstated infant divinity" was "showered again among the flowers of English meadows."[12]

The statue was placed in situ in May 1912, concealed behind curtains during installation; overnight the curtains were removed so that "the children will just find Peter Pan there as if he had grown out of the turf on May morning."[13] Newspapers reported "hundreds of children with their nurses flocked to the statue in the course of the day."[14] The statue, located by the bank of the Serpentine, was flanked by a raised mound, theatrically planted with shrubs and flowers that created a sheltered nook. Daffodils and other bulbs were scattered, in naturalistic fashion, across the arced grassy bank (fig. 54). A flagstone path circled the statue to invite circumambulation.

Turning the opening into a children's activity brings into relief the reinvention of Kensington Gardens as a space appropriate for children, no longer reserved for promenades of the royals and the fashionable set. Increasingly, over the course of the nineteenth century, parks came to be designed to encourage healthful leisure activities, charged with moral value and aimed at the broad middle classes. In London, in the mid-1840s, Victoria Park, to the east, and Battersea Park, to the

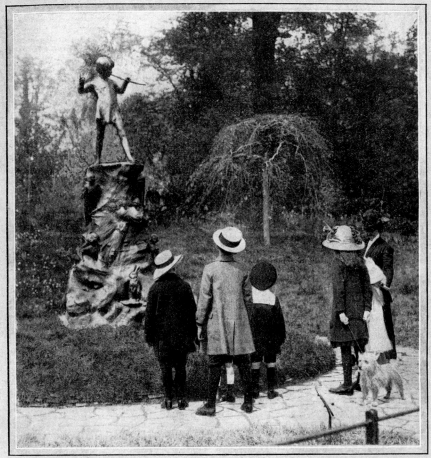

THE DAILY GRAPHIC, THURSDAY, MAY 2, 1912.

ANOTHER "AWFULLY BIG ADVENTURE" FOR PETER PAN.

"Peter Pan" has embarked upon another "awfully big adventure"—it is to live for ever in his own Kensington Gardens, quite close to the Serpentine, where he will listen all day and every day to the personal remarks made by his little worshippers. To some this might be more of an ordeal than an adventure, but not to the "Boy Who Wouldn't Grow Up." For, thanks to the genius of Mr. Barrie, "Peter" has become a very real and a very dear person to little people, and those who do believe in fairies will have nothing but what is nice to say about him as they stand before his bronze representation. To Mr. Barrie, who has presented the statue, and to Sir George Frampton, who has so cleverly interpreted the spirit of "Peter Pan" in metal, the children of all time will say "Thank you."

PETER PAN IN BRONZE.

STATUE THAT CAME TO KENSINGTON GARDENS BY NIGHT.

When, with the break of yesterday, the morning sunlight began to weave its golden patterns on the leafy foliage of Kensington Gardens, it came to shed effulgence over a little boy made of bronze.

This is the statue of Peter Pan, who is the little patron saint of Kensington Gardens. He came somehow, from somewhere in the night, so that it can be said again with the truth that Peter is the boy who never grew up. He has taken

lies, while the babies stare at him with that lofty air of inscrutable wisdom which is so peculiarly their own.

And what wonderful mornings when a sort of sighing, everywhere yet nowhere, goes up from the slumbrous trees when the elfs scuttle home to bed across the short, keen-bladed grass into the mazes of elfin-spun ferneries, where a fairy's diamonds glitter in the cobweb leaves! And what wonderful nights when the darkening shadows collect amid the now grey meadows like flocks of ghostly sheep, when in his solitude he will pipe beneath a trellis work of cool stars and feel a night wind freshening up from the softness and dusk of the shrouded trees! Who will attend to his pipings then? Will he descend from his tree and sport awhile beneath the moonshine with Puck and Master Cobweb? Will he sail the Serpentine in a boat of water-lilies?

Who shall tell us? Who shall know! Perhaps little Peter will one day whisper the secrets of

"DAILY GRAPHIC" SUMMER FUND.

The attention of those who wish to assist the Summer Relief Scheme in connection with the DAILY GRAPHIC Charity is directed to the coupon printed at the top of the first column on page 2.

One hundred of these coupons represent a week's holiday for a convalescent case, or daily dinners for a mother and her child during a whole month. Coupons should be sent once or twice a week in order to facilitate the work.

Please cut out the Coupon on page 2, and post to the Relief Editor, "Daily Graphic," Tallis House, Whitefriars, E.C. A halfpenny stamp is sufficient postage if the envelope is unsealed.

54. "Another 'Awfully Big Adventure' for Peter Pan," from *Daily Graphic* (London), 2 May 1912, 3. The Trustees of the National Library of Scotland.

west, were begun; in 1852 Kennington Common was enclosed to form a park, and, toward the end of the century, the Kyrle Society, which was founded in 1877 to support beautification projects, established Vauxhall Park. Early designs for public parks emphasized walks, and not until later in the nineteenth century were public parks increasingly regarded as appropriate places for games and play.[15] Concern to ensure that Britain's children were given access to exercise and fresh air was further fueled by the dismal findings of the *Report of the Inter-Departmental Committee on Physical Deterioration* (1904).

But parks were not merely sites for leisure activity. They were also public locales dedicated to commemoration and memorialization. The latter understanding of the public park provoked Robbie Ross, former confidant of Oscar Wilde and manager of the Carfax Gallery in London, to write a series of negative notices about Frampton's statue in the *Morning Post* (London), lambasting the choice of a figure of popular culture, or what he referred to as a "trivial idea," for a permanent monument:

> When so many great men, so many great movements, are unrecorded in the London streets and parks there is something ineffably sad in the thought that this twaddling composition should be erected at all; that anyone should be found ready to perpetuate their sickly sentimentality. How dismal a comment on the emasculation of an age which prefers the memory of a pretty fantasy to that of the stately figures which adorned the Victorian and other eras of our history.[16]

Haranguing Barrie's supporters, he queried what would happen if every well-known fictive character received a statue in Kensington Gardens; if so, he predicted, "We shall have Kensington Gardens looking like a branch of a newspaper book club, or a sort of Mudie *en plein air*." A supporter of Auguste Rodin (whom he had worked strenuously to represent at the Carfax Gallery), he thought the subject of Peter Pan to be beneath the "dignity of sculpture and the dignity of literature," and, his diatribe implied, beneath the dignity of a public park.[17]

The debate spread to other journals. *Everybody Weekly* (London), in sympathy with Ross, published a cartoon of other juvenile characters as statues (fig. 55). In retort, Frampton's supporters defended the appropriateness, perhaps even the need, for a memorial "to perpetuate a Twentieth Century god of youth and joyousness refusing to grow up into a utilitarian age" and, moreover, insisted that Kensington Gardens was "its proper environment," for "surely since the childhood of Victoria of blessed memory Kensington Gardens have been sacred to the dreams and laughter of childhood."[18] As another publication expressed it,

55. Illustration accompanying "A New Line in Statues," from *Everybody Weekly,* 29 May 1911, between 14 and 15, from scrapbook of clippings about George Frampton. Victoria and Albert Museum, London.

Yet a more excellent site for this piece of work, which symbolizes the idyllistic side of young life in the Twentieth Century, it would be difficult to discover. To the charm of Kensington Gardens there is the added atmosphere of a resort of children from the time of Queen Victoria herself, making the environment and the statue thoroughly en rapport.[19]

The public debate about Frampton's statue thrust into light competing claims to Kensington Gardens as part of the civic fabric. On the one hand was Ross's camp, which envisioned the gardens as a decorous site for national commemoration—indeed, nearby in Hyde Park were the monumental memorial to Prince Albert and George Frederic Watts's heroic equestrian tribute, *Physical Energy* (1906; fig. 56).

56. George Frederic Watts, *Physical Energy,* bronze (1906). Kensington Gardens, London.

A cast of the latter was also chosen as the grave marker for Cecil Rhodes upon his death in 1902, forever linking Watts's motif of horse and rider, on which he had labored for decades, with "the energy & outlook so peculiarly characteristic of him [Rhodes]," who had long dreamed of a federation of English-speaking countries.[20]

On the other hand was Frampton and Barrie's camp, which envisioned the gardens as a playground, the perfect setting for the magic of an eternal youth, and a site of recuperative fantasy in rejection of utility and materialism. For these audiences Frampton's statue enabled the recovery in the modern age of the arcadian *fête galante*, now populated with children and their nurses. Peter Pan was also a means of recovering the noble savage—one who lives among mermaids, Indians, and pirates—at a moment when the British imperial project had reached its seeming apogee, as marked by the pageants and other displays of Edward VII's coronation.[21] But, with historical hindsight, one could argue that what Frampton's statue most effectively memorializes is the invention of modern childhood as a separate sphere of pleasure, protected on an island of park in the midst of a thriving metropolis and presided over by a new heroic icon, the boy who never grew up.

The epigraph is from the *Pall Mall Gazette*, quoted in Press Cuttings Scrapbook, George Frampton, Victoria and Albert Archive of Art and Design, AAD 13/614-1988, vol. 14 for 1910–11, 61.

1. J. M. Barrie, *Peter Pan and Other Plays*, ed. Peter Hollindale (Oxford: Clarendon Press, 1995), 75.

2. J. M. Barrie, *Peter Pan in Kensington Gardens* (New York: Charles Scribner and Sons, 1910), 1, 2, 3, 4, 22, 31, 32, 56.

3. Lucy Trench, *Buildings and Monuments in the Royal Parks* (London: Royal Parks, 2007), 55.

4. Trench, *Buildings and Monuments*, 56.

5. Trench, *Buildings and Monuments*, 56.

6. *Glasgow Evening News*, 10 March 1910, from Press Cuttings Scrapbook, George Frampton, Victoria and Albert Archive of Art and Design, AAD 13/614-1988, vol. 14 for 1910–11, 26.

7. Susan Beattie, *The New Sculpture* (New Haven and London: Paul Mellon Centre for Studies in British Art / Yale Univ. Press, 1983), 3 and passim.

8. *Morning Leader* (London), 24 March 1911, from Press Cuttings Scrapbook, George Frampton, Victoria and Albert Archive of Art and Design, AAD 13/614-1988, vol. 14 for 1910–11, 62.

9. See, for example, the *Daily Express* (London), 9 March 1910, from Press Cuttings Scrapbook, George Frampton, Victoria and Albert Archive of Art and Design, AAD 13/614-1988, vol. 14 for 1910–11, 25.

10. *Birmingham Dispatch*, 23 March 1911, Press Cuttings Scrapbook, George Frampton, Victoria and Albert Archive of Art and Design, AAD 13/614-1988, vol. 14 for 1910–11, 58.

11. See note 8. In addition, "The technical advances in casting that had been made by Singer's and Burton's, the two leading foundries in Britain, enabled Frampton to be as radical in his conception of base and figure as an integral unity, as Gilbert had been in his use of aluminum for the figure of Eros." Peyton Skipwith, *Sir George Frampton and Sir Alfred Gilbert: Peter Pan and Eros: Public and Private Sculpture in Britain, 1880–1940* (London: Fine Art Society, 2002), 6.

12. John Ruskin, *Art of England* (Orpington, UK: George Allen, 1884), 140.

13. From the *Times* (London), 1 May 1912, quoted in Skipwith, *Sir George Frampton and Sir Alfred Gilbert*, 3.

14. *Globe* (London), 1 May 1912, Press Cuttings Scrapbook, George Frampton, Victoria and Albert Archive of Art and Design, AAD 13/614-1988, vol. 16 for 1912–13, 22.

15. George Chadwick, *The Park and the Town: Public Landscape in the 19th and 20th Centuries* (London: Architectural Press), 99, 111–36.

16. *Morning Post* (London), 29 April 1911, Press Cuttings Scrapbook, George Frampton, Victoria and Albert Archive of Art and Design, AAD 13/614-1988, vol. 14 for 1910–11, inserted following 70.

17. *Morning Post* (London), 2 May 1911, Press Cuttings Scrapbook, George Frampton, Victoria and Albert Archive of Art and Design, AAD 13/614-1988, vol. 14 for 1910–11, 72.

18. A. T. E., letter to the editor, *Morning Post* (London), 1 May 1911, Press Cuttings Scrapbook, George Frampton, Victoria and Albert Archive of Art and Design, AAD 13/614-1988, vol. 14 for 1910–11, 72.

19. *Newcastle Journal*, 2 May 1911, Press Cuttings Scrapbook, George Frampton, Victoria and Albert Archive of Art and Design, AAD 13/614-1988, vol. 15 for 1911, 3.

20. Veronica Franklin Gould, *G. F. Watts: The Last Great Victorian* (New Haven: Paul Mellon Centre for Studies in British Art / Yale Univ. Press, 2004), 343.

21. For more on childhood as recuperation and an overview of the relevant literature, see John R. Gillis, "The Birth of the Virtual Child, a Victorian Progeny," in *Beyond the Century of the Child: Cultural History and Developmental Psychology*, ed. Willem Koops and Michael Zuckerman (Philadelphia: Univ. of Pennsylvania Press, 2003), 82–95.

George Frampton's *Peter Pan* in Kensington Gardens

Gillian Beer

PETER PAN IN J. M. BARRIE'S PLAY OF 1904 is a dangerous figure, incapable of emotion beyond a narcissistic glee. The stage directions make it clear that he is never to be touched by any other character on stage.[1] He is damaged and glamorous, a lost boy shut out, unable to get back into the nursery, the window closed against him and another child in his bed. So his wish never to grow up is explored by Barrie as an exuberant and self-protective fantasy that lures other children into his realm of pirates and "redskins" and underground domesticity. He is pied piper and cripple boy at once. Tinker Bell, the light-fairy and his closest companion, is riven by jealousy and spite. Yet Peter remains immensely attractive. For one thing, he can fly and he can teach children to fly. He speaks to children's dread and scorn of the adult world and their flight from the inexorable oncoming of puberty. Of course, children also wish to be grown up, and the tale of Wendy, little mother to the lost boys, chimes with that fantasy of stereotypical womanhood. But even here Barrie sharpens his pen. In the outer family that surrounds the world of Neverland, domestic roles are changed: the nurse is a dog, and the father whose irascibility prompted the loss of the children ends up in penitence sleeping in the dog's kennel.

This troubled and alluring fantasia on childhood fears and longings, and on the follies of adult assumptions, took a variety of written forms that gradually clustered together to make the mythic being Peter Pan, who still, however sentimentalized, haunts our screens and theaters and imaginations. *The Little White Bird* (1902) and *Peter Pan in Kensington Gardens* (1906) tell the tale of a younger Peter. The play *Peter Pan* was first performed in 1904, and the novel based on it, *Peter and Wendy*, was published in 1911. Finally, in 1928, the text of the play was published. Almost equally well known now is the poignant story of Barrie's own devoted, obsessional involvement with the five boys of the Llewellyn Davies family, from whose games with Barrie the various imaginings of Peter Pan all sprang.[2] After their mother's death, Barrie adopted the family. So, looking back, the story of Peter Pan becomes the story also of J. M. Barrie and his child friends—a story

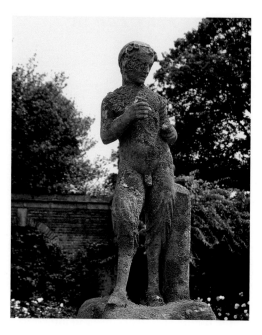

57. *Statue of Pan*, marble (n.d.). Hever Castle, Kent.

that at the same time seems to shed light on all that is exotic to us about the Edwardian era with its unguarded non-Freudian understanding and its mix of social inhibition and rampant fantasy life.

Precisely this backward glance may make it hard for us to construe the significance for his contemporaries of George Frampton's statue of Peter Pan in Kensington Gardens (see fig. 52). The first thing that must strike us about the sculpture is how distant it is from the tradition of Pan statuary. If one turns to the figure of Pan at Rousham Park or, even more, at Hever Castle, the Pan displayed is a virile figure, at Hever (fig. 57) naked and threatening, at Rousham half-clothed, with his own voyeuristic menace, and both goat-footed, challenging the gap between man and animal. These are representations set to startle the visitor to the gardens, looming up and capable of precipitating Pan's effect: panic.

Peter Pan, as represented in Frampton's bronze, is, by contrast, sylvan and childlike. The only link with the older world of Pan's power is the pipe that the child is playing with just his left hand and to which he seems to be listening, while balancing lightly on his back foot, his other arm in the air (fig. 58). Barrie commissioned this work himself and wished the sculptor to model Peter Pan on

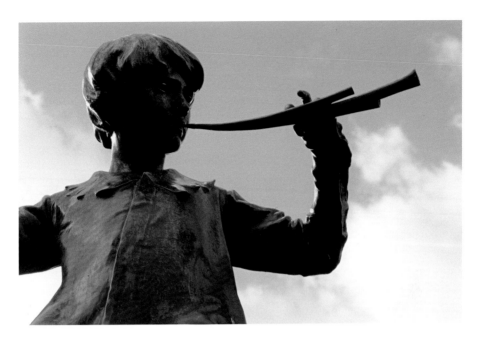

58. George Frampton, *Peter Pan* (detail), bronze (1912). Kensington Gardens, London.

Michael Llewellyn Davies. Instead, Frampton chose other models. There were further tensions around the commission, most strikingly that Barrie felt the statue did not "show the Devil in Peter."[3] This benign woodland scene, enhanced by its setting in a glade, beside water, certainly does not evoke any of the cockiness or captiousness that is a part of Peter Pan's allure in the play.

Nevertheless, the unmasking of the statue was an immensely successful coup de théâtre, a kind of anti-publicity master moment of publicity. During the night, before the dawn of May Day 1912, the statue was erected and an announcement from Barrie appeared in the *Times* (London) that morning:

> There is a surprise in store for the children who go to Kensington Gardens to feed the ducks in the Serpentine this morning. Down by the little bay on the south-western side of the tail of the Serpentine they will find a May-day gift by Mr J.M. Barrie, a figure of Peter Pan blowing his pipe on the stump of a tree, with fairies and mice and squirrels all around. It is the work of Sir George Frampton, and the bronze figure of the boy who would never grow up is delightfully conceived.

Men were engaged on Monday and yesterday in placing the work of the sculptor in position behind drawn curtains. These will be removed during the night, and the children will just find Peter Pan there as if he had grown out of the turf on May morning. It was the wish of Mr Barrie and of Sir George Frampton that there should be no formal unveiling, and the Office of Works fell in with the happy idea.[4]

Peter Pan, as in the play, emerges through the curtains again. Inevitably, questions were asked, including in the House of Commons, about the liberty taken by the author and sculptor in planting a statue in a public space, but objections seem to have died away fast in the face of the statue's popularity.

Barrie's choice of May Day morning is significant for the sculpture's cultural presence. It blended the work into the then-current revival of interest in folk traditions such as the dance round the maypole, morris dancing, and the fascination with fairies. Indeed, Barrie's description of the tree stump places "fairies and mice and squirrels" on a par. Moreover, the figure of Pan himself was potent for Edwardian creativity: witness E. M. Forster's "The Story of a Panic"[5] and Ezra Pound's series of essays, "Affirmations" (1915), including a tribute to Arnold Dolmetsch, the pioneer maker and performer of early instruments and music:

'I have seen the god Pan.' 'Nonsense.' I have seen the God Pan and it was in this manner: I heard a bewildering and pervasive music moving from precision to precision within itself. Then I heard a different music hollow and laughing. Then I looked up, and saw two eyes like the eyes of a wood-creature peering at me over a brown tube of wood. . . . Everyone who has been cast back into the age of truth for one instant—gives honour to the spell which he worked, to the witch-work, or the art-work, or whatever you like to call it. Therefore I say, and stick to it, I saw and heard the God Pan; shortly afterwards I saw and heard Mr. Dolmetsch.[6]

Peter Pan's three-pronged pipe in the statue is neither a recorder nor a traditional panpipe, but it does evoke exotic-seeming early instruments, then coming into use again.

Barrie's siting of the statue gave fanciful verification to an incident in the earlier Peter Pan tale *Peter Pan in Kensington Gardens*, in which the child Peter, having been locked into the gardens overnight, learns to survive among the fairies. He is trapped for a long time on the island in the middle of the Serpentine but at last escapes and lands on this precise spot. So there was a willful fantasy of authentication in the placing of the statue, which is also realized in the detailed realism of Frampton's work.

Although the theme of the sculpture may have been to some degree nostalgic, its technique and execution were novel. For one thing, the base and figure were cast as a single unit. This became possible because of technical advances made at British foundries in this period, in particular those of Singer and Burton. The lost-wax bronze casting process enabled the transference of refined detail into bronze. Like Alfred Gilbert, Frampton was a member of the Art Workers' Guild, and he was one of the group of young sculptors whom the poet and critic Edmund Gosse praised in 1894 in an article, "The New Sculpture," in the *Art Journal*. They emphasized naturalism, symbolism, and lightness of touch. They sought to combine brilliant presence with mystery, as in Gilbert's *Eros* in Piccadilly Circus. Frampton's earlier work included *Lamia*, Keats's ambiguous snake-woman, in bronze, with ivory and opals, and a strange bronze relief entitled the *Mysteriarch* (Walker Art Gallery, Liverpool).[7] Frampton's father was a stonemason, and the sculptor also worked as a jeweler, so that he was able, with ease, to embody intricacy and stable poise. All these effects are manifest in the Peter Pan statue: the child seems singularly free in his pose, as if on an arc of movement. The figure of Peter Pan clothed as Frampton figured him, in collared tunic, rapidly became the way he is usually depicted: Walt Disney retained it in his film of Peter Pan, and even now a "Peter Pan collar" is a recognized feature on women's blouses and dresses.[8]

The delight of the Peter Pan statue for children is that the woodland creatures—rabbits, mice, a lizard, a squirrel, a frog—mingle with fairies at a height where they can be touched, and the shine on many of the creatures shows how persistently they have been enjoyed. Indeed, the whole statue has an effect somewhat like a fountain, because of the bronze gleam that cascades across it as the clouds shift above. One figure only, a fairy—but much like a sinuous and voluptuous grown woman—interrupts the space of the plinth on which the boy is standing. She reaches with a thrusting upward gaze, half her body above the plinth (fig. 59). The boy remains unaware; the viewer is unsettled. This figure may allude to Tinker Bell, Peter Pan's possessive companion, but she also serves to remind us of the threat of oncoming adulthood that Peter is determined to refuse. That threat is here suspended, merely hinted at in the single figure.

Indeed, the woodland aspect of the statue is lighthearted and benign. Its creatures are faintly anthropomorphic: Frampton himself remarked that "one of the mice is completing his toilet before going up to listen to the music, and the squirrel is discussing political matters with two of the fairies."[9] And here there is a difference from the tale of Peter Pan in Barrie's various versions. Indeed, it more closely resembles a portion of another of the great children's books of the Edwardian era. In 1908, four years after the play was first produced and four years before the unveiling of the statue, *The Wind in the Willows* by Kenneth Grahame was

59. George Frampton, *Peter Pan* (detail), bronze (1912).
Kensington Gardens, London.

published. Here the fully anthropomorphized creatures Mole, Ratty, and Mr. Toad
have a series of adventures that move at very different paces: some as leisurely as
summer picnics, some in a froth of road rage. In the midst of these adventures is
a single chapter in a different vein: chapter 7, "The Piper at the Gates of Dawn."
The little otter Portly has vanished for days, and his father has grown desperate.
Mole and Rat search the river for him at night:

> The night was full of small noises, song and chatter and rustling, telling of
> the busy little population who were up and about, plying their trades and
> vocations through the night till the sunshine should fall on them at last.

The two animals in their boat hear wonderful music far off, "the thin, clear,
happy call of the distant piping," and the scene moves into a mystical experience

in which wafts of sound transcend the everyday. Ratty cries, "This time, at last, it is the real, the unmistakable thing, simple—passionate—perfect." And the two creatures are drawn as if in a trance downstream to a small island, where they "picked through the blossom and scented herbage and undergrowth that led up to the level ground, till they stood on a little lawn of marvellous green, set round with Nature's own orchard-trees—crab-apple, wild cherry, and sloe." The setting is very like that of Frampton's sculpture of Peter Pan in Kensington Gardens. The imagined presence of Pan, though, is quite other. This is Pan as God, with "curved horns" and "stern hooked nose between the kindly eyes that were looking down at them humorously."[10] In his lap lies the unharmed baby Portly. The last gift of Pan to his creatures is that afterward they forget the experience.

Grahame's lucid and tender imagining of Pan as a redeeming figure may seem at a long distance both from the statuary tradition of Rousham and Hever Castle and from Barrie's captious boy, Peter Pan. But Frampton's benign sculpture, with its "busy little population . . . plying their trades and vocations" and the boy engrossed in his perfect unheard melody, seems to draw quite as much on the mood of this one scene in *The Wind in the Willows* as it does on Barrie's creation. The assimilation of this other mythical children's book into the temper of Frampton's sculpture certainly chimes with Barrie's complaint that the statue does not "show the Devil in Peter." Only the straining figure of the single fairy woman interrupting the child's solitary space above the plinth hints at the conflicts, dissonances, and refusals out of which Peter Pan was born, never to grow up.

1. J. M. Barrie, *Peter Pan* (London: Hodder and Stoughton, 1928), 62–63.

2. See Andrew Birkin, *J. M. Barrie and the Lost Boys* (New Haven and London: Yale Univ. Press, 2003).

3. "Barrie said of the sculpture: 'It doesn't show the Devil in Peter.'" As quoted on the Royal Parks website, http://www.royalparks.org.uk/parks/kensington_gardens/peter_pan_statue.cfm.

4. *Times* (London), 1 May 1912, page 11.

5. "The Story of a Panic" is the opening story in Forster's first collection, *The Celestial Omnibus and Other Stories* (London: Sidgwick and Jackson, 1911).

6. Ezra Pound, "Affirmations," *New Age* 16 (14 Jan. 1915): 246.

7. Introduction to Peyton Skipwith, *Sir George Frampton and Sir Alfred Gilbert: Peter Pan and Eros: Public and Private Sculpture in Britain, 1880–1940*, exh. cat. (London: Fine Art Society, 2002), quoted at http://www.victorianweb.org/sculpture/skipwith1.html.

8. Peter Pan has also been represented by important artists: Arthur Rackham illustrated the 1906 edition of *Peter Pan in Kensington Gardens*, and Paula Rego the Folio Society edition of *Peter Pan* in 1992.

9. See http://www.publicartaroundtheworld.com/Peter_Pan_Statue.html (accessed 18 June 2009).

10. Kenneth Grahame, *The Wind in the Willows* (London: Methuen, 1908), 79–84.

Making Sculpture and the Two Worlds of *Peter Pan*

Martina Droth

J. M. BARRIE'S *Peter Pan* has elicited a wide literature that has revealed multiple levels at which the story and the character can be read: what it tells us about late Victorian and Edwardian attitudes toward children and gender roles, as well as about travel, empire, and colonial attitudes, which have been variously described as conforming to, and as mocking of, racial stereotypes.[1] In contrast to this rich literature, relatively little has been said about *Peter Pan* the sculpture, or indeed its creator, George Frampton (see fig. 52).[2] In its explicit relationship to the play, the work raises the question of what a sculpture derived from a preexistent narrative or character represents on its own terms. The statue transforms the phantasm of the fictional character into a concrete viewable and touchable object. It is a projection of how we might imagine Peter Pan, and it also becomes Peter, as once seen it imposes itself on our subjective image. But while the statue therefore has agency, it is also inescapably derivative. Limited by its medium in a way that words are not, it necessarily represents the story in abbreviated form, and thereby seems to lose much of Barrie's nuanced, multifaceted character. It is difficult to know how to read it as a sculpture: if it cannot embody complexities yielded by the play, what is its function and what does it offer us?

In this essay I want to get away from the idea of the sculpture as an illustration of the story, which seems like a reductive approach; while the work needs to be considered in relation to the text, it also repays closer attention on its own terms. Here I want to examine the piece in the context of Frampton's oeuvre and of a particular moment in the history of sculpture. I will examine it from a sculptural perspective, to explore what it tells us beyond or separately from the story, as a creative work in its own right.

213

GEORGE FRAMPTON AND THE NEW SCULPTURE

The emergence in late-nineteenth-century Britain of a sculptural revival that became known as the "New Sculpture" has recently attracted increasing scholarly attention, and, though still a relatively small field, it has begun to reassert sculpture's relationship and relevance to the art world as a whole.[3] Much of this attention, however, has focused on key works by a small handful of artists (especially Frederic Leighton, Hamo Thornycroft, and Alfred Gilbert), leaving substantial oeuvres by these and other sculptors still unexamined—and, in turn, leaving a substantial gap in our understanding of this moment in the history of British sculpture. In particular, those works that appear overtly imperial, or that seem excessively ornate, sentimental, or romantic, have been either sidelined or entirely ignored, as have many of those that were made after about 1900, that is, outside the period generally considered the high point of the New Sculpture's achievements. This holds true even when other works in the same artists' oeuvres have been subjected to critical appraisal. Statues of Queen Victoria, for example, have hardly begun to be reevaluated, and many of the period's more bizarre decorative creations have yet to be studied with the same seriousness as the iconic figurative works, such as the male nudes by Gilbert, Thornycroft, and Leighton. For example, while Leighton's large, masculine sculptural statements—the *Athlete* and the *Sluggard*, in particular—have been posited as significant initiatory exemplars of the New Sculpture, a work such as his distinctly whimsical *Needless Alarms*—a nude figure of a girl looking in exaggerated surprise at a frog—has been largely ignored, even though exhibited alongside the *Sluggard* at the Royal Academy in 1886.

Peter Pan, first exhibited at the Royal Academy in 1911, falls into this marginal category. It may be Frampton's most famous work (with versions in London, Liverpool, Brussels, and Newfoundland), but its fame rests on Barrie's play, rather than on its maker. Frampton himself is now largely cited for the much earlier polychrome busts *Mysteriarch* (1896) and *Lamia* (1899), which have become exemplars of a British interest in Symbolism.[4] Considered within this trajectory, *Peter Pan* seems to fall between two camps: it is neither "Victorian" nor "modernist," and it was made by an artist who was part of the New Sculpture, but at a time when that movement is considered to have ended. Though based on a contemporary play, its apparently lighthearted imagery of childhood, in particular its depictions of fairies and rabbits, brings to mind outdated Victorian sentiments. From its first appearance, the statue was consistently framed in terms of childhood and innocent delight. A notice published in the *Times* (London) in 1912 on the day of its appearance in South Kensington described it as "delightfully conceived" and "a surprise . . . for the children who go to Kensington Gardens to feed the ducks."[5]

Its apparently deliberate childishness seems a world away from the enigmatic Symbolist appeal of Frampton's earlier work, thus apparently confirming Susan Beattie's assertion of the New Sculpture's "decline" into sentimentalism and convention in the twentieth century, a view that remains largely unchallenged.[6] Once examined more closely, however, *Peter Pan*'s potential to yield meaning beyond a light-hearted interpretation of the play becomes apparent in both its visual and its formal qualities.

Within the terms of sculptural conventions, *Peter Pan* is an unusual, even contradictory work. It is both garden ornament and portrait statue, albeit of a fictional character and thus also an embodiment of abstract ideas. It is life-size, yet, because it represents a child, it is relatively small as a piece of public statuary. It seems more comparable to the oversize statuettes that became a motif of the New Sculpture than to other public statues. In common with Gilbert's large statuette *Icarus*, for example, Frampton's boy similarly rests on a pedestal representing a fragment of natural ground, omitting—unusually for a public statue—any strictly architectural plinth or structural support.

Peter Pan has been compared to another of Gilbert's works, the *Eros* fountain in Piccadilly Circus (1886–93).[7] But while there are certain superficial compositional and aesthetic similarities, *Peter Pan* does not fare well in the comparison. *Eros* was mired in controversy from its inception; it is a complex, puzzling, and somewhat deviant and disreputable work, and for all those reasons fascinating and of continuing interest to scholars.[8] Although Barrie's Peter Pan has similar potential for deviant, disruptive, and controversial behavior, Frampton's characterization of the figure appears, in contrast, decidedly uncontroversial and uncomplicated, a pleasurable representation of childhood fantasy. But what about the choices Frampton made in determining how to represent Peter? Notably, Frampton chose to present Peter as an embodiment of ordinary boyhood, without explicit indication of his magical properties. He is stepping, rather than poised for flight, and although his habitat is magical, it seems much more familiar, tamer and friendlier, than the foreign, slightly threatening world of Barrie's Neverland. Frampton appears to suppress Barrie's explicit references to empire. But there are other, more subtle ways in which the sculpture asserts ideas that are related to, without being literal renditions of, the text. The sculpture's location in a royal park, attached to the seat of royalty in the metropolis, also signifies the heart of empire. Together with its imagery of fairies and woodland creatures—images redolent of Victorian sentiment, and thus of the empire's high point, now endangered—the statue begins to suggest itself as a meditation on its time. This raises the question of whether it can really be taken as a simple image of naive delight, or whether the world it represents is rather a terra incognita where nothing is what it seems.

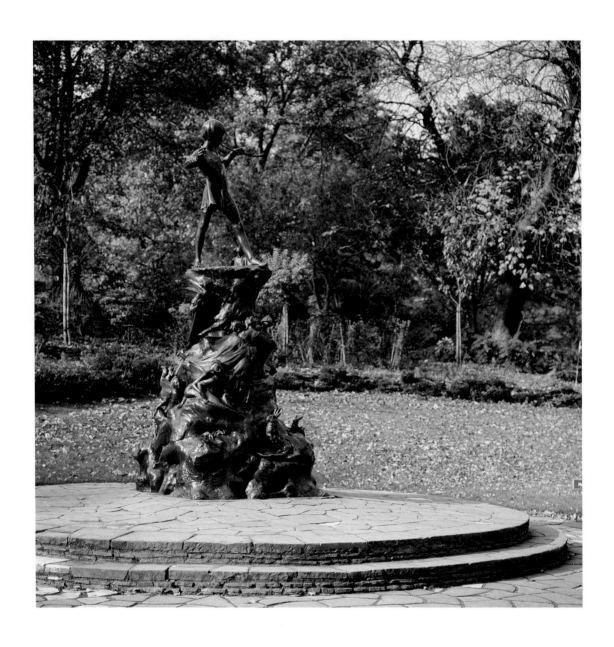

60. George Frampton, *Peter Pan*, bronze (1912). Kensington Gardens, London.

THE TWO WORLDS OF *PETER PAN*

Compositionally, *Peter Pan* is a strangely disjointed work. The clarity and realism of the figure are in stark contrast to the emphatically busy, and rather obscure, pedestal. Although it ostensibly depicts a decaying tree trunk, the pedestal is figuratively ambiguous (fig. 60). It is evocative of roots and undergrowth, but it comprises large areas that do not represent anything identifiable, suggestive rather of the indeterminate matter that makes up earth. The bronze thereby calls to mind its origin in modeled clay, and some of the surfaces seem simply to present their original material rather than being figuratively defined. The fairies that populate this clay mound similarly evoke their materiality. They seem to emerge from the matrix of the clay, modeled from it but still embedded within it, only partially freed. The presence of rabbit warrens further accentuates this, literally representing shifted, molded earth. Even transformed into bronze, there is a softness to the surfaces that evokes the pliable quality of wet soil, the whole adding up to an image of instability: a precarious, perforated ground that could collapse in on itself at any moment.

This sense of instability is heightened by the figure of Peter, who is lightly stepping forward and off the plinth, in a seemingly somnambulistic state, as if about to walk onto air. The sculpture is thus split into two distinct parts, representing an above and a below. Descriptions of the work often mention the "naturalistic" base conceived as "integral" with the figure, and the fact that the whole work—in a remarkable technical feat—was cast in a single piece. But records of the work in progress in Frampton's studio indicate that figure and base were in fact made separately and then joined together (fig. 61). While this was most likely a practical way to proceed, the separate nature of the process resonates in the final work. Although the parts are in dynamic relation to each other, there is an inescapable disjunction between them. Seen without the figure, the pedestal's strangeness becomes accentuated; it needs the figure in order to make sense. The figure, however, can exist alone, self-sufficient, on any support (fig. 62).

Just as the work thus represents two realms in unequal relation to each other, so the activities that take place there, and the apparent disposition or states they each embody, seem to work in opposite directions, Peter's trancelike, meditative step countering the turbulent, spiraling motion in the pedestal. The fairies, scrambling upward as if trying to extricate themselves from the material, are acutely aware of Peter and are striving to reach his plateau. Peter, however, absorbed in his piping, seems detached from what is going on beneath his feet, as though oblivious, or unmoved, by the underground forces called up by his tune. This dissonance resonates in the paradox presented by the imagery: the fairies, like Peter, can fly, but

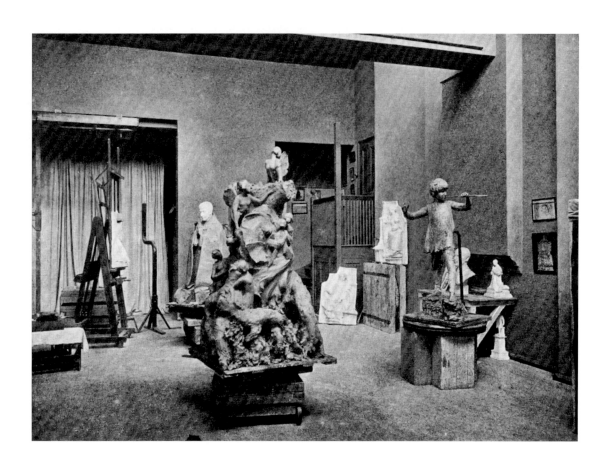

61. View of George Frampton's studio, from "Recent Designs in Domestic Architecture," *Studio* 49 (1910). Courtesy of the Yale University Library.

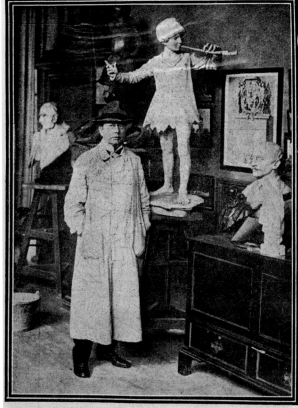

62. George Frampton in his studio with the *Peter Pan* figure, from *Daily Mirror*, 1912. National Archive of Art and Design, Victoria and Albert Museum, London.

unlike him they seem curiously grounded, their wings and cloaks apparently muddy and sodden. In an unsettling inversion of roles, it is the wingless boy, standing barefoot on top of their habitat, who seems flighty and free. Frampton's sculpture thus seems to operate on different levels. Beneath its lightheartedness is a murky, vaguely uncomfortable visuality that hints at a world where fantasy and reality are in conflagration, and where the order of things, the natural balance, has been turned upside down.

PETER PAN AND THE WORK OF SCULPTURE

The top of the plinth acts as a destination; it is a place that is aspired to, thus in a sense doubling the function of a pedestal as a sculptural device that elevates and exalts. The work thereby brings to mind again some of the physical elements of sculptural practice. Rather than appearing to transcend its materiality, it insistently draws attention to itself as a materially bound object, as something that is formed, crafted, and fabricated of an earthy substance. The pedestal, in its molded earthiness, and the fairies, in their struggle to free themselves from the material, extend this notion: as metaphors of becoming, they provide both a visual reminder and a metaphorical parallel to the "work"—the making—of sculpture.

Peter Pan might thus be seen as an extension of Frampton's own work ethic and, indeed, as alluding to a concern with the wider cultural position of artisanal practice. Like many of his contemporaries, Frampton was intensely interested in the materials, processes, and craft of sculpture, and he emphatically cultivated a self-image as an "art-worker" and "all-round craftsman," a "master of many methods,"[9] and a "workman."[10] His artistic philosophy was consistently drawn in terms of work: "effort in art" was "the work of the imagination";[11] sculpture was "a craft as well as an art," involving "much hard work" and "severe manual labour."[12] Frampton's aggressively antihierarchical stance informed his interdisciplinarity, which, in turn, was grounded in his political worldview: "specialisation" for Frampton represented the "the pigeon-holing of people," the division of labor that was "the outcome of the factory system."[13] Not surprisingly, Frampton, like other sculptors of his generation, has consistently been aligned with the Arts and Crafts movement, although his engagement with key issues linked to crafts reform was specifically oriented toward recasting the terms of sculptural practice.[14] Frampton, clearly, was concerned about the quality and condition of both process and execution in sculptural work, as well as the role and status of the sculptor—as a manual worker—in society. *Peter Pan* might thus be seen as a self-reflexive mechanism whose formal and physical properties provide a parallel to the political and ethical connotations of sculptural work.

Based on a contemporary story concerned with a refusal of the accepted order, the sculpture shows a world that is turbulent and potentially oppressive but also shifting and in flux. Peter Pan's state of reverie and detachment as well as his identification with music—a disembodied abstract art that floats, like Peter himself, on air—suggest a being unlimited by materiality. The split nature of the piece, its two halves, seems to mirror the contradictory condition of sculpture: earth-bound and physical as well as abstract and poetic. The earthy, dirty work of sculpture—Frampton's "effort in art"—is also the path to the world of ideas, "the work of the imagination."

I would like thank Nicholas Mead for his thoughtful comments and insights in the writing of this piece.

1. Recent examples include Paul Fox, "Other Maps Showing Through: The Liminal Identities of Neverland," *Children's Literature Association Quarterly* 32, no. 3 (Fall 2007): 252–68, and Mary Brewer, "Peter Pan and the White Imperial Imaginary," *New Theatre Quarterly* 23 (2007): 387–92.

2. Relevant exceptions include Peyton Skipwith, "Peter Pan and Eros," in *Sir George Frampton and Sir Alfred Gilbert: Peter Pan and Eros: Public and Private Sculpture in Britain, 1880–1940* (London: Fine Art Society, 2002), and Andrew Jezzard, "The Sculptor Sir George Frampton" (MA thesis, Univ. of Leeds, 1999). Discussions of other work by Frampton include Sue Malvern, "'For King and Country': Frampton's *Edith Cavell* (1915–20) and the Writing of Gender in Memorials to the Great War," in *Sculpture and the Pursuit of a Modern Ideal in Britain c. 1880–1930*, ed. David Getsy (Aldershot, UK, and Burlington, Vt.: Ashgate, 2004), 219–43.

3. See, in particular, Jason Edwards, *Alfred Gilbert's Aestheticism: Gilbert Amongst Whistler, Wilde, Leighton, Pater and Burne-Jones* (Aldershot, UK: Ashgate, 2006); David Getsy, *Body Doubles: Sculpture in Britain, 1877–1905* (New Haven and London: Yale Univ. Press, 2004); and Tim Barringer and Elizabeth Prettejohn, eds., *Frederic Leighton: Antiquity, Renaissance, Modernity* (New Haven and London: Yale Univ. Press, 1999).

4. See, for example, Henk van Os, ed., *Femmes Fatales, 1860–1910*, exh. cat. (Koninklijk Museum voor Schone Kunsten, Antwerp, and Groninger Museum, Groningen, 2002), and *Reverie, Myth, Sensuality: Sculpture in Britain 1880–1910*, exh. cat. (Stoke-on-Trent City Museum and Art Gallery, 1992).

5. *Times* (London), 1 May 1912.

6. Susan Beattie, *The New Sculpture* (New Haven and London: Paul Mellon Centre for Studies in British Art by Yale Univ. Press, 1983).

7. Skipwith, "Peter Pan and Eros."

8. See, in particular, Alex Potts, "Eros in Piccadilly Circus: Monument and Anti-monument," in Getsy, *Sculpture and the Pursuit of a Modern Ideal*, 105–40.

9. Fred Miller, "George Frampton, A.R.A., Art Worker," *Art Journal* 59 (1897): 323.

10. "Recent Designs in Domestic Architecture," *Studio* 49 (1910): 217.

11. Miller, "George Frampton," 323.

12. E. B. S., "Afternoons in Studios: A Chat with Mr. George Frampton, A.R.A.," *Studio* 6 (1896): 205.

13. Miller, "George Frampton," 324. An interesting discussion of the "co-opting" of sculpture and arts and crafts, referencing Frampton, is in S. K. Tillyard, *The Impact of Modernism, 1900–1920: Early Modernism and the Arts and Crafts Movement in Edwardian England* (London and New York: Routledge, 1988), 146–52.

14. For an extended discussion on the divergence between the New Sculpture's engagement with the politics of art making and that of the Arts and Crafts movement, see Martina Droth, "The Ethics of Making: Craft and English Sculptural Aesthetics 1851–1900," in "Art and Craft: A Dangerous Liaison," ed. Grace Lees-Maffei and Linda Sandino, special issue, *Journal of Design History* 17, no. 3 (2004): 221–36.

Elgar's Aesthetics of Landscape

Tim Barringer

"MY IDEA," Edward Elgar famously once told an interviewer, "is that there is music in the air, music all around us, and you simply take as much as you require!"[1] In another resonant phrase, Elgar argued for "something that shall grow out of our own soil, something broad, noble, chivalrous, healthy and above all, an out-of-door sort of spirit."[2] Essential equipment for the composer, according to Elgar's favorite trope of self-fashioning, was a good tweed suit, along with a stout pair of walking shoes (fig. 63). Elgar's body thus attired, as much as his music, has come to epitomize Edwardian England. This essay examines and challenges the construction of the rural Elgar and argues that his work—and the cultural production of Edwardian England in general—should be understood within the matrix of a troubled symbolic geography in which metropolitan, provincial, and imperial landscapes compete and overlap.

How can music embody "an out-of-door sort of spirit"? Our dominant mode for the apprehension of the landscape is visual: maps, photographs, landscape paintings—these are the media through which we tend to record and recognize the world around us. Music's pretensions to derive from, even to represent, landscape challenge this visual hegemony, and it is with the relationship between the visual and the aural, between art and music that this essay is concerned. Among emblems of music's relation to landscape, few are more vivid than a map, transformed into a historical document of some importance by the addition of inscriptions in the hand of Elgar (fig. 64). The one-inch-to-a-mile Ordnance Survey sheet of Gloucester and Cheltenham details an area notable for the calligraphic meandering of the river Severn, whose course is charted from Tewksbury to Gloucester and onward through a majestic oxbow toward the sea. The map's purview is indicated on its cover by a starkly schematic diagram of major topographical features, principally land and water, viewed as if from a great height, the imagined all-seeing perspective of the cartographer. Invisible under this regime of representation is the cultural topography of the area, woven with historical associations and punctuated by landmarks of medieval ecclesiastical architecture and ancient

"THE most brilliant champion of the National School of Composition which is beginning to bloom in England." These are the words in which one of the most distinguished German writers on music has summed up the position of Dr. Edward Elgar, whose newest work, "The Apostles," is underlined for production at the Birmingham Musical Festival. So great is the demand for tickets that a second performance is already contemplated during the Festival week. "The Apostles" differs from many other oratorios in that no librettist has been associated with Dr. Elgar in its production. The book has been selected by Dr. Elgar from the words of the Scripture. The subject, he once confided to an interviewer, has thrilled him ever since he was a boy, from which time he regarded the Apostles "from their human side; as men, not as theological figures."

As a boy, the last career which appeared open to him was that of music. True, his father before him was a musician, filling the position of organist at St. George's Catholic Church, Worcester; and in the little village of Broadheath, three miles from that city, his brilliant son was born. When the time came for the choice of a profession, Mr. Elgar senior placed his son in a solicitor's office, with a view to his being articled. Law, however, could not claim the soul which the Muses had marked for their own, and Edward Elgar determined to follow his bent. As a child, he used to sit by his father's side on the stool in the organ-loft, watching him play, and occasionally tried his own hand on the instrument, to his father's great delight.

As an instrumentalist, however, Dr. Elgar, in his youth, decided for the violin, and he took lessons from Herr Pollitzer. But beyond these lessons he has received no musical instruction. All the time he was composing, although he had never received a lesson in instrumentation or counterpoint. That does not say, however, that he was not deeply read in those subjects, for his knowledge was obtained by careful observation, the study of scores, and the practical studies of his own composition.

In those early days of his career there was a Glee Club in Worcester. Dr. Elgar led the small orchestra and accompanied the vocal music, while he also established a wind-quintet, of which he was the fagottist; for it he wrote a great deal of music.

While in Worcester, playing and teaching, Dr. Elgar was a not infrequent visitor to the Saturday Concerts at the Crystal Palace. He would leave home at six o'clock in the morning and not return until late at night in order to hear the orchestral music. At the Crystal Palace, too, several of his earlier works have been performed. It is, however, Dr. Elgar's immovable opinion that his first real introduction to the larger musical public was through the kindness of Mr. W. C. Stockley, the pioneer of orchestral music in the Midlands, to whom Dr. Elgar always expresses sincere and lasting gratitude. Mr. Stockley produced several orchestral works at a time when Dr. Elgar was known only as a violinist. He was, in fact, one of the first-violins in the orchestra in the Town Hall, where his latest work will be produced this month.

When he once had got a hearing, Dr. Elgar's fame soon spread throughout the country, though it was not until the completion of his thirty-sixth Opus that London had the opportunity of forming anything like an adequate judgment of his abilities. This was at a Richter Concert,

63. "Photographic Interview," *Sketch*, 7 Oct. 1903, 418–19. Courtesy of the Yale University Library.

"THAT'S EDGEHILL—THIRTY MILES AWAY."

"NOTHING LIKE OUTDOOR LIFE. BICYCLING——"

"——OR A CLIMB——"

where his "Variations on an Original Theme" for the orchestra was produced by Dr. Richter in June 1899, and created an extraordinary sensation. These "Variations" were character-studies, intended to be portraits of his friends, a description which must seem to the ordinary individual as decidedly fantastic. Musicians saw in them, however, exactly what the composer intended, and they marvelled now at the extraordinary ease and originality of his method, now at his great mastery of contrapuntal knowledge, now at his great manipulation of orchestral effects.

The next year, at the Birmingham Festival, the "Dream of Gerontius" was produced, a work which Dr. Lessmann, perhaps the most celebrated German critic, singled out for special commendation, remarking particularly on the extraordinary independence of its outlook; while Dr. Julius Buths, the famous conductor of Düsseldorf, was so enchanted with it that he determined to produce it in Germany, and to that end himself translated the libretto. The success of this performance was so great that the "Dream" was repeated at the Lower Rhine Festival—a unique event in the annals of British music. Since then it has been given many times in Germany, and is underlined for production on several occasions between now and Christmas in various cities in the Fatherland, while during the same interval it will be given at least eight times in the United States. These circumstances are so unusual that England may well pride herself on the achievement of one of her sons whose "Gerontius" has been declared to be "the greatest composition of the last hundred years, with the single exception of the Requiem of Brahms."

He is a great admirer of Wagner, in whose footsteps he not unnaturally walks, though there is nothing of the imitator in his method, for it is "always original and always noble," as one of his critics has said.

Personally, with his slight physique, his brown hair, cut short, and his heavy moustache, his quick, nervous movements and quick speech, Dr. Elgar gives no hint of the popular notion of a musician, and might rather pass for an Army officer in mufti than anything else.

Musician, however, he is to the core, and if his intention to write an opera is fulfilled, a great step will be taken towards the advancement of a form of musical composition in which we are beaten by other nations of the world. Dr. Elgar's opera, if it is written, will be of a heroic or fantastic character, for, as he has himself said, "Art has nothing to do with the frivolous, nor have I," a statement which may well be believed in view of what was said of him in November 1900, when the Honorary Degree of Doctor of Music was conferred upon him by the University of Cambridge. Then the orator, after referring to several of his most important works, declared, "If ever this votary of the Muse of Song looked from the hills of his present home at Malvern, from the cradle of English poetry, the scene of the vision of Piers Plowman, and from the British Camp, with its legendary memories of his own 'Caractacus,' and in the light of the rising sun sees the towers of Tewkesbury and Gloucester and Worcester, he might recall in that view the earlier stages of his career, and confess, with modest pride, like the bard in the 'Odyssey'—

Self-taught I sing; 'tis Heaven, and Heaven alone,
Inspires my song with music all its own."

"——OR GOLF (JUST NINE HOLES), IS WONDERFULLY REFRESHING."

"THIS FOR THE MATCH, I THINK."

"DON'T SULK, LITTLE ONE!"

64. Ordnance Survey Map, Gloucester and Cheltenham, with annotations by Elgar. Courtesy of The Elgar Birthplace Museum, Broadheath, Worcestershire.

archaeology. For Elgar himself, moreover, these acres were inscribed with subjective associations of great power: memories of childhood travels, personal and professional successes, friends made and lost, and his own music, taken from the air all around him.

Across the folded spine of the map, worn perhaps from use along country rambles, can be seen another formalized and coded language—passages of a musical score in Elgar's own hand. Implied in this juxtaposition is a direct relationship between landscape and musical creativity, as if music and environment were inseparably bound together in an immutable dialectic. This relationship suggests parallels between the contours of hills and valleys, or the flowing of the river Severn, and the undulating topography of Elgar's melodic lines. In map and music, lines and spaces indicate the rise and fall of pitch; in both cases, a traversal from one

side of the page to the other will take time. Implicit in the intimate binding together of the map and Elgar's sketch is the idea of landscape as the source of artistic creativity, the raw materials from which music ultimately derives. These raw materials must pass through a process of visual representation, and it is the visual through which landscape is perceived before it can inspire music. To create music from landscape is to effect a synesthetic alchemy, to transform a visual experience to an aural one.

"THE VIEW ACROSS MY NATIVE COUNTY IS INSPIRING"

If music can be derived from, inspired by, the landscape, is the English landscape, then, actually represented in Elgar's music? Or are we merely being led to believe this as a result of his own brilliant campaign of visual self-fashioning? Elgar certainly found the graphic milieu a most effective way in which to present himself as the bluff countryman whose untutored genius miraculously produced works such as the *Enigma Variations* (1899) and the choral work *The Dream of Gerontius* (1900). A heavily illustrated celebrity interview in the *Sketch* in 1903 (see fig. 63) offered the perfect vehicle. The captions mimic the brusque diction of an army officer retired to the country: "Nothing like outdoor life," "Bicycling," and "Golf." The key image, however, is "The view across my native county is inspiring," in which the moment of magical transformation from picturesque view to musical score is carefully emblematized. This image was undoubtedly Elgar's own careful fabrication, and it retains its potency to the present day. It remains, nonetheless, only one aspect of his complex and paradoxical self-image.

For there are other Elgars. With the award of a knighthood and the Order of Merit and a plethora of honorary degrees and the eventual acquisition of a large house in London in 1911, Elgar himself did much to inhabit a very different environment, removing the mud from his boots. He was no longer the tweedy man of the shires but now metropolitan, formal, and even military in demeanor, and it was this later persona that made Elgar absurd to the Bloomsbury intellectuals of the 1920s. Osbert Sitwell, for example, wrote that Elgar "with his grey moustache, grey hair, grey top hat and frock-coat looked every inch the personification of Colonel Bogey."[3] The underlying snobbishness of this critique was revealed when, in 1931, three years before the composer's death, Edward Dent, professor of music at Cambridge University, commented:

> He was a violin player by profession. . . . He was, moreover, a Catholic, and
> more or less a self-taught man, who possessed little of the literary culture of

Parry and Stanford. . . . For English ears, Elgar's music is too emotional and not quite free from vulgarity.[4]

There is no mention of the landscape or the open air here, merely an allusion to Elgar's lowly origins. By the time Dent was writing, Elgar's work seemed reactionary to the musical elite, the epitome of all that modernism strove to reject. Earlier in Elgar's career, as he struggled for recognition, the extravagant emotionalism of his music, his self-taught Wagnerism, and his refusal to acknowledge the respectable Brahmsian proprieties insisted on by late Victorian establishment figures such as Hubert Parry and Charles Villiers Stanford were read as symptomatic of his social and religious otherness. The implication of Dent's comment is that "English ears" are those of the traditional university men of the upper middle class. Among Elgar's contemporaries in English music, there were other voices that could seem more sophisticated and urbane: as an anonymous rhyme has it, "Delius is for the superceelious, who consider Elgar velgar." After his death in 1934, this image of Elgar—not a man of furrow and field, but a vulgarian in spats and bowler hat, the personification of the upward social aspirations of the Edwardian lower middle class—held sway.

The centenary year of 1957 saw attempts to rehabilitate Elgar's reputation, with a spate of new recordings on long-playing records. The most brilliant intervention, five years later, was the heartfelt, if desperately low-budget, reassertion of the connection between Elgar and the rural environment in Ken Russell's film made for the BBC's *Monitor* series in 1962. With his unforgettable depiction of Elgar as a boy on his pony on the Malvern Hills, juxtaposed with the Introduction and Allegro for Strings (1904), Russell rehabilitated the composer as a countryman (fig. 65). Since 1962 a large historiography has grown up around Elgar, all of which broadly conforms to the interpretation Russell put forward of a troubled but essentially rural genius, an emanation of a particular and cherished form of Englishness.

A highly significant aspect of Elgar's identity and practice, intuitively identified by Russell, has been overlooked, however. I would argue that Elgar's musical scores, his writings, and the performance of his own artistic identity are imbricated with ideas of space, place, and association that are profoundly *visual* in origin. In other words, I want to suggest that for Elgar, landscape was mediated by the visual, enculturated in landscape painting and other such forms of representation, prior to the composer's response to it in music. Romantic composers from Ludwig van Beethoven onward had, of course, sought inspiration in the forests and mountains, and the image of the melancholic withdrawal of the saturnine artist into sylvan solitude, as the art historian Rudolf Wittkower demonstrated, has a strong classical and Renaissance pedigree.[5] Landscape music, like landscape painting, is gener-

65. Film still from Ken Russell, *Elgar* (1962), for the BBC series *Monitor*. British Film Institute, National Archive.

ally associated with picturesque virtues: the reassuring traditional values of the country placed against the dynamic and dangerous pressures of the modern city. Like Virgil and his many followers among pastoral poets, the creator of pastoral music could safely be assumed to have retreated from questions of politics and empire into a *locus amoenus* (pleasant place), a safe haven from the pressures of modernity and the claims of epic and grand narrative.[6] But I want to trouble the simplistic identification between Elgar and the rural landscape—and to argue that, looked at more closely, Elgar's ruralism is deeply ambivalent, and that his compositional practices and the explicit and implicit engagements of his scores are redolent of urban modernity. To make this move is to complicate the ideas of England, Englishness, and the English landscape, and to endorse a revisionist view of the

Edwardian era as a moment of crisis in which long-established binaries—town-country; center-periphery; high-low; even male-female—were placed under strain, even erasure.

MIDDLE ENGLISHNESS

The Australian critic Donald Horne, in a crude but stimulating analysis, discerned in late Victorian Britain two metaphors of Britishness: a northern metaphor, in which "Britain is pragmatic, empirical, calculating, Puritan, bourgeois, enterprising, adventurous, scientific, serious, and believes in struggle"; and a southern metaphor, in which, by contrast, "Britain is romantic, illogical, muddled, divinely lucky, Anglican, aristocratic, traditional, frivolous, and believes in order and tradition."[7] This binary of North and South is implicitly also an environmental distinction between the industrial city and the rural world. While the industrial landscapes of the North were almost invisible in the fine arts and figured only through popular media such as lithography, this southern metaphor stood at the heart of much English landscape painting of the Edwardian era—soothing, technically accomplished, nostalgic works by artists such as Alfred East, whom Elgar knew and admired, in which an English version of the Virgilian pastoral is glimpsed from a leafy shade as if chanced upon during a summer ramble. Where labor is acknowledged, its presence is devoid of social critique, as in the warmly evocative representations of rural labor by John Arnesby Brown, purchased from the walls of the Royal Academy or New English Art Club exhibitions by industrialists for display in their suburban villas. Like these images the rural Elgar, then, could ostensibly be considered the musical epitome of the southern metaphor—in which the environment is subjected to subtle and slow historical change rather than to the radical transformations of the industrial model. For Martin Wiener, in his early Thatcherite polemic of 1981, *English Culture and the Decline of the Industrial Spirit, 1850–1980*, the northern metaphor offered all that was good about the thrustful British economy and culture of Victorian Britain.[8] The southern metaphor, celebrated by nostalgic socialists just as much as pessimistic Tory squires, was offered by Wiener as the essential cause of British decline: rusticated, aestheticized, backward looking, compassionate, and wholly useless in the modern world.

But I suggest that the rural and the metropolitan—the agrarian and the industrial, southern and northern—were not alternatives in the Edwardian era, representing respectively an obsolete conservative past and a radical futurity, but interwoven parts of the same modernizing world. Furthermore, these apparently insular forces were bound together with the vast territories of the British Empire,

welded by global economic forces, by mass communications and political ideology, and by the multifarious forms of culture. It is the slippages between country, city, and empire, their complete inter-reliance, that provides a geo-cultural matrix for understanding of the music of Edward Elgar and of the landscape imagery of the period, visual and musical. Elgar's art belongs on the margins, in the interstices between city and country, north and south, and triangulated between province, metropole, and colony. At the historical moment of Elgar's musical maturity in the Edwardian era, each of these elements was threatened by unprecedented forces of change. The rural environment was weakened by industrialization and international competition, and rural culture, as Elgar's friend and would-be librettist, Thomas Hardy, chronicled, was subject to the economic forces of change. Edwardian London's unstable social and political mix was characterized by increased class antagonism and the rise of organized labor, of suffragism, and of Irish nationalism; further, Britain's increasingly tenuous grip on imperial power in the face of German militarism and American commercial competition was all too apparent on the eve of World War I. It is not, I think, far-fetched to posit analogies between Elgar's turbulent scores and these explosive historical tensions: from this context, surely, Elgar's music derives its mercurial changefulness, its demonic energy, and its melancholy grandeur.

Edward William Elgar was born on 2 June 1857 in Worcestershire, whose picturesque beauty and antiquarian interest had long been noted and inscribed into visual culture. With the arrival of the railway at Worcester in 1850, and at the nearby spa town of Great Malvern in 1859, the picturesque landscape and the curative waters spawned a burgeoning tourist trade. The county became the subject of a substantial topographical and historical literature, and Elgar is listed as a subscriber to W. Salt Brassington's *Historic Worcestershire* (1894). This book opens with an unmistakably Elgarian account of climbing the Malvern Hills, from which on a fine day the view extends to Wiltshire and to Wales, and it also affords a magnificent panorama of "the wide reach of the River Severn before it opens out toward the Bristol Channel."[9] Brassington concludes, "It has been truly said of Worcestershire that it combines within itself more elements of English life than any other county. . . . Here are . . . the numerous trades of the 'Black Country,' as well as the pastures, cornfields, orchards, hop-yards, and quiet villages of the southern plains."[10] Brassington's book makes extensive use of lithographically reproduced photographs, which he carefully connects to local archaeological discoveries and folkloric traditions (fig. 66). Characteristically Edwardian, and absolutely Elgarian, is this harnessing of the technologies of industrial modernity in the assertion of historical continuities between ancient and modern. The Worcestershire

Droitwich, seen across the plain. Droitwich, where survives one of the oldest industries in Britain—the making of salt. Salwarpe, birthplace of Richard Beauchamp, hero of Shrewsbury and of Agincourt. Redditch, renowned for needles. Bromsgrove, once famous for cloth and now for the making of nails. Hewell, seat of the Windsors, since the Reformation. Still further north, behind the Lickey Hills, lies Birmingham, the Midland capital, a hive of industry, widening its ancient boundaries into Worcestershire.

Dudley, centre of the iron and coal fields, black with the soot of innumerable furnaces, and presided over by a grim castle, the cradle of a lordly race.

MALVERN FROM THE LINK.

Hagley, associated with the great name of Lyttelton, the poetry and refinement of Shenstone, and the legend of the Mercian martyr Kenelm. Kidderminster, memorable as the abiding place of Richard Baxter, and now the seat of a great carpet-weaving industry. Stourbridge, an old country town, world-famed for glass and fire clay. Bewdley, formerly a busy market, now decaying, but retaining memories of olden days, the jurisdiction of the Lord of Marches of Wales, legends of Wyre Forest, and the Royal House at Tickenell. Lastly, from this hill top, we may see the beautiful Teme Valley, full of quaint villages and abounding in scenery, both cultivated and picturesque, and now our survey of Worcestershire is complete.

66. "Malvern from the Link," from William Salt Brassington, *Historic Worcestershire: Worcestershire Historical, Biographical, Traditional, Legendary and Romantic* (Birmingham: Midland Educational Co.; London: Simpkin, Marshall, Hamilton, Kent, 1894), 10. Courtesy of the Yale University Library.

landscape was already richly documented, coded as picturesque, celebrated as a national treasure; overdetermined, one might say, in more traditional forms of representation, from watercolors and engravings to large oil paintings, including many by local artists proudly donated to the Victoria Institute in Worcester and on public view throughout Elgar's adult life.[11]

Elgar's biographers have made much play of the rustic circumstances of his birth, in this county that is neither northern nor southern, but the most rural extreme of the West Midlands—a borderland in many ways. Elgar was, as might be inferred, born in the cottage in the village of Broadheath that is now the Elgar Birthplace Museum. But the truth is that in 1859, with Edward only two years old, the family moved into the center of Worcester, where W. H. Elgar opened a piano-tuning and music business on the High Street. Elgar would live within a handful of miles of this spot almost continually until he finally moved at fifty-four, in 1911, into London. The life of a tradesman's son in a large cathedral town was far from the rustic idyll that Elgar's later self-fashioning would suggest. Despite much-vaunted sentimental returns to the house of his birth, Elgar's upbringing was urban, rather than rural, and his earliest recollections were the names of the industrial tugboats on the river at Worcester, names redolent of the northern metaphor: *Enterprise*, *Reliance*, and *Resolution*.[12] These were words to conjure with for a piano tuner's son who, deprived of any formal musical education, and frustrated in his wish to study in Leipzig, was determined to become a composer. Elgar's life in Worcestershire, in fact, only flirted with the rural; with increasing affluence he rented a series of small, often suburban houses, which allowed easy access to the countryside but were firmly located within the town.

LANDSCAPE COMPOSITION

It was from these houses that Elgar was able to develop a compositional practice closely resembling that of a landscape painter. It was quite different from the essentially urban and usually metropolitan lifestyle traditionally associated with the composer, from church musicians and Kapellmeisters to the creators of operas and symphonies. He described his compositional method in the following way:

> An idea comes to me, perhaps when walking. On return I write it down. Weeks or months after I may take it up and write out the movement of which it had become the germ. But the piece has gradually shaped itself in my mind in the meantime, and the actual writing is thus a small matter.[13]

Among Elgar's pronouncements none has been more widely quoted than his claim, made in a letter to the art historian Sidney Colvin in 1921, that "I am still at heart the dreamy child who used to be found in the reeds by the Severn Side trying to fix the sounds and longing for something very great—source, texture and all else unknown. I am still looking for This."[14] Colvin would surely have noted in these words an echo—perhaps a deliberate one—of John Constable's equally memorable, and widely quoted, dictum, "Still I should paint my own places best; painting is with me but another word for feeling, and I associate my 'careless boyhood' with all that lies on the banks of the Stour."[15] As with Constable, Elgar rooted his aesthetic practice in sketching from nature, a process that allowed access to a personal past. The artist and the composer both made swift annotations from nature, then transformed them, at length, into fully orchestrated works for public consumption.

Yet it is in a more modest figure in the history of art, Benjamin Williams Leader, a leading Royal Academician and painter of picturesque landscapes in the later Victorian and Edwardian years, that we can find a landscape painter whose works—so Elgar acknowledged—had inspired his own processes of musical creation. Leader was born in Worcester twenty-six years earlier than Elgar, in 1831. Like the composer, he was the son of a tradesman, spending his early years above the ironmonger's shop at 94 High Street, only a few doors from the music shop of the Elgar Brothers.[16] When in 1914 Leader was designated a "Freeman of the City of Worcester" (an honorary status given to esteemed members of the community), Elgar was asked to make the oration. According to the *Worcester Journal*, the composer alluded to the "darker or mysterious recesses of [music,] the art he [himself] had followed," and he thanked Leader "for the inspiration which his picture of the country had been to [Elgar] in carrying out what he had been able to do in his own art."[17] Leader's early work, under the influence of John Ruskin's *Modern Painters* (1843–60), provides topographically precise and sharply detailed studies of Worcestershire landscapes. In *The Smooth Severn Stream* (1886), which draws its title from John Milton's *Comus*, Leader carefully delineates the familiar outline of the Malvern Hills—seen in Brassington's illustration, and in a thousand picture postcards—in the right distance, much as they appear from Broadheath (fig. 67). An understated dichotomy of leisure and labor structures the composition, with the bourgeois equipment of the painter carelessly left around a garden chair in the foreground, and the work of bargemen and shepherds continuing beyond. Like Elgar, Leader fashioned himself as the perfect countryman, sketching from nature and dressing in tweeds, and made a socially advantageous marriage, occupying a series of increasingly grand country residences.[18]

A tension between London and Worcestershire made itself felt in Leader's professional practice, as, later, it would in Elgar's. Craving metropolitan exposure

67. Benjamin Williams Leader, *The Smooth Severn Stream*, oil on canvas (1886), 35⅞ x 64 in. (91 x 162.3 cm). Collection of Worcester City Museums.

and advancement at the Royal Academy, Leader held an annual private view of his paintings in the Langham Hotel, Portland Place, though, unlike his major competitors, he never held a London address. Leader became the most popular landscape painter of the late Victorian era, achieving his most lasting success with the desolate sunset panorama *February Fill Dyke* (1881; Birmingham Museums and Art Gallery), in which wholesome labor and productivity are banished and a lurid, depopulated emptiness prevails. It is a landscape of the rural depression, of a Hardyesque, doomed countryside. An inventory of Elgar's London house reveals, poignantly perhaps, that an engraving after Leader, alone, decorated the composer's personal dressing room, and it was, perhaps, this melancholy strain in the painter's work that most appealed to Elgar.[19] Although occasionally Leader strayed beyond tested picturesque formulas, as in his impressive study of the Manchester ship canal, his unmistakable idiom constituted a Victorian reworking of Constable, sometimes with an explicitly religious overtone.[20] Writing of a typical Leader work in 1885, the *Art Journal* commented:

The scene is indeed one which it is not strange that Englishmen should love.
A long national history and the immemorial laws and traditions that rule

over the hamlet, the parish, the fold and field, and the river, have had their slow but sure effect upon every part and detail of the landscape. All refer back to feudal England. . . . The whole story, lost in the modern town, is written in the modern fields, in the very growth of the hedges and clustering of the trees.[21]

This trope of rural utopia "lost in the modern town" held a deep fascination for Elgar and his contemporaries. Indeed, Leader's modest, unspectacular evocations of the picturesque Worcester landscape find a nice parallel in an early example of Elgar's evocation of the very same landscape, the "Woodland Interlude" (1898), in which a limited, sylvan palette of orchestral color balances muted strings with the clarinet. A deliberately simplified harmonic language hints at the dance of woodland spirits in this interlude, which is a genre piece reminiscent of Elgar's early career as a composer of salon music.

AN ENGLISH HERO

Although the "Woodland Interlude" was enjoyed as a concert work, Elgar's charming sylvan miniature is by no means a freestanding nature piece, nor is it an evocation of a modern landscape. Rather, it separates two parts of the most ambitious of his early works, the dramatic cantata *Caractacus* (1898), based on the life of the ancient Briton who defied Rome but was eventually crushed by imperial power.[22] The dramatic cantata is essentially an oratorio, the form of music most closely associated with England in the eighteenth and nineteenth centuries. The existence both of the Three Choirs Festival, shared among the Anglican cathedrals of the West Country, and of major choral societies in all the great industrial cities created a regular demand for large-scale works that could sit alongside George Frideric Handel's *Messiah* (1742) and Felix Mendelssohn's *Elijah* (1846) in festival programs. Oratorio called into existence a new building type, the grandiose concert hall that could house a sizable orchestra, a chorus, and a mass audience for large-scale musical works. Oratorio shared opera's basic musical forms of aria, chorus, and recitative but disavowed the stage and substituted biblical and historical drama for the baser passions of the operatic libretto. Elgar's innovation was to attempt to fuse the Wagnerian music drama with the oratorio.

The perfect subject for a work in this vein presented itself to Elgar from the pages of Brassington's *Historic Worcestershire*, where he found in Caractacus a hero whose origins lay in the Malvern Hills. This leader of the ancient Britons had entered national mythology as a racial archetype—a hero whose bravery and phys-

ical stature were matched by a patriotism so noble that, even in defeat, he was offered a pardon by his Roman captors. This, of course, was the stuff of history painting, and Caractacus had been taken up by painters from Francis Hayman to George Frederic Watts. The artists concentrated on Caractacus's "noble behavior" in Rome.[23] But for Elgar, the key to the narrative lay in the fact that the British chieftain's last stand against the invading Romans was believed to have taken place at the camp in the Malverns, which remained a major local landmark. Elgar's working methods and his evocative ambitions were more those of a landscape painter than a history painter as he distilled his ideas for the cantata. As he worked on the score, a friend recalled, Elgar "trampled over the hills and went along the Druid path from end to end, along the top of the [Malvern] Hills."[24]

The broad historical canvas of *Caractacus* involved more than one kind of landscape. If the deepest England of the interlude was a vision wrested from the ancient woodlands of Worcestershire, Elgar also rose, like the history painters, to the challenge of evoking the barbaric splendors of ancient Rome, in his "Triumphal March," and in doing so evolved a musical idiom suitable for the ceremonial music he would provide for Edward VII, such as the *Coronation Ode* (1902).

The "Triumphal March" was certainly imperial music of an order that no British composer had created before, swaggering and stately, epic and stoic; it amplified the *Imperial March*, which Elgar had written for Queen Victoria's Diamond Jubilee in 1897, a march whose orchestral effects matched the visual splendor of the occasion. Yet the *Caractacus* march celebrated the pomp and circumstance of the Roman oppressor and not of the British hero, and those associations were by no means undercut by the libretto's jingoistic ending, which looks forward two millennia to the eventual reign of freedom under the British Empire. The parallel between these related examples of martial music opens up the possibility of critique—the idea that Elgar might have perceived the similarities between Caractacus and those whom the British Empire had conquered. In the cantata Elgar achieves the fusion of the triumvirate of territories—country, city, and empire—central to the Edwardian imaginary.

Before concluding my remarks on *Caractacus*, I would like to return briefly to the map with which I opened (see fig. 64). For the music inspired by walks through Gloucestershire countryside was, in fact, *Pomp and Circumstance*, no. 5, a rousing march in C-major, the same key that Elgar used to conjure up the militaristic splendors of ancient Rome. The music was jotted down by the seventy-one-year-old Elgar not on a country walk but on a drive with his chauffeur in June 1929—its rusticity severely compromised by the technological modernity of the circumstances. Yet is a drive in a car any less authentic than a ramble? And is military music—of a superior quality—necessarily an inauthentic response to the

rural environment of a still-imperial Britain? The relationship between landscape and music, mediated through Elgar's imagination, was by no means one of straightforward representation. The music suggested to Elgar by the English landscape rarely sounds pastoral; he makes no use of tone painting; there are no birdcalls or evocative shepherd's horn calls. There is much that could be understood as urban and even imperial in all of Elgar's major scores, even those penned among the leafage of Worcestershire.

Caractacus himself becomes a dramatically credible figure only when, in scene 6, humiliated and imprisoned in Rome, he appeals proudly to Emperor Claudius. Here, in the heart of the greatest city on earth, Caractacus evokes the Worcester landscape with these words:

> A free born chieftain, and a people free,
> We dwelt among our woodlands
> And were blest.[25]

Elgar reintroduced here the dipping semiquaver figure from the "Woodland Interlude" and added an agogic pause after the word "woodlands." As he pointed out to August Jaeger, "I made old Caractacus stop as if broken down . . . & choke & say 'woodlands' again, because I'm so madly devoted to my woods."[26] Caractacus in Rome takes on, perhaps, shades of Elgar in London—a displaced, broken figure in whom rural and urban uneasily collide.

THE URBAN MUSE

Despite Elgar's resolutely provincial persona, at least until 1911, his music was most frequently performed in London. There was little opportunity to hear contemporary music in Worcester, and scores were expensive and difficult to procure. So, like any budding artist of the period keen to assimilate the latest styles, Elgar took full advantage of every opportunity to visit the metropolis. The concerts of August Manns at the Crystal Palace at Sydenham offered rich and imaginative programs featuring the latest works of Richard Wagner, Peter Ilyich Tchaikovsky, Antonín Dvořák, and Johannes Brahms.[27] Victorian technology allowed Elgar to attend such a concert, as he recalled years later:

> I rose at six—walked a mile to the railway station;—the train left at seven;—arrived at Paddington about eleven;—underground to Victoria;—on to the Palace, arriving in time for the last three-quarters of an hour of the

rehearsal. . . . Lunch; Concert at three; at five a rush for the train to Victoria; then to Paddington;—on to Worcester arriving at ten-thirty. A strenuous day indeed; but the new work had been heard and another treasure added to a life's experience.[28]

In his remarks about B. W. Leader in 1914, Elgar noted that "a young man who was ambitious and lived in a country town had only one anxiety—to get away," adding that "when he was settled down in a big city, his only anxiety was to earn enough money to get home again."[29] This was undoubtedly a personal testimony. Upon his marriage in 1889, Elgar moved to London with high hopes, and he struggled for two years to make a living in the city, first in Kensington, convenient to the Albert Hall, and then in Norwood, near the Crystal Palace. Despite his bitterness at the failure of his debut in the capital, Elgar stored up memories—visual and musical—of the imperial city that became the basis for his most topographical work. In 1901 it took the form of *Cockaigne (In London Town)*, a robust and light-hearted portrait of the city, whose name was both a pun on the word "Cockney" and the medieval term for a place of ease and prosperity. Elgar described it as "cheerful and Londony—stout and steaky." A wealth of orchestral effects allowed Elgar to paint aural pictures that closely parallel key themes of the artists of this era. Uniquely among Elgar's works, the cover of the score of *Cockaigne*, by Patten Wilson, includes a group of illustrations brilliantly approximating the combination of Gothic Revival medievalism and pictorial depiction of the modern city underpinning Elgar's glittering exercise in program music. Wilson's iconography parallels Elgar's demotic musical idiom, by paraphrasing the imagery of contemporary advertising and popular graphics. In the sphere of fine art, images of London scenery were consistently popular throughout the nineteenth century, such as the teeming chaos portrayed in *Ludgate Hill* (1887; Guildhall, London), a canvas by the Paris-trained William Logsdail; or W. L. Wylie's evocation entitled *Toil, Glitter, Grime and Wealth on a Flowing Tide* (1883; Tate Britain, London). The prominence in exhibitions and the extensive reproduction of such imagery offered Elgar the materials for a musical portrayal of key tropes and sites in the capital. In a tour de force of musical depiction, Elgar's *Cockaigne* evokes a series of London environments, including a park scene with a pair of lovers (whose theme he identified as such in a letter of 1901) and the arrival of a military band.

For many years Elgar claimed to be writing an overture, "Cockaigne 2—City of Dreadful Night," the dark shadow of his brash Edwardian showpiece. Although the title derived from the Victorian poet James Thomson, the impetus behind this unwritten, perhaps unwritable work was the soulless modernity of the metropolis. Unlike his contemporary Gustav Mahler, Elgar was not seduced by the sleazy

sonorities of street musicians, nor did he allude to the decadence of urban low life or popular culture. But music from the abandoned "Cockaigne 2" found its way into the Second Symphony (1911), a symphonic panorama that seems to comprise both a personal testimonial and a portrayal of the multifarious facets of Edwardian England.[30] This work announced Elgar's move away from Herefordshire to a grand residence in Hampstead, once the property of the artist Edwin Longsden Long, which Elgar promptly renamed Severn House. It also presaged the collapse of his popular following. As complex in its range of associations as it is in musical form, Elgar's Second Symphony combines aspects of elegy with vigorous eulogy, moving from a euphoric opening across vast musical territories to an ending whose peacefulness speaks of nostalgia more than fulfillment. The symphony is dedicated to the memory of Edward VII in the spirit of a "loyal tribute," and the second movement is a funeral march. Paying homage to the slow movement of Beethoven's Symphony no. 3, the *Eroica*, Elgar's impassioned largo inexorably conjures up the movement of a stately funeral cortege. He described the third movement, a stormy scherzo in rondo form, as "very wild and headstrong . . . with soothing pastoral strains in between."[31] The opening is indeed flecked with woodwind music distantly echoing the delicate figuration of the "Woodland Interlude" in *Caractacus*; however, this soon gives way to a mechanistic dystopia, the "City of the Dreadful Night," bringing the cultural geography of Elgar's world into a stark juxtaposition. The dark energies of "Cockaigne 2" perhaps informed a ferocious episode in which the full range of orchestral percussion hammers out each beat marcato as fortissimo brass in bare octaves snarl a theme first heard in more benign orchestral coloring in the first movement. This central crisis of Elgar's scherzo unleashes the feverish activity of the modern city. The "dreadful beating that goes on in the brain . . . [a] hammering [that] must gradually overwhelm everything" that Elgar asked the orchestra to emulate while playing this section is surely of urban, perhaps even industrial, origin.[32] Elgar's dehumanized, mechanized London brings him strikingly, and surprisingly, close to the visual and textual representations of urban life in Vorticism, which was emerging at the very same moment in 1911. Elgar's Second Symphony comes as close as any work of art to being a portrait of the Edwardian era.

It was at this agonizing, metropolitan moment in his life that Lady Elgar commissioned Philip Burne-Jones, son of the great Victorian painter and inheritor of his baronetcy, to portray her husband (fig. 68). Here, Elgar's body, slender and vulnerable, seems trapped between the social requirements of the city and the desired but vanished utopia of the country, "lost in the modern town." Its presence is indicated by a dimly evoked landscape painting, its composition with lowering clouds severed in Whistleresque fashion. Once again for Elgar, landscape is

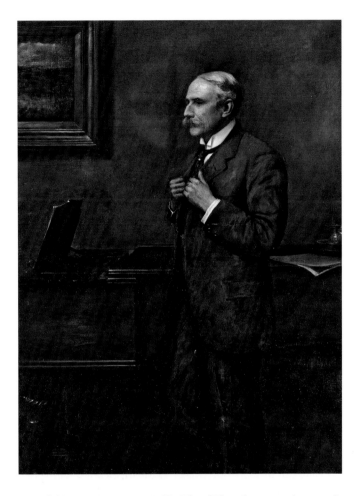

68. Philip Burne-Jones, *Portrait of Sir Edward Elgar,* oil on canvas (ca. 1911–12), 43⅜ x 26⅞ in. (110 x 68 cm). Collection of Worcester City Council.

approached through art and the reality of the rural idyll is unattainable. The truncated painting hangs almost illegibly in the bourgeois gloom above a grand piano, which is both professional symbol and upper-middle-class urban accoutrement. This is an eloquent symbolic device for the piano tuner's son who, in his youth, would enter the houses of the wealthy through the tradesmen's entrance but now possessed his own wood-paneled mansion. The social discomfort expressed by the position of Elgar's hands, nervously fingering his lapels, seems, however, to undermine any sense of masculine bravado in this strangely tentative portrait, exhibited at the Royal Academy in 1913. Comparison with James Abbott McNeill Whistler's

At the Piano (1858–59; Taft Museum, Cincinnati), which would surely have been known to Burne-Jones if not to Elgar, underscores the feminizing qualities of the domestic interior space. The composer himself later sought to suppress the work on the explicit ground that it rendered him as insufficiently masculine. The sittings took place during a period of deep depression after the relative failure of the Second Symphony, and a looming period of creative inactivity is, perhaps, indicated by the lifeless, even coffinlike, piano, its keyboard obscured. The painting hangs today in the genteel public tearoom of the Worcester Town Hall, an ironically provincial resting place for an image in which London's discontents play such a crucial role.

IMPERIAL RECESSIONAL

The first music to emanate from the funereal wood-paneled music room at Severn House was neither metropolitan nor rural in character, although it was performed in London at the Coliseum Music Hall. It was *The Crown of India* (1912), music for a masque celebrating the Indian durbar (a meeting of the "native princes" and officials of the British Raj) for the newly crowned George V, and it offered an allegory of the redemptive role of Britain in Indian history. If city and country were placed in violent juxtaposition both in Elgar's work and in his life, then the presence of empire further unsettles any construction of Englishness. Empire was everywhere in Elgar's world: the librettist of *Caractacus*, Henry Acworth, had been in the Indian civil service; Elgar's wife, Alice, was born in India, the daughter of one of the great imperial warriors, Major General Henry Gee Roberts; and the interior of Severn House was cluttered with trophies of her father's Indian campaigns. Elgar's programmatic music offers hints, at least, of the intermingling of imperial and domestic themes. In Patten Wilson's illustrated cover for *Cockaigne* (fig. 69), for example, the troops wear Indian army gear, including helmets specially adapted to avoid sunstroke, a precaution strictly unnecessary "in London town." The set design for the finale of *The Crown of India* presented an orientalized version of the Gothic flummery of the state opening of Parliament, with Britannia crowned and ensconced in a throne, receiving loyal obeisance from female figures allegorically representing the Indian cities.[33]

But the musical climax of *The Crown of India*—interestingly—arrives earlier, in the form of "The March of the Mogul Emperors," a piece of processional music with a swagger and a heady barbarism. Here a direct connection is forged with the modern visual landscape of the British Empire, epitomized by the great durbar processions. The barbaric military music was, of course, no more than an orientalized

69. Edward Elgar, *Cockaigne (In London Town)*, original cover of score with illustration by Patten Wilson (London: Boosey, 1901). British Library.

echo of the Romans' triumphal march from *Caractacus*, the British marching music of the *Pomp and Circumstance* marches, and the joyous Salvation Army band in *Cockaigne*. Elgar's metaphoric world of music blends past and present, imperial metropolis and colonial periphery, just as deftly as—in *Caractacus* and in his Shakespearean symphonic study *Falstaff*, completed at Severn House in 1913—introspective rural interludes are dialectically linked to scenes of urban exuberance. The brilliance of Elgar's orchestration, however, could no more mask the fragility of the Indian empire than could the bombastic durbar celebrations in Delhi. Clinically depressed, Elgar withdrew from conducting *The Crown of India* in March 1912, but the masque was still playing at the Coliseum when, in April, the sinking of the *Titanic* seemed to portend a more general disaster.

ELEGY

Although Elgar completed little significant music in the last fourteen years of his life, he did experience a final period of intense creativity in 1917–20, during and immediately after the crisis that destroyed almost every vestige of his cultural world, and with it the visual and musical currency of Edwardian England: World War I. During the war he produced occasional pieces but little major art music. A retreat into the countryside precipitated Elgar's return to productivity; this time, however, it was not Worcestershire but Sussex that would provide respite, through the lease of Brinkwells, a cottage near Fittleworth. Brinkwells had been occupied since 1906 by the artist Rex Vicat Cole, and once again Elgar's experience of the landscape—now more than ever conditioned by a pervading sense of loss—was mediated by an intensified engagement with landscape painting of the Edwardian era.[34] Elgar installed his piano among the sketches and unsold canvases in Vicat Cole's studio, facing its large windows that commanded a panoramic view of The Weald of Sussex, with the Sussex Downs in the distance. Enshrined in Vicat Cole's quintessentially Edwardian interpretations of this view and the surrounding countryside was a vision of the landscape strikingly akin to Elgar's own. Elgar wrote to Arthur Troyte Griffith (the subject of one of the *Enigma Variations*): "I am so dreadfully disappointed that you cant come to Brinkwells you wd have loved it (It's *Vicat Coles*) there are many sketches and pictures. . . . I shd have something to say also on British R.Academic art, no Art. Gosh!"[35]

The Home Field (1906; fig. 70) can stand as emblematic of Vicat Cole's canvases from the first decade of the new century, which featured regularly and prominently at the Royal Academy's annual summer exhibition. Painted on a large scale, richly impastoed, and opulent in coloring, these works were ecstatic in their cel-

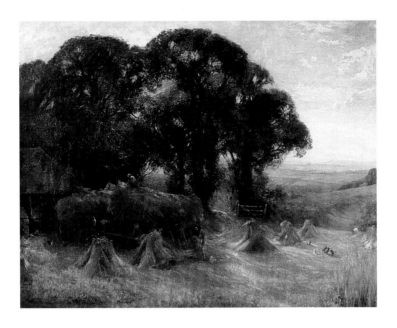

70. Rex Vicat Cole, *The Home Field*, oil on canvas (1906), 50 x 60⅛ in. (127 x 152.5 cm). Private collection.

ebration of rural vistas apparently untouched by the industrialization of farming. *The Harvest Field* lovingly represents an idyll intact. But another work of Vicat Cole's representing the view from the studio at Brinkwells—made in 1916, a year earlier before Elgar arrived, and probably left in the studio—captures the somber mood of the period, allowing the blustery clouds to mute the colors of the cottage garden (fig. 71). Vicat Cole, younger than the composer, enlisted for the army, joining the Artists Rifles in 1916. Although he did not see active service on the front, the experience of the war transformed Vicat Cole's work, impressing upon it a note of elegy that never lifted. For the composer, even in the heart of deepest southern England, there was no escape from the tragic events in France, since, as Alice Elgar noted in her diary on 30 May 1918, "incessant gunfire (distant cannon)" could be heard echoing through the Sussex Woods.[36] The paintings around him, like the landscapes beyond the studio, came to stand for a lost Edwardian world, contrasting bitterly with the cacophony of industrial warfare. Elgar sought out melancholy aspects of the local environment, which resonated through the austere new music created in the studio at Brinkwells. As W. H. Reed recalled,

A favourite short walk from the house up through the woods brought one clean out of the everyday world to a region [close to] Flexham Park. . . . The strangeness of the place was created by a group of dead trees which, apparently struck by lightning, had very gnarled and twisted branches, stretching out in an eerie manner as if beckoning one to come nearer.[37]

Elgar explicitly connected these strange natural formations with the unearthly but frankly Brahmsian opening of his Piano Quintet, completed in 1919, one example of the "wood magic" that Alice Elgar discerned in these late works. Here, as in the String Quartet and Violin Sonata (both completed in 1918), Elgar employed a reduced palette to speak of austerity and grief, a strategy shared by Vicat Cole's landscapes painted at Brinkwells after the war. Elgar's late works form an elegiac commentary on the opulent orchestral compositions of his Edwardian heyday. In them he employed a refined musical language that no longer appealed to a large public, and—to critics—seemed obsolete at the moment of modernism's sudden triumph. Certainly Elgar had retreated from the larger programmatic aims of works such as the Second Symphony, and in his late work he made no attempt to survey the shattered panorama of the battlefield (as Ralph Vaughan Williams would do in his Symphony no. 3, the *Pastoral*, of 1922) or the transformed postwar urban environment. Yet in the chamber music and the Cello Concerto written at Brinkwells, Elgar's artistry was at its finest, and the Sussex compositions, composed in an artist's rural studio and deeply imbricated in the visual culture of Edwardian pastoralism, stand as moving elegies for a lost world.

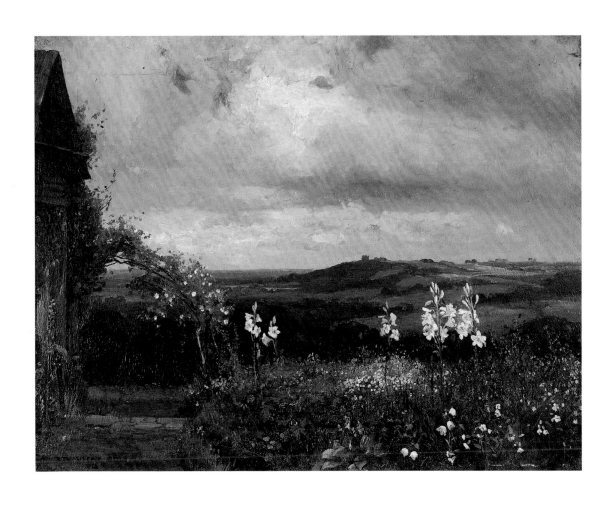

71. Rex Vicat Cole, *Brinkwells Garden*, oil on canvas (1916), 14 x 18 in. (35.6 x 45.7 cm). Private collection.

1. Edward Elgar, interview by R. J. Buckley, reprinted in *An Elgar Companion*, ed. Christopher Redwood (Ashbourne, UK: Sequoia, 1982), 112.

2. *A Future for English Music, and Other Lectures, by Edward Elgar*, ed. Percy M. Young (London: Dobson, 1968), 57. See also Jerrold Northrop Moore, *Edward Elgar: A Creative Life* (Oxford: Oxford Univ. Press, 1984), 459.

3. Osbert Sitwell, *Laughter in the Next Room* (London: Macmillan, 1949), 196.

4. Edward J. Dent, quoted in Basil Maine, *Elgar: His Life and Works* (London: Bell, 1933), 2, 277–78. See also Moore, *Edward Elgar*, 789.

5. Rudolf and Margaret Wittkower, *Born under Saturn: The Character and Conduct of Artists: A Documented History from Antiquity to the French Revolution* (London: Weidenfeld and Nicolson, 1963).

6. See, for example, Robert C. Cafritz, Lawrence Gowing, and David Rosand, *Places of Delight: The Pastoral Landscape* (Washington, D.C.: Phillips Collection, 1988).

7. Donald Horne, *God Is an Englishman: So Why Is England Such a Mess?* (Harmondsworth, UK: Penguin Books, 1970), 22. See also Alan R. H. Baker and Mark Billinge, eds., *Geographies of England: The North-South Divide, Imagined and Material* (Cambridge: Cambridge Univ. Press, 2004).

8. Martin J. Wiener, *English Culture and the Decline of the Industrial Spirit, 1850–1980* (Cambridge: Cambridge Univ. Press, 1981).

9. William Salt Brassington, *Historic Worcestershire: Worcestershire Historical, Biographical, Traditional, Legendary and Romantic* (Birmingham: Midland Educational Co.; London: Simpkin, Marshall, Hamilton, Kent, 1894), 2.

10. Brassington, *Historic Worcestershire*, 11.

11. An example is Henry Harris Lines's *British Camp and Herefordshire Beacon, Malvern* (1872, Worcester City Art Gallery), presented after the artist's death to the Victoria Institute in 1889. A reproduction is available at http://www.worcestercitymuseums.org.uk/coll/art/oiljkl/fa027.htm (accessed 10 Jan. 2008). Lines was a professional artist but also a keen amateur archaeologist whose plans of ancient British camps were donated to the Worcester Free Library. See *Collections Archaeological and Historical Relating to Montgomeryshire and Its Borders*, vol. 23 (London: Whiting, 1889), 321–23.

12. This detail is found in Philip Leicester's manuscript notes on Elgar's speech at the luncheon following the presentation of the Freedom of Worcester to B. W. Leader, 3 June 1914, quoted in Moore, *Edward Elgar*, 19.

13. Edward Elgar, quoted in the *Music Student*, Aug. 1916, reprinted in Moore, *Edward Elgar*, 454.

14. Jerrold Northrop Moore, ed., *Edward Elgar: Letters of a Lifetime* (Oxford: Clarendon Press, 1990), 359.

15. John Constable to Rev. John Fisher, 23 Oct. 1810, in R. B. Beckett, ed., *John Constable's Correspondence* (Ipswich, Suffolk Records Society, 1962–1970), vol. 6, 77.

16. Leader's family name was Williams, but in 1857 he adopted his mother's maiden name of Leader to avoid confusion with the dynasty of landscape painters named Williams, to whom he was not related. Ruth Wood, *Benjamin Williams Leader, RA, 1831–1923: His Life and Paintings* (Woodbridge, UK: Antique Collectors' Club, 1998).

17. "Mr Leader Honoured," *Berrow's Worcester Journal*, 6 June 1914, Elgar Press Cuttings, June 1911 to July 1914, 98, Elgar Birthplace Museum, Broadheath.

18. Wood, *Benjamin Williams Leader*, 54–55.

19. Hampton & Sons, London, "Inventory of Furniture, Pictures, Books, China, Jewellery etc, the Property of Sir Edward Elgar, OM, Valued for Insurance Purposes. Severn House, 42 Netherhall Gardens, Hampstead NW," Jan. 1913, Elgar Birthplace Museum, Broadheath.

20. Benjamin Williams Leader, *The Excavation of the Manchester Ship Canal: Eastham Cutting* (1891; Tatton Park, Cheshire, National Trust).

21. Lewis Lusk, "The Life and Work of B.W. Leader, RA," *Art Annual* (1901): 6, quoted in Rosemary Treble, *Great Victorian Pictures: Their Paths to Fame* (London: Arts Council, 1978), 49.

22. See Charles Edward McGuire, "Elgar and Acworth's *Caractacus*: The Druids, Race, and the Individual Hero," in *Elgar Studies*, ed. J. P. E. Harper-Scott and Julian Rushton (Cambridge: Cambridge Univ. Press, 2007), 50–77.

23. Matthew Riley has drawn attention to this tradition, which reaches back to Francis Hayman's painting *The Noble Behaviour of Caractacus, before the Emperor Claudius* (1751). See Riley, *Edward Elgar and the Nostalgic Imagination* (Cambridge: Cambridge Univ. Press, 2007), 162.

24. Rosa Burley, quoted in Percy M. Young, ed., *Letters to Nimrod: Edward Elgar to August Jaeger, 1897–1908* (London: Dennis Dobson, 1965), 21. See also Moore, *Edward Elgar*, 232.

25. Edward Elgar, *Caractacus*, scene 6, libretto by Henry Acworth.

26. Edward Elgar to August Jaeger, 21 Aug. 1898, in *Elgar and His Publisher: Letters of a Creative Life*, ed. Jerrold Northrop Moore, 2 vols. (Oxford: Clarendon Press, 1987), 1:86.

27. See Michael Musgrave, *The Musical Life of the Crystal Palace* (Cambridge: Cambridge Univ. Press, 1995).

28. Edward Elgar, MS draft for a speech given at a "His Master's Voice" reception in London, 16 Nov. 1927, quoted in Moore, *Edward Elgar*, 79.

29. "Mr Leader Honoured."

30. For a powerful analysis of this work, see James Hepokoski, "Elgar," in *The Nineteenth-Century Symphony*, ed. D. Kern Holoman (New York: Schirmer Books, 1997), 327–44.

31. Edward Elgar to Alice Stuart-Wortley, 16 Feb. 1911, in *Edward Elgar: The Windflower Letters: Correspondence with Alice Caroline Stuart Wortley and Her Family*, ed. Jerrold Northrop Moore (Oxford: Clarendon Press, 1989), 79.

32. Bernard Shore, *The Orchestra Speaks* (London: Longmans, Green, 1939), page 135.

33. For *The Crown of India*, see Tim Barringer, "Sonic Spectacles of Empire: The Audio-Visual Nexus, Delhi–London, 1911–12," in *Sensible Objects: Material Culture, the Senses, Colonialism, Museums*, ed. E. Edwards and others (London: Berg, 2006).

34. For a full account, see Brian Harvey and Carol Fitzgerald, *Elgar, Vicat Cole and the Ghosts of Brinkwells* (London: Philimore, 2007), and Tim Barringer, *The Cole Family: Painters of the English Landscape, 1838–1975* (Portsmouth: Portsmouth City Art Gallery, 1988), 125–38.

35. Edward Elgar to A. Troyte Griffith, 7 June 1917, in *Letters of Edward Elgar and Other Writings*, ed. Percy M. Young (London: G. Bles, 1956), 231.

36. Alice Elgar, diary, 30 May 1918, quoted in Carol Fitzgerald and Brian W. Harvey, *Elgar, Vicat Cole and the Ghosts of Brinkwells* (Chichester, UK: Phillimore, 2007), 56.

37. William Henry Reed, *Elgar as I Knew Him* (London: V. Gollancz, 1973), 63.

Edwardian Cosmopolitanism, ca. 1901–1912

Andrew Stephenson

O N THE DEATH OF THE MONARCH in January 1901, H. G. Wells recorded that "Queen Victoria was like a great paperweight that for half a century sat upon men's minds and when she was removed, their ideas began to blow."[1] Many contemporary artists concurred and sensed that the death of Victoria was indeed a turning point marking "the funeral of the England of the late nineteenth century" and accompanied by the deaths in the first four years of the new century of John Ruskin on 20 January 1900, Oscar Wilde on 30 November 1900, James Abbott McNeill Whistler on 17 July 1903, and George Frederic Watts on 1 July 1904.[2] Given this sense of closure, many British intellectuals speculated about the nature of the much-anticipated, now-dawning, Edwardian "golden age."[3] While some commentators believed that the legacies of the British Arts and Crafts movement in the United States and the impact of Austro-German aesthetics indebted to the beliefs of William Morris and his followers would lead to the resurgence of a vital, pan-European design reform, others celebrated the Celtic revival of William Butler Yeats and John Millington Synge and promoted the experimental aesthetics of Friedrich Nietzsche, Henri Bergson, and Richard Wagner.[4] From wherever this new "awakening" would derive, it was clear that the years of about 1901–12 were marked by the sense of British culture at a watershed, one in which foreign influences and ideas were revitalizing the modernist experiment and offsetting accusations of cultural isolationism.

Writing a review of recent London exhibitions in the *Art Journal* in July 1906, the critic Frank Rinder celebrated the growing sense of cosmopolitanism among the metropolitan intelligentsia and observed that:

> One of the most promising developments of our time is the desire of nations to better understand one another, to meet in amity instead of on the field of battle. Art has always reached out beyond mere territorial boundaries and in the *entente cordiale* movement—neither in English or German is there an equivalent for this happy phrase—its possibilities are great. Thus while in

admirably practical ways of every-day life we have, during the last few months, been drawing closer to France and to Germany, art in London Galleries has been quickening, deepening our knowledge of a common meeting ground not subject to the vicissitudes of transitory differences.[5]

As modern art's progress seemed inextricably to mirror changes in European political alliances, so Rinder believed that a "new internationalism" was gaining ground, which would herald the spread of new art clubs, debating societies, artists' associations, and contemporary art galleries, as well as the launching of new journals and reviews that would generate a dynamic interaction among British, French, American, and German cultures.[6]

Six days after the death of Edward VII on 6 May 1910, however, Alfred Orage, writing in the *New Age*, lamented that this earlier optimism had seemed largely misplaced:

> At each successive death of the great men who lived during the reign of Queen Victoria, the public has been instructed to believe that each was indeed the closing of his age. Tennyson was the last, so was Lord Salisbury. Then it was Meredith and only recently it was Swinburne. But all these announcements of the real close of the Victorian age have been premature. The last genuine link with the Victorian age has been broken with the death of King Edward VII. . . . King Edward was spiritually the mere executor of Queen Victoria. The impulse of her epoch flowed over as it were and merged in his reign. . . . If it is felt, as it is clearly felt, that the era of Victoria is indeed, at last over, who is so bold as to dare to forecast the nature of the epoch that is now opening.[7]

At least two young and ambitious intellectuals arriving in London in 1908 ventured to predict what the future would hold. For the poet Ezra Pound, London "was the intellectual capital of America," and it was the rising fortunes of the United States that marked the "imminence of an American Renaissance coming from across the Atlantic in the form of a '*Risorgimento*' or Awakening."[8] In 1912 Pound declared that "our American *Risorgimento* . . . will make the Italian Renaissance look like a tempest in a teapot! The force we have, and the impulse, but the guiding sense, the discrimination in applying the force, we must wait and strive for."[9] For the artist Percy Wyndham Lewis, it was an ambitious engagement with urban life that marked the way forward toward a confident modernism. Lewis's explosive attitude was demonstrated in his work by combining the "primitive" impact of contemporary dance with the celebration of urban dynamism derived

from the Italian Futurists, seen at the *Italian Futurist Painters* exhibition at the Sackville Gallery in London in March 1912.[10] Influenced by the writings of Thomas Ernest Hulme published in the *New Age*, Lewis was electrified by the potentialities that modern life in London presented for developing a cosmopolitan modernism that might be approached through Bergsonian evolutionary theories and framed according to Nietzschean philosophy.[11] Given these different and conflicting attitudes toward the Edwardian period, its achievements, and its legacies, this essay aims to examine this growing cosmopolitan outlook and dramatic metropolitan transformations in British culture during the years of about 1901–12. Pushing beyond familiar and well-rehearsed Anglo-French parameters, this account will situate changing artistic practices and aesthetic concerns within a broader internationalist context for modern British art than has previously been proposed, noting in particular the significance that German, Viennese, and American contacts and affiliations had in architecture, art, and design.[12]

"ENTENTE CORDIALE": BRITISH-FRENCH ARTISTIC ALLIANCES

The signing of the Entente Cordiale between Britain and France on 8 April 1904 initiated a sustained period of diplomatic cooperation, during which Anglo-French artistic, literary, and theatrical connections thrived. There was a rapid transfer and interaction between the two cultures, culminating in the 1908 Franco-British Exhibition in London, where the largest number of French Art Nouveau objects ever assembled in the United Kingdom were displayed in the Pavillon Collectivité André Delieux.[13] Just as many French artists, writers, and designers had or were developing British connections, so many British expatriates continued to study and live in the French capital, attracted by its impressive teaching academies, its cheap studios, and the cosmopolitan lifestyles of Montmartre and Montparnasse. As Clive Holland reported in the *Studio* in 1903, "Lady artists of the present day are going to Paris in increasing numbers"; among this great influx was Gwen John, who established herself firmly as part of the Parisian art world by studying at the Académie Colarossi.[14] Farther afield, British artists, male and female, eagerly participated in French rural artists' colonies, most noticeably those in Brittany, Normandy, and around Barbizon.[15] Other London-based writers and critics regularly crossed the Channel to see art exhibitions, engage dealers, or participate in the international expositions, notably the 1900 Paris Exposition Universelle, where the two French Salons—the Société des Artistes Français and the Société Nationale des Beaux-Arts—combined as part of the exposition itself in the newly built Grand

Palais, next to an extensive retrospective, *Centennial Exhibition of French Paintings and Sculptures, 1800–89*.[16] From its formation in 1903, the Salon d'Automne, with its practice of holding retrospectives alongside its regular shows, also attracted regular British participation and garnered widespread European press attention.[17]

One feature of this energetic culture of mobility was the ability of artists, dealers, and art critics to move back and forth, and work effectively, in more than one capital city and national art market. Another was that artists could take advantage of available opportunities for self-promotion by showing simultaneously in state-sponsored academy systems and at the regular international expositions as well as participating in independent group shows (such as the German and Austrian secessions). Within the Edwardian era, this fragmentation accelerated considerably as the centralized professional systems dictated by the ruling academies in France and Germany became more open to external commercial forces and were in greater competition with independent artists' organizations, more liberal exhibition societies, and dealers.[18] To cite two of the most successful artistic examples of such ambition, Whistler and his American compatriot John Singer Sargent became adept at moving between London, Paris, Boston, and New York. Both artists marketed their work in major European and American cities in order to exploit the emerging opportunities developing within these dynamic markets.[19] Such sensational self-advertisement was aided by the innovations experienced in the international press (notably telegraphy) that allowed art news to be syndicated quickly and internationally by multinational news agencies.[20]

Similarly, many British or London-based artists traveled extensively and sustained commercial practices that allowed them to exhibit simultaneously in state-sponsored exhibitions, international expositions, commercial galleries, and artists' independent societies as well as to network within expatriate artistic and literary colonies. To take one successful example, in 1898 Walter Sickert moved to Dieppe, where he resided until his return to London in early October 1905. Managing his career from Dieppe, then a thriving artists' community popular with Anglophile French and Francophile British and American expatriates, Sickert traveled regularly to Paris and Venice and less frequently to London. The artist carefully managed his career and reputation, achieving considerable success teaching in Paris while exhibiting at the Société Nouvelles des Peintres et Sculpteurs, the Salon d'Automne, the Salon, the Salon des Indépendants, and the Durand-Ruel Gallery in Paris, along with the New English Art Club, the International Society of Sculptors, Painters and Gravers, and the Carfax Gallery in London.[21] As a mark of his cosmopolitan outlook, Sickert exhibited one of his Venice scenes, *Le Palais des Doges*, in April–June 1903 at the Paris Salon, where the director of the Musée du Luxembourg considered purchasing the painting for the French state.[22] Such offi-

cial approval led to Sickert's being invited to contribute work to the French section of the annual Glaspalast exhibition in Munich, where he showed *Katie Lawrence at Gatti's* (ca. 1903), depicting a London music-hall performance. At that exhibition he also displayed *The Toast* (1898), representing a scene from the London production of Arthur Pinero's *Trelawny of the "Wells"* at the Royal Court Theatre in January 1898, and subsequently bought by André Gide and, later, Noël Coward.[23]

Following his success in Munich, Sickert was invited to exhibit in the French section at the Fifth Venice Biennale later in June, and he secured an invitation to hold a one-man exhibition at the Bernheim Jeune Gallery in Paris in June 1904, a large show that included ninety-six works by the artist. By autumn 1905 Sickert, now residing in London, sent work to be hung at the Salon d'Automne, and in 1907 he showed eighty-five works in a solo exhibition at the Bernheim Jeune Gallery. Between December 1900 and 1909, Sickert had been involved in at least fifteen Paris exhibitions; he had also exhibited work at the Glasgow Institute of Fine Art (1905), the Grosse Berliner Kunst-Austellung (1909), and, in London, at the International Society (1905), the New English Art Club (1907 and 1909), and the Allied Artists Association (regularly from June 1908).[24] By the time of his last important show in Paris, in 1909 at the Salon d'Automne, where the artist exhibited two paintings, *The Camden Town Murder* (ca. 1907–8, also referred to as *L'Affaire de Camden Town*) and another work whose subject was the notorious Camden Town sex murder, Sickert had already established himself as an important modern British artist in France and Germany and as a leading painter on the French and British art markets of female nudes set in London interiors.[25]

Working within such a dynamic art market and an expanding dealer-critic system, entrepreneurial art dealers became alert to the ways in which the spread of international art exhibitions could be used profitably to launch artistic careers and establish commercial reputations. Forming alliances of independent galleries, dealers were active as publishers of art journals, auction catalogues, artists' biographies, and monographs.[26] They energetically marketed artistic reputations by having laudatory art reviews and criticism translated into other languages and disseminated internationally. It is significant that many British critics had keen Francophile interests, most notably Robert Allan Mowbray Stevenson, Roger Fry, and David Croal Thomson, who was the manager of the Goupil Gallery in London from 1885 to 1897 and the editor of the *Art Journal* from 1892 to 1902.[27] Consequently, British art audiences were quickly exposed to recent developments in France, especially the work of Barbizon painters, by leading Continental art dealers such as Paul Durand-Ruel, Georges Petit, and Adolphe Goupil in France, along with the Goupil Gallery in Paris and London.[28] In Britain William Agnew in London and Manchester, as well as Ernest Gambart and Alexander Reid in

Glasgow, fostered the interest of wealthy industrialist and aristocratic collectors by organizing exhibitions in major cities promoting the work of the French Barbizon school. For his part, Croal Thomson eagerly cultivated this developing modern Anglo-French taste by publishing a series of articles on Camille Corot, Théodore Rousseau, Narcisse-Virgile Diaz de la Peña, Charles-François Daubigny, and Jean-François Millet in the *Magazine of Art* in 1888–89 that were published in book form in 1891, 1892, and 1902.[29] There were also significant collectors in Scotland. At the 1901 Glasgow International Exhibition, twenty-two local collectors lent works by leading Barbizon painters, showing not only the depth of Scottish Francophilia in the arts but also the success achieved by Scottish dealers such as Reid in selling Barbizon paintings, by Corot in particular, to Scottish collectors, some of whom were now based in England.[30]

The major Parisian dealers of French Impressionism oriented their efforts much more toward the American, German, and Russian markets. From 1904, cooperation by French, German, American, and British dealers enabled large collections of French Impressionist art to be sent on tours to leading European and American cities. In 1905 the Parisian dealer Durand-Ruel organized the largest exhibition of Impressionist paintings ever mounted in the British capital, 315 pictures at the Grafton Galleries; it attracted critical attention but secured sales of only thirteen works: two paintings by Claude Monet to Scottish collectors and the rest mainly to non-British purchasers.[31] Notably, the show was restaged in Berlin to sensational success.[32] In February 1906 selections from the 1905 Salon d'Automne were shown at the Lafayette Gallery in London, again quickly exposing British audiences to recent artistic developments in Paris.[33]

These enlightened international dealers also facilitated the display or purchase (or both) of modern French paintings by museums and public art galleries, since they were eager to educate British audiences about Continental art developments and thereby attract audiences and purchasers. In 1898 the Guildhall Art Gallery organized the largest show of contemporary French art held in London and not relying on public funding.[34] Incorporating the works of leading Paris Salon artists, including Fernand Cormon, Jean-Louis-Ernest Meissonier, and Rosa Bonheur, it also included paintings by several Impressionist artists. Few works by French, or indeed any foreign, artists entered the national collections of the National Gallery or the National Gallery of British Art at the Tate Gallery (which had opened on 21 July 1897), but the C. A. Ionides Bequest to the Victoria and Albert Museum (entering in 1900), the Salting Bequest to the National Gallery (in 1910), and the great collection of French Romantic art formed by the fourth Marquess of Hertford and his son Richard Wallace, bequeathed to the nation as the Wallace Collection in 1897, resulted in works by leading nineteenth-century French artists

entering British national collections even when state resistance to acquiring French Impressionism remained strong.[35]

As Frances Fowle and Edward Morris have demonstrated, this was not the case in Scotland. Although the dominant taste of Scottish collectors was for paintings of the Barbizon and Dutch Hague schools, a significant number of them, between about 1901 and 1910, had invested in works by Whistler and bought French Impressionist paintings by Monet, Edgar Degas, Edouard Manet, and Alfred Sisley that would eventually enter Scottish public collections.[36] Fowle quotes Thomas Rennie, curator of the Glasgow Art Gallery in 1910, who boasted, "Glasgow occupies the proud position of possessing the most complete collection of pictures by modern French and Dutch masters of any public gallery in the kingdom."[37] This situation promoted a healthy interest on behalf of Scottish, especially Glasgow-based, artists in contemporary French art and in the work of Whistler (promoted at a special retrospective exhibition of his work at the Royal Scottish Academy in Edinburgh in 1904).[38] It also encouraged Scottish artists to travel abroad, especially to Paris, for their training. From 1907, artists such as Jessica Dismorr, John Duncan Fergusson, Samuel John Peploe, and Ethel Wright, like the American painter Anne Estelle Rice, spent much of their time in the French capital, not only studying but also engaging with the recent color innovations of the Parisian avant-garde art circles. Fergusson moved to Paris in 1907, and Peploe in 1910; there they encountered Fauvist and early Cubist works and met Pablo Picasso.[39] These "Anglo-American Fauves," as they became labeled, eagerly cultivated new forms of artistic and aesthetic practice influenced by Paul Cézanne (encountered at his 1907 Salon d'Automne retrospective, where fifty-six of his works were shown) and informed by the writings of Bergson.[40] Their work was applauded by British critics at the 1912 exhibition of American, English, and Scottish Fauves at the Stafford Gallery, London, where the critic P. G. Konody felt that "they apply the new principles as passionately and fearlessly as their French fellow workers."[41] Probably aware that both Fergusson and Estelle Rice resided in Paris and showed regularly at the Salon d'Automne exhibitions, the art critic Frank Rutter noted approvingly that "Paris has done wonders for Mr Fergusson."[42]

Scottish Francophile inclinations encouraged British artists' participation in new art-exhibiting societies that fostered a cosmopolitan perspective, such as the Allied Artists Association, which Rutter founded in July 1908.[43] Its first two exhibitions featured more than three thousand works, including a range of recent art by French, German, and Russian artists. It was, however, through the journal *Rhythm*, founded by Fergusson and John Middleton Murray and appearing from the summer of 1911 to 1913, that the group's internationalist allegiances became most emphatically declared.[44] With Fergusson as art director, works by these Scottish Fauves illustrated the covers of the journal, including a simplified drawing of

72. John Duncan Fergusson, *Rhythm*, oil on canvas (1911),
64¼ x 45 in. (163.2 x 114.3 cm). Art Collection, University
of Stirling.

his own *Rhythm*, first exhibited at the Salon d'Automne in 1911 (figs. 72 and 73).
Using photographs and prints supplied by the French dealer Daniel-Henry
Kahnweiler and art reviews written by Michael Sadler, *Rhythm* promoted the
Anglo-American artists' links with Fauvism and early Cubism and supported the
work of Picasso, Henri Matisse, André Derain, Othon Friesz, and others, as well
as reproducing works by Vasily Kandinsky and Natalia Goncharova. It also situ-
ated Fergusson's and Estelle Rice's paintings in relation to the Bergsonian notion
of *élan vital* and to their encounter with Serge Diaghilev's Ballets Russes in Paris
in 1911–12 (explicitly acknowledged in an article by Estelle Rice in *Rhythm* in
August 1912).[45]

One of the most instructive examples of the ways in which British artists resid-
ing on the Continent got involved with experimental art and design aesthetics and
became adept at exploiting the transnational opportunities such allegiances pro-

73. Cover of *Rhythm* 1 (1911), with John Duncan Fergusson
design. Beinecke Rare Book and Manuscript Library,
Yale University.

vided can be seen by examining the career of Frank Brangwyn. Born in Bruges,
Belgium, Brangwyn had no formal art education, although his employment in
William Morris's Queen Square workshops in London and his association with
Arthur Heygate Mackmurdo and the Century Guild from 1882 established his Arts
and Crafts background and credentials.[46] Promoted by the *Studio* as an up-and-
coming *artiste-décorateur*, Brangwyn created paintings, murals, and designs that
attracted considerable international attention, notably at the Paris Salon from
1891. In 1896 Brangwyn's reputation flourished when his painting *Trade on the
Beach* (1893) was purchased by the French state for the Musée du Luxembourg.[47]
Brangwyn's success in France was mirrored in Germany and Austria through his
membership in the Munich Secession (1893) and the Vienna Secession (1897), as well
as by positive reviews of his work by the leading art writers Hermann Muthesius,
Julius Meier-Graefe, and Hermann Bahr.[48]

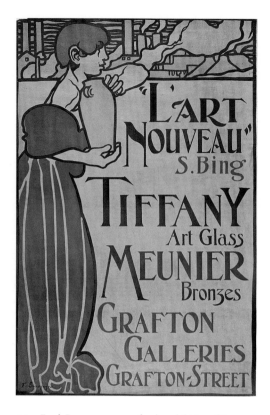

74. Frank Brangwyn, poster for the exhibition of Art
Nouveau at the Grafton Galleries, London, lithograph (1899),
29¾ x 19½ in. (75.6 x 49.5 cm). The Museum of Modern Art,
New York, Gift of Erwin Swann.

What was particularly important for Brangwyn was an invitation to work on
the exterior murals for Siegfried Bing's La Maison de l'Art Nouveau in Paris in
1895. Bing's inclusion of Brangwyn as part of his energetic advertisement of Art
Nouveau secured the British artist's reputation as a leading member of the Franco-
Belgian avant-garde that was associated with this movement.[49] Bing was an eager
advocate of "English" designers, an enthusiasm that led to French criticism of his
promotion of British taste and forced a reorientation of the work displayed in the
Paris gallery in about 1899.[50] Nevertheless, between May and July 1899, Bing orga-
nized an exhibition at the Grafton Galleries in London that placed Brangwyn's
stained-glass designs alongside bronzes by the Belgian artist Constantin Meunier
and the American glass designer Louis Comfort Tiffany; the poster for the exhibi-
tion was designed by Brangwyn (fig. 74). The exhibition included an array of Art
Nouveau pieces, notably works by Paul-Albert Besnard, Camille Pissarro, Edward

75. Frank Brangwyn, *The Blacksmiths*, oil on canvas (ca. 1904–5), 65 x 81 in. (165.1 x 205.7 cm). Leeds Museums and Galleries (City Art Gallery).

Colonna, and Charles Conder, as well as some miniatures from Japan and India, underlining the international reach of Art Nouveau.[51]

The parallels between Brangwyn's work and Meunier's was apparent once again at the 1905 Venice Biennale, where the Belgian sculptor's bronze relief *Return from the Mine* (ca. 1896–97) was exhibited with Brangwyn's four large murals on labor themes, which formed part of the interior design of the British rooms. The interior decor, with gray buff walls and a dark blue frieze separated by vertical pilasters, incorporated specially designed, high-backed oak benches. Set above the entrance doors and in the center of the long walls were Brangwyn's four oil-on-canvas panels: *Navvies at Work* (1904), *The Rolling Mill* (ca. 1904–5), *The Blacksmiths* (ca. 1904–5; fig. 75), and *The Potters* (ca. 1904–5).[52] The much-applauded decorative ensemble was awarded a Gold Medal by the international jury. Following their display at Venice, the panels, purchased by the Leeds art collector and

patron Sam Wilson, were presented to the Leeds City Art Gallery.[53] What Brang-wyn's example underscores is how his work, when seen within a broader context, was appreciated by contemporary commentators across Europe and North America as marking out the updating of a distinctive, socially informed English Arts and Crafts approach within a cosmopolitan language of the artist-decorator evolving in Belgium, France, and Germany (a tendency reaffirmed by his membership in Austro-German secession groups and by the success of his 1905 Venice interiors).[54]

Brangwyn's cosmopolitan modernism, as marketed by entrepreneurial dealers such as Bing, formed part of an international language of Art Nouveau that encour-aged the diversification of fine artists into interior design and decoration and thereby advocated the notion of the *Gesamtkunstwerk*. This critical vocabulary was supported by many English writers publishing in the *Studio*, as well as by leading German, Belgian, and French art writers eager to applaud the emergence of mod-ern thinking in art, architecture, and design. Such a sophisticated approach embraced communities of spectators and consumers far across continental Europe, the British Empire, and North America. Although its commercialism attracted considerable concern from certain quarters, evidently this outlook was subscribed to by important British patrons and collectors such as Wilson, who saw it as a testament to a distinctively modern artistic and civic responsibility, one that was applauded by members of the Leeds Arts Club and reaffirmed by the inclusion of Brangwyn's labor panels in the Leeds City Art Gallery collection.[55]

THE ARTS AND CRAFTS MOVEMENT: INTERNATIONAL IMPACT AND LEGACIES

In August 1910 the *Studio* reported on the success of the various national displays at the Brussels Exposition Universelle in that year. Comparing the impressive installation of German art and design with the small and "disappointing" British showing (and contrasting the German government's financial generosity with the "limitations" of the restricted Treasury Grant), the reviewer praised "the great forward strides made by German workers" and applauded the achievement of the Deutscher Werkbund directors, Bruno Paul, Otto Wagner, and Peter Behrens, in promoting modern design aesthetics:

> It is generally recognized by German writers on applied art, as it is in the
> official catalogue . . . that it was from England that the ideas which underlie
> the modern developments of arts and crafts in Germany came to them, but

the question is whether the lead taken by Britain has not been lost, or, at all events, will not be soon lost.[56]

In the following issue, the praise went even further as the reviewer concluded that "nothing approaches in magnitude to the German display." Evaluating Bruno Paul's design for a vestibule, the critic argued:

> At first sight, if the visitor be a cultured man of the Latin race, all this manifestation of German decoration and furnishings will perhaps clash with his taste and habits, but the determined energy which the whole reveals and the efforts of the realization are such that the feeling of disturbance he may have experienced at first will quickly give place to one of admiration and astonishment.[57]

By 1910 links among British artists, critics, and designers, the German academies, the Austrian and German secessions, and the Deutscher Werkbund were already well established and underlined the pro-Austro-German allegiances of many contemporary British artists. Interaction was encouraged through close personal connections and by professional exchanges. For example, Charles Robert Ashbee traveled to Germany often in this period, exhibited work at the Munich Glaspalast in 1898, and was a member of the Munich Academy from 1902.[58] Similarly, Mackay Hugh Baillie Scott designed interiors for the Mannheim collector Carl Reiss and contributed to the Dresdener Werkstätten für Handwerkskunst (Dresden Workshops for Arts and Crafts) exhibitions.[59] As the presence of Ashbee's writing cabinet (1898–99; fig. 76) in the Central Hall of the Eighth Vienna Secession exhibition (1900) demonstrates, it was in the development of the central European secessions in Berlin, Vienna, and Munich that British designers like Ashbee played a crucial role as part of an elite concerned with aesthetic reform and the promotion of cosmopolitan thinking.[60] At the 1900 Vienna Secession, which was almost entirely devoted to the applied arts, Ashbee's Guild of Handicraft was the second-largest exhibitor (after Meier-Graefe's La Maison Moderne, Paris), with fifty-three pieces displayed.[61] Reflecting the English artist's revered status, Josef Hoffmann from the Wiener Werkstätte visited Ashbee's Guild of Handicraft in 1902 in order to gain firsthand knowledge about the modern application of guild workshop production methods as they had been pioneered at Chipping Camden.[62]

In the decorative arts, the role of the *Magazine of Art* (1878–1904), the *Art Journal* (1839–1912), and the *Studio* (from 1893) were important in circulating British ideas abroad and directing public attention to show how Morrisian ideals and earlier Arts and Craft thinking could be (and had been) refracted through localized

76. "C. R. Ashbee's Writing Cabinet (1898–99) in the Central Hall of
the Eighth Vienna Secession Exhibition, 1900," from Fernand Khnopff,
"Hoffman, Josef. Architect and Decorator," *Studio* 22 (1901): 265.
Courtesy of the Yale University Library.

concerns and made responsive to changing economic circumstances. Positive coverage in the *Studio* of the Wiener Werkstätte from its foundation in December 1903 offered insights into the ways in which Continental artists, architects, and designers were developing a vigorous discipline out of English Arts and Crafts ideals.[63] In 1906, the *Studio* published a special issue, "The Art Revival in Austria," to cater to the interest in Viennese art and design.[64] Extolling the international nature of the Arts and Crafts communities, the *International Studio* (published in New York from 1897) and the *Craftsman* (New York, 1901–16) reviewed artistic developments all over Europe, North America, and in the British colonies and dependencies.[65] The *Craftsman*'s editor, Gustav Stickley, urged American artists to engage with design reform inspired by the Arts and Crafts movement and to found organizations, settlements, and journals to promote and disseminate that viewpoint. These American publications not only featured established artists but

encompassed a broad church of younger artists, women artists, illustrators, designers, and architects eager to affirm their global commitment to contemporary articulations of cosmopolitanism.[66]

Key Arts and Crafts texts by Morris (who had died in 1896), Ruskin, and Walter Crane had been translated into German, and their ideas were extensively disseminated in journals influential in Scandinavia, Russia, and Eastern Europe.[67] Of the German-language journals, *Dekorative Kunst* (Munich, 1897–1929), *Deutsche Kunst und Dekoration* (Darmstadt, 1897–1932), and *Kunst und Kunsthandwerk* (Vienna, 1898–1928) were significant in promoting common British, Austrian, and German interests in the Arts and Crafts movement and in promulgating a distinctive, shared modernism in architecture, design, and the decorative arts, notably through the advocacy of German writers such as Muthesius and Meier-Graefe.[68] For example, Muthesius's essay "The Guild and School of Handicraft in London" (published in *Dekorative Kunst* in 1898) informed German readers about Ashbee's work, and his highly influential study *Das Englische Haus* in 1904–5 praised the virtues of the English garden city movement.[69] Meier-Graefe had launched *Dekorative Kunst*, modeled on the *Studio*, in 1897, and the German critic was eager to spread knowledge about contemporary German design abroad. Consequently, in the following year, he launched the French-language publication *L'Art Décoratif*, the first issue of which was devoted to the work of the Belgian Arts and Crafts designer Henry Van de Velde. Settling in Paris in 1899, Meier-Graefe opened up the gallery La Maison Moderne to promote Austrian, German, and British designers; it was a business venture modeled on the Viennese Secession, involving a cooperative of artists producing designs for the Parisian interior decoration market, and it lasted until 1903.[70]

Many leading British figures such as Ashbee, Crane, Charles Voysey, and Thomas James Cobden-Sanderson had supported artistic initiatives that promoted design reform through the establishment of new workshops, schools, and artists' cooperatives in Munich, Dresden, Darmstadt, and Weimar. Receiving invitations through the Arts and Crafts Exhibition Society, leading British artists and designers also participated in the major international expositions, notably in Turin (1902), St. Louis (1904), and Ghent (1913), and it is significant that the largest Continental exhibition of works by Crane was held at the National Museum of Decorative Arts in Budapest in October 1900, also the site of the largest show of British Arts and Crafts ever seen on the Continent, in 1902.[71]

It is clear that in the German-speaking design world, the thinking of Morris, Ruskin, and the leaders of the English Arts and Crafts movement was invoked to sustain and support new ideals formulated according to Austro-German artistic concerns, economic demands, and political convictions. With great interest, German

and Austrian artists and writers followed developments in the main British Arts and Crafts organizations: namely, the Century Guild (founded in 1882–83), the Home Arts and Industries Association (from 1884), the Art Workers' Guild (from 1884), the Arts and Crafts Exhibition Society (from 1887), and the Women's Guild of Arts (from 1907).[72] Many central European audiences felt that British approaches were often too fiercely anti-industrial and too much opposed to serial production; nevertheless, the idea of design unity and the radical reform of machine production as carried out by the Deutscher Werkbund were seen as continuing in the English Arts and Crafts reformist tradition.[73]

In his book *An Endeavour towards the Teachings of Ruskin and Morris* (1901), Ashbee measured the vitality of the Arts and Crafts practitioners through his participation in "a continuous round of exhibits" in Manchester, Liverpool, Dublin, Berlin, Munich, Frankfurt, Paris, and the Cape province in South Africa.[74] Five years later, however, the survival of the English Arts and Crafts movement seemed in jeopardy, as declining sales from 1903–4 led to the closure of the Guild of Handicraft in autumn 1906. By 1912 the Arts and Crafts Exhibition Society was also in financial difficulties, and its annual London exhibition had lost money.[75] Nevertheless, the legacies of the English Arts and Crafts ideology, with the movement's desire to improve decorative taste, engage new materials, and reform art education, had influenced aesthetic debates and design reforms across continental Europe, North America, and throughout the British Empire. Ashbee noted, not without some degree of irony, that "the principles of the movement are now consistently and more logically studied in Germany and America and in some of the smaller countries of Europe [Belgium, Holland, and Denmark] than in the United Kingdom."[76]

Besides Ashbee's Guild of Handicraft and Meier-Graefe's La Maison Moderne, the 1900 Vienna Secession, organized by Hoffmann, had also included interior designs and furniture by the Scottish designers who became known as the "Glasgow Four": Margaret and Frances Macdonald, Charles Rennie Mackintosh, and J. Herbert MacNair (with illustrations of their room settings reproduced in *Dekorative Kunst* in 1901).[77] Austrian and German readers already knew of the work by Mackintosh and of recent developments in Glasgow, through articles in the *Studio* (a special issue on "Modern British Domestic Architecture and Decoration") and *Ver Sacrum* in 1901 but also in *Dekorative Kunst* (notably on Mackintosh by Muthesius in March 1902, again in March 1905 on the Scottish architect's Hill House, completed in the previous year, and on the Willow Tea Rooms in Glasgow in April 1905).[78] *Deutsche Kunst und Dekoration* in May 1902 had featured Margaret Macdonald Mackintosh's refined designs on the cover (fig. 77) and, on the inside, the Mackintoshes' interior decoration for Alexander Koch in Darmstadt (1901); the designs for that were published in 1902 in *Das Haus eines Kunst-Freundes* (*A House*

Künstlerische Kostüme · Porzellane · Fotogr. Porträts · Buchgewerbe.

DEUTSCHE KUNST
UND DEKORATION

V. JAHRG. HEFT 8. MAI 1902. EINZELPREIS M. 2.⁵⁰

77. Margaret Macdonald Mackintosh, design for cover of *Deutsche Kunst und Dekoration* (May 1902). Private collection.

for an Art Lover), a lavish print portfolio.[79] Again in that year, the Mackintoshes were commissioned by the cofounder of the Wiener Werkstätte, Fritz Wärndorfer, to design a unified artistic interior for the music room in his Vienna villa.[80]

Although recent scholarship has cautioned against overstating the extent of Mackintosh's influence on Continental design, it is accurate to say that Mackintosh's and Macdonald Mackintosh's growing reputation as leaders of the modern design and dress reform movement in Glasgow was reaffirmed by their inclusion in the 1902 *First International Exhibition of Modern Decorative Art* in Turin.[81] The Scottish section, selected by the director of the Glasgow School of Art, Francis H. Newbery, included their Rose Boudoir (1902). Highly praised by Muthesius for the way it integrated architecture, interior design, fittings, and color scheme into a "*House Beautiful*" ensemble, the Rose Boudoir was awarded a Diploma of Honor, and illustrations of it were reproduced in *Deutsche Kunst und Dekoration*

PORTION OF "THE ROSE BOUDOIR" BY CHARLES R. MACKINTOSH AND MARGARET M. MACKINTOSH

PORTION OF "THE ROSE BOUDOIR" BY CHARLES R. MACKINTOSH AND MARGARET M. MACKINTOSH

92

78. Charles Rennie Mackintosh and Margaret Macdonald Mackintosh, the Rose Boudoir, 1902, part of the Scottish section, *First International Exhibition of Modern Decorative Art*, Turin (1902), from *Studio* 26 (1902): 92. Courtesy of the Yale University Library.

in September 1902 (fig. 78), adding to the importance of the Mackintoshes.[82] In the following year, their growing reputation was reinforced when they submitted a white bedroom for the 1903–4 exhibition of the Dresdener Werkstätten für Handwerkskunst.[83]

While attracting considerable public and press attention in Austria and Germany, as Pat Kirkham has demonstrated, the impact of the "Glasgow Four" was not only one way since "from 1903 on, Mackintosh's designs increasingly revealed the

stylistic influence of the Viennese art- and design-reform movement," especially in relation to interior design and furniture.[84] The success of Glasgow-based designers in continental Europe, especially Vienna and Germany, was at least in part to do with the energetic exposure and support offered by German and Austrian publishers, writers, artists, and patrons who helped to publicize how the legacies of the Arts and Crafts movement and the speedy transcultural exchange of ideas meant that sophisticated design reform was rapidly advancing in the first decade of the twentieth century in cities such as Glasgow, Berlin, Vienna, and Dresden. As Muthesius summarized it, "The Glasgow style . . . has a contagious effect. The stimulus it has given is felt not only in Glasgow, it has penetrated deep into the Continent and certainly as far as Vienna where it has found fertile soil."[85]

THE INTERNATIONAL LYCEUM CLUBS AND THE INTERNATIONAL SOCIETY OF SCULPTORS, PAINTERS AND GRAVERS

One feature of Edwardian London, as Judith Walkowitz has argued, was that models of cosmopolitanism became re-gendered from their earlier masculinist codings and "rendered as a cultural practice widely available to women."[86] A key sign of this new understanding of the relationship between cultural expression and sexual emancipation was the foundation in 1903, by Constance Smedley Armfield, of the International Lyceum Clubs for women artists and writers. The aim of the clubs was "to promote interchange and thought between cultured women of all ages,"[87] and they played a pivotal role in ensuring an ongoing dialogue between women across all nations to promote pan-European suffrage and support claims for sexual equality. Following the deterioration of Anglo-German political relationships after the Boer War and the Anglo-French Entente Cordiale of 1904, the clubs were particularly crucial in maintaining and asserting strong political and cultural alliances with Germany, and they demonstrated a keen Anglo-German sympathy in which, as G. L. Dickinson emphasized, "Prussianism, not Germanism," was viewed as the greatest threat to a mutual Anglo-Saxon understanding and cooperation.[88]

Operating through women's friendship societies, art exchanges, and international groups, as Grace Brockington has shown, there were thirty-six international societies across continental Europe by 1906, including centers in London, Florence, and Berlin that were especially active in art, music, dance, theater, avant-garde performance, aesthetics, and literature.[89] By this period Berlin was second only to Paris as the European center for exhibiting and selling modern art, and the

German city had overtaken Munich, Dresden, Hamburg, Frankfurt, and Vienna in importance.[90] Recognizing the city's newfound status, an exhibition of artists from the London Lyceum Club was organized in Berlin in 1905. This invitation was reciprocated in May 1906 with the *Exhibition of Contemporary German Artists* at the Prince's Gallery in London. The show was curated by William Rothenstein, and it had a catalogue edited by Crane. To mark this moment of close cultural cooperation, a letter published in the *Times* (London) in May 1906 deploring the deterioration of Anglo-German relationships was signed by such important artistic figures as William Michael Rossetti, William R. Lethaby, Philip Webb, Walter Crane, and William Strang. At the same time, an equivalent letter expressing similar sentiments was published in leading German newspapers above the signatures of Count Harry Kessler, Richard Strauss, Siegfried Wagner, and Max Liebermann, among many others.[91]

A second organization that promoted a contemporary cosmopolitan outlook in the arts and was influential throughout the Edwardian era was the International Society of Sculptors, Painters and Gravers, formed in February 1898. The main instigators of the society were Francis Howard, a rich American with Irish connections; the Irish-born painter John Lavery; the painter Edward Arthur Walton, one of the artists known as the Glasgow Boys; the artist and writer Charles Shannon; and George Sauter, a London-based German artist with strong links to Germany.[92] With Whistler as its first president, elected in February 1898, and comprising an honorary membership drawn from leading artists across Europe and North America, the International (as it became known) constituted "an Art Congress for artists of the world."[93] Through key advisers such as Albert Ludovici, Jacques-Emile Blanche, Théodore Duret, and Albert Besnard, loans of major artworks were negotiated with the leading Parisian dealers Ambroise Vollard, Goupil, and Durand-Ruel. Sauter and Lavery similarly exploited their close connections with dealers and patrons in Germany, Austria, and Scandinavia. Consequently, the honorary membership of the International had unrivaled and extensive links with artists, dealers, and collectors across England, Scotland, Ireland, France, Germany, Belgium, Holland, Austria, Switzerland, Italy, Norway, Sweden, and the United States.[94]

Reflecting the accelerating pace of change in the global art economy, the International displayed works by 256 painters, sculptors, and printmakers at its first annual exhibition, at the Prince's Skating Rink in Knightsbridge in May–July 1898. Paintings by Whistler, Degas, Manet, Henri de Toulouse-Lautrec, and Pierre Puvis de Chavannes were included alongside works by the Americans James J. Shannon, Cecilia Beaux, and William Merritt Chase. With a strong Scottish entry that included works by Walton, Lavery, Edward Atkinson Hornel, and James Guthrie, the show reinforced the significance not only of artists trained in Glasgow

and Paris, but also of the Berlin, Munich, and Vienna secessions. The presence of sculpture by leading international figures such as Auguste Rodin, Meunier, and Augustus Saint-Gaudens reinforced this innovative and inclusive approach.[95] The three carefully color-coordinated galleries were decorated by Whistler in French gray, under a glass roof screened by gray muslin, and with a similar-colored velarium. As the art critic Frank Rutter later recalled, this international range of artists and the meticulously modulated interior design had a great impact on him and other spectators: "The International opened up a new world to me. . . . Until I visited the first International, I did not really know what a modern art exhibition could be like."[96]

In addition, two significant exhibitions by the International's members successfully toured continental Europe in 1902 and the United States in 1903, promoting the society's eclecticism and its adherence to the importance of a global aesthetic culture. The first exhibition, organized by Sauter, was shown in Budapest, Munich, and Düsseldorf. The second show, beginning in October 1903, traveled to the Academy of Fine Art, Philadelphia; the Carnegie Institute, Pittsburgh; the Cincinnati Art Gallery; and the St. Louis Museum of Fine Arts, as well as venues in Chicago, Boston, and Detroit.[97] As Lavery later recalled, these tours attracted a great deal of attention, and "we made some return for the recognition we had received on the Continent and in America."[98]

On 17 July 1903, Whistler, then president of the International Society, died. Rothenstein recorded in his memoirs how Whistler had been ill for a long period and "had taken C.R. Ashbee's house—a house with a beaten copper door, arty-and-crafty, too, inside. I wondered at his choice. . . . I was greatly affected by Whistler's death, he and his art had counted for much in my life."[99] The Whistler memorial exhibition organized by the International Society took place the following year, from 22 February to 15 April, at the New Gallery on Regent Street, London (the location of the society's annual exhibitions since 1904). About 750 works were on display, and it was a testament to Whistler's prestige that alongside well-respected artists and critics on the honorary organizing committee were senior curators and art officials from leading European and North American museums and galleries (including the Musée du Luxembourg in Paris, the Berlin museums, the Gemeentemuseum den Haag, the Victoria and Albert Museum, and the Chicago and Pennsylvania academies of art). The retrospective not only underlined Whistler's status as a major figure within an international context, but it also provided an opportunity to rewrite recent history and secure his place within a canonical history of modern art's development, as evidenced by the inclusion of his works in the leading national collections in Europe, North America, and throughout the British Empire.[100]

What the International Society had achieved through its annual shows in London and its foreign tours was to establish a new cosmopolitan context for understanding contemporary international developments in painting, sculpture, and printmaking. These exhibitions provided a crucial means of understanding modern art's allegiances, histories, and genealogies in ways that positively valued the contributions of British artists and other artists working in London, such as Whistler. The significance of German critics and scholars in offering a compelling revisionist account of artistic and aesthetic developments and in validating a convincing historical exegesis on international modernism was crucial. In this respect, one of the most important publications was Julius Meier-Graefe's *Entwicklungsgeschichte der Modernen Kunst* (1904), which was translated into English in two volumes as *Modern Art: Being a Contribution to a New System of Aesthetics* (1908).[101] It became one of the leading accounts in English of artistic developments after Impressionism, and the German writer's thinking directly influenced Roger Fry's selection for the pathbreaking *Manet and the Post-Impressionists* show in 1910, as well as informing Fry's subsequent formalist approach to art as promoted in *Burlington Magazine*, founded in 1903.[102]

The International Society also testified to a transformation in outlook in which its artist members were not confined by national or imperial imperatives, by the trap of the stereotype, or by rigid cultural categorization and racial clichés (often the dominant tropes in art criticism and art journalism). Instead, the International's membership was global, and its exhibitions were hung in a self-consciously modern way without consideration of the nationality of the artist or according to national schools, thereby making "a feature of . . . the non-recognition of nationality in art."[103] As Lavery stressed, "Up until our advent there was scarcely a modern picture to be seen in England except with dealers. It was considered unpatriotic to include the foreign artist and we had a hard struggle, because few were interested in art outside their own country."[104]

Significantly, Rodin's election as president after Whistler's death clearly signaled the internationalism of the society, as Rodin's work was already well known in London. In 1900 Rothenstein, Sargent, Alphonse Legros, and Dugald Sutherland MacColl, along with Rodin's friend John Tweed, had launched a public subscription for the purchase of his *Saint John the Baptist* (1879) for the Victoria and Albert Museum, the first work by Rodin to enter a British national collection (although the Glasgow Art Gallery had been the first gallery in Britain to purchase a work by Rodin, his *Bust of Victor Hugo* in 1888).[105] In recognition of Rodin's status, Edward VII visited his home at Meudon, France, on 6 March 1908.[106] In December 1910 Rodin visited the British capital again. The purpose of his journey was to discuss the prospective site in Victoria Tower Gardens for his *Burghers of*

Calais (fig. 79), which would be purchased by the National Art-Collections Fund the following year and placed next to the Houses of Parliament in 1913, though it was not formally unveiled until July 1915 because of wartime delays.[107] Indeed, in acknowledgment of his high esteem in Britain, in 1914 Rodin presented eighteen of his works to the British nation; they were eventually included in the collections of the Victoria and Albert Museum.[108]

In January 1904, following his election as society president, Rodin had paid a triumphal visit to London for the opening of the *Fourth Exhibition* of the International Society. Photographs show him alongside other leading members of the International in front of his recently enlarged, patinated plaster version of *The Thinker* (1904), then on display in the galleries (fig. 80).[109] A smaller bronze from 1881–82 had been purchased by the Manchester-born collector Constantine Ionides in 1884 and exhibited in Rodin's influential 1900 Paris show. In 1921 this bronze would be bought from the collector's widow for the Felton Bequest and dispatched to the National Gallery of Victoria in Melbourne.[110] Following the International show, the large version of *The Thinker* was sent to Paris, where it was exhibited at the Exposition de la Société Nationale des Beaux-Arts from 17 April to 30 June 1904; it attracted such widespread attention that a public subscription was launched to buy it for "the people of Paris."[111] A large bronze version was subsequently commissioned, and it was this piece that was first displayed in front of the Pantheon in Paris on 21 April 1906. In acknowledgment of Rodin's status and in homage to his *Thinker*, in 1906 the American photographer Alvin Langdon Coburn took a photograph of a naked George Bernard Shaw entitled "George Bernard Shaw Assuming the Pose of 'The Thinker.'"[112] What this complex reception history indicates is how Rodin's role as president reinforced the cosmopolitan aspirations of the International Society and reaffirmed its global outlook. Rodin's wide-ranging collectors, subscribers, and patrons constituted an international community of admirers across Britain, Ireland, France, the rest of Europe, Australia, and North America who bore witness not only to the French sculptor's renown and importance but were a testament to the extent, complexity, and sophistication of British artistic, cultural, social, and political affiliations in the Edwardian era.

THE DAWNING OF THE AGE OF AUGUSTUS JOHN

In 1908 Virginia Woolf recorded that "the Sargent-Furse age was over. The age of Augustus John was dawning."[113] Referring to the decline of Sargent as the leading modern portraitist at the turn of the nineteenth century and to the death of the English painter Charles Furse on 16 October 1904, Woolf saw the period after

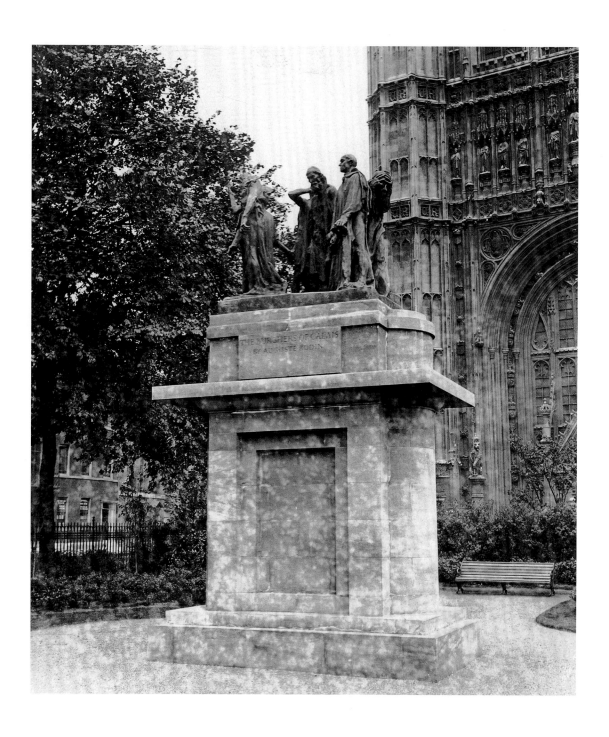

79. Auguste Rodin, *The Burghers of Calais*, bronze (1889). Victoria Tower Gardens, London (July 1915). Photo by Topical Press Agency / Hulton Archive / Getty Images.

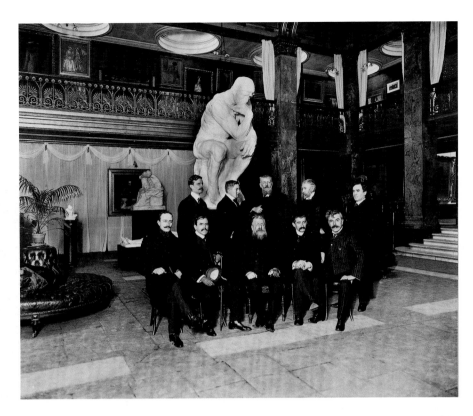

80. "Auguste Rodin and Members of the International Society with *The Thinker* at the 4th Exhibition of the International Society, London" (9 Jan. 1904). Musée Rodin, Paris.

1908 as marking the start of a new era in the London art world. If, as Woolf asserted, London's artistic taste had shifted, one indicator was the fact that John was now credited with a major role as "the leader of the Post-Impressionist movement in England," as the critic of the *Daily Chronicle* who reviewed the New English Art Club winter show on 26 November 1912 put it.[114] In this respect John's painting *The Way Down to the Sea* (1909–11; fig. 81) was especially significant when it was exhibited at the New English Art Club in May 1909. The large-scale figure composition in its archaizing and highly stylized pastoral style demonstrated John's indebtedness to Puvis de Chavannes, whose work John had seen in Paris in 1907 and whom he considered "to be the finest modern."[115] John's painting would soon be transported across the Atlantic and given pride of place at the groundbreaking Armory Show in New York City from February 1913. This exhibition was destined to become a landmark in the reception of European modernism in North America, and it was crucial in establishing John's reputation as one of the major figures of

81. Augustus John, *The Way Down to the Sea*, oil on canvas (1909–11),
30 x 26⅜ in. (76 x 67 cm). Private collection.

early-twentieth-century art.[116] In New York *The Way Down to the Sea*—one of the twenty-three paintings and fourteen drawings by John included in the show—would be displayed close to *Girl Reading at the Window* (1911) by his sister, Gwen John. Previously exhibited at the New English Art Club's winter 1911 exhibition, her painting had been bought from the artist in late 1912 by the New York collector John Quinn. Gwen John, too, was a fan of Puvis de Chavannes, and she had written to Quinn in 1911, less confidently posing her claim that "surely he is the greatest painter of the last century?"[117] Afterward, reflecting the high esteem in which American audiences held her brother's work, Augustus John's painting would be loaned to the Metropolitan Museum of Art from 1915 until 1924, when, just before Quinn's death in July of that year, it was removed from display. By contrast, Gwen John's painting would not enter the Metropolitan's collection until 1971, when it was bequeathed in memory of Quinn's sister by her daughter.[118]

While conventional art histories of the Edwardian period have stressed the continued significance of portraiture and the important role of the Royal Academy

of Arts, modernist accounts have tended to sideline the era, instead choosing to underline the speed of change in London's artistic bohemia in the years afterward, from about 1910 to the start of the Great War in 1914.[119] In this vein Paul Edwards has concluded, "In the four years from 1910 to 1914 in parallel with the social and political ferment of the times, radically new ideas and practices in the visual arts were introduced into Britain."[120] Reinforcing this view, recent exhibitions and accompanying publications have reexamined the activities of the Camden Town Group between 1911 and 1912, the role of the Bloomsbury Group and the establishment of the Omega Workshops in the spring of 1913, and the impact of the Vorticists and their first *Blast* publication in 1914.[121] A 1997 Barbican Art Gallery exhibition monitored these shifts in London's status as an influential modern art center by documenting the important contemporary art exhibitions that were hosted in the metropolis, seeing them as an indicator of the British intelligentsia's openness to Continental ideas and modernist aesthetics.[122] Key exhibitions have been highlighted as crucial in the English reception to French and Continental modernism, including Roger Fry's *Manet and the Post-Impressionists* at the Grafton Galleries in London (8 November 1910–15 January 1911); *Pictures by Paul Cézanne and Paul Gauguin* at the Stafford Gallery (November–December 1911); *Drawings by Pablo Picasso* at the Stafford Gallery (April–May 1912); *Exhibition of Pictures by J.D. Fergusson, A.E. Rice and Others (the Rhythm Group)* at the Stafford Gallery (October 1912); *The Second Post-Impressionist Exhibition of English, French and Russian Artists* at the Grafton Galleries (5 October–31 December 1912); and *Italian Futurist Painters* at the Sackville Gallery (March 1912).[123] The annual exhibitions of the Allied Artists Association, founded by Rutter in 1908; *Post-Impressionist and Futurist Exhibition* at the Doré Gallery, London (October 1913); and three important shows of Kandinsky's work in 1909, 1910, and 1911, frequently overlooked and marginalized, have also been highlighted as significant in this strategic review of the English reception to Continental modernism.[124]

In an attempt to reevaluate this history, however, and building on earlier scholarship and exhibitions that have assessed the impact on the visual arts of social and political change during the Edwardian era, this essay has argued that the period between about 1901 and 1912 needs to be seen as one in which late-nineteenth-century European metropolitan tastes and contemporary styles were being radically modernized and confidently revitalized.[125] It was one in which Britain's thriving artistic, literary, and theatrical coteries engaged positively with international connections celebrating the cultural vitality, sexual emancipation, and social diversity of London as an imperial metropolis. Female intellectuals and their male counterparts reveled in the city's social and sexual freedoms, with women as independent consumers self-confidently exploiting the new professional

opportunities that presented themselves in journalism, theater, and other arts and entertainment in Britain and abroad.[126]

This "new internationalism" forms part of a broader understanding of modernism in these years, which was, in part, a consequence of the rapid influx of foreigners and émigrés into British society and constituted, at least to some extent, the lure of London and many other British cities. Imperial, American, and European artists came to establish themselves in British metropolitan culture, because they were attracted as much by its vibrant economic potential and vigorous social life as by Britain's rich history and its self-confident sense of cultural refinement. This polyglot situation, deriving from the interplay between British, imperial, Continental, and American ideas and attitudes, generated a thriving and self-consciously global cosmopolitanism. It was one that was most conspicuous in London's art societies, literary and debating clubs, exhibition spaces, ballets, and theaters, but also evidenced in art journals, magazines, and other publications. Such an outlook positively valued the shared legacies of the Arts and Crafts movement that thrived abroad, and it also highly valued the commitment to modernism demonstrated by Glasgow architects, artists, and designers. It encouraged the close association of British artists with German, Austrian, and North American intellectuals, among others, promoting art and design reform, and it applauded the broad sociality of liberal-art societies such as the International Society and the International Lyceum Clubs.

Let it be clear that my intention in broadening this discussion of Edwardian art is not to understate or dispute the strength of Anglo-French artistic affiliations or undercut the role of Paris, especially following the Entente Cordiale in 1904. The current literature on these interactions and the importance of the French capital for the arts is significant and extensive.[127] Rather, it is to reinforce the importance to British artists, critics, collectors, and dealers of artistic networks and cultural interactions with Germany, Austria, central and Eastern Europe, North America, and the empire in order to signal a broader, more complex, and deep-rooted picture of cultural connectivity, artistic correspondence, and avant-garde aspiration than has previously been acknowledged. My aim has been to demonstrate the sophisticated and cosmopolitan outlook that, among others, London's, Glasgow's, and Chipping Camden's intelligentsia, natively born or incoming, had of contemporary French, German, Austro-Hungarian, and American artistic developments and of emerging forms of colonial modern culture, even if the vital contributions of the Austro-German intelligentsia were later eclipsed by the traumatic political events of World War I and consequently occluded in histories of art written after 1918.

1. H. G. Wells, quoted in Norman and Jeanne MacKenzie, eds., *The Diary of Beatrice Webb*, vol. 2, *1892–1905, All the Good Things of Life* (Cambridge, Mass.: Belknap Press / Harvard Univ. Press, 1983), 3.

2. See Anne Gray, ed., *The Edwardians: Secrets and Desires*, exh. cat. (National Gallery of Australia, Canberra, 2004), 11.

3. MacKenzie, *Diary of Beatrice Webb*, 2:3.

4. For the complex overlapping of social, artistic, and political formations, see Peter Brooker, *Bohemia in London: The Social Scene of Early Modernism* (Basingstoke, UK: Palgrave Macmillan, 2004), 55–59.

5. Frank Rinder, "London Exhibition," *Art Journal* (July 1906): 218.

6. Peter Brooker notes how Ford Madox Ford, Ezra Pound, and Yeats saw the interplay among the United States, Britain, France, and Germany as forming a single civilization. Brooker, *Bohemia in London*, 58. For a broader discussion of cosmopolitanism, see Rebecca L. Walkowitz, *Cosmopolitan Style: Modernism beyond the Nation* (New York: Columbia Univ. Press, 2006); James Clifford, "Travelling Cultures," in *Cultural Studies*, ed. Lawrence Grossberg, Cary Nelson, and Paula A. Treicher (New York: Routledge, 1992); and Carol A. Breckenridge, Sheldon Pollock, Homi K. Bhabha, and Dipesh Chakrabarty, eds., *Cosmopolitanism* (Durham, N.C.: Duke Univ. Press, 2002).

7. Alfred Orage, *New Age* 7 (12 May 1910): 26, quoted in Wallace Martin, *The "New Age" under Orage: Chapters in English Cultural History* (Manchester: Manchester Univ. Press, 1967), 129.

8. See Brooker, *Bohemia in London*, 62.

9. Ezra Pound to Harriet Monroe, Aug. 1912, from *Selected Letters of Ezra Pound, 1907–41*, quoted in Richard Humphreys, "Demon Pantechnicon Driver: Pound in the London Vortex, 1908–1920," in *Pound's Artists: Ezra Pound and the Visual Arts in London, Paris and Italy*, ed. Ezra Pound, Richard Humphreys, and John Alexander (London: Tate Gallery, 1985), 36.

10. See Lisa Tickner, *Modern Life and Modern Subjects: British Art in the Early Twentieth Century* (New Haven and London: Yale Univ. Press, 2000), 62–69, 81–82.

11. See Paul Edwards, *Wyndham Lewis: Painter and Writer* (New Haven and London: Paul Mellon Centre for Studies in British Art / Yale Univ. Press, 2000), 62–68.

12. The most substantial histories of painting and sculpture in Edwardian Britain have primarily focused on the London art world and mainly on Anglo-French connections prioritizing links between Paris and London. See, for example, Charles Harrison, *English Art and Modernism, 1900–1939* (London: Allen Lane, 1981); Anna Gruetzner Robins, *Modern Art in Britain, 1910–14* (London: Barbican Art Gallery, Merrell Holberton, 1997); Anna Gruetzner Robins and Richard Thomson, *Degas, Sickert and Toulouse-Lautrec: London and Paris, 1870–1910* (London: Tate Publishing, 2005); and Kenneth McConkey, *The New English: A History of the New English Art Club* (London: Royal Academy of Arts, 2006). Recent studies have also underscored the significance of lively and internationally well-connected art communities in Glasgow, Leeds, Bradford, and Dublin, notably Jude Burkhauser, ed., *"Glasgow Girls": Women in Art and Design, 1880–1920* (Glasgow: Canongate Publishing, 1990); Tom Steele, *Alfred Orage and the Leeds Arts Club, 1893–1923* (Aldershot, UK: Scolar Press, 1990); Elizabeth Cumming, *Glasgow 1900: Art and Design* (Amsterdam: Van Gogh Museum, Waanders Publishing, 1993); Philip Long and Elizabeth Cumming, *The Scottish Colourists, 1900–30* (Edinburgh: National Galleries of Scotland, Mainstream Publishing, 2000); Kenneth McConkey, *Memory and Desire: Painting in Britain and Ireland at the Turn of the Twentieth Century* (Aldershot, UK: Ashgate, 2002); and Robert Upstone, *William Orpen: Politics, Sex and Death* (London: Imperial War Museum, Philip Wilson Publishers, 2005). Surveys of Edwardian art, design, and material culture, such as Jane Beckett and Deborah Cherry, eds., *The Edwardian Era* (London: Phaidon Press and Barbican Art Gallery, 1987), have also engaged with these developments in other British and Irish cities. The imperial legacies of British art and patronage in former colonies and dependencies have also been reexamined, notably in relation to Australian and New Zealand collections, building on Anne Kirker and Peter Tomory, *British Painting 1800–1990 in Australian and New Zealand Public Collections* (Sydney: Beagle Press, 1997). These include Gray, *Edwardians*, and Ted Gott, Laurie Benson, and Sophie Matthiesson, eds., *Modern Britain 1900–1960: Masterworks from Australian and New Zealand Collections* (Melbourne: National Gallery of Victoria, 2007). In contrast, architecture and design histories of the period have mapped out substantial German, Austrian,

French, Belgian, and Scandinavian interconnections as well as stressing pan-European, pan-imperial, and pan-Atlantic associations. Some of these connections are explored in this essay and linked to the legacies of the Arts and Crafts movement and to German and Austrian design reformers. These studies include S. K. Tillyard, *The Impact of Modernism, 1900–1920: Early Modernism and the Arts and Crafts Movement in Edwardian England* (London and New York: Routledge, 1988); Wendy Kaplan, ed., *Designing Modernity: The Arts of Reform and Persuasion, 1885–1945: Selections from the Wolfsonian* (Miami Beach: Wolfsonian; New York: Thames and Hudson, 1995); Paul Greenhalgh, ed., *Art Nouveau: 1890–1914* (London: V&A Publications, 2000); Kaplan, ed., *The Arts and Crafts Movement in Europe and America: Design for the Modern World* (Los Angeles and London: Los Angeles County Museum of Art, Thames and Hudson, 2004); and Karen Livingstone and Linda Parry, eds., *International Arts and Crafts* (London: V&A Publications, 2005).

13. The Pavillon is discussed and illustrated by Paul Greenhalgh in his essay "The Style and the Age," in Greenhalgh, *Art Nouveau*, 32–33.

14. Clive Holland, "Lady Art Students' Life in Paris," *Studio* 30 (1903): 225–31, quoted in Lisa Tickner, "English Modernism in the Cultural Field," in *English Art 1860–1914: Modern Artists and Identity*, ed. David Peters Corbett and Lara Perry (Manchester: Manchester Univ. Press, 2000), 15. For John in Paris, see Alicia Foster, *Gwen John* (London: Tate Gallery Publishing, 1999), 24–25, and more recently Foster, "Gwen John's *Nude Girl*," in *The History of British Art*, vol. 3, *1870–Now*, ed. Chris Stephens (London: Tate Britain / Yale Center for British Art, Tate Publishing, 2008), 70–71.

15. See Nina Lübbren, *Rural Artists' Colonies in Europe, 1870–1910* (Manchester: Manchester Univ. Press, 2001), 2–7.

16. For the impact of these exhibitions in Germany and central Europe, see Robert Jensen, *Marketing Modernism in Fin-de-Siècle Europe* (Princeton, N.J.: Princeton Univ. Press, 1994), 220–23.

17. See Jensen, *Marketing Modernism*, 55.

18. Jensen, *Marketing Modernism*, 161–65.

19. For Whistler, see Andrew Stephenson, "Refashioning Modern Masculinity: Whistler, Aestheticism and National Identity," in Peters Corbett and Perry, *English Art 1860–1914*, 137–39.

20. See Hélène E. Roberts, "Exhibition and Review: The Periodical Press and the Victorian Art Exhibition System," in *The Victorian Periodical Press: Samplings and Soundings*, ed. Joanne Shattock and Michael Wolff (Leicester: Leicester Univ. Press, 1982), 79–107. For an analysis of the impact of literacy and the expansion of the reading public for Edwardian cultural weeklies, see Martin, *"New Age" under Orage*, 6–8, 12–13.

21. See Wendy Baron, *Sickert: Paintings and Drawings* (New Haven and London: Paul Mellon Centre for Studies in British Art, Yale Univ. Press, 2006), chap. 6, "1898–1905: Dieppe Landscapes," 37–42, and chap. 8: "1900–1904: Venice and Dieppe: Portraits and Figures," 49–54.

22. Baron, *Sickert: Paintings and Drawings*, 136–37.

23. Baron, *Sickert: Paintings and Drawings*, 215.

24. For Sickert's participation in the Salon d'Automne, see Anna Gruetzner Robins, "Sickert and the Paris Art World," in Gruetzner Robins and Thomson, *Degas, Sickert and Toulouse-Lautrec*, 156–57.

25. For the French reception to the "Camden Town Murder" works, see Gruetzner Robins and Thomson, *Degas, Sickert and Toulouse-Lautrec*, 176–79. For a wider social context, see Lisa Tickner, "Walter Sickert and the Camden Town Murder," in *Walter Sickert: The Camden Town Nudes*, ed. Barnaby Wright (London: Courtauld Gallery, Paul Holberton Publishing, 2007), 45–55.

26. Jensen, *Marketing Modernism*, 119–20.

27. Edward Morris, *French Art in Nineteenth-Century Britain* (New Haven and London: Paul Mellon Centre for Studies in British Art, Yale Univ. Press, 2005), 239–43. For a wider context, see Frances Fowle, ed., *Impressionism and Scotland* (Edinburgh: National Galleries of Scotland, 2008), 65–71.

28. Jensen, *Marketing Modernism*, 122–23.

29. See Anne Helmreich, "The Art Dealer and Taste: The Case of David Croal Thomson and the Goupil Gallery, 1885–1897," *Visual Culture in Britain* 6, no. 2 (2005): 40–41.

30. Morris, *French Art in Nineteenth-Century Britain*, 242, and Fowle, *Impressionism and Scotland*, 19–20.

31. See Kate Flint, ed., *Impressionists in England: The Critical Reception* (London: Routledge and Kegan Paul, 1984), 26, 193–225, and Fowle, *Impressionism and Scotland*, 70.

32. By 1902 Paul Cassirer had negotiated an exclusive contract with Durand-Ruel to show works from his gallery in Germany. See Jensen, *Marketing Modernism*, 75–77.

33. From 1900, the *Times* and the *Athenaeum* regularly reviewed the annual Salon d'Automne and Salon des Indépendants exhibitions, including the 1905 show. See J. B. Bullen, ed., *Post-Impressionists in England: The Critical Reception* (London: Routledge, 1988), 7.

34. Morris, *French Art in Nineteenth-Century Britain*, 141.

35. The very first private collectors of French Impressionism in the United Kingdom were Samuel Barlow of Stakehill, Lancashire (from about 1872), and Captain Henry Hill of Brighton (from 1876). Ionides bought Edgar Degas's *Ballet Scene from Meyerbeer's Opera "Robert le Diable"* (1876) in June 1881; it was one of the earliest works to gain entrance to a British national collection (now in the Victoria and Albert Museum, London). For the response of English national museums to modern French painting, see John House, ed., *Impressionism for England: Samuel Courtauld as Patron and Collector* (London: Courtauld Institute Galleries, 1994), 9–11.

36. See Morris, "Barbizon, Rodin and Scotland," in *French Art in Nineteenth-Century Britain*, 231–44, and Fowle, *Impressionism and Scotland*, 16–20, 65–75. For Whistler and Scotland, see Fowle, *Impressionism and Scotland*, 49–63.

37. *Glasgow Herald*, 9 April 1910, quoted in Frances Fowle, "Prejudice and Parsimony: Early Acquisitions of Modern French Paintings at the National Gallery of Scotland," *Visual Culure in Britain* 6, no. 2 (2005): 5.

38. Fowle, *Impressionism and Scotland*, 63.

39. Long and Cumming, *Scottish Colourists*, 21.

40. See Tickner, *Modern Life and Modern Subjects*, 106–10, and Long and Cumming, *Scottish Colourists*, 50.

41. P. G. Konody, "Art and Artists: English Post-Impressionists," *Observer*, 27 Oct. 1912, quoted in Gruetzner Robins, *Modern Art in Britain*, 108.

42. Frank Rutter, "The Autumn Salon," *Sunday Times* (London), 2 Oct. 1910, quoted in Gruetzner Robins, *Modern Art in Britain,* 109.

43. For the rivalry between various art groups and the Allied Artists Association, see McConkey, *New English*, 110.

44. See Tickner, *Modern Life and Modern Subjects*, 106–7, and Gruetzner Robins, *Modern Art in Britain*, 109.

45. Anne Estelle Rice, "Les Ballets Russes," *Rhythm* 2, no. 7 (Aug. 1912): 106–10.

46. Libby Horner and Gillian Naylor, eds., *Frank Brangwyn, 1867–1956* (Leeds: Leeds City Art Gallery / Groeningemuseum / Arenthuis, 2006), 30–31.

47. Horner and Naylor, *Frank Brangwyn,* 59–60.

48. For Meier-Graefe's promotion of Brangwyn, see Horner and Naylor, *Frank Brangwyn*, 62; for positive German critical reaction, ibid., 65–66.

49. See Edwin Becker, "Les Salons de L'Art Nouveau," in *Les Origines de l'Art Nouveau: La Maison Bing*, ed. Gabriel P. Weisberg, Edwin Becker, and Evelyn Possémé (Amsterdam: Van Gogh Museum, Les Arts Décoratifs, Paris, and Mercator, Antwerp, 2006), 115–26.

50. For Bing's Anglophile taste, see Evelyn Possémé, "Bing et L'Angleterre," in Weisberg, Becker, and Possémé, *L'Art Nouveau*, 151–63; for French criticism of this taste, see Nancy J. Troy, *Modernism and the Decorative Arts in France* (New Haven and London: Yale Univ. Press, 1991), 26–27.

51. For the London exhibition, see Gabriel P. Weisburg, "La Métamorphose des Intérieurs: Les Ateliers Art Nouveau de Bing," in Weisberg, Becker, and Possémé, *L'Art Nouveau*, 173–79.

52. For Brangwyn and Meunier, see Horner and Naylor, *Frank Brangwyn*, 66–68; for the 1905 Venice Biennale designs, ibid., 138–39. The Meunier work is reproduced and discussed in context in MaryAnne Stevens and Robert Hoozee, eds., *Impressionism to Symbolism: The Belgian Avant-Garde, 1880–1900* (London: Royal Academy of Arts, 1994), 196–97, no. 53.

53. The series in the Leeds collection are illustrated in the Public Catalogue Foundation, *Oil Paintings in Public Ownership in West Yorkshire: Leeds* (London: Public Catalogue Foundation, 2004), 36–37. The donation is discussed in A. S. Covey, "The Brangwyn Room at the Leeds City Art Gallery," *Studio* 40 (April 1907).

54. For Bing's indebtedness to Arts and Crafts thinking, see Troy, *Modernism and the Decorative Arts in France*, 8, and Jensen, *Marketing Modernism*, 240–41.

55. See Horner and Naylor, *Frank Brangwyn*, 166.

56. "The Brussels International Exposition," *Studio* 50 (1910): 245–47.

57. "Brussels Exhibition: Furnished Interiors by Fernand Khnopff," *Studio* 50 (1910): 312.

58. Alan Crawford, *C. R. Ashbee: Architect, Designer and Romantic Socialist*, 2nd ed. (New Haven and London: Yale Univ. Press, 2005), 410–11, and Kaplan, *Arts and Crafts Movement in Europe and America*, 286 n. 6.

59. Rüdiger Joppien, "Germany: A New Culture of Things," in Kaplan, *Arts and Crafts Movement in Europe and America*, 70.

60. This is discussed by Christian Witt-Dörring in "Austria: Idealism or Realism," in Kaplan, *Arts and Crafts Movement in Europe and America*, 124–27.

61. Crawford, *C. R. Ashbee*, 411.

62. Crawford, *C. R. Ashbee*, 414–15.

63. Crawford, *C. R. Ashbee*, 411.

64. Wendy Kaplan, ed., *Charles Rennie Mackintosh* (Glasgow, New York, and London: Glasgow Museums and Abbeville Press, 1996), 203.

65. Kaplan, *Arts and Crafts Movement in Europe and America*, 248, 274–75.

66. The relationship of the British to the American Arts and Crafts movement is discussed in Gillian Naylor, *The Arts and Crafts Movement: A Study of Its Sources, Ideals and Influence on Display Theory* (London: Studio Vista, 1971), 174–76, and Randell L. Makinson, *Greene and Greene: Furniture and Related Designs* (Salt Lake City: Gibbs Smith–Peregrine Smith Books, 1979), 16–19.

67. Kaplan, *Arts and Crafts Movement in Europe and America*, 69–70. It is important to note that the dissemination of Arts and Crafts thinking into Scandinavia was largely through exposure to these German translations and publications, a point reiterated by Elisabet Stavenow-Hidemark in ibid., 180.

68. For Meier-Graefe and the decorative arts, see Grischka Petri, "The English Edition of Julius Meier-Graefe's *Entwicklungsgeschichte der modernen Kunst*," *Visual Culture in Britain* 6, no. 2 (2005): 178–80; for the role of Morris, see ibid., 182.

69. Kaplan, *Arts and Crafts Movement in Europe and America*, 70.

70. See Jensen, *Marketing Modernism*, 241, and Weisberg, Becker, and Possémé, *L'Art Nouveau*, 235–40.

71. Kaplan, *Arts and Crafts Movement in Europe and America*, 151.

72. Kaplan, *Arts and Crafts Movement in Europe and America*, 34–41.

73. See Frederic J. Schwartz, *The Werkbund: Design Theory and Mass Culture before the First World War* (New Haven and London: Yale Univ. Press, 1996), 10.

74. C. R. Ashbee, *An Endeavour towards the Teachings of Ruskin and Morris* (London: E. Arnold, 1901), quoted in Naylor, *Arts and Crafts Movement*, 169.

75. Livingstone and Parry, *International Arts and Crafts*, 61.

76. Quoted in Naylor, *Arts and Crafts Movement*, 176.

77. "Die VIII. Ausstellung der Weiner Secession," *Dekorative Kunst* (Sept. 1901): 172–75.

78. "Modern British Domestic Architecture and Decoration," special issue, *Studio* (Summer 1901): 112.

79. See Kaplan, *Charles Rennie Mackintosh*, 237. For Margaret Macdonald Mackintosh's contribution, see Pamela Robertson, "Margaret Macdonald Mackintosh (1864–1933)," in Burkhauser, *"Glasgow Girls,"* 115.

80. This commission is discussed by Elizabeth Clegg in Tobias G. Natter and Christoph Grunenberg, eds., *Gustav Klimt: Painting, Design and Modern Life* (London: Tate Publishing, 2008), 118–25.

81. See Kaplan, *Charles Rennie Mackintosh*, 85–86, 101–5.

82. Burkhauser, *"Glasgow Girls,"* 54–55, 80–82.

83. See Pat Kirkham, "'Living Fancy': Mackintosh Furniture and Interiors," in Kaplan, *Charles Rennie Mackintosh*, 252–54.

84. Kirkham, "'Living Fancy,'" 254.

85. Muthesius, preface to the Mackintosh folio of *Meister der Innenkunst* (Darmstadt, 1902), 3, quoted in Cumming, *Glasgow 1900*, 112.

86. Judith R. Walkowitz, "The 'Vision of Salome': Cosmopolitanism and Erotic Dancing in Central London, 1908–1918," *American Historical Review* 108, no. 2 (April 2003): 1–2, <http://www.historycooperative.org/journals/ahr/108.2/walkowitz.html> (30 Dec. 2008).

87. Quoted by Grace Brockington in her unpublished manuscript based on her DPhil dissertation, "Above the Battlefield: Art for Art's Sake and Pacifism in the First World War" (Univ. of Oxford, 2003), 168.

88. G. L. Dickinson, "The Illusion of War," *Nation* 11, no. 9 (10 Aug. 1912): 702.

89. Brockington, "Above the Battlefield," 167. She notes that Lyceum Clubs were formed in Holland from 1904; Berlin, 1905; Paris, 1906; Florence, 1908; Athens, 1910; Stockholm, 1911; and Melbourne, 1912; ibid., 173.

90. Jensen, *Marketing Modernism*, 70, 194–95.

91. Brockington, "Above the Battlefield," 181–82. It is interesting to see the overlaps between the Arts and Crafts membership and those of the Lyceum Clubs, whose exhibitions were regularly reviewed in the *Studio*, notably in "Studio Talk," *Studio* 38 (1906): 241.

92. See Philip Athill, "The International Society of Sculptors, Painters and Gravers," *Burlington Magazine* 127 (1985): 21–22.

93. Elizabeth Robins and Joseph Pennell, *The Life and Times of J. M. Whistler*, 2 vols. (Philadelphia: J. B. Lippincott, 1908), 2:216.

94. Athill, "International Society," 23.

95. Athill, "International Society," 25.

96. Quoted by Morris, *French Art in Nineteenth-Century Britain*, 141.

97. Athill, "International Society," 29.

98. John Lavery, *The Life of a Painter* (London: Cassell and Co., 1940), 111.

99. William Rothenstein, *Men and Memories: Recollections, 1872–1938* (London: Chatto and Windus, 1978), 140.

100. For the Whistler memorial exhibition, see International Society of Sculptors, Painters and Gravers, *Memorial Exhibition of the Works of J. McNeill Whistler* (London: William Heinemann, 1905).

101. Julius Meier-Graefe, *Modern Art: Being a Contribution to a New System of Aesthetics*, trans. Florence Simmons and George W. Chrystal (London: William Heinemann, 1908). Textual differences between the German edition and the English translation are analyzed by Petri in "English Edition," 171–88.

102. See Petri, "English Edition," 185, and Christopher Green, ed., *Art Made Modern: Roger Fry's Vision of Art* (London: Courtauld Gallery, Merrell Holberton, 1999), 58.

103. Review of the formation of the International Society, *Morning Post* (London), 9 Feb. 1898, quoted in Athill, "International Society," 21.

104. Lavery, *Life of a Painter*, 111.

105. For the role of William Ernest Henley and the role of the *Magazine of Art* in promoting Rodin in Britain, see Morris, *French Art in Nineteenth-Century Britain*, 237–38.

106. For the reception of Rodin's work in Britain, see Catherine Lampert, ed., *Rodin* (London: Royal Academy of Arts, 2006). For Rodin's involvement with the International Society, see ibid., 123; for the king's visit, ibid., 125.

107. Lampert, *Rodin*, 99–100.

108. See Lampert, "The Donation of 1914," in Lampert, *Rodin*, 287.

109. Reproduced in Lampert, *Rodin*, 284, no. 349.

110. Reproduced in Lampert, *Rodin*, 225, no. 76.

111. Discussed and quoted in Lampert, *Rodin*, 225, no. 77.

112. Reproduced in Lampert, *Rodin*, 285, no. 360.

113. Virginia Woolf, "Old Bloomsbury," in *Virginia Woolf: Moments of Being*, ed. Jeanne Schulkind (Sussex, UK, 1976), 173–74, quoted in Peter Stansky, *On or about December 1910: Early Bloomsbury and Its Intimate World* (Cambridge, Mass.: Harvard Univ. Press, 1996), 10.

114. *Daily Chronicle*, 26 Nov. 1912, quoted in Lisa Tickner, "'Augustus's Sister': Gwen John, Wholeness, Harmony and Radiance," in *Gwen John and Augustus John*, ed. David Fraser Jenkins and Chris Stephens (London: Tate Publishing, 2004), 30 n. 9.

115. Augustus John to William Rothenstein, 1907, quoted in Michael Holroyd, *Augustus John: A Biography*, vol. 1, *The Years of Innocence* (London: Heineman, 1974), 253, and in Gray, *Edwardians*, 32.

116. Fraser Jenkins and Stephens, *Gwen John and Augustus John*, 129, no. 79, and discussed in Tickner, "'Augustus's Sister,'" 30.

117. Quoted in Foster, *Gwen John*, 67.

118. Fraser Jenkins and Stephens, *Gwen John and Augustus John*, 89, no. 39.

119. See Kenneth McConkey, *Edwardian Portraits: Images of an Age of Opulence* (Woodbridge, UK: Antique Collectors' Club, 1987), and MaryAnne Stevens, ed., *The Edwardians and After: The Royal Academy, 1900–1950* (London: Royal Academy of Arts, 1988).

120. Paul Edwards, introduction to *Blast: Vorticism, 1914–18*, ed. Paul Edwards (Aldershot, UK: Ashgate Press, 2000), 9.

121. See Robert Upstone, ed., *Modern Painters: The Camden Town Group* (London: Tate Publishing, 2008); Richard Shone, ed., *The Art of Bloomsbury: Roger Fry, Vanessa Bell and Duncan Grant* (London: Tate Publishing, 1999); and Edwards, *Blast* (an English-language adaptation of the publication that accompanied an exhibition at the Springel Museum and Haus der Kunst, Munich, in 1996–97).

122. Gruetzner Robins, *Modern Art in Britain*, is the catalogue that accompanied the exhibition of the same name, 20 Feb.–26 May 1997.

123. Gruetzner Robins, *Modern Art in Britain*, 7.

124. Gruetzner Robins, *Modern Art in Britain*, 10–12.

125. In this respect my approach builds on Beckett and Cherry, *Edwardian Era*, and is indebted as well to Tickner, *Modern Life and Modern Subjects*; Peters Corbett and Perry, *English Art 1860–1914*; and Ysanne Holt, *British Artists and the Modernist Landscape* (Aldershot, UK: Ashgate Press, 2003).

126. The broad understanding that emerges of the involvement of women as producers and consumers of visual culture is indebted to Deborah Cherry, *Painting Women: Victorian Women Artists* (London and New York: Routledge, 1993); Pamela M. Fletcher, *Narrating Modernity: The British Problem Picture, 1895–1914* (Aldershot, UK: Ashgate Press, 2003); and Meaghan Clarke, *Critical Voices: Women and Art Criticism in Britain* (Aldershot, UK: Ashgate Press, 2005).

127. See, for example, Sarah Wilson, ed., *Paris: Capital of the Arts, 1900–1968* (London: Royal Academy of Arts, 2002). It is significant that London was conspicuously absent from the epic series of "Paris-city exchange" exhibitions pioneered by the Centres Georges Pompidou in collaboration with other major international museums in the late 1970s, such as Paris–New York (1977), Paris–Berlin 1900–1933 (1978), and Paris–Moscow 1900–1930 (1979), and from the later exhibitions organized by the Réunion des Musées, Paris–Brussels/Brussels–Paris (1997) and Paris–Barcelona (2001). Similarly, Jensen, *Marketing Modernism*, largely sidelines London's importance as a world and imperial art market.

A Political Theory of Decoration, 1901–1910

Morna O'Neill

Decoration played an important role in Edwardian art discourse, because the central problematic of the formulation "decorative art" mirrored a pressing political question of the period: what is the relationship of an individual part to a larger whole? Roger Fry attempted to prepare English audiences for European modernism in 1910 by couching his discussion in familiar terms: a critical language of "decoration." Fry's use of the decorative drew upon French avant-garde theory, as he explained the virtues of modernism within a critical lexicon already attentive to patterning, vivid coloration, and decorative lines. Yet he also borrowed from the parallel notion of the decorative popularized by the Arts and Crafts movement in the last two decades of the nineteenth century.[1]

In fact, "decoration" was an elastic term in this period, an umbrella that included the works of James Abbott McNeill Whistler and Claude Monet as well as the furniture of Ernest Gimson, for example. Notions of the decorative and decoration predominate in art criticism from this period in both British and broader European contexts. Recent scholarship has elucidated one strand of this discourse to recast the history of modernism.[2] Decoration functions as the disparaged "other" of abstract painting, "sullied by connotations of materiality, domesticity, femininity, decadence, and excess."[3] So avidly disavowed by modernism, it can paradoxically be found at its heart. For many theorists a work of art or an object, to be considered decorative, must be envisioned as an integrated part of a decorative environment, and its meaning must be subordinate to this larger context.[4] Is the decorative work of art first and foremost an autonomous object, or does its decorative status compromise this autonomy?

This question of independence amid deeper controlling structures likewise troubled politics during the Edwardian era, a period that Terry Eagleton described in *The Ideology of the Aesthetic* as the "transition from market to monopoly capitalism." As a result, he wrote that "the old vigorously individualist ego, the self-determining subject of classical liberal thought" seemed to become "an obedient function of some deeper controlling structure . . . thinking and acting for it."[5] One

287

could substitute "easel painting" for "ego" in this formulation without altering its fundamental meaning. A "deeper controlling structure," such as the integrated decorative environment, threatened the aura of the work of art. The political and the decorative were interchangeable, as Edwardian art and Edwardian politics pondered the relationship of part to whole.

Against this backdrop, it is possible to formulate a "political theory of decoration" for the Edwardian period, an early-twentieth-century reworking of John Barrell's "political theory of painting" for the late eighteenth century.[6] Barrell outlined a symbiotic relationship between painting and the discourse of civic humanism, wherein "the most influential attempts to provide the practice of painting with a theory were those which adopted the terms of value of the discourse we now describe as civic humanism."[7] By forsaking the imitation of nature for the depiction of ideal and universal truth under the category "history painting," painting became a liberal art and a tool to propagate the ideals of civic humanism, "recommending those virtues which will preserve a civil state, a public, from corruption."[8] The Edwardian period similarly witnessed an equally important attempt to provide art with a theory; yet the art theorized was not history painting, but rather decoration, a cultural product that represented a collective impulse and a civic ideal. For T. J. Clark, the ubiquity and expansiveness of the decorative in the late nineteenth century resided in its reputation for "soldering together the aesthetic and the social" in its consideration of public art and spectatorship.[9] Janus-like, the designation "decorative" is both the apex of a moralizing public understanding of fine art and the epitome of its private, quotidian substitute. The decorative is able to be both private and public in the same moment, a product of individual will and collective action.

A constellation of ideas clustered around decoration in the first decade of the twentieth century indicates the extent to which Edwardian artistic and political crises converged. In fact, decoration provides an artistic analogue to precisely the issues that George Dangerfield identified as the most pressing political concerns of the Edwardian period: organized labor, Irish Home Rule, and the conflict between the House of Commons and the House of Lords.[10] In the first example, debates within the Arts and Crafts Exhibition Society about the future direction of the group, and increasingly vociferous outside critiques of the form and content of their exhibitions, allude to broader debates within the organized labor movement. A group display of craft could no longer find equilibrium between individual will and collective ideals. This political theory of decoration also informed debates about the donation of modern art to the city of Dublin by the Anglo-Irish art dealer Hugh Lane. Through the discourse of decoration, Lane and his gallery imagined a non-British lineage for Irish art, a potentially nationalist gesture. In

both of these cases, decoration itself becomes politically charged. As David Solkin has pointed out, theories of art (such as the one discussed by Barrell) respond in pragmatic ways to the marketplace and commercial society.[11] In the Edwardian period, the political theory of decoration found itself pushed to its limits: tested, adapted, and eventually co-opted by the Liberal Party itself. The gift of mural painting to the House of Commons by Liberal peers, unveiled in 1910 amid a legislative stalemate between the Liberal government and the more conservative House of Lords, reverses this dynamic; that it to say, politics becomes decoration as the murals attempt to cover over this political crisis with a visually integrated narrative of national unity.

DECORATIVE ART AND THE ARTS AND CRAFTS EXHIBITION SOCIETY

By 1900 the Arts and Crafts movement had become an official national style, a status ratified by the Morris & Company decorations for the British Pavilion at the Exposition Universelle of 1900 in Paris (fig. 82). The interest in vernacular forms and historical modes of production found in the work of William Morris, as well as Walter Crane and Gimson, for example, came to be understood as patriotic expressions of national identity rather than critiques of contemporary industrial production.[12] The Arts and Crafts Exhibition Society faced international criticism along these lines at the *First International Exhibition of Modern Decorative Art* at Turin in 1902.

An Italian reviewer dismissed the English section as "purely retrospective," characterizing both the objects on display (a retrospective of the work of Crane occupied half the exhibition space) and the design aesthetic that determined their forms.[13] According to the organizers, "the exhibition will consider artistic manifestations and industrial products that address the aesthetics of the street, and well as that of the house and of the room."[14] The English display failed to answer this brief. The official program of the exhibition criticized the English section and Crane, the society president, for organizing a display of domestic decoration with all the appeal of "a museum vitrine":[15] exhaustive and important, but nevertheless sterile and even a bit boring. Most European national displays featured model interiors with architectural fittings or the arrangement of furniture ensembles. In the Arts and Crafts display, in contrast, objects were grouped by medium, and they were sometimes exhibited alongside working drawings or studies. This "museum" approach, which ignored the domestic mandate of the exhibition, highlighted the intellectual process of the designer and the manual skill of the craftsman. It also

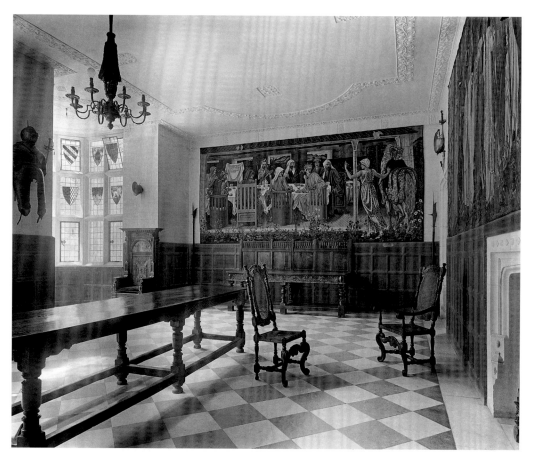

82. Morris & Company, "Section of the British Pavilion, Paris Exhibition" (Exposition Universelle, Paris, 1900). Country Life Picture Library.

highlighted an ongoing point of conflict within the society; namely, the presentation of a single "corporate" identity for what was, in reality, a loose collective of individual designers and makers.

The society responded to this criticism in the catalogue for its 1903 exhibition in the New Gallery in London. In the foreword, Crane acknowledged that it is difficult to "do justice to the large and varied collection of works" that constitute such group exhibitions.[16] Implicit in this statement is the constant tension between individual contribution and collective ideal. The exhibition committee attempted to give "unity and relation" to certain groups of objects, however, by subdividing the north room of the cavernous New Gallery into "recesses" that featured combined groups of works, often selected by a single exhibitor. A photograph reproduced in

the *Studio* of furniture designed by George Walton and executed by J. S. Henry and Company gives a sense of these spaces (fig. 83): small, shallow dioramas for the arrangement of objects. In a further acknowledgment of Continental exhibition practice observed in Turin, the society covered the west gallery space with white canvas for the display of two-dimensional design and needlework.

The cubicle arrangement prompted a debate among society members about the individual will of the designer.[17] W. R. Lethaby protested that by allowing individual members to determine the content of the recesses, the exhibition committee forfeited its control over the quality of the exhibition.[18] Even the subcommittee responsible for the north gallery display (W. A. S. Benson, George Jack, and Halsey Ricardo) agreed with Lethaby.[19] The *Studio*, however, praised the 1903 arrangement as evidence of the society's "guild spirit" that also allowed for the individuality of the designer, since it allowed him (in each case, a male member of the society) to determine the arrangement of his own works or collaborate with a like-minded colleague.[20] For some reviewers the new organization, along with the continued society practice of naming exhibitor, designer, and executor in the catalogue and the exhibition labels, constituted a radical stance. According to the *Times* (London), these practices defied "the capitalist system" of exhibition inaugurated at the Crystal Palace in 1851, wherein the commercial firm appeared as a corporate entity rather than a collective of individual designers and makers.[21] The display format and the labels provide "detailed evidence of the activity and abundance of our artistic workers"; in short, they testified to the inventive power of "individuality."[22]

The contents of the cubicles, however, prompted criticism. To the *Studio* reviewer, the objects seemed willfully, even perversely, divorced from the realities of modern life.[23] This critique gathered strength at the 1906 exhibition, with the majority of it given over to "the fine crafts" of bookbinding, jewelry, and needlework, rather than "the crafts relative to domestic architecture and domestic equipment."[24] The Arts and Crafts Exhibition Society seemed to have abandoned the socialist ideals of many of its members and embraced elaborate brooches and gold-bound volumes. Rumors circulated after the exhibition that the society had disbanded, which forced Crane to publish a denial letter in the *Times*.[25]

This decline prompted Alfred Orage to take stock of the movement in his essay "Politics for Craftsmen" (1907).[26] He presented himself as the ideal commentator, a partisan who owed his own politics to the societal critique developed by the Arts and Crafts movement.[27] Both the Leeds Art Club (founded by Orage with Holbrook Jackson in 1903) and the Fabian Arts Group (another joint venture, begun in 1907) explored the dynamic interaction between political ideals and artistic practice.[28] Orage provided a new perspective on this question, which had

puzzled English social critics since John Ruskin. As a theosophist, Orage had looked to spiritual evolution for societal renewal. This belief in the "world soul" became fused with his reading of Friedrich Nietzsche and a eugenicist's faith in what Francis Galton termed "a highly gifted race of men."[29] In Orage's published work on Nietzsche, including the volume *Nietzsche in Outline and Aphorism* (1907), he emphasizes the unique and necessary work done by artists and philosophers in society; for this very reason, art has a moral value, and artists have a moral obligation to enable society to improve—to create a race of supermen. His editorship of the influential journal the *New Age* provided a platform for his ideals, and it eventually led him to publicly disavow the Arts and Crafts movement.[30]

Orage begins his discussion in "Politics for Craftsmen" by praising the "sociological" goal of the early movement, which was (and here he quotes Crane) "a revolt against the hard mechanical conventional life and the impossibility of beauty."[31] The movement was nothing less than a "protest" against "cheapness," "degradation," and "turning men into machines."[32] Orage allies the Arts and Crafts movement (the activism of craftsmen) to the trade unions movement of the 1880s (the activism of laborers). This is the crux of his critique: the socialist movement "absorbed" the politics of the Arts and Crafts movement, to the detriment of the craftsmen. Craftsmen "resigned" their separate efforts at political propaganda with disastrous results, as socialists "neglected" their concerns.[33]

For Orage, socialists "betrayed" artists, craftsmen, and all "imaginative minds" by focusing their attentions on the working class.[34] The collectivist reconstruction of society that socialists proposed would privilege working-class concerns, leaving arts and crafts an "enfeebled" "parasite."[35] Here Orage reveals his own affiliations, as he considers the working class an "inferior class."[36] In particular he takes issue with the collectivist model of socialism, since, as many other artist-socialists argued, collectivism suppressed the individualism essential to craft: "it is personality that the craftsman seeks both in his own work and in his market. . . . The supremacy of labour would mean the extinction of the craftsman."[37] For Orage the Arts and Crafts movement best expressed its politics on an individual level, through the personal expression of designer and craftsman.

Orage rejected the collective ideal of the Arts and Crafts Exhibition Society. As president of the society, Crane defended collectivism in his introduction to the 1907 pamphlet *Socialism and Art*, by Jack Squire. As he had done before in other such statements, Crane allied the cause of art to that of labor in general, stating that "there is no labour which does not recognize the exercise of some kind of mental or manual skill, or both—we may reasonably come to regard Art, in its social bearing and connected as it is with the crafts of common life, as a *necessity*."[38] The necessity of art to life would guide the reorganization of society

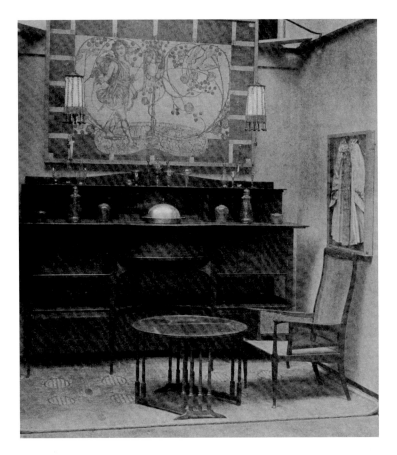

83.　"Cubicle at the 1903 Arts and Crafts Exhibition at the New Gallery with Furniture Designed by George Walton and Executed by J. S. Henry & Company," from *Studio* 28 (1903): 29. Courtesy of the Yale University Library.

under socialism, he stated; although "a certain amount of ordinary useful work or service" would be required of each citizen, everyone "would still have a large margin of spare time which might be spent in the pursuit of Art by any who developed talent and taste in that direction."[39] What Crane was defending, then, was the radical democratization of art originally proposed by Arts and Crafts founding theorists such as Ruskin and Morris. Art would pervade the everyday life of everyone.

The collectivism and unity proposed by Crane worried Orage, whose politics advocated the protection of craft as a particular type of labor and "the separate political action on the part of craftsmen."[40] The social forces working to unify the interests of laborers and bring them together were joined by other pressures that

threatened to pull them apart. The last three decades of the nineteenth century witnessed a transformation in the organization of labor. Earlier in the century, unions had developed out of the traditional guilds of skilled laborers; however, as industrialization and mechanization progressed, unskilled laborers were playing a crucial role in the workforce as well. With the Great Dock Strike of 1889, unskilled laborers joined unions in record numbers, posing a challenge to the "labour aristocracy" of the traditional craft-based unions formed earlier in the century.[41] For the most part, this new membership supported the Independent Labour Party (ILP), which in turn affiliated with the Labour Party, formed in 1906.

Orage's *New Age* first criticized Crane's view of the dynamic between art and labor in its October 1907 review of Squire's *Socialism and Art*. Crane defended his position in a letter to the editor, in which he again addressed the question of a "professional" class of artists. He asserted that the separation of artists as a distinct group was "detrimental" to art, and that "nothing in art is of any worth unless done for love," reaffirming his original proposition that the "leisure hours" promised by collectivism would allow every citizen to be an artist and would instill art in everyday life.[42] Orage saw an ominous future for the craftsmen in this assertion. Trade unions and socialists, he averred, would mandate that individuals perform the work that society requires, and that artists and craftsmen would not have a choice in their profession.

By 1910 the *New Age* coterie of Orage and his followers had broken with the ILP and the Labour Party. Instead of cooperation with the existing strands of the socialist movement, Orage proposed a separate socialism for craftsmen: Guild Socialism.[43] He founded the Guilds Restoration League with Arthur Penty, a Leeds architect and author of the polemic *The Restoration of the Guilds* (1906). Based on the model of the medieval guilds, it allowed craftsmen to determine their own standards and regulate their own work. Orage wrote that Guild Socialism would entail "vigorous assertion of the political needs of the crafts and a rigorous insistence upon the political conditions that alone can make craftsmanship flourish."[44] In a dramatic departure from Morris and Crane, who both suggested that socialism could help "craftsmanship flourish," Orage advocated a protectionist platform. He did not advocate a radical reorganization of society that would necessarily entail a reorganization of artistic labor. Rather, he indicated that artistic labor must reorganize itself. Perhaps a similar moment of reflection in 1910 prompted C. R. Ashbee to call for a reorganization of the Arts and Crafts Exhibition Society as a commercial gallery with a permanent exhibition space and sales. The society rejected this proposal, because it would "change the character" of the group, which understood decoration as a collective ideal.[45] The society failed to respond to the shifting dynamic of decoration, and the 1912 exhibition left it insolvent.[46]

DECORATIVE POLITICS IN DUBLIN

The expansiveness of decoration as a critical term, as well as its political charge, is evident in an 1891 essay by Grant Allen entitled "The Celt in English Art."[47] Allen cut across traditional boundaries between fine art and decorative art in his discussion of "the decorative impulse"; the Pre-Raphaelite painters and the designers and makers affiliated with the Arts and Crafts movement were "Celtic" and therefore decorative. For Allen, the Celt aimed to produce "a beautiful object" rather than a narrative, which was the primary goal of its opposite, the realist "Teutonic" impulse in art.[48] The Teutonic desire for "technical mastery" too easily approached the industrial imperatives of the late Victorian era and the market demand for easel painting. And Allen was emphatic that the Celtic decorative was politically radical: "it has brought with it . . . fresh forces in political life" such as socialism and Irish Home Rule.[49]

Allen singled out the painting *The Rose Bower* (1870–90; The Faringdon Collection Trust, Buscot Park, Oxfordshire), by the nominally Celtic Edward Burne-Jones, as an exemplary "Celtic product." This canvas was part of *The Legend of the Briar Rose*, a series of paintings treating the narrative of Sleeping Beauty that the artist reworked in various versions throughout his career. For Allen, the "beautiful dream" of the Sleeping Princess presents the talents of the Celt for intricate fretwork pattern, overall design of a composition, and poetic, symbolic subject matter, in opposition to the industrialism and materialism of contemporary English life.[50] The Celt in Britain, Allen wrote, "like Mr. Burne-Jones's enchanted princess, has lain silent for ages in an enforced long sleep" but has returned with a vengeance, "bringing all the Celtic ideals, the Celtic questions, and the Celtic characteristics into the very thick and forefront of the actual fray in England."[51] Thus, he added, the "Celtic temperament" had the potential to transform not only British art, but also British culture and British politics: radicalism, socialism, and above all Home Rule agitation were all part of Allen's "Celtic upheaval."[52]

Hugh Lane invested in this notion of Celtic decoration when he acquired one of Burne-Jones's paintings of sleeping princesses from a second series of *The Legend of the Briar Rose* at an unknown date (fig. 84). The art dealer made the painting the centerpiece of the British room in his gift to the city of Dublin, a Municipal Gallery of Modern Art. The saga of Lane's thwarted attempt to establish a gallery of modern art in Dublin is well known. He first proposed the gallery in 1905, and it opened to the public in temporary premises in January 1908, displaying 280 works of art. Thirty-nine works, including Impressionist paintings by Pierre-Auguste Renoir, Edgar Degas, and Edouard Manet, were a "conditional gift" to be given to the city once it established a permanent home for the collection.

84. Edward Burne-Jones, *The Sleeping Princess: Briar-Rose Series,* oil on canvas (1874), 49⅝ x 93⅜ in. (126 x 237 cm). Dublin City Gallery, The Hugh Lane.

Lane's collection also included British and Irish art, as well as a group of portraits that he hoped would be the beginning of an Irish National Portrait Gallery.[53] When Lane offered this collection to Dublin, he suggested an Irish identity for his French Impressionist pictures as part of a decorative tradition that included Celtic art.

Lane's own interest in Celtic art can be traced to his introduction to the Celtic Revival circle of his aunt Lady Augusta Gregory,[54] which coincided with his (failed) attempt to exhibit a collection of Irish art at the Louisiana Purchase Exposition in St. Louis in 1904.[55] He displayed the works instead at the Guildhall in London that same year. In a prefatory note to the catalogue, Lane praised the artistic production of the Irish "of early times," especially what he called the "perfect forms" of twelfth-century decorative practices, including "illumination, design, architecture, and metalwork."[56] He considered these examples of Celtic art as a primal form of artistic expression. But the "Anglo-Norman invasion," he added, "laid its forbidding hand on the crafts."[57] The art of painting, therefore, did not develop in Ireland organically from the decorative arts but instead "grew up as an offshoot of the schools of

other nations."[58] Lane praised the decorative "Irish race instinct" in the arts, especially in literature, and noted that "it can hardly be absent in the sister art" of painting. He went on to suggest that a gallery of modern art in Dublin would help the Irish develop "a distinct school of painting."[59] Lane deployed ethnographic stereotypes to draw a continuity between past and present: his Dublin gallery proposed a non-British lineage for Irish art, a provocatively nationalist gesture.

In Dublin at least, modern art merged with Celtic ornamentation: according to one (exasperated) Irish critic of Lane's gallery, "We hear so much nowadays of the desirability of a school of distinctive Irish art. The man who draws intricate designs of interlaced ornament is looked on as an evangelist."[60] Lane's exhibition efforts were often connected to Arts and Crafts activities as vernacular expressions of decorative art thought to embody "Celticness."[61] Dermot Robert Wyndham Bourke, seventh Earl of Mayo, the honorary president of the Arts and Crafts Society in Ireland, connected the dealer's efforts to those of the Arts and Crafts movement during a speech at the opening of Lane's 1905 exhibition.[62] In 1908, the same year the Dublin gallery opened, Lane organized a display of Irish art in Ballymaclinton, the Irish village at the Franco-British Exhibition in London.[63] Material culture constituted much of this spectacle at the Irish village: "Donegal carpet weaving factory, a linen-loom, soap-making, lace-making, and embroidery."[64] Within the context of Lane's concern for a national artistic culture, the presentation of Irish fine art within the Irish village asserted a shared Celtic heritage. Invitation cards to the opening of the Dublin gallery in 1908 were printed in both Gaelic and English, as were labels and the catalogue.[65] Furthermore, Stephen Gwynn of the Gaelic League spoke at this event and declared Lane's project "sympathetic" to the goals of the nationalist league.[66]

Decoration became something of a watchword for the gallery: Lane oversaw the adornment of each room with furniture and decorative objects.[67] Lane's aunt, the Anglo-Irish Revivalist Lady Gregory, recalled that Lane gave her and other ladies flowers at the opening and directed them to pose in certain corners of the galleries to add to the "decorative effect" of the pictures.[68] Lane also devised a scheme to decorate his gallery with mural paintings depicting important events from Irish craft, folklore, and history.[69] Decoration thus provided a "Celtic" context for the prized Impressionist pictures. The Irish painter William Orpen had introduced Lane to the work of Manet and the Impressionists during a single day's visit to Paris in 1904. Lane purchased a number of paintings from the dealer Paul Durand-Ruel, including Manet's *Portrait of Eva Gonzales*, the centerpiece of Orpen's 1909 canvas *Homage to Manet* (fig. 85).[70] Yet in 1905 Lane's selections were hardly new, even for a supposedly provincial Irish audience.[71] In fact, Lane rejected an invitation from the dealer Félix Fénéon to consider buying more recent works

by Paul Cézanne, Vincent van Gogh, and Henri Matisse, among others.[72] Rather, it seems that he gravitated to Impressionism as a form of modernism aligned with the decorative. Renoir's Impressionist scene of city life entitled *Les Parapluies* (1883), for example, took its place alongside Burne-Jones's fantastical *Sleeping Princess*; both collapse the space of the picture plane in favor of planes of color.[73] The French term "décoratif" occurs frequently in discussions of Impressionist painting, especially from 1880 on, to denote an emphasis on color and, later, patterning of the painted surface.[74] A number of artists in the Lane Collection were considered decorative in outlook: Renoir and Monet, as well as Pierre Puvis de Chavannes and Giovanni Segantini, to name a few.[75]

I have suggested that Lane connected the innate "artistry" of the ancient Celt with the contemporary idea of decoration in painting. Irish nationalists also claimed the ethnographic notion of the decorative "Celt" for their cause. Both the "Irish Ireland" brand of nationalism and the Celtic Revival promoted the essential goodness, piety, and nobility of the Irish people, as well as their innate artistry, as evident in, for example, the "Derry Horde" of Celtic gold discovered in 1896 and the celebrated Book of Kells. By 1911 the nationalist author and Arts and Crafts advocate Alice Stopford Green evoked an ethnographic view of "the Celt" to construct a lineage for Irish Ireland nationalism in her book *Irish Nationality*. "The real significance of Irish history," she asserted, is "the idea of a society loosely held together in a political sense, but bound together in a spiritual union" based in "periodical exhibitions of everything people esteemed," especially art.[76] The ethnographic link between an Irish state, however ancient or imaginary, and Celtic art became a part of Irish nationalist rhetoric.[77]

Lady Gregory considered Lane's gallery scheme a nationalist project, as she stated in an editorial published in Gaelic in the Gaelic League weekly paper, *An Claidheamh Soluis*. She later published the text, in English, in her biography of Lane, but its first appearance in the recently radicalized mouthpiece of Irish Ireland activism emphasizes the nationalist context of Lane's project.[78] She suggested that those who were suspicious of it were actually suspicious of individual liberty and philanthropy. To counter this contempt, she argued that there is a "logical force" when a project is undertaken "through a single mind." She alluded to the ambivalence of some Irish nationalists to the project and hinted that they misunderstand Lane's motives. Lady Gregory wrote, "Parnell did it in our day in politics, and it must surely be done in things of the spirit; *Sinn Fein*—'we ourselves'—is well enough for the day's bread, but is not *Mise Fein*—'I myself'—the last word in art?"[79]

Her conclusion struck at the heart of the tension between individual liberty and collective identity within the decorative, through a play on the motto of the Gaelic League, "Sinn Fein," usually translated as "we ourselves" or "ourselves

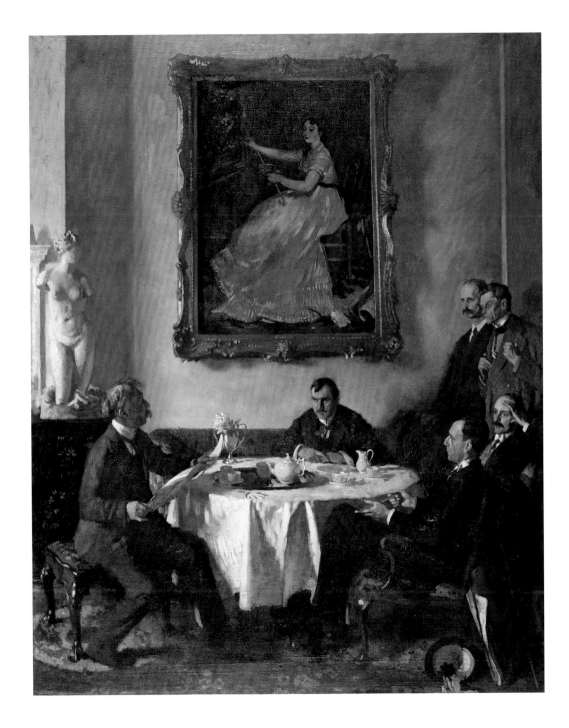

85. William Orpen, *Homage to Manet*, oil on canvas (1909), 64⅛ x 51¼ in. (162.9 x 130 cm). Manchester
Art Gallery.

alone." Arthur Griffith borrowed this phrase from an earlier campaign to support Irish-made products for the nationalist political party he founded in 1905. Sinn Fein emerged in this moment as a more radical alternative to the defeated Irish Parliamentary Party of Charles Stewart Parnell and its support for an Ireland ruled from home yet still part of the British Empire. Griffith and his followers challenged the "Liberal alliance" of individualism, Irish nationalists, and Home Rule.[80] Rhetorically, Lady Gregory undid the decorative collectivism of Lane's project by decoupling the art offered by the dealer from the craft of daily life and a day's bread. In her defense of Lane's project, she suggested that any collective movement requires leadership and, therefore, individual leaders.

From the opening of the gallery in a temporary location in 1908, Lane battled the Corporation of the City of Dublin on provisions for the collection, including the selection of the location and the architect for the permanent home.[81] Lady Gregory equated Lane's efforts in the realm of culture with the political efforts of Parnell for an independent Ireland. In a sense she implied that the art gallery would be as effective as legislation in creating an Irish state.[82] The final council vote on the gallery reveals that this argument did not convince all of the nationalist members.[83] Some withdrew their support from Lane, exasperated by what they saw as his desire for a monument to himself "far more conspicuous" than the one to Parnell.[84]

The rejection by the Dublin Corporation of his proposed scheme in 1913 led Lane to change his will and leave many of the pictures to the National Gallery in London. An unsigned codicil from 1915, however, transferred the pictures back to Dublin. The two institutions now share the "conditional gift." Lucy McDiarmid has discussed the "Hibernization" of Lane and his paintings, the way in which the works became "talismanic national objects for the people of Ireland."[85] Yet the Hibernian identity of these Impressionist paintings was not merely contextual; rather, Lane's gallery suggested continuity, rather than conflict, with Irish identity through a discourse of decoration.

LIBERAL ART?

Decoration became a key part of Edwardian cultural politics, because decorative art could be, and often was, public art.[86] The placement of paintings within public interiors had been a national preoccupation since the unveiling of a scheme for the new Palace of Westminster in the 1840s, and because of the enthusiasm for public art, there were plans for mural decoration in several public buildings.[87] Ruskin looked to the past to offer a clear vision of *decorative* painting as public art.

In his third lecture on the subject "Modern Manufacture and Design," delivered in Bradford on 1 March 1859, he argued that "*all the greatest art which the world has produced*" was, in fact, decorative: for example, "Raphael's best doing is merely the wall-colouring of a suite of apartments in the Vatican, and his cartoons were made for tapestries."[88] While conceding that precisely what constitutes decorative art "remains confused and undecided," Ruskin maintained that decorative art is not "degraded" or "separate" from other art. Rather, "its nature or essence is simply its being fitted for a definite place"; this condition is the "only essential distinction between Decorative and other art." Therefore, he said, all art "*may* be decorative" if the artist is attentive to its place, purpose, and material.[89]

In 1901 the British government announced that no public funds would be available to continue the decoration of the Palace of Westminster. The placement of decorative mural paintings within the palace had formed a national preoccupation since the formation of the Royal Fine Arts Commission in 1841; the historical and legendary subjects favored by its chair, Prince Albert, constructed a glorious, though imagined, national past.[90] The understanding of public art fostered by these commissions encouraged plans for mural decoration in numerous public buildings.[91] The end of mural decoration in Parliament seemed to signal the end of hopes for a national school of history painting in England.[92]

In 1906, however, Arthur Charles Hamilton Gordon, first Baron Stanmore, and the select committee appointed to investigate the unfinished condition of the decorations proposed the revival of them, but with a crucial difference: this time individual patrons would back individual artists, under the organization of Lewis Harcourt, MP, who served as first commissioner of works.[93] The Liberal victory of 1906 allowed Lord Stanmore's project to go forward, and the select committee voted to begin renewed decoration with the East Corridor of the House of Commons, a busy location traversed each day by the members of the lower house. Six patrons commissioned six artists for subjects from Tudor history.

Envisioning the execution of single panels by individual artists as an integrated decor was an attempt to strike a balance between individual and collective. Harcourt approved the artists and the subjects, and the Royal Academician Edwin Austin Abbey oversaw the selection of the artists and the overall design of the murals, ensuring that they formed an integrated decorative program. In the arrangement of the murals to create a "beautiful pattern," as well as a narrative, upon the walls, Abbey strove for a visual coherence that recalls the "Celtic" decorative impulse. He coordinated the palette among the artists, ensuring visual unity through a color scheme of red, gold, and black. In addition, he instructed artists to paint figures with a fixed horizon line for each composition. Such uniformity created the effect of a visual pattern among the various scenes.

This revival of mural painting not only reconfirmed the historical relationship between public art and private commission, but also further embroiled the conceptual category of decoration in political debates about Liberal cultural politics. What is the dividing line between public and private? Many of the crises of the Edwardian period stemmed from this fault line. For example, the assertion of a public, political identity for women exemplifies this divide: the "spectacle of women" parading through the streets and engaging in acts of civil disobedience as part of the women's suffrage moment.[94] Traditionally the Liberal Party stood for "the free individual in civil society, the free market, private property, and the patriarchal domestic household."[95] But Liberal policies became increasingly interventionist throughout the 1880s and 1890s, putting forth legislation that sought to regulate not only the economy but also civil society, especially in areas such as education, the arts, and the family. According to the historian Jordanna Bailkin, such legislation renegotiated the "status of individual and group rights of ownership."[96]

Questions of patronage and publics came to the fore during the completion and unveiling of the murals, as that coincided with a constitutional reform crisis. The Liberal government of Prime Minister Henry Campbell-Bannerman (and that of his successor, Herbert Henry Asquith) sought the appointment of Liberal peers to the House of Lords in order to control the Liberal legislative agenda. The rejection by the House of Lords of David Lloyd George's "people's budget" in 1909 led to counterthreats to strip the lords of power. Edward VII indicated that he was unwilling to create 500 Liberal peers to carry the Parliament bill. He died in the middle of this crisis, which was not fully resolved until the reign of George V with the Parliament Act of 1911. In contrast to this upheaval, the Tudor period provided exemplars of decisive leadership and cooperation, in some instances, among factions. Late-nineteenth-century historians such as Mandell Creighton and G. M. Trevelyan viewed the reign of Henry VIII as a period of constitutional reform that marked the emergence of national identity in the modern period.[97] The official guidebook to the historical paintings in Parliament, by William Martin Conway, elucidates the Liberal political values—from education to constitutional reform—underpinning each mural.

The parallel between Tudor history and early-twentieth-century politics is apparent in the scene funded by William Lygon, seventh Earl Beauchamp: *The Origin of Parties, Picking the Red and White Roses in Old Temple Gardens* by Henry A. Payne (fig. 86). (The subject invited censure since it was, strictly speaking, an event drawn from William Shakespeare's *Henry IV, Part I* rather than the historical record.) The decoration represents the origins of the dynastic quarrel between the houses of York and Lancaster, which Conway, for one, directly connected to the origin of "party government" in England.[98] The War of the Roses marked the decline

86. Henry A. Payne, *The Origin of Parties, Picking the Red and White Roses in Old Temple Gardens*, fresco (1910), 78¾ x 79⅛ in. (200 x 201 cm). Houses of Parliament, Westminster, London.

of the "old nobility" of England and the emergence of parliamentary government under the leadership of a "strong monarch."[99] Payne adapts some of the conventions of decorative painting to his scene, such as the compression of pictorial space and the division of the composition into areas of pattern and color, as seen in Burne-Jones's *Sleeping Princess*.[100]

Yet Payne balances these Celtic allusions with a Teutonic delight in the "pictorial record of things" found in the paintings of Jan van Eyck, for example.[101] The Arts and Crafts designer W. R. Lethaby had praised the ability of Van Eyck to combine pictorial realism with a rich "ornamental" quality.[102] This interest in balancing decoration with the desire for realism alludes to the complex and impossible demands placed on these paintings. Alan Powers has described them as "historical illustration," to distinguish them in both subject matter and style from "history painting" in the tradition of the Royal Academy. Yet, paradoxically, Powers suggested that the panels also "reflect" the Royal Academy's emphasis on subject painting, as opposed to "compositional design," usually privileged in decorative painting.[103] In subject matter and style, then, Payne's mural provides a dystopian postscript to Burne-Jones's Sleeping Beauty. The blooming roses in the Parliament painting do not herald the rebirth of art and culture, but instead portend the development of modern political parties. If the collective Celtic impulse implied socialism, then the Teutonic character matches the ethos of Liberal Party mural painting—individualistic, realistic, and moralistic.

These murals reveal the Liberal investment in decoration as an important mode for national culture, albeit one that seeks to paper over Parliamentary party strife.[104] Contemporary observers noted the importance of a gift from Lords to Commons in a government characterized by increasingly tense legislative stalemates. The *Illustrated London News*, for one, considered the murals in political terms, declaring them "Coals of Fire!" (a reference to the directive from Paul in Romans 12:20 to show kindness to an enemy, "for in doing so thou shalt reap coals of fire on his head"). As the newspaper explained, "Thus members of another place have heaped coals of fire on those who would abolish their order by bringing gifts to the House of which their political enemies—as well as many of their friends—are members."[105] By 1910 critics were seeking contemporary politics, rather than decorative effects, in the murals.

I have argued that a "political theory of decoration" attempted, and failed, to hold the demands of individualism and collectivism in balance in the Edwardian period. The civic humanism that John Barrell located in eighteenth-century history painting expanded in the first decade of the twentieth century to encompass not only public decorative schemes, but also the Arts and Crafts Exhibition Society and Hugh Lane's Municipal Gallery of Modern Art in Dublin. And decoration

precipitated its own moments of crisis: the Arts and Crafts Exhibition Society pondered the failure of the 1912 exhibition, while Lane turned his attention to South African collectors in 1913 as he dismantled his plans for a Dublin gallery, and mural paintings of Tudor history could not escape the political fray. Each instance moved decoration further away from the collective ideal. One month after the murals were revealed to the public, Roger Fry used the discourse of decoration to legitimize the modernism of Manet and the Post-Impressionists in England. Reflecting on the event in 1924, Virginia Woolf declared that "on or about December 1910 human character changed,"[106] alluding to the reaction of London audiences to the visual idiom of Cézanne, Matisse, and Paul Gauguin, among others. Perhaps it was the political theory of decoration, and not human character, that had changed.

Thanks to Jay Curley for his helpful comments on this essay.

1. S. K. Tillyard, *The Impact of Modernism 1900–1920: Early Modernism and the Arts and Crafts Movement in Edwardian England* (London and New York: Routledge, 1988), esp. chap. 2, "Early Modernism and the Arts and Crafts Movement," 47–80. See also Elizabeth Prettejohn, "Out of the Nineteenth Century: Roger Fry's Early Art Criticism, 1900–1906," in *Art Made Modern: Roger Fry's Vision of Art*, ed. Christopher Green (London: Merrell Holberton, in association with the Courtauld Gallery, Courtauld Institute of Art, 1999), 31–44.

2. For a cogent summary of this scholarship, see Elissa Auther, "The Decorative, Abstraction, and the Hierarchy of Art and Craft in the Art Criticism of Clement Greenberg," *Oxford Art Journal* 27, no. 3 (2004): 339–64.

3. As described in Jenny Anger, *Paul Klee and the Decorative in Modern Art* (Cambridge: Cambridge Univ. Press, 2004), 2.

4. See, for example, William Morris, *The Decorative Arts, Their Relation to Modern Life and Progress* (London: Ellis and White, 1878), 4–5: "Our subject is that great body of art, by means of which men have at all times more or less striven to beautify the familiar matters of everyday life."

5. Terry Eagleton, *The Ideology of the Aesthetic* (Cambridge, Mass.: Basil Blackwell, 1990), 316.

6. John Barrell, *Political Theory of Painting from Reynolds to Hazlitt: "The Body of the Public"* (New Haven: Yale Univ. Press, 1986).

7. Barrell, *Political Theory of Painting*, 1.

8. Barrell, *Political Theory of Painting*, 10.

9. T. J. Clark, *Farewell to an Idea: Episodes in the History of Modernism* (New Haven: Yale Univ. Press, 1999), 130.

10. See George Dangerfield, *The Strange Death of Liberal England* (1935; repr., New York: Capricorn Books, 1961). Dangerfield also included a fourth topic: the agitation for women's suffrage. See Lisa Tickner, *The Spectacle of Women: Imagery of the Suffrage Campaign, 1907–1914* (Chicago: Univ. of Chicago Press, 1988). I have considered Walter Crane's influence on suffragette decoration in Morna O'Neill, *Art and Labour's Cause Is One: Walter Crane and Manchester, 1880–1915* (Manchester: Whitworth Art Gallery, 2008), 113–14. For further discussion, see the essay by Deborah Sugg Ryan in this volume.

11. David Solkin, *Painting for Money: The Visual Arts and the Public Sphere in Eighteenth-Century England* (New Haven: Yale Univ. Press, 1993). Andrew Hemingway provides a cogent critique of Barrell's text in "The Political Theory of Painting without the Politics," *Art History* 10, no. 3 (Sept. 1987): 381–95.

12. See, for example, Tanya Harrod, *The Crafts in Britain in the Twentieth Century* (New Haven: Yale Univ. Press, 1999), 15–28. For a more contemporary perspective, see C. R. Ashbee, "English Arts and Crafts at the Royal Academy," *American Magazine of Art* 8, no. 4 (Feb. 1917): 137–45.

13. Vittorio Pica, *L'Arte Decorativa all'Esposizione di Torino del 1902* (Bergamo: Instituto Italiano d'Arti Grafiche, 1903), 181–82.

14. "L'Esposizione comprenderà le manifestazioni artistiche ed i prodotti industriali che reguardino sia l'estetica *della via*, come quella *della casa* e *della stanza*" (emphasis in the original). Articolo 2, *Catalogo Generale Ufficiale, Prima Esposizione Internationale d'Arte Decorativa Moderna Torino 1902*, Archivio Storico Città di Torino, Collezione Simeon CN2003, 11. All translations are author's own.

15. The display resembled "the vitrines of a museum or the engravings in a volume of the history of art: one admires, one analyzes, one compares, but one finds that there is very little to say about the stimulating interest in the current day" [le vetrine di un museo o le incisioni di un volume di storia dell'arte: si ammira, si analizza, si raffronta, ma assai dir ado vi si trova lo stimolante interesse dell'attualità]. Pica, *L'Arte Decorativa all'Esposizione di Torino*, 185.

16. Arts and Crafts Exhibition Society, *Catalogue of the Exhibition* (London, 1903), Archive of Art and Design collection, Victoria and Albert Museum (hereafter, AAD).

17. The catalogue for the 1903 exhibition of the Northern Art Workers' Guild (in the collection of the British Library) notes that "individualism being an article of the Guild's creed, it does not identify itself as a whole with the particular views of each of its members. Though all work exhibited meets the general approval of the guild, it must not be assumed that each object exhibited represents its collective ideal." Northern Art

Workers Guild, *Catalogue of Works Exhibited by Members of the Northern Art Workers Guild Municipal School of Technology Manchester* ([Manchester?]: Northern Art Workers Guild, 1903).

18. Minutes of the General Committee, 25 Feb. 1903, AAD (1/48-1980).

19. They suggested that the subcommittee would have to approve plans for the recesses in the future. It seems that exhibitors did not enter into the spirit of the plan, using their recesses "as so much space available for exhibition purposes." Minutes of the General Committee, 25 Feb. 1903.

20. "Second Notice," *Studio* 28 (1903), 117–26, esp. 117. See also "The Arts and Crafts Exhibition at the New Gallery: First Notice," *Studio* 28 (1903): 27–40.

21. "Arts and Crafts at the New Gallery," *Times* (London), 17 Jan. 1903, 3.

22. "Arts and Crafts at the New Gallery," 3.

23. "Arts and Crafts Exhibition at the New Gallery: First Notice," 32.

24. The exhibition provoked "melancholy" since "the advance which one had every right to expect has not taken place." "The Arts and Crafts Exhibition at the Grafton Gallery, First Notice," *Studio* 37 (1906): 48–56, esp. 48, 50.

25. Walter Crane, "Arts and Crafts Exhibition Society," *Times*, 24 June 1907, 8.

26. A. R. Orage, "Politics for Craftsmen," *Contemporary Review* 91 (June 1907): 782–94, esp. 783. Eric Gill also formulated a critique of the Arts and Crafts movement soon after; see Eric Gill, "The Failure of the Arts and Crafts Movement," *Socialist Review* 10 (Dec. 1909): 291, and his later "Revival of Handicraft," in *Art Nonsense* (London: Cassell & Co., 1929), 117.

27. For another early history of the Arts and Crafts movement, see Holbrook Jackson, *Eighteen Nineties: A Review of Art and Ideas at the Close of the Nineteenth Century* (London: G. Richards, 1913).

28. For Orage and the Leeds Art Club, see Tom Steele, *Alfred Orage and the Leeds Art Club, 1893–1923* (Aldershot, UK: Scolar Press, 1990).

29. Quoted in Tom Gibbons, *Rooms in the Darwin Hotel: Studies in English Literary Criticism and Ideas, 1880–1920* (Crawley, Perth: Univ. of Western Australia Press, 1973), 103.

30. For Orage and the *New Age*, see Ruth Livesey, *Socialism, Sex, and the Culture of Aestheticism in Britain, 1880–1914* (Oxford: Oxford Univ. Press, 2007), esp. chap. 6, "Engendering a New Age: Isabella Ford and Alfred Orage," 161–92.

31. Orage, "Politics for Craftsmen," 782.

32. Orage, "Politics for Craftsmen," 782.

33. Orage, "Politics for Craftsmen," 783.

34. Orage, "Politics for Craftsmen," 787. While Orage recommended a break with the workmen, W. R. Lethaby advocated a union with economists, since "they have unction and conviction; they can touch the springs of faith in the modern mind about 'science' with texts on supply and demand, and the laws of diminishing returns." Through such an alliance, the Arts and Crafts movement could found "a new school of Productive Economy in England." W. R. Lethaby, "Political or Productive Economy?" (1915), in *Form in Civilization: Collected Papers on Art and Labour* (London: Oxford Univ. Press, 1957), 159.

35. Orage, "Politics for Craftsmen," 787.

36. This elitism also emerges in his essays and opinion pieces for the *New Age*, such as "New Romanticism," *New Age* 19 (4 March 1909): 379, which advocated the establishment of a superior "guardian" class inspired by Plato's ideal Republic.

37. Orage, "Politics for Craftsmen," 789.

38. Crane, introduction to Jack C. Squire, *Socialism and Art* (London: Twentieth Century Press, 1907). Italics in the original.

39. Crane, introduction to *Socialism and Art*.

40. Orage, "Politics for Craftsmen," 790.

41. According to Eric Hobsbawm, "The theory of the founders of the general unions (and of their predecessors) was fairly simple. The 'labourer', mobile, helpless, shifting from one trade to another, was incapable of using the orthodox tactics of craft unionism." Eric Hobsbawm, *Labouring Men: Studies in the History of Labour* (London: Weidenfeld and Nicolson, 1964), 181. See also Gareth Stedman Jones, "Working Class

Culture and Working Class Politics in London, 1870–1900," *Journal of Social History* 7, no. 4 (1974): 460–508.

42. Crane, letter to the editor, *New Age*, 2 Nov. 1907, MS in Beinecke Rare Book and Manuscript Library, Yale University; written in response to a review of *Socialism and Art* in *New Age*, 31 Oct. 1907.

43. For a discussion of Guild Socialism, see Stanley Pierson, *British Socialists: The Journey from Fantasy to Politics* (Cambridge, Mass.: Harvard Univ. Press, 1979).

44. Orage, "Politics for Craftsmen," 794. Ruth Livesey pointed out that Guild Socialism was anti-collectivism, and that Penty in particular allied the artist and the aristocrat. See Livesey, *Socialism, Sex, and the Culture of Aestheticism*, 185–86.

45. Arts and Crafts Exhibition Society minute books, AAD 1/50-1980.

46. According to Arts and Crafts Exhibition Society minute books, AAD 1/50-1980.

47. Grant Allen, "The Celt in English Art," *Fortnightly Review* 55, n.s. 49 (1 Feb. 1891): 267–77.

48. These categories were probably influenced by the French art critic Ernest Chesneau, who first opposed the abstract nature of "Latin art" to the realist impulse of "Saxon art" in 1868. See Patricia Mainardi, *Art and Politics of the Second Empire: The Universal Exhibitions of 1855 and 1867* (New Haven: Yale Univ. Press, 1987), 163. The English context can be traced back to the rise of Victorian ethnography in the 1850s, although Matthew Arnold's 1867 text "On the Study of Celtic Literature" is the best-known exposition on this topic. See George Stocking, *Victorian Anthropology* (New York: Free Press, 1987).

49. Allen, "Celt in English Art," 267.

50. Allen, "Celt in English Art," 267.

51. Allen, "Celt in English Art," 267.

52. Allen, "Celt in English Art," 271. See also Grant Allen, "Spencer and Darwin," *Fortnightly Review* 67 (1897), reprinted in Allen, *The Hand of God and Other Essays* (London: Watts and Co., 1909).

53. The gallery opened to the public in 17 Harcourt Street (Clonmell House) on 20 Jan. 1908.

54. Lane's Irish relatives included his cousin Captain John Shawe-Taylor, whose suggestion, in 1902, alongside agitation by the United Irish League, reinvigorated discussions of the redistribution of land. See Fergus Campbell, "Irish Popular Politics and the Making of the Wyndham Land Act, 1901–1903," *Historical Journal* 45, no. 4 (2002): 755–75. The resulting Wyndham Land Act, passed in 1903, seemed to put an end to the Irish Land War. See Margaret O'Callaghan, *British High Politics and a Nationalist Ireland: Criminality, Land, and the Law under Forster and Balfour* (New York: St. Martin's Press, 1994).

55. See Hugh Lane, *Catalogue of the Exhibition of Works by Irish Painters* (London: Guildhall, 1904), x. For the failure of the Irish to stage their own exhibition, see Nicola Gordon Bowe, "The Search for Vernacular Expression: The Arts and Crafts Movements in America and Ireland," in *The Substance of Style: Perspectives on the American Arts and Crafts Movement*, ed. Bert Denker (Winterthur, Del.: Winterthur Museum and Univ. Press of New England), 5–24, esp. 16.

56. Lane, *Catalogue of the Exhibition*, x.

57. Lane, *Catalogue of the Exhibition*, ix.

58. See Frances S. Connelly, *The Sleep of Reason: Primitivism in Modern European Art and Aesthetics, 1725–1907* (University Park, Pa.: Pennsylvania State Univ. Press, 1995), 5.

59. Lane, *Catalogue of the Exhibition*, ix. Lane's plans also included a loan exhibition for Belfast in 1906.

60. "Gallery of Modern Art in Dublin," *Cork Examiner*, 8 March 1907, in MS 35,828/15, National Library of Ireland, Dublin.

61. See Gordon Bowe, "Search for Vernacular Expression," 5–24, and Nicola Gordon Bowe, "A Contextual Introduction to Romantic Nationalism and Vernacular Expression in the Irish Arts and Crafts Movement, c. 1886–1925," in *Art and the National Dream: The Search for Vernacular Expression in Turn-of-the-Century Design*, ed. Nicola Gordon Bowe (Dublin: Irish Academic Press, 1993), 181–200. In 1908 Lane organized an exhibition of Irish art for Ballymaclinton, the Irish village, at the Franco-British Exhibition.

62. The connection made by the Earl of Mayo is described by a newspaper correspondent in "The Art Movement in Dublin," *Dublin Express*, 18 April 1905. See National Library of Ireland, Dublin, press clipping album, Ruth Shine collection.

63. For this exhibition, see Annie E. Coombes, *Reinventing Africa: Museums, Material Culture and Popular Imagination* (New Haven: Yale Univ. Press, 1994), 187–213.

64. *Times* (London), 3 June 1908, 8, quoted in Coombes, *Reinventing Africa*, 256 n. 57.

65. Thomas Bodkin, *Hugh Lane and His Pictures* (Dublin: Stationary Office for the Arts Council, 1956), 19.

66. National Library of Ireland, Dublin, press clipping album, Ruth Shine collection.

67. "A few choice eighteenth-century couches and chairs, and side-tables" adorned with "porcelain bowls and bronze vases full of flowers and foliage" decorated the gallery, according to Lane's friend Thomas Bodkin. Bodkin, *Hugh Lane and His Pictures*, 18–19, quoted in Neil Sharp, "The *Wrong* Twigs for an Eagle's Nest? Architecture, Nationalism and Sir Hugh Lane's Scheme for a Gallery of Modern Art, Dublin, 1904–13," in *The Architecture of the Museum*, ed. Michael Giebelhausen (London: Palgrave MacMillan, 2003), 40.

68. Lady Gregory, *Hugh Lane's Life and Achievement, with Some Account of His Dublin Galleries* (London: John Murray, 1921), 49.

69. While plans for the Dublin gallery stalled, Lane made provisions for its decoration: "In spring 1912, he had offered three prizes of £100 each for artists to produce designs for panels measuring eight feet square to be approved by him and to be installed in his proposed new Dublin gallery." Robert O'Byrne, *Hugh Lane, 1875–1915* (Dublin: Lilliput Press, 2000), 171. The winners were Walter Bayes for *Irish Linen*, Frederick Cayley Robinson for *The Coming of Saint Patrick*, and James Mark Willcox for *Deirdre Presenting Cuchulain to Her Husband*. The artists were not Irish.

70. Orpen began the painting in 1906 when the Manet was hanging in his studio, on loan from Lane. He changed the cast of characters and the composition over the course of three years, before exhibiting the final version at the New English Art Club exhibition of 1909. The Manchester City Art Gallery purchased the work in 1910. The assembled admirers create a genealogy for Impressionism in Britain: Philip Wilson Steer, Walter Sickert, Henry Tonks, D. S. MacColl, George Moore, and Lane himself. See Bruce Arnold, *Orpen: Mirror to an Age* (London: Jonathan Cape, 1981), 227–36.

71. See Kate Flint, *Impressionist in England: The Critical Reception* (London: Routledge and Kegan Paul, 1984), 28, and Flint, "Moral Judgment and the Language of English Art Criticism, 1870–1910," *Oxford Art Journal* 6, no. 2 (1985): 59–66. For the Irish context in particular, see S. B. Kennedy, *Irish Art and Modernism* (Belfast: Institute for Irish Studies, 1991).

72. National Library of Ireland, Dublin, MS 13071-2.

73. See Robert Herbert, *Nature's Workshop: Renoir's Writings on the Decorative Arts* (New Haven: Yale Univ. Press, 2000), 66.

74. See, for example, Stephen Levine, "Décor/Decorative/Decoration in Claude Monet's Art," *Arts Magazine* 51 (Feb. 1977): 136–39.

75. See Levine, "Décor/Decorative/Decoration," and Robert Herbert, "The Decorative and the Natural in Monet's Cathedrals," in *Aspects of Monet: A Symposium on the Artist's Life and Times*, ed. John Rewald and Frances Weitzenhoffer (New York: Harry N. Abrams, 1984), 162–69.

76. See Alice Stopford Green, *Irish Nationality* (London: Williams and Norgate, 1911), 20–21. Stopford Green supported nationalist causes, which she often allied with traditional crafts practices.

77. See, for example, Jeanne Sheehy, *The Rediscovery of Ireland's Past: The Celtic Revival, 1830–1930* (London: Thames and Hudson, 1980), and Paul Larmour, *The Arts and Crafts Movement in Ireland* (Belfast: Friar's Bush Press, 1992).

78. Eoin MacNeill served as the first editor of the paper, but the appointment of Patrick Pearse, after a "Home Ruler of the School of John Redmond" like MacNeill, indicated a new direction for the publication. See F. S. L. Lyons, *Ireland since the Famine* (London: Weidenfield and Nicolson, 1973), 320–21, and Donal MacCartney, "MacNeill and Irish Ireland," in *The Scholar Revolutionary: Eoin MacNeill, 1867–1945, and the Making of the New Ireland*, ed. F. X. Martin and F. J. Byrne (Shannon: Irish Univ. Press, 1973), 77. MacNeill founded the Gaelic League in 1893 to advocate for a spoken Irish language for Ireland.

79. See Gregory, *Hugh Lane's Life and Achievement*, 62–64.

80. See Coombes, *Reinventing Africa*, 210. See also John Hutchinson, *The Dynamics of Cultural Nationalism: The Gaelic Revival and the Creation of the Irish Nation State* (Boston: Allen & Unwin, 1987), as well as Robin

Wilson, "Imperialism in Crisis: The 'Irish Dimension,'" in *Crises in the British State, 1880–1930*, ed. Mary Langan and Bill Schwarz (London: Hutchinson, in association with the Centre for Contemporary Cultural Studies, Univ. of Birmingham, 1985).

81. Lane did not make a provision in his gift for funding that would extend to a building fund or staff. For a full account of the history of the Hugh Lane Gallery, see Barbara Dawson, "Hugh Lane and the Origins of the Collection," in *Images and Insight*, ed. Barbara Dawson (Dublin: Hugh Lane Municipal Gallery of Modern Art, 1993), 13–33. See also Sharp, "*Wrong* Twigs for an Eagle's Nest?" 32–53.

82. Lane's chief opponent, the newspaper magnate William M. Murphy, discounted the notion of the gallery as a philanthropic project, however: "I look upon it all as business, and very good business." Quoted in Lucy McDiarmid, *The Irish Art of Controversy* (Ithaca, N.Y.: Cornell Univ. Press, 2005), 31.

83. Council members affiliated with the Labour Party voted against an amendment that Lane's chosen "bridge site" was "expensive, unpopular, and highly impractical," while Sinn Fein and Unionist councillors supported this amendment. See J. V. O'Brien, *"Dear Dirty Dublin": A City in Distress, 1899–1916* (Berkeley: Univ. of California Press, 1982), 56.

84. Quoted in McDiarmid, *Irish Art of Controversy*, 27.

85. McDiarmid, *Irish Art of Controversy*, 38–39.

86. Morna O'Neill, "'Art Reborn': Painting, Politics, and Decoration in the Work of Walter Crane, 1870–1900" (PhD diss., Yale Univ., 2004).

87. For further discussion, see Clare A. P. Willsdon, *Mural Painting in Britain, 1840–1940: Image and Meaning* (Oxford: Oxford Univ. Press, 2000).

88. John Ruskin, *The Two Paths*, in *Library Edition of the Works of John Ruskin*, ed. E. T. Cook and Alexander Wedderburn, 39 vols. (London: G. Allen, 1903–12), 16:320–21. Italics in original.

89. Ruskin, *Two Paths*, 320–21. Italics in original.

90. As discussed in Willsdon, *Mural Painting in Britain*, 169.

91. For further discussion, see Willsdon, *Mural Painting in Britain*, and Malcolm Hay and Jacqueline Riding, eds., *Art in Parliament: The Permanent Collection of the House of Commons* (London: Palace of Westminster and Jarrold Publishing, 1996).

92. See, for example, both Will Vaughan, "'God Help the Minister who Meddles in Art': History Painting in the New Palace of Westminster," and Debra N. Mancoff, "Myth and Monarchy: Chivalric Legends for the Victorian Age," in *The Houses of Parliament: History, Art, Architecture*, ed. David Cannadine (London: Merrell, 2000). Alan Powers addresses the continuation of this debate in the twentieth century with his consideration of the later murals in "History in Paint: The Twentieth-Century Murals," *Apollo* 135, no. 363 (May 1992): 317–21.

93. According to Alan Powers, the suggestion of individual patronage came from the art critic and administrator D. S. MacColl, who advocated individual patrons for particular artists in order to create "an interesting picture gallery." Powers, "History in Paint," 317. In contrast to earlier efforts, the revival of the decorative scheme resulted from "private enthusiasm and generosity," as described in William Martin Conway, *The Historical Paintings in the Houses of Parliament* (London: Fine Arts Publishing, 1911), 1.

94. See Tickner, *Spectacle of Women*.

95. Stuart Hall and Bill Schwarz, "State and Society, 1880–1930," in Langan and Schwarz, *Crises in the British State*, 10.

96. Jordanna Bailkin, *The Culture of Property: The Crisis of Liberalism in Modern Britain* (Chicago: Univ. of Chicago Press, 2004), 12.

97. See Willsdon, *Mural Painting in Britain*, 100. The scenes include the following: George James Howard, ninth Earl of Carlisle, sponsored a panel by F. Cadogan Cowper, *The New Learning in England*, a scene of Erasmus and Sir Thomas More visiting the children of Henry VII in 1499. Ernest Board treated the sixteenth century in his decoration, *Latimer Preaching before Edward VI at Saint Paul's Cross, 1548*, with the patronage of Sydney James Stern, first Baron Wandsworth. In *Cardinal Wolsey at the Trial of Catherine of Aragon and Henry VIII at Blackfriars* in 1528, the artist Frank O. Salisbury depicts the one non-Liberal patron, Lord Stanmore, as a bishop. Denis Eden painted *John Cabot and His Sons Receive the Charter*

from Henry VII to Sail in Search of New Lands, 1496, with a commission from William Henry Wills, first Baron Winterstoke.

98. Conway, *Historical Paintings*, 7.

99. Quoted in Willsdon, *Mural Painting in Britain*, 100.

100. The German critic Hermann Muthesius described this school as "Neo-Pre-Raphaelite," a group that also included Gerald Moira and Frank Brangwyn. See Hermann Muthesius, "Kunst und Leben in England," *Zeitschrift for Bildenden Kunst* 13 (1902), 69, quoted in Willsdon, *Mural Painting in Britain*, 97.

101. Allen, "Celt in English Art," 268, 269.

102. W. R. Lethaby, *The Study and Praise of Artistic Crafts*, address delivered to the students at the Birmingham Municipal School of Art, 15 Feb. 1901 (London and Birmingham: Birmingham Municipal School of Art, 1901), 11, quoted in Willsdon, *Mural Painting in Britain*, 102.

103. Powers, "History in Paint," 318.

104. Harcourt kept the panels secret until their unveiling, and many of the artists seemed unaware of the political thrust of their subject matter, as noted in Willsdon, *Mural Painting in Britain*, 102.

105. *Illustrated London News*, 5 Nov. 1910, 699, quoted in Powers, "History in Paint," 319. Claire Willsdon points out that "the date of this article (Guy Fawkes Night) would of course have added a further critical innuendo." See Willsdon, *Mural Painting in Britain*, 102 n. 38.

106. Virginia Woolf, "Mr. Bennett and Mrs. Brown" (1924), in *The Essays of Virginia Woolf*, 4 vols. (San Diego: Harcourt Brace Jovanovich, 1966–67), 1:320. For a discussion of this essay as a marker of Edwardianism, see Simon Joyce, "On or about 1901: The Bloomsbury Group Looks Back at the Victorians," *Victorian Studies* 46, no. 4 (Summer 2004): 631–55.

Notes on Contributors

Tim Barringer is Paul Mellon Professor of the History of Art at Yale University. His research interests have focused on Victorian Britain. His books include *Reading the Pre-Raphaelites* (1998) and *Men at Work: Art and Labour in Victorian Britain* (2005). He coauthored, with Andrew Wilton, *American Sublime: Landscape Painting in the United States, 1825–1880* (2002), the accompanying catalogue to an exhibition for which he was co-curator. He was co-curator, with Gillian Forrester and Barbaro Martinez-Ruiz, of *Art and Emancipation in Jamaica: Isaac Mendes Belisario and His Worlds* (Yale Center for British Art, 2007) and coeditor of the accompanying publication. He is currently conducting research for a book entitled *Broken Pastoral: Art and Music in Britain*.

Dame Gillian Beer is Professor Emeritus at the University of Cambridge. She is a Fellow of the British Academy and of the Royal Society of Literature and is an Honorary Foreign Member of the American Academy of Arts and Sciences. Among her books is *Darwin's Plots* (3rd ed., 2009), and she is at present completing a study of Lewis Carroll's *Alice* books in the light of intellectual controversies in Britain in the mid-nineteenth century.

Christopher Breward is Head of the Research Department at the Victoria and Albert Museum. Before joining the V&A, he was Head of Research at the London College of Fashion, University of the Arts, London, where he holds a Visiting Professorship. His research interests lie in the field of fashion history, and he has published widely on fashion's relation to masculinity, metropolitan cultures, and concepts of modernity. He is also co-curator of the V&A's headline exhibition for 2012, entitled *Britain Designs 1948–2012*.

Martina Droth is Head of Research at the Yale Center for British Art, where she also holds the position of Curator of Sculpture. She works on sculpture and the decorative arts, primarily nineteenth-century British, and her research interests include materiality and making, collecting and display, the studio and domestic interior, and the self-fashioning of the artist. Recent projects include an exhibition (and accompanying catalogue) entitled *Taking Shape: Finding Sculpture in the*

Decorative Arts, organized with the J. Paul Getty Museum, the Henry Moore Institute, and Temple Newsam; recent articles include "Sculpture and Aesthetic Intent in the Late Victorian Interior," in *Rethinking the Interior* (2010). She is currently working on a book provisionally entitled *Sculpture and the Cult of Domesticity*.

Bronwen Edwards is Senior Lecturer in Human Geography at Leeds Metropolitan University. She has written on twentieth-century metropolitan retail cultures, landscapes, and architecture, focusing particularly on London. She is currently conducting research on the John Lewis Partnership.

David Gilbert is Professor of Urban and Historical Geography at Royal Holloway, University of London. His work over the past fifteen years has been closely focused on the history of modern London. He has written extensively, in particular, on the history of urban tourism, London in the planning imagination, fashion and the city, and suburban London. Earlier work concerned the historical geographies of protest, community, and collective identity, and it was particularly concerned with strikes and the British coal industry. His publications include *Fashion's World Cities* (coedited with Christopher Breward, 2006) and *Imperial Cities* (coedited with Felix Driver, 2003).

Tom Gunning is the Edwin A. and Betty L. Bergman Distinguished Service Professor in the Department of Art History and the Committee on Cinema and Media at the University of Chicago. He is the author of *D. W. Griffith and the Origins of American Narrative Film* (1991) and *The Films of Fritz Lang: Allegories of Vision and Modernity* (2000), well as more than one hundred articles on early cinema, film history and theory, avant-garde film, film genre, and cinema and modernism.

Imogen Hart is a Postdoctoral Research Associate at the Yale Center for British Art. The author of *Arts and Crafts Objects* (forthcoming) and coeditor, with Jason Edwards, of *Rethinking the Interior, 1867–1896: Aestheticism and Arts and Crafts* (forthcoming), she has also published essays on Arts and Crafts magazines. More recently, her research has focused on the work of William Morris.

Michael Hatt is Professor of History of Art at the University of Warwick. Previously he was Head of Research at the Yale Center for British Art. He has worked on a wide range of topics in nineteenth-century British and American art, and his publications include *Art History: A Critical Introduction to Its Methods*, coauthored with Charlotte Klonk (2006). He is currently completing a book on homosexuality, imagination, and vision in Britain, 1885–1910.

Dr. Anne Helmreich is Associate Professor of Art History at Case Western Reserve University and Director of the Baker-Nord Center for the Humanities at the university. Her work on nineteenth-century British art ranges from garden design to print culture and is characterized by an interest in investigating the links

between art and the broader sociohistorical context. Her most recent monograph is *The English Garden and National Identity: The Competing Styles of Garden Design, 1870–1914* (2002). She is currently researching the dynamic interchange between art and science in nineteenth-century Britain and relationships between the art market in Paris and London in the nineteenth century.

Lynda Nead is Pevsner Professor of the History of Art at Birkbeck College. Her research addresses the history of nineteenth-century British visual culture. Her books include *The Haunted Gallery: Painting, Photography and Film c. 1900* (2008), and *Victorian Babylon: People, Streets and Images in Nineteenth-Century London* (2000), both for Yale University Press; *The Female Nude: Art, Obscenity and Sexuality* (1992); and *Myths of Sexuality: Representations of Women in Victorian Britain* (1988). She is currently engaged in research for a book entitled *The Art of Boxing: A Book in Twelve Rounds*, which examines the philosophical and aesthetic aspects of the sport.

Morna O'Neill is Assistant Professor of Art History in the Department of Art, Wake Forest University. Her research considers the work of Walter Crane (1845–1915) within the context of the Aesthetic movement, the Arts and Crafts movement, and socialist politics. She curated the exhibition *Art and Labour's Cause Is One: Walter Crane and Manchester, 1880–1900* at the Whitworth Art Gallery at the University of Manchester (2008) and authored the accompanying publication of the same title. Her book *Walter Crane: The Arts and Crafts, Painting, and Politics, 1875–1900* is forthcoming. Her current research considers the history of displaying decorative arts at international exhibitions.

Barbara Penner is a Lecturer in Architectural History at the Bartlett School of Architecture, University College London. With Jane Rendell and Iain Borden, she coedited *Gender Space Architecture* (2000) and is the author of *Newlyweds on Tour: Honeymooning in Nineteenth-Century America* (2009). She and Charles Rice collaborate specifically on work concerning domesticity, interiors, and their representations within culture.

Christopher Reed is Associate Professor of English and Visual Culture at Pennsylvania State University. His primary scholarly focus has been on the Bloomsbury Group, most extensively in his book *Bloomsbury Rooms* (1996). His edited volumes include *A Roger Fry Reader* (1996) and *Not at Home: The Suppression of Domesticity in Modern Art and Architecture* (1996). He co-organized (with Nancy Green) *Rooms of Their Own: Bloomsbury Artists in American Collections* (2008), an exhibition of Bloomsbury art in American collections. He is researching a new project concerning constructions of Occidental forms of masculinity through attitudes toward Japanese art and design. His book *The Chrysantheme Papers: The Pink Notebook of Madame Chrysantheme and Other Documents of French Japonism* is forthcoming.

Charles Rice is Associate Professor of Architecture, Director of Research Programs, and Director of the Centre for Contemporary Design Practices in the Faculty of Design, Architecture and Building at the University of Technology, Sydney. He is the author of *The Emergence of the Interior: Architecture, Modernity, Domesticity* (2006). Recent essays on the interior, atmosphere, and the city appear in *Intimate Metropolis: Urban Subjects in the Modern City* (2008) and *Space Reader: Heterogeneous Space in Architecture* (2009). An ongoing collaboration with Barbara Penner looks at questions of evidence in architectural history.

Andrew Stephenson is Subject Director for Visual Theories and Architecture and Visual Arts Research Leader at the University of East London. He has published extensively on British art and design of the late nineteenth and twentieth centuries; most recently "'Telling Decoratively': Ben Nicholson's *White Reliefs* and Debates around Abstraction and Modernism in the Home in the Late 1920s and 30s," in *Visual Culture in Britain* (2008), and "Palimpsestic Promenades: Memorial Sculpture and the Urban Consumption of Space in Post-1918 London," in *The Political Economy of Art* (2008). He is currently working on a study of British modernism, 1920–40, and *Patrilenes: Masculine Self-fashioning and Artistic Performance in Britain, 1850–1910*.

Deborah Sugg Ryan is Senior Lecturer in Histories and Theories of Design at University College Falmouth. Her research focuses on the design and visual and material culture of popular modernity in the first half of the twentieth century in Britain. Her publications include *The Ideal Home through the Twentieth Century* (1997) and several articles on Edwardian pageants, the most recent of which is "'Pageantitis': Frank Lascelles's 1907 Oxford Historical Pageant, Visual Spectacle and Popular Memory," in *Visual Culture in Britain* (2007). She is currently writing *The Inter-War Home: The Design and Decoration of the Middle-Class Suburban House in Britain, 1919–39*.

Angus Trumble is Senior Curator of Paintings and Sculpture at the Yale Center for British Art and was previously Curator of European Art at the Art Gallery of South Australia in Adelaide. He is the author of *Bohemian London: Camden Town and Bloomsbury Paintings in Adelaide* (1997), *Love and Death: Art in the Age of Queen Victoria* (2001), *A Brief History of the Smile* (2004), and *The Finger: A Handbook* (forthcoming).

Photography Credits

Every effort has been made to credit the photographers and sources of all illustrations in this volume; if there are any errors or omissions, please contact Yale University Press so that corrections can be made in any subsequent edition.

Courtesy of Agnew's: front cover, fig. 26

Beatrice Webb House, Dorking, Surrey, UK / The Bridgeman Art Library International: fig. 48

Beinecke Rare Book and Manuscript Library, Yale University: fig. 73

Courtesy of Christopher Breward: fig. 37

Courtesy of the British Film Institute / National Archive: back cover, figs. 1, 2, 4, 6, 65

© The British Library Board. All Rights Reserved (h.3930.c.[9.]): fig. 69

© The British Library Board. All Rights Reserved (LON224): fig. 21

© Country Life: figs. 45, 46, 49, 82

© Samuel Courtauld Trust, The Courtauld Gallery, London, UK / The Bridgeman Art Library International: fig. 27

Courtesy of the Dover Pageant Society: fig. 10

Dublin City Gallery, The Hugh Lane: fig. 84

Courtesy of The Elgar Birthplace Museum: fig. 64

Reproduced by permission of English Heritage. NMR: figs. 33, 34

Getty Images: figs. 15, 16

© 2005 Getty Images: fig. 79

Courtesy of David Gregory, Postcards of the Past: fig. 7

Houses of Parliament, Westminster, London, UK / The Bridgeman Art Library International: fig. 86

Kensington Gardens, London, UK / The Bridgeman Art Library International: figs. 52, 56, 58, 59, 60

© Leeds Museums and Galleries (City Art Gallery), UK / The Bridgeman Art Library International: fig. 75

© Manchester Art Gallery, UK / The Bridgeman Art Library International: fig. 85

Mirror Group Newspapers Ltd, © Museum of London: fig. 19

Musée Rodin, Paris: fig. 80

© Museum of London: figs. 14, 20

© The Museum of Modern Art / Licensed by SCALA / Art Resource, NY: fig. 74

Collection of Eckart Muthesius: fig. 32

National Gallery of Australia, Canberra: fig. 29

The Trustees of the National Library of Scotland: figs. 5, 54

© National Portrait Gallery, London: fig. 39

Private Collection / The Bridgeman Art Library International: figs. 28, 77

Private Collection, Richard Greenly Photography: fig. 81

Scottish National Gallery of Modern Art, Edinburgh, UK / The Bridgeman Art Library International: fig. 51

Image courtesy of the State Library of South Australia (SLSA: B 49700): fig. 31

Art Collection, University of Stirling: fig. 72

Courtesy of Deborah Sugg Ryan: fig. 12

© Tate, London 2010: fig. 30

© Time Life Pictures (Getty Images): fig. 13

© V&A Images / Victoria and Albert Museum, London: figs. 35, 38, 41, 55, 62

Worcester City Council Collection: figs. 67, 68

Richard Caspole, Yale Center for British Art: figs. 9, 11

Courtesy of the Yale University Library: figs. 3, 17, 18, 22, 23, 24, 25, 36, 40, 42, 43, 44, 47, 50, 53, 61, 63, 66, 76, 78, 83

Artists' Copyright Credits:

Frank Brangwyn

Courtesy of The Bridgeman Art Library International: figs. 74, 75

John Duncan Fergusson

© The Fergusson Gallery, Perth & Kinross Council, Scotland: figs. 72, 73

Augustus John

Courtesy of The Bridgeman Art Library International: fig. 81

Charles Harry Jones (photographer)

© 2010 Artists Rights Society (ARS), New York / DACS London: fig. 50

William Nicholson

© Desmond Banks: front cover, figs. 26, 28

Index